Vertigo

Released in 1958, *Vertigo* is widely regarded as Alfred Hitchcock's masterpiece and one of the greatest films of all time. This is the first book devoted to exploring the philosophical aspects of *Vertigo*. Following an introduction by the editor that places the film in context, each chapter reflects upon Hitchcock's film from a philosophical perspective. Topics discussed include:

- memory, loss, memorialization, and creativity
- mimetic or representational art and art as magic
- the nature of romantic love
- gender, sexual objectification, and identity
- looking, "the gaze," and voyeurism
- film and psychoanalysis
- fantasy, illusion, and reality
- the phenomenology of color.

Including annotated further reading at the end of each chapter, this collection is essential reading for anyone interested in *Vertigo*, and an ideal resource for students of film and philosophy.

Contributors: Noël Carroll, Eli Friedlander, Gregg M. Horowitz, Andrew Klevan, Katalin Makkai, Nickolas Pappas, William Rothman, and Charles Warren.

Katalin Makkai is Junior Professor of Philosophy at ECLA of Bard, Berlin (Germany). She is the author of "Kant on Recognizing Beauty," which appeared in the *European Journal of Philosophy*.

Philosophers on Film

In recent years, the use of film in teaching and practicing philosophy has moved to center stage. Film is increasingly used to introduce key topics and problems in philosophy, from ethics and aesthetics to epistemology, metaphysics, and philosophy of mind. It is also acknowledged that some films raise important philosophical questions of their own. Yet until now, dependable resources for teachers and students of philosophy using film have remained very limited. *Philosophers on Film* answers this growing need and is the first series of its kind.

Each volume assembles a team of international contributors to explore a single film in depth, making the series ideal for classroom use. Beginning with an introduction by the editor, each specially-commissioned chapter will discuss a key aspect of the film in question. Additional features include a biography of the director and suggestions for further reading.

Philosophers on Film is an ideal series for students studying philosophy and film, aesthetics, and ethics, and for anyone interested in the philosophical dimensions of cinema.

Available

- *Talk to Her*, edited by A. W. Eaton
- *The Thin Red Line*, edited by David Davies
- *Memento*, edited by Andre Kania
- *Eternal Sunshine of the Spotless Mind*, edited by Christopher Grau
- *Fight Club*, edited by Thomas Wartenberg

Forthcoming

- *Blade Runner*, edited by Amy Coplan
- *Mulholland Drive*, edited by Zina Giannopoulou

Vertigo

Edited by
Katalin Makkai

LONDON AND NEW YORK

First published 2013
by Routledge
2 Park Square, Milton Park, Abingdon, Oxon OX14 4RN

Simultaneously published in the USA and Canada
by Routledge
711 Third Avenue, New York, NY 10017

Routledge is an imprint of the Taylor & Francis Group, an informa business

© 2013 Katalin Makkai for selection and editorial matter;
individual contributors for their contributions.

The right of the editor to be identified as the author of the
editorial material, and of the authors for their individual chapters,
has been asserted in accordance with sections 77 and 78 of the
Copyright, Designs and Patents Act 1988.

All rights reserved. No part of this book may be reprinted or reproduced or
utilized in any form or by any electronic, mechanical, or other means,
now known or hereafter invented, including photocopying and recording,
or in any information storage or retrieval system, without permission in
writing from the publishers.

Trademark notice: Product or corporate names may be trademarks or
registered trademarks, and are used only for identification and explanation
without intent to infringe.

British Library Cataloguing in Publication Data
A catalogue record for this book is available from the British Library

Library of Congress Cataloging in Publication Data
Vertigo/edited by Katalin Makkai.
 p. cm. — (Philosophers on film)
 Includes bibliographical references and index.
 1. Vertigo (Motion picture: 1958) 2. Hitchcock, Alfred,
 1899–1980—Criticism and interpretation. I. Makkai, Katalin.
 PN1997.V479V47 2013
 791.43′72—dc23 2012021669

ISBN: 978-0-415-49446-5 (hbk)
ISBN: 978-0-415-49447-2 (pbk)
ISBN: 978-0-203-10057-8 (ebk)

Typeset in Joanna
by Florence Production, Stoodleigh, Devon, UK

Printed and bound in Great Britain by
TJ International Ltd, Padstow, Cornwall

Contents

Notes on contributors vii
Note on the director ix
Acknowledgments xi

1 Katalin Makkai 1
 INTRODUCTION

2 Nickolas Pappas 18
 MAGIC AND ART IN *VERTIGO*

3 William Rothman 45
 SCOTTIE'S DREAM, JUDY'S PLAN, MADELEINE'S REVENGE

4 Noël Carroll 71
 VERTIGO: THE IMPOSSIBLE LOVE

5 Charles Warren 89
 OFFENSIVE

6 Gregg M. Horowitz 112
 A MADE-TO-ORDER WITNESS: WOMEN'S KNOWLEDGE IN *VERTIGO*

7	Katalin Makkai *VERTIGO* AND BEING SEEN	139
8	Eli Friedlander BEING-IN-(TECHNI)COLOR	174
9	Andrew Klevan *VERTIGO* AND THE SPECTATOR OF FILM ANALYSIS	194

Index — 225

Notes on the contributors

Noël Carroll is Distinguished Professor of Philosophy at the Graduate Center of the City University of New York, USA. Some of his recent books include The Philosophy of Motion Pictures, On Criticism, Art in Three Dimensions, and Living in an Artworld.

Eli Friedlander is Professor of Philosophy at Tel Aviv University, Israel. He is the author of Signs of Sense: Reading Wittgenstein's Tractatus (2000), J.J. Rousseau: An Afterlife of Words (2005), and Walter Benjamin: A Philosophical Portrait (2011). His more recent research has been devoted to Kant's aesthetics as well as to the Kantian legacy in the history of analytic philosophy.

Gregg M. Horowitz is Professor of Philosophy and Chair of Social Science and Cultural Studies at Pratt Institute in Brooklyn, USA, and Adjoint Associate Professor of Philosophy at Vanderbilt University in Nashville, USA. He writes on aesthetics and the philosophy of art, psychoanalysis, and political theory. His publications include the books Sustaining Loss: Art and Mournful Life (2001) and The Wake of Art: Philosophy, Criticism and the Ends of Taste (Routledge, 1998, with Arthur C. Danto and Tom Huhn).

Andrew Klevan is University Lecturer in Film Studies at the University of Oxford, UK, and a Fellow of St Anne's College, Oxford. His areas of

interest are film interpretation, the history and theory of film criticism, and film aesthetics. He is author of *Disclosure of the Everyday: Undramatic Achievement in Narrative Film* (2000) and *Film Performance: From Achievement to Appreciation* (2005). He is co-editor (with Alex Clayton) of *The Language and Style of Film Criticism* (2011).

Katalin Makkai is Junior Professor of Philosophy at ECLA of Bard in Berlin, Germany. She is the author of "Kant on Recognizing Beauty" (*European Journal of Philosophy*, 2010).

Nickolas Pappas is Professor of Philosophy at City College and the Graduate Center, the City University of New York, USA. His main areas of study are ancient philosophy and aesthetics. He is the author of the *Routledge Philosophy Guidebook to Plato and the Republic* (2003), now coming out in a third edition, and of numerous articles, principally on Plato. He is finishing a book on Plato's *Menexenus*.

William Rothman is Professor of Cinema and Interactive Media and Director of the MA and Ph.D. Programs in Film and Media Studies at the University of Miami, USA. An expanded edition of his landmark study *Hitchcock – The Murderous Gaze* has just been published. Among his other books are *The "I" of the Camera*, *Documentary Film Classics*, *Reading Cavell's* The World Viewed: A Philosophical Perspective on Film, *Jean Rouch, Three Documentary Filmmakers*, and the forthcoming *Must We Kill the Thing We Love? Emersonian Perfectionism and the Films of Alfred Hitchcock*.

Charles Warren teaches film studies at Boston University, USA, and in the Harvard Extension School in Cambridge, USA. He edited *Beyond Document: Essays on Nonfiction Film* (1996) and, with Maryel Locke, *Jean-Luc Godard's* Hail Mary: Women and the Sacred in Film (1993). He has contributed recently to books on Jean Rouch and Michael Haneke, to *The Language and Style of Film Criticism*, and to *The Wiley-Blackwell History of American Film*.

Note on the director

Sir Alfred Hitchcock was born in 1899 in Leytonstone, east London. At the age of (nearly) fifteen, and after a year of study at a school of engineering and navigation, he took a clerical job. In his spare time, he attended evening classes in drawing and began to haunt the theater and the cinema. It was with his transfer to the advertising department that he could begin to do creative work for a living. But his real passion was film, and in 1920 Hitchcock landed a job designing title cards for silent films. He was soon entrusted with the far more wide-ranging responsibilities of scriptwriter, art director, and assistant director. By 1925 Hitchcock was directing his first film. It was a co-production filmed in Germany, as was his second film. His third, The Lodger (1926), was a popular and critical triumph. Blackmail (1929) is commonly called the first British "talkie"; it was certainly the first British "talkie" to be a success, and was praised for its imaginative use of sound and dialogue. Both were early works in the genre of suspense thriller that Hitchcock would reinvent and make his own over the course of his career. Hitchcock directed Murder! in 1930 and Number Seventeen in 1932, but in this period he was still exploring subjects and approaches, his efforts ranging across a prizefighting story he scripted with his wife Alma Reville, a musical operetta, and adaptations of West End plays. With the six films of 1934–38, including The Man Who Knew Too Much (1934), The 39 Steps (1935), and The Lady Vanishes (1938) – hits in Britain as well as in the U.S. – he returned to recognizably "Hitchcockian" territory.

In 1939 Hitchcock, now the top British film director, was offered a contract by Hollywood producer and studio owner David O. Selznick. The family moved to California. Hitchcock's first American film, Rebecca (1940), won the Academy Award for Best Picture. Shadow of a Doubt (1943), Spellbound (1945), and Notorious (1946) stand out among the films Hitchcock directed under Selznick before they parted ways in 1948. With Strangers on a Train (1951) Hitchcock entered upon the golden decade-or-so that yielded some of his most admired work, including Rear Window (1954), Vertigo (1958), North by Northwest (1959), Psycho (1960), The Birds (1963), and Marnie (1964). These years saw Hitchcock's collaboration with Bernard Herrmann, who was responsible for the score – or, in the case of the scoreless The Birds, the sound design – of all of Hitchcock's films from The Trouble with Harry (1955) through Marnie (with a partial exception: Herrmann wrote much but not all of the score for the 1956 remake of The Man Who Knew Too Much). Hitchcock continued to make films well into his seventies, releasing Frenzy in 1972 and Family Plot – his fifty-third and final film – in 1976. He was knighted in 1980, three months before his death.

Widely recognized as among the greatest of film directors, Hitchcock entered the pantheon within his own lifetime. His films continue to appeal to the general public and to critics and filmmakers alike. But if he is heralded as uniting the popular and the serious, entertainment and art, in his public pronouncements Hitchcock presented himself as innocent of "highbrow" aspirations. Eminently quotable and featuring a characteristic blend of dry wit, macabre humor, laconic understatement and self-mockery, these contributed to one of the canniest of his creations, a public persona that became a pop-culture icon. Hitchcock played off this persona in his signature cameo appearances in his own films and in his film trailers. The trailer for North by Northwest was the first in a series that featured his performance of a droll introduction to his film, a nod to his role as "host" in Alfred Hitchcock Presents (renamed The Alfred Hitchcock Hour), the successful television program, running from 1955 to 1965, with which Hitchcock embraced the most popular and commercial of media.

Acknowledgments

I am grateful for the support and patience of Tony Bruce and Adam Johnson at Routledge. I extend special thanks to Adam for always being at the ready to help. My thanks go also to my students at Barnard College and Columbia University, and at ECLA of Bard, with whom I have enjoyed thought-provoking discussions about *Vertigo*. It is a distinct pleasure to record on these transfigured tree rings my gratitude for the hard work, graciousness, enthusiasm, and encouragement of my collaborators.

All illustrations in this volume are reproduced from *Vertigo*, dir. Alfred Hitchcock (1958).

K.M.
Berlin, Germany
September 2012

Chapter 1

Katalin Makkai
INTRODUCTION

THIS VOLUME OF ROUTLEDGE'S *Philosophers on Film* series departs from past practice by pondering a "classic" rather than a contemporary film. First released in 1958, *Vertigo* has since gained the sort of standing that requires the passage of time. It is often called Hitchcock's masterpiece, and although its initial reception was mixed and predominantly negative, it has come to be widely admired as one of the finest achievements of cinema. *Vertigo* has just been crowned with new laurels: the 2012 edition of *Sight and Sound*'s well-known once-a-decade poll of film critics has declared it to be "the greatest film of all time," a move to the top from its second place ranking of 2002.

Vertigo is adapted from the 1954 French novel *D'entre les morts* by Pierre Boileau and Thomas Narcejac, the title of which is generally translated as "From Among the Dead." (It might also be rendered as "From Between the Dead" or "From Between the Deaths," variants that seem more specifically attuned to both the film and its "ancestor" text.) Bernard Herrmann's celebrated score is also based on the reworking of existing material: it is (in part) quotation – a remake, if you will – of music from Wagner's *Tristan und Isolde*. For the viewer familiar with the opera this means that the experience of a sort of déjà vu is joined by one of a sort of déjà entendu. *Vertigo* seems to evoke Tristan and Isolde in other ways as well, for example in elements of its story, as is more obviously the case with Orpheus and Eurydice. And perhaps traces may be found in it

of Oedipus and his travails. All figures, these, who live in myths and legends that have themselves been told and retold, with minor and major variations, and exist for us in this untidy multiplicity.

In its composition *Vertigo* thus enacts certain recastings or restagings. It is also, of course, a film that centrally depicts performances of recasting and restaging. And these seem to touch the project of making something of *Vertigo* – the project at hand. When I first began planning this volume, I frequently heard voiced, and felt myself, the worry that much – perhaps too much – has already been written on *Vertigo*. So frequently, in fact, as to suggest that the worry that naturally hovers over any venture to offer new thinking about a canonized object becomes heightened here, in connection with a work that is all about authorship and the dangers and draws of duplication, imitation, uncontrolled repetition and other failures of self-awareness, unrealized fresh starts, faked originality, inferior copying, reprisals that pale in the light of the original, and cliché and pastiche. The essays collected here, new and rich contributions to the on-going conversations *Vertigo* inspires, put the lie to the worry (heightened or not).

A difficulty from another direction is that *Vertigo* concerns some of the basic questions of life, writing on which knows itself to run the risk of being or seeming maudlin, romanticizing, or melodramatic; or ponderous; or trite. (Academia can provide a haven for such questions, as it can a space for their domestication.) But perhaps these risks reflect something about ourselves: not just that there are unavoidable questions we find ways to avoid (as, perhaps, we try to answer questions that are unanswerable), but that (for example) romanticization and melodrama are, in a sense, natural to us. We sometimes romanticize and theatricalize ourselves and our lives, as we sometimes believe or act as though we believed in magic, and this is part of what *Vertigo* is about. (This thought is suggested to me by several of the essays that follow, especially that by Nickolas Pappas.) And perhaps the way to clearing such distortions involves entering into them, not rejecting them as known enemies. All this is to say that while *Vertigo* is about the extravagant and the overripe – ghosts and plotting and obsession – it is also, at the same time and not incompatibly, about the tensions of everyday life and ordinary relationships, and the dark forces, the desires and frustrations and violence, that move us: one form of the extraordinary at home in the ordinary. (Almost all the essays here sound this theme; it is most prominent in those by Charles Warren, Gregg M. Horowitz, and Eli Friedlander, and in my own.)

Another subject of *Vertigo* is reflection. I have in mind its abundant use of reflection in mirrors and surfaces, and of the reflection of one scene, shot, character, act or line in its (almost) doubled other. But *Vertigo* also concerns and conducts reflection in the sense of thinking, of turning back in thought – contemplation or meditation. We reflect upon the characters and their inner lives, as they reflect (or studiously avoid reflection) upon whatever it is that so possesses each of them. In its own way, the film too reflects upon them and upon our reflection. And it reflects upon filmmaking and viewing, and upon itself and its history. (It thinks, for example, about its relation to its ancestor in *Rear Window*, made five years earlier.) With these modes of reflection it lays claim to participating in the work of philosophy.

The essays that follow express or suggest a range of ways of conceiving of philosophy and of how it can come into play in *Vertigo* (and in film more generally) and in writing about it (and about film more generally). These include taking the film to expose to the searching viewer the defects of a particular theoretical view and to point up the direction its replacement must take (Noël Carroll); finding the film to extend, and to invite us to resist, the invitation to quick and occluding generalization – the temptation of philosophy in its deadening mode of evasion – and to call instead for philosophy as a willingness to see and to reflect on difference (Pappas); and attending to the ways in which writing out one's experience of the film may disrupt one's efforts at abstract theorizing about it and its viewing (Andrew Klevan). I include, too, William Rothman's investigation of the blind spots, and their sources, in his own earlier interpretation of the film; and the hearkening of Warren's essay to the way in which film thinks, finding an attunement with its details and its drift. Horowitz's essay relies on the commitment psychoanalysis shares with philosophy to a readiness to turn back questioningly upon itself; and Friedlander's essay and my own imagine an encounter between the film and a text written by a major philosopher of the same generation as Hitchcock (Martin Heidegger and Jean-Paul Sartre, respectively). Are these approaches variations upon a common theme, are they in conflict with one other, or are they not to be compared because they are incommensurable or because comparison misses the point? These sound like questions *Vertigo* poses about its world. That's less of a change of topic than it might at first seem.

In his "Magic and Art in *Vertigo*," Nickolas Pappas notes the many examples of art or near-art in *Vertigo*, including two paintings (the portrait of Carlotta Valdes and Midge's adaptation) and two dramatic performances (Judy's two performances of "Madeleine," one directed by Elster and the other by Scottie), and understands the film to be asking us to think about the relations between them. "Philosophy" in the pejorative sense will turn to generalizations and jargon; thus one might try to come up with a single word ("imitation," for example) to group these instances neatly together. But in its laudatory sense, philosophy resists this temptation and recognizes that the terms for talking about these objects and the relations between them are not given in advance. That does not mean simply ignoring the philosophical tradition. Rather, the terms that tradition offers with the aim of providing covering generality, as with Plato's "mimesis" and, later, "representation" and "imitation," must – since they, along with discussion of the extent of their covering power, keep coming up – be recognized as part of the conversation through which philosophy thinks about *Vertigo* and art.

In *Republic* Book X Plato aligns dramatic (and literary) portrayals and paintings as both mimetic. Playwright, actor, and painting produce copies of a sort, which appeal to a lower part of the soul. *Vertigo* invites us to subsume likewise under the category of mimesis its range of art objects, but it extends this invitation precisely in order to test Plato's account, for its portrayals and portraitures resist such univocal categorization. The portrait of Carlotta, for example, has a certain power for Scottie, for Madeleine (apparently), and, at least for a while, for the viewer. But this power does not have to do with any mimetic relation it has to Carlotta or Madeleine. Its function is, instead, like that of Carlotta's headstone in the graveyard, or the felled redwood tree: means through which the dead Carlotta communicates with and acts upon her great-granddaughter. Pappas proposes that we think of these objects – and others dotting *Vertigo* – in terms not of mimesis, but of the role of the *kolossos*, part of an older Greek tradition that mimesis replaced. A *kolossos* (for example, a grave marker or a magical sculpture) stands in for a dead or missing person. Its point is not to reproduce the qualities of the object it stands in for (which indeed it often contradicts). Instead it makes "present" the invisible and allows communication with the divine realm.

If Carlotta's portrait is a kind of *kolossos*, Midge's painting embraces mimesis, and Scottie's recoil from it betrays his attraction to the ghostly

underworld to which Madeleine is connected. Far from hoping to explain away Madeleine's apparent haunting, Scottie loves her on condition that none be forthcoming. He loves her as the scene of communication between waking life and the ghost world. Then the *kolossos* he makes in making Judy over into Madeleine presents an insoluble problem. How can she come under his control, as a *kolossos*, and continue to enchant him? He seems to have two alternatives, both of which mean the end of love: keep Judy and lose the magic (then her performance reduces to the mimesis that it was under Elster's direction), hence lose the possibility of loving her; or keep the magic, but at the high cost (for Judy) of her sacrifice and (for Scottie) of the loss of love – a real love that her consent (to accept the fantasy his magic serves) made possible.

Picking up on Hitchcock's cameo appearance outside Elster's shipyard, crossing paths with Scottie, Pappas closes his essay with some reflections that go back to his having spoken of Elster and Scottie as "directors." Elster imitates a visible reality, while Scottie conjures up an invisible reality – which, Pappas asks, and takes *Vertigo* to ask, is a better image of the film director's art? If filmmaking aims to create a world just like the one we know, then Elster models the director. If film allows viewers to "glimpse a world they pine for and do not know, populated by otherwise unseen shades," then Scottie does. This alternative registers something about the nature of the movie star, who is a presence conjured up in the medium of film. Kim Novak on film, in other words, is more like *kolossos* than mimesis.

Pappas cites William Rothman's essay "*Vertigo*: The Unknown Woman in Hitchcock" (2004) when he claims that Scottie is drawn to Madeleine's mysterious hauntedness. As befits this film that is all about return, revelation and transformation, Rothman's essay in the present volume goes back to his own earlier interpretation and offers a thoughtful revision of it, developed through his signature close reading of images.

Rothman was prompted to revisit the film by an essay the filmmaker Chris Marker wrote for the magazine *Positif*, which had invited its "favourite film-makers to write a piece about an actor, or a film, or a director who has had special significance for them, or who has evoked a strong response in them" (Ciment 1995: 7). Marker chose *Vertigo*, a film upon which his *La Jetée* (1962) and *Sans Soleil* (1982) are widely recognized as offering the deepest of cinematic meditations. (In that essay

Marker speaks of *Vertigo*'s "remake in Paris," an oblique reference to *La Jetée* (Marker 1995: 129).) On Marker's "dream reading," everything that follows the scene at the sanatorium is a dream or a fantasy of Scottie's that serves his wish to undo Madeleine's (real) death. (As Rothman points out, the nightmarish qualities that build up in this part of the film must then be understood in terms of something like the "return of the repressed.") The "twist" revealed in Judy's letter-writing scene is a decoy, hiding the film's real twist.

In Rothman's view, and contra Marker, *Vertigo* does not seek to deceive us into mistaking fantasy for reality. Rather, Hitchcock approaches the fantasy/reality distinction from another level altogether. Rothman develops this thought through a detailed study of the sequence that precedes the scene at the sanatorium. Through his deployment of certain film conventions, Hitchcock invites us to read this sequence as depicted dream, and so it is usually read. But, Rothman notes, Hitchcock goes on to problematize the very distinction between reality and dream upon which such a reading relies. Rothman argues that this sequence serves "to demonstrate that the world on film is not reality but a projection of reality, and that as a projection it is at once real and unreal."

In his earlier essay on *Vertigo*, Rothman assumed – as it generally is assumed – that in the second part of the film Judy is following Scottie's lead. He did recognize that "deep down" Judy wishes for Scottie to "change" her, but he took that wish to be unconscious, and, correspondingly, construed her act of putting on Carlotta's necklace as a Freudian slip. The startling proposal he now makes works a vertiginous reversal: Judy deliberately (and consciously) puts on the Carlotta necklace, and she does so as part of a plan meant to realize her (conscious) wish that Scottie know the truth about her. Rothman is interested in why he, and *Vertigo*'s other interpreters, had neglected or dismissed the very possibility of such a reading. In taking it for granted that Judy cannot have this conscious wish, much less this plan, they were falling into the trap for which Hitchcock sets us up in the sequence of Judy's flashback and her letter to Scottie.

With her gaze into the camera, Hitchcock cues us to believe that the flashback images that follow show us what she is thinking and seeing in her mind's eye. Her voiceover continues after she has stopped writing her letter, and so we believe that we are hearing her inner monologue, by the end of which she decides to "stay and lie" in order to make Scottie

love her "as she is, for herself"; and we think, furthermore, that we know what she means by these words. But this woman, Rothman claims, thereby contesting his own earlier assumption, recognizes that "Judy" is as much one of her roles as is "Madeleine" – neither is her "self." This means that she wishes for Scottie to love her (not as "Judy," but) as the actress she is. More specifically: she stakes her quest for selfhood, for an identity apart from the roles she plays as an actress, on winning Scottie's love, which requires his knowing the truth about her and forgiving her.

And so, Rothman argues, she lets herself be "found" by Scottie in front of the florist's shop and then leads Scottie to believe that "changing" her is his idea, not hers. Asking Scottie to help her put on her necklace is part of her plan, as is Scottie's reaction, dragging her back to the "scene of the crime." Their kiss at the top of the tower marks the moment in which her plan has succeeded.

The vengeful ghost of the real Madeleine Elster – who came up in Rothman's discussion of the "dream sequence" – is the source, with the complicity of Hitchcock's camera, of the vision of her own death that drives "Judy" to her fatal fall or leap from the tower. What Scottie cannot do, what no living person is in a position to do, is to forgive her for the part she played in the murder of the real Madeleine. Rothman closes with some reflections on Hitchcock's complicity in murdering (the real) Madeleine as well as "Judy." The film is Hitchcock's tragedy, in both senses: one he makes, and one in which he figures. For the death of "Judy" is Madeleine's revenge against Hitchcock as well, showing him that as his art is murderous, so his desire.

Rothman understands that final kiss to betoken the fact that "Scottie acknowledges her, has forgiven her and himself, and loves her unconditionally," but in "*Vertigo*: The Impossible Love," Noël Carroll is more pessimistic. In his view, Scottie does not love Judy or Madeleine, and indeed misconstrues the very nature of love.

Carroll argues that *Vertigo* is compelling not primarily as a thriller – not because of its elements of mystery or suspense – but as a love story. *Vertigo* is, more precisely, the story of an "impossible love," that is, of a relationship that cannot amount to (genuine) romantic love, and it is philosophical insofar as it offers viewers the resources to uncover the roots of this impossibility by reflecting upon the essential conditions of romantic love.

As Carroll points out, the film actually depicts two "love" stories, the first between Scottie and "Madeleine," and the second between Scottie and Judy. The second echoes the first at the level of images and events, specifically in Scottie's search for his lost "Madeleine" and then in his effort to replicate her through Judy. In both cases, Scottie's "love" fails to be genuine, Carroll argues, because it is founded in a deeply flawed, but commonplace, understanding of romantic love. On this view, romantic love is love of a person's properties. The "Madeleine" Scottie "loves" is a cluster of properties, both for Scottie and, Carroll later remarks, in fact (insofar as she is an invention of Gavin Elster's). What he undertakes with Judy is to replicate this cluster of properties by transferring them onto Judy.

The properties-view of love has several counterintuitive implications. In principle, the cluster of properties of my beloved could be instantiated in someone else, and were this to occur, I would have no less reason to love the "double." Were someone else to possess the prized properties to a greater extent than my beloved, I should prefer to "trade up." Were a clone created and my beloved destroyed, I would have no cause for distress. And indeed Judy protests against Scottie's project to use her to replicate "Madeleine," because she wants Scottie to love *her*, for herself, and not for some transferrable cluster of properties. Judy's protests capture our intuitions that something is amiss with Scottie's view of love.

By thus engaging our intuitions, *Vertigo* invites the viewer to think more deeply about what is wrong with that view. *Contra* the properties-view of romantic love, two elements necessary for genuine romantic love are missing from Scottie's attitude toward Judy. The first is a desire on Scottie's part to benefit Judy for her own sake. More generally, Scottie fails to regard Judy as an autonomous agent who is valuable for her own sake and whose needs and desires merit respect. Instead, he uses her as an instrument for satisfying his desires. By contrast, his concern for "Madeleine" (in the first "love" story) is genuinely disinterested: he wants to help her because he loves her. (As indicated above, Carroll's full view qualifies this last claim: Carroll points out that Scottie's campaign to transfer the properties of "Madeleine" to Judy suggests that his "love" for "Madeleine" was already properties-based, and adds that in any event Scottie cannot truly love "Madeleine" precisely because "Madeleine" *is* nothing more than the cluster of properties Gavin Elster invents.)

The second element missing from Scottie's attitude toward Judy is recognition of the historical dimension of love. The properties-view ignores the fact that love is a historical relation, a relation that depends on a particular shared history. Scottie can't base a relationship with Judy on his previous relationship with "Madeleine" (since she was, for him, a different person). And Scottie cuts off the possibility of developing a historical relationship with Judy (*as* Judy), since he quickly shifts to the campaign to transform her into "Madeleine."

If Scottie's "love" for Judy is impossible because it is based on the idea that the object of love is a transferrable cluster of properties rather than a unique particular with whom one has a shared history, what about Judy: does she love Scottie? *She* has had a relationship with Scottie from the start. But theirs is not the right kind of shared history, because they had different "agendas," and indeed her project was based on a lie. In other words, what keeps Judy's "love" for Scottie from being genuine is her failure to realize that love requires a true (not illusory) historical bond. The importance of this requirement is reflected in the harm caused by infidelity. By building a history with one's beloved, the lover at the same time builds a sense of his or her identity. Infidelity is harmful not merely because it is a form of lying, but because in destroying a person's sense of a shared history it shatters his or her self-conception.

The history of a couple, the history of the wider world in which they live, and the relation between them – these are topics of Charles Warren's essay, which opens with a characterization of a recurrent, if not explicitly foregrounded, theme in Chris Marker's "essay film" *Sans Soleil*: the memory and fear of war "hovering just behind everything, or lying just below the surface" of everyday life. Warren's turn to *Vertigo* is a reflection of and on *Sans Soleil*'s. For *Sans Soleil* is concerned with contemporary life in parts of Asia and Africa, with social rituals, politics, and history, until it unexpectedly moves, two-thirds of the way through, to take up *Vertigo*. Yet if this seems to mark a change of forms and topics – from anthropology, history and philosophy to film (classic Hollywood film, at that), from essay and documentary to fiction, from abstraction from the individual to focus on a particular romantic relationship – reflection, the reflection that *Sans Soleil* calls for here precisely in this move, reveals continuity.

Elaborating the voiceover's remark earlier in *Sans Soleil* that "Poetry is born of insecurity," Warren speaks of memory as creation, one among the creative acts people perform in order to hold on to things in the face of the destructive forces, such as war, that seem always ready to break out or rise up, from somewhere, blighting or blocking happiness. *Sans Soleil*'s turn to *Vertigo* is made with the voiceover's declaration that *Vertigo* is the single film that "has been capable of portraying impossible memory – insane memory." Through a close reading spanning the whole of *Vertigo*, Warren shows how its central characters (Scottie, Judy/Madeleine, Midge, and Elster) perform creative acts of design, art, plotting: "impossible, insane memorial/creative gestures." Elster plots to conceal the murder of his wife with an elaborate scenario involving Judy/Madeleine; Midge, the artist, has designs on Scottie; Scottie recreates Madeleine, but Judy/Madeleine may (as Rothman claims in his essay) be guiding "his" re-creation project. *Vertigo*, Warren adds, identifies the memorial/creative gestures it portrays with film, indeed with itself (and in this respect too it is close to *Sans Soleil*): Elster makes an as-if film with Judy for the spectator Scottie; Scottie and Judy make an as-if film for themselves.

What is the source of this destructiveness that both films are concerned with, the "somewhere" from which, as I noted above, it threatens to emerge? In *Vertigo*, Warren suggests, destructiveness seems to arise from within us as much as from without. Madeleine's line about "someone within" her who tells her she must die is echoed in Scottie's broken-off "There's something in you that . . ." to Judy. This "someone or something within" is figured in the black form that rises up from the tower stairs just before the end, a presence that is both projection from within and external visitation, and that Warren links to the modes of offensiveness through which *Vertigo*'s characters persistently engage with each other. His essay has traced this giving and taking of offense – exchanges into which its participants seem both to enter and to be drawn – in Scottie's relationships with Judy/Madeleine and with Midge. Noting the cuts to intense close-ups of Midge's face as she and Scottie touch upon their old engagement, Warren calls them violent acts of film that seem both to provoke and to be provoked by the violence kept barely beneath the surface of their interaction. The effect is of a meeting or mirroring of film and life, a theme that runs throughout the essay.

Roles shift within *Vertigo*'s as-if films. Scottie the spectator becomes participant in the making of the as-if film in which Elster had been directing Judy/Madeleine, who, meanwhile, moves from performance toward authorship. These shifts occur as the as-film comes to work beyond the control of its makers, comes, that is, to have a mind of its own. *Vertigo* too seems to have, or to be, its own mind – to think. Of the first scene at Ernie's, Warren asks us to notice the camera's pause on the red wallpaper, slightly out of focus, before it cuts back to Scottie. This image strikes him as meant more by the film itself than by its makers. Along with thought, the film seems to partake in madness, the very madness with which it identifies the creative gestures it portrays. (And since it identifies those gestures *as* mad it identifies itself, too, as mad.) The pause on the red haze and the "super-realization" of that scene at Ernie's of which it is a small piece "seem an over-reaching – on the film's part – to avoid insecurity, nothingness, death, even as the scene propels Scottie and Madeleine, Hitchcock and the film itself, and all of us absorbed in the film, toward a new destiny of insecurity and nothingness." It is one of the film's own "impossible, insane" memorial/creative gestures.

We may feel a resonance with Warren's essay in Gregg M. Horowitz's remark that the relationship of Scottie and Madeleine is a projection of "the deeper forces at work in *Vertigo*." Horowitz begins his essay by noting that Hitchcock's films of the two decades beginning with *Spellbound* engage explicitly with psychoanalysis, those of the second half or so of this period ascribing to its viewers a certain familiarity with basic psychoanalytic theory and practice. Some seem flat-out to call for interpretation in psychoanalytic terms. And this call has been answered, most prominently by Laura Mulvey, drawing upon Jacques Lacan and his reading of Freud. Hitchcock makes the invitation to psychoanalytic interpretation so "openly," Horowitz argues, that it seems calculated to nourish the supposition that a more-or-less mechanical application of psychoanalytic theory will yield a definitive, complete interpretation of his film. Hence Horowitz's suspicion, itself psychoanalytically grounded, that to succumb to such a temptation is to be taken in by a piece of Hitchcockian misdirection, to engage a "defense against insight" akin to that provided by the "secondary revision" of dream-work.

Mulvey briefly mentions *Rear Window* and *Vertigo* in support of the case she makes in her piece on narrative cinema, which introduces the idea

of the cinematic male gaze and links it to scopophilia and to castration anxiety. On the Mulvey-style reading of *Rear Window* that Horowitz works out, Lisa's relocation to the position of the to-be-looked-at and Jeff's recovery of the position of the one looking, so his recovery of the authoritative point of view, are required for the main pair to be reconciled and for the film to end on its note of romantic comedy. This means that Lisa must eroticize her own objectification "with a smile on her face," as Horowitz puts it.

But such a reading, Horowitz argues, neglects the irony that shades the closing of *Rear Window*. Hitchcock here grants narrative and visual authority (not to Jeff, but) to Lisa, for whom the course of the film has meant gaining knowledge of Jeff that she cannot share with him or with us. The hiddenness of her knowledge is a condition of the film's passage into romantic comedy. *Rear Window*, then, suggests that heterosexual union depends on perpetual asymmetry and non-reciprocity. *Vertigo*, Horowitz proposes, is also about the woman's secret, dangerous knowledge. This film, however, rules out the transition to comedy.

In the first scene at Ernie's, Scottie's avoidance of meeting Madeleine's eyes reveals the threat he feels in being seen looking, a threat to the authority of his gaze. Madeleine's answering avoidance of his eyes is the lure, showing us why the sight of Madeleine compels Scottie to take the job Elster presses upon him – showing, that is, what sort of object of Scottie's desire she is constructed by Elster to become: here Scottie can look without being looked back at, without being known to look. What in the end he cannot forgive Judy for, what makes reconciliation impossible, is the knowledge of him, acquired from Elster, that she turns out to have possessed all along. Just what Elster knows, so what Judy knows, is not made clear to us, but the dialogue and filming in the scene in Elster's office suggest that he knows more than he says. He knows, evidently, that if Scottie accepts his invitation to see Madeleine he will be compelled to take the job of following her. It is as though Elster has prior knowledge of Scottie's "tendency to stalk," his "scopophilia." Scottie's partial censoring of the word "psychoanalyst" seems to register anxiety about Elster's knowledge of his unconscious impulses.

Midge is the other locus of knowledge of and from Scottie's past. As with Elster, the film bestows authority upon her, validating her claims to knowledge of him while leaving unspecified the content of this knowledge. "As the first half of *Vertigo* plays out Elster's plot, the second

half plays out Midge's knowledge," but the validation of her knowledge requires her disappearance. It is knowledge of the nature of Scottie's desire, which neither we nor Scottie can be shown: this is the "deeply unreconciled woman's knowledge" that *Vertigo* is about.

While Midge shares Elster's asymmetric knowledge of Scottie, unlike Elster she suffers her knowledge of him and the costs it entails. Horowitz closes with two moments that indicate that no "happy ending" of reconciliation can be built on such ground. In their exchange around their engagement in college, Midge's silence makes clear that whatever knowledge she has concerning this (to us) enigmatic matter she must keep hidden, from Scottie and from us. But she paints an open avowal of her knowledge of Scottie in the portrait she presents to him. It drives him away. Horowitz calls it "a knowing image of a knowing woman." Might *Vertigo* itself be called that?

Rothman's essay returned our attention to Judy's "leading" role, and so to the issue of her knowledge of Scottie and of the care with which she must handle his learning of it. If for Rothman this handling must be extremely delicate, for Horowitz it is dangerous beyond hope. My essay too concerns the issue of Scottie's being known. It covers some of the same ground as Horowitz's, but comes out with a somewhat different view of the lay of the land. Setting out from the idea, familiar if variously developed, that Scottie has a fundamental stake in or desire for looking – Mulvey, as noted above, speaks of his "scopophilia" – it suggests, with the help of a discussion of Sartre on the look, that his stake in seeing be understood in terms of his flight from being seen, from, that is, being known. The essay then shifts to showing how this idea is complicated by the sense in which Scottie seems to want to be seen (by an extra-human gaze), and by the struggle he later undergoes with Judy, in the course of which he comes to know something of what it is to be openly known by a human other. In my view, then, Judy's knowledge of Scottie is not simply Elster's, taken over from him at the start (as Horowitz has it), but rather grows from being with Scottie in the struggle that so disturbs us – and this matters to Scottie. Or perhaps it does: we may wonder, but the film keeps hidden, whether Scottie comes to accept or even to embrace being known by another human being, and whether (what that would be a condition of) his relationship with Judy holds the promise of a genuine love, before the shattering end.

In its engagement with Sartre's "phenomenological essay" *Being and Nothingness*, among other ways, my essay pairs with Eli Friedlander's "Being-in-(Techni)color," a study of color in *Vertigo* that proposes an extension of the phenomenological thinking of Heidegger's *Being and Time*. In Friedlander's view, the role of color does not end with the much-noticed beauty it lends to the film; nor does color simply delineate a symbolic schema in which certain colors are markers for certain characters or psychological states. *Vertigo*'s use of color must be understood, rather, as internal to its argument. Drawing upon Stanley Cavell's treatment of color in *The World Viewed*, a book that inherits Heidegger's turn to fundamental ontology, Friedlander argues that *Vertigo* explores color as disclosing a form of the unity of experience, hence as revealing experience as experience of a world.

Consider, for example, the interplay of red and green in the first scene at Ernie's and repeated throughout the film. The film tempts us to a symbolic association of the contrasting colors: red as signifying "desire," green as signifying "anxiety" (for example). But such a simplistic "code" of colors is undercut within the film, for instance by its attention to traffic signals (suggesting red as stop, green as go) *paired* with its depiction of modes of travel that are the opposite of what they purport to be (driving that is a kind of being driven; wandering that is orchestrated). Likewise, red and green are not contrasts but (parts of) names for the same thing in "redwood" and "*Sequoia sempervirens*" (ever-green). It is, rather, their repetition that emerges as important, its significance connected to the fact that, as complementary colors, each is the after-image of the other. Thus they are related to each other not simply as contrasts but (also) more intimately, through the logic of reversal or of ambiguity.

Following upon the bursts of color presented to Scottie (and to us) at Ernie's and in the earlier scene at the florist's, it is Madeleine's "discolored" appearance that fascinates Scottie – her wardrobe of gray, white, and black, and (one might add) her white-blonde hair as well as her makeup, which seems to tone down her natural coloring. Judy wears bright green, violet, and yellow; her hair is dark and her makeup emphatic. But these contrasts are to be understood not merely in terms of Elster's effort to make Madeleine seem distant or ghostly, or Judy's wish to distance herself from Madeleine, a wish that would then be opposed by Scottie's effort to put her in Madeleine's clothes. Indeed, continuity as much as contrast is at work here. Friedlander reads Scottie's replacement of Madeleine's gray

suit with his red robe (the only article of clothing he provides when she "wakes up" undressed in his bed) as of a piece with his effort in the second part of the film to get Judy to replace her colorful wardrobe with Madeleine's: both can be described as efforts to bring Madeleine back to life and to provide her with clothing. Scottie's attempt to "color" Madeleine is thus (not opposed to, but) like his attempt later to "discolor" Judy. Both are obsessive attempts at reanimation through design, producing a deeper form of discoloration of the woman.

Color is one of film's ways of animating the world, hence one of its modes of magic (alongside that of its photographic reproduction of reality). But what is the nature of this animation, and how is it related to the space for fantasy created by film as projection of reality? Friedlander begins to address such questions by considering the dream sequence. He distinguishes two senses of dream or fantasy, the first as looking out of this world into another, and the second as bringing out the transformability of this world. Color can partake in the first, but what is of particular interest to Friedlander is the way in which it can partake in the second – not through invention or deformation, but through a use of the imagination Friedlander, drawing upon Walter Benjamin, aligns with contemplation.

Film brings out the way in which color can confer upon experience fluidity and a related wholeness. Friedlander thinks of this as a capacity to "enliven" the world. The experience of the world as enlivened in this way draws upon film's property of being an image of the past. Correspondingly, the "wholeness" of color is bound up with ephemerality. And one can distort the enlivening capacity of color – and thus distort the world – if one attempts to freeze or force the connection to the world that it provides. Friedlander closes by relating to the violence of such a designed introduction of color Scottie's treatment of Judy, which ends with a representation of Judy as drained of color and of life.

Suitably, perhaps, given our subject, Andrew Klevan's essay is a not-quite repeat performance: it was written for this volume and published in the interim in a volume co-edited with A. Clayton (2011). As a film in which the spectator's viewing of it is prominently related, by the film itself, to the viewing that takes place within the film, Vertigo has become a central reference point for theories of "film spectatorship." Klevan undertakes to canvass a number of these, in order to show how each constructs or

exposes a particular type of spectator – or rather, since these theories tend to abstraction, Klevan focuses on particular stretches of analysis in which the writer articulates the (their) experience of being a "spectator" of *Vertigo*.

He begins with Mulvey, who invokes *Vertigo* to make the case that Hollywood cinema sets the spectator up to identify with the active and controlling "male gaze" of the (male) protagonist, directed against the "to-be-looked-at" passive woman. But her characterization of *Vertigo* actually presents it as to some degree aware of, commenting upon, precisely the mechanisms it is supposed to deploy. Klevan discusses ambiguities in three "slippery" sentences to suggest that, as Tania Modleski puts it, Mulvey "unwittingly undercuts her own indictment of narrative cinema" (Modleski 2005: 13). Klevan's version of the thought is that Mulvey's attempt to articulate the particular experience of viewing *Vertigo* betrays her essay's ambition of categorical pronouncement concerning that experience and the viewing experience of Hollywood film in general. Is the film's complexity disrupting Mulvey's essay, taking over its writing and interfering with its explicit aims?

Klevan turns to the "medium-conscious" spectator of David Thomson and Stanley Cavell, who is aware of the film's, or the director's, awareness of her, and is aware, too, of various aspects of the medium of film. Discussing Cavell's "philosophical" spectator, he notes Cavell's use of close reading and touches upon the dangers as well as the riches that such close reading can entail. He considers next the "camera-conscious" spectator of William Rothman, who is aware of the camera and its actions, and of the ways in which the camera-work shapes the meanings of the film as well as the meanings of Hitchcock's making of it. George Toles's version of this spectator position is more radical (on Klevan's reading): now the camera "ensures that film is equivocal and unresolved at the core of its being, and it encourages a spectator that is fluctuating and indeterminate." If the camera records what lies before it, it is not necessarily – perhaps necessarily not – truth-telling. The images it makes require interpretation, and, Klevan claims, "worthwhile" images sometimes invite it quietly, as they do in *Vertigo*, so that the invitation has first to be recognized, and may indeed be missed.

Klevan remarks that James Harvey's description of the scene of Judy's and Scottie's first "date" deploys writing that is not conventionally academic. The *way* in which Harvey writes, as much as *what* the writing says, conveys what he sees (and sees the film to be doing). His sentences,

moreover, work through the process of elaborating (understanding and developing) his experience of the film, rather than presenting the outcome of some process conducted elsewhere. This spectator's experience of the film involves a consciousness of experiencing the film and the articulation of that consciousness.

Cavell, V. F. Perkins, and Raymond Durgnat, Klevan goes on to propose, evoke a spectator who is aware of various aspects of the film's "context," including the star performers' other roles, the characteristic qualities they project in film, and their very status as "star," as well as other films, artistic forms, and cultural reference points. This is the "evaluating" spectator – the least acknowledged in academic work on film spectatorship – for whom the qualities, and quality, of the work, reflecting creative choices that have been made, are internal to the experience of it. Klevan ends with a brief mention of the "analysis-conscious" spectator, an example of which his essay perhaps provides.

References

Ciment, M. (1995) "For Pleasure," Introduction to *The Positif Collection*, in J. Boorman and W. Donohue (eds.) *Projections* 4½, London: Faber and Faber, pp. 3–7.

Clayton, A. and Klevan, A. (eds.) (2011) *The Language and Style of Film Criticism*, London: Routledge.

Marker, C. (1995) "A Free Replay (Notes on *Vertigo*)," in J. Boorman and W. Donohue (eds.) *Projections* 4½, London: Faber and Faber, pp. 123–30.

Modleski, T. (2005) *The Women Who Knew Too Much: Hitchcock and Feminist Theory*, London: Routledge.

Rothman, W. (2004) "*Vertigo*: The Unknown Woman in Hitchcock," in *The "I" of the Camera: Essays in Film Criticism, History and Aesthetics*, New York, NY and Cambridge: Cambridge University Press, pp. 121–40.

Chapter 2

Nickolas Pappas
MAGIC AND ART IN *VERTIGO*

The arts in *Vertigo*[1]

EXAMPLES OF ART in *Vertigo* include the Mozart recording that Midge plays for Scottie and the portrait of Carlotta that Madeleine sits and stares at in the Palace of the Legion of Honor; the books in the Argosy Bookshop; maybe Midge's drawings of brassieres and Madeleine's wardrobe; not the stepladder that Scottie climbs to habituate himself to heights and not the car he drives, nor his doctor's diagnosis, "acute melancholia together with a guilt complex." Plenty of things belong on the list but not everything.

Actually, one of *Vertigo*'s charms is the wealth of art forms and near-art forms that it contains. Just among the ones that the plot and mood depend on are San Francisco's monuments and Madeleine's antique jewelry; the dress that Scottie wants Judy to wear;[2] a wooden horse in the stable at San Juan Bautista. Rather than collect and display the objects for aesthetes' titillation, what this film does, which philosophically is to be much admired, is to ask – precisely and with more than a little insistence – how what look like many univocal cases of art differ from one another, and what it means that they differ. This is especially true of four acts or objects:

- Judy Barton's portrayal, under the direction of Gavin Elster, of a young woman named Madeleine, putatively Elster's wife;

- Judy Barton's portrayal, under the direction of Scottie Ferguson, of the young woman Scottie knew as Madeleine;
- the portrait of Carlotta Valdes that hangs in the Legion of Honor;
- Midge Wood's painting that combines the portrait of Carlotta with Midge's own face.

In part *Vertigo* thinks about art by assigning a particular significance and weight to each of these four. Despite their similarities, the two dramatic performances emerge as differently minded activities from one another, very much as the two paintings do.

Some of the relations among these items are obvious. Midge's painting follows the portrait of Carlotta as pastiche or parody follows its predecessor: her painting derives from that portrait and partly copies it. Judy's second performance as Madeleine also reprises the first performance and would not have existed without it, even if it takes Scottie until the end of the film to realize he has been rerunning a previous performance. There is no parody when Scottie dresses Judy as Madeleine. He is a monument to earnestness, and any pastiche in the act he produces is unwitting and desperate. But even without mocking intent Scottie's dramatic production resembles Midge's painting, and her visual work's repetition of an antecedent visual work is a foretaste of the dramatic work's remake of another dramatic work.

Meanwhile, Elster's production of Madeleine also re-enacts the Carlotta portrait. In this case the relationship between the performance and the painting is exactly the question of the film's mystery. Has a disturbed young woman set out to recreate the portrait of an ancestor? Or (Scottie begins to wonder) could the dead woman's ghost be working through that portrait to draw Madeleine toward her? No, it's neither; it turns out that Gavin Elster used the portrait of Carlotta in designing the Madeleine-performance he arranged.

If you had to say something you might say that under all three descriptions Madeleine copies the image of Carlotta. But you *don't* always have to say something, or not in such a hurry, and this word "copy" forces a misleading uniformity onto three distinct kinds of things: morbid emulation, supernatural visitation, and staged impersonation. As for the similar idea "imitation," in this instance that word brings Oscar Wilde's aphorism to mind, "Life imitates art"; and the grim irony of classifying as "life" either a death-obsessed young woman, a vicious

ghost, or a murderous husband, underscores the inadequacy of "imitation" as a catch-all too.

What matters here is not that people can come up with a single word to cover all the possible relationships between a painting and the woman who sits in front of it, but that the word would cover over incompatible differences among the relationships.

Mimêsis

With the puzzle about Madeleine and the Carlotta portrait *Vertigo* has already become an occasion for philosophical thinking, whether in the pejorative sense of "philosophy" or the laudatory sense – philosophy prone to generalizations and technical terms, on the other hand patient and wary. Maybe *Vertigo* is philosophical by virtue of forcing such discussions. The portraits and portrayals of women in this film invite viewers to talk about these art objects as a coherent group, and yet the vocabulary for such a conversation is not given in advance. If philosophy goes astray when it does by imposing the wrong terms on a situation, such as the word "copy" when speaking of Madeleine and the portrait, even that act of precipitous generalization acknowledges that one's choice of terminology is not established, that a philosophical conversation begins with the effort to decide on the language this conversation will be held in; all the more so when philosophy proceeds with the most care and attentiveness.

"Art," for starters, will not go nearly far enough to explain these four items. Drama is an art form, and painting is as good an example of art as anything else. But *Vertigo*'s soundtrack, composed by Bernard Herrmann, has earned praise as music, and Coit Tower appears pointedly on screen and in the script, and neither of them can be talked about with the language that arises in response to the paintings and the Madeleine-performances – e.g.: Are both of Judy's performances *impersonations* of Madeleine? Does Elster's dramaturgy seek to *reproduce* Carlotta's portrait in the same way that Midge's painting does? These paintings and performances have subject matters. Each of them is about someone, a portrayal of Madeleine, a portrait of Carlotta or Midge. Portraits are portraits-of and dramatic portrayals are portrayals-of, whether or not the one they portray exists. And in discussions of *Vertigo*'s essential portraits and portrayals the questions about those objects have to do with the

things that those objects are of. Coit Tower is not a building about Lillie Hitchcock Coit, the woman it's named after.

The philosophical tradition joins the conversation with its catalogue of terms that name the relationship between certain works of art and their subject matter, "representation" and "imitation" and the first in the group, one of philosophy's oldest technical terms, the Greek mimêsis.[3] In Xenophon and Plato who introduced the term, in Aristotle who systematized its uses, and in later philosophers who appealed to one synonym or another,[4] mimêsis aims at generality. The word typically applies to more than one kind of art. Republic 10 forces the word into multiple uses by making painting an imitative form analogous to poetry. And long after Plato the goal of generality still informs theories about representation. Some philosophers identify mimêsis at work in music, for instance, while others deny the possibility. The energy behind such disagreements derives from the unifying purpose that had been envisioned for mimêsis and its descendants, if not to identify the essence of all art then at least to bring together a number of art forms under one rubric.

The standing discussion within philosophical aesthetics dovetails with the inquiry into arts that takes place within *Vertigo*. For if a word such as mimêsis both names the general relationship between an art work and its subject matter, and keeps prompting a debate over how general such a relationship can be, then such a word needs to be part of a reading of *Vertigo*. The two dramatic portrayals of Madeleine, and the paintings of Carlotta and Midge, all raise questions about their connections to their subject matter. They are representational works, and it matters that they are, but this film does not let "representation" become a single and monotonic relation.

Plato

The questions about mimêsis in *Vertigo* bring the film into conversation with Book 10 of Plato's *Republic*.[5] Republic 10 invents the analogy between the literary or dramatic presentation of characters and a painting's depiction of its objects (Republic 10.596a, 10.597e, 10.605a). In Book 10 mimêsis is, nearly by definition, the manner of reference to a subject that those two art forms have in common.[6]

What Plato calls mimetic poetry is an elastic category. It always includes both tragedy and the lines from Homer in which, instead of a narrator, a character is speaking and quoted directly. Socrates expounds this definition early in the *Republic* (3.392d–3.394c). By the time Plato arrives at his harshest accusation against poetic *mimêsis*, however, he is thinking of tragedy performed in a theater in front of an audience entranced by the play's depictions (thus *Republic* 10.598d). Both the writing of dramatic parts by a playwright and the actors' performances of those parts amount to types of copying (3.393a–3.396c), instructively comparable to what a painting does when it captures the look of a couch or table (10.598b). The processes resemble one another by producing phantom objects that appeal not to the soul's rational faculties – which direct themselves only to what is real – but rather to a lower part (10.603a–c).

Vertigo invites the same analogy between acting and painting, not to illustrate Plato's aesthetic theory, but with the contrary effect of testing Plato's account against a set of ostensibly comparable objects that resist being subsumed under a single category, whether it is called *mimêsis* or anything else. Drama again follows painting in *Vertigo*, but this time because more than one relation can hold between a portrait or dramatic portrayal and what it portrays. Drama resembles portraiture, in other words, not because they both illustrate a univocal relation to their objects but rather insofar as neither form of representation relates to its objects univocally.

Vertigo also evokes *Republic* 10 by using language of deceit for artistic representations. Scottie equates drama with fraud when he figures out that Madeleine had been Judy's performance. Plato thematizes the lie in visual *mimêsis* in *Republic* 10, where paintings reveal their true nature by occasionally deceiving fools and children (10.598c); and even the beauty of poetic language is a spurious charm (10.601a–b).

Then too the *Republic* associates *mimêsis* with ungovernable passions. The disordered soul belongs to tragic characters (10.605a). In *Vertigo* the concocted Madeleine acts at the behest of dreams and otherworldly impulses. The author of the final script said, "I used a kind of language for her deliberately to heighten the feeling of somebody who is trying to be vague, trying to be unearthly, trying to be seized by an otherworldly identification" (Taylor 1991: 291). And in both cases the trouble does

not remain within the souls that drama depicts but spreads to unsettle the souls of its spectators, as Madeleine's fictional derangement unsettles even Scottie the man of reason. When the film begins, Scottie expects to overcome acrophobia with a reasonable habituation to ever-taller heights. In Elster's office he doesn't buy the ghost story. "Still the hard-headed Scot," Elster says. But Elster's trickery softens Scottie, as *Republic* 10 says that tragic mimêsis strengthens the illogical part of its spectator's soul at the expense of the rational part that is normally in charge.

Among the other things it does in Plato's psychology, the illogical part of the soul falls in love. So the *Republic* rounds off its critique of poetry with an astonishing simile: tragedy's appeal is like the attractiveness of someone you've fallen in love with. The city's founders will harden themselves against poetry as people do who force themselves to stay away from a loved one because they see that the passion is harmful (10.607e). If Plato feels the lure of dramatic mimêsis to be as strong and as wrong as that of illicit love, in *Vertigo* the two are the same thing.

Mimêsis in paintings

Whether in *Vertigo* or in the *Republic*, the best route to the greater mystery of drama may run through the lesser mystery of painting. In *Vertigo* this is because the two paintings refuse to fit into a single category, and refuse more transparently than the two performances do.

Midge's painting has some complexity, as imitations go. Midge superimposed her face on a reproduction of the portrait of Carlotta Valdes, so her painting partly represents a human face but mainly mimics another artist's painting of a human torso and limbs. She and Scottie have decided to go out for a movie when she shows this double-imitation to him; it repels him and he leaves, and Midge stays behind calling herself "fool" and "stupid."

What was stupid was Midge's act of inserting herself into the painting that represented Madeleine to Scottie. And *that* was stupid because (as Midge now understands) Scottie has fallen in love with Madeleine.

What makes Carlotta's portrait represent Madeleine to Scottie? That Madeleine sat for hours gazing at that portrait? But even the most solicitous lover does not rush away just because he sees another woman's face on a painting his beloved looked at. Is it that Madeleine resembles

Carlotta's portrait? She does wear her hair in a bun like Carlotta's; her bouquet and the one Carlotta is holding could be twins. The word for this resemblance is mimêsis when the person sits for the painting. But this painting existed before the person. And then Scottie is told that Carlotta was Madeleine's great-grandmother who came to a bad end. Madeleine knows nothing about that. Instead, approaching the age at which Carlotta killed herself, Madeleine inexplicably puts her hair up and carries flowers so that she resembles Carlotta posing for her portrait.

In light of this new information Carlotta's portrait appears to be something other than an object of mimêsis. Imitation has nothing to do with this spooky relation in which the portrait draws Madeleine under its spell and within its influence. Everything Scottie knows seems to be telling him that a supernatural force connects Madeleine with her great-grandmother's ghost. And what was stupid about Midge's painting was that it misperceived the appeal of Carlotta's portrait. An uncanny charm binds Madeleine to that portrait, and for the same reason Scottie sees her as haunted, and he sees Carlotta's portrait as the charged object capable of haunting the woman he loves. Midge replaced the weird connection between Carlotta and Madeleine with the pedestrian magic of visual resemblance. "I can be a girl in a painting too," but exactly because of how she has made the painting she cannot be related to it in the way that charmed Scottie.

In fact, both Scottie and *Vertigo*'s audience (before learning the truth) imagine Carlotta's portrait to be functioning as certain things function that are *not* usually called art works: Carlotta's headstone in the graveyard, the chopped-down redwood tree, the McKittrick Hotel. These are the means by which Carlotta's ghost communicates with her great-granddaughter and acts upon her.

For instance Carlotta lived in the building now called the McKittrick Hotel. The building draws Madeleine to come sit in it as Carlotta had sat in her home, not because it looks like Carlotta but because of that past contact. She had been in it. By the way, this hotel shares a name with California's McKittrick Tar Pits, less well known than the pits at La Brea but like La Brea a place where Paleozoic fossils have been found in uncannily preserved condition. The right name for a hotel within which Madeleine can be a fossil.

The felled sequoia seems to have the powers of a headstone too. When Scottie takes Madeleine to the redwood forest, she professes to

find the tree repellent. Its rings record the years of "her" – Carlotta's – birth and death, as headstones do. But although Madeleine protests against the death ahead, this huge downed tree is one of the objects that connect her with Carlotta. Standing by the tree Madeleine feels Carlotta's ghost entering and speaking through her.

The list of these non-artwork objects could include the Portals to the Past and the tower at San Juan Bautista. The effective objects are fixed and for the most part upright. Their fixity is what lets *Vertigo* be a film shot on location, displaying images of San Francisco that can't be found anywhere else. By the same token these objects representing the city turn San Francisco as a whole into a headstone. Madeleine's haunting happens here; Carlotta's ghost remains in San Francisco. Gavin Elster finds the city a sepulchral reminder of its earlier self: "The things that spell San Francisco to me are disappearing fast . . . I should have liked to have lived here then."

According to Donald Spoto (1983), Hitchcock had long loved *The Picture of Dorian Gray*,[7] a novel relevant to this movie in several ways, in which he may well have seen his first description of the city. Lord Henry says in that novel, of the character Basil's disappearance:

> I suppose in about a fortnight we shall be told that he has been seen in San Francisco. It is an odd thing, but every one who disappears is said to be seen at San Francisco. It must be a delightful city, and possess all the attractions of the next world.[8]

– those attractions no doubt (coming from Wilde) being both the splendors of heaven and the magnetism of hell. In *Vertigo* the otherworldly attractions of San Francisco include Carlotta's grave, the redwood forest, the Portals of the Past, and the McKittrick Hotel. They do not fool the unwary eye into thinking it sees Carlotta. Even the most mimetic object in the group, the portrait, is non-illusionistic: flat, head too small, bun pulled impossibly around the neck to face forward.

But in the end the portrait's verisimilitude is beside the point. To associate it with a tree or pillars on the far shore of a lake, rather than with Midge's version of the painting, is to say that despite what the portrait looks like its power and its effects flow from a relation between it and its object that is not the relation of similarity.

Replacement-figurines

What kinds of objects are "about" other things without purporting to resemble their subjects? This is one way of asking: What has Plato left out of his theory? Does every object that stands in for another one invite the criticisms that Plato directs against dramatic and pictorial mimicry?

A large scholarly literature describes ancient funerary and otherwise magical sculpture and assesses its meaning. Ancient statues channeled the gods' powers.[9] "Prayer was addressed to cult statues . . . because direct communication with divinity could take place through them" (Collins 2003: 39).[10]

Grave markers offered links through recently deceased humans to underworld divine forces – hence the practice of writing curses on sheets of lead and burying them at the grave of someone who had died violently, so that the unquiet ghost could carry malevolent wishes to lower-down higher-ups. Fritz Graf calls the dead person thus enlisted in the curse errand an "infernal postman" (1997: 131), which makes the gravestone a mailbox from hell and the point of contact between visible and invisible realities.

In other instances too the statue stood in for a dead or missing person and made contact possible between the land of the living and the invisible underworld. A grave marker could be treated as if the stone were itself the dead person. It was washed and anointed on the festival of the dead, sometimes symbolically dressed with a woolen wrapper (Burkert 1985: 193–94; Collins 2003: 38, 38n.94). Human effigies were buried in place of people whose bodies were unavailable. A chamber tomb near Midea containing stone effigies and no human remains suggests that this practice dated back to the Mycenean Bronze Age (Faraone 1991: 183), while Herodotus reports on its persistence in Sparta 700 years later, when *eidôla* "idols" of kings killed in battle were buried as if they were the kings' own bodies (*Histories* 6.58). Substitute sculptures provided mourners with the means to a shadowy communication with their lost loved ones.

Modern discussions of some replacement-figurines date to the 1930s;[11] more recently Jean-Pierre Vernant brought examples together into a category of communications with the divine and showed how this category offered an alternative to *mimêsis* (2006a, 2006b). Vernant argues that Xenophon and Plato did not dream up *mimêsis* as an ahistorical term

to cover everything that sculptures could be. Instead their technical use of the term "marks the moment when in Greek culture the turn is completed that leads from the 'presentification,' the making present, of the invisible to the imitation of appearance" (2006a: 335). Mimêsis is the term Plato brings to visual works he finds desacralized. It is his name for what happens when picturing replaces possession.

One artifact in Vernant is the *kolossos*. Despite its name this is not a towering object but just one that has been *set up* and *fixed in place*. Sometimes a grave marker, sometimes a surrogate, the *kolossos* "is not meant to reproduce the features of the dead man" (2006b: 321–22). It is a double to the dead *psuchê* ("soul, shade"), though not in the sense of being a twin or lookalike. The *kolossos* stands in for the person who died or was long missing and feared dead. It often represents through complementary features that contradict the qualities of the object represented instead of by replicating the look of the lost object.

For example the *psuchê* is mobile in the extreme while the *kolossos* cannot move. The *psuchê* is invisible, so the *kolossos* has no eyes. These are not codes of representation that would deceive fools and children. On the contrary, those too young or too simple to have learned funerary customs will be the ones who fail to take the *kolossos* as a stand-in for the dead. Knowledge is part of this representation and not the antidote to its effect.

Vernant observes that where there is no need for visual imitation many things can function as *kolossoi*. Their shape matters less than "the material of which they are made: a certain type of tree or even a particular tree the god has selected" (2006a: 337). Roughly speaking the tree does have the proportions of a human; this is probably why English calls a torso a trunk. But the tree's roots, which do not make it look like a human being, fix it in the ground as a lasting marker of human lives. The roots let the tree be a *kolossos*. Presumably, San Francisco's Portals of the Past, two pillars at the edge of the San Francisco Bay, count as a *kolossos*;[12] a longstanding hotel, an upright headstone would positively have to.

The film multiplies its *kolossoi*. Scottie finds a wooden horse in the stable at San Juan Bautista. "Here's your gray horse. Have a little trouble getting in and out of the stall without being pushed," underscoring the object's immobility. The still images in Elster's office speak of a lost San Francisco as if marking its grave. Naturally enough for the city that Wilde's Lord Henry imagined, the San Francisco in *Vertigo* is full of markers that

connect the living to the absent dead. In most of these cases the grave markers earn the name of *kolossoi* by conjuring up their objects through means other than the *mimêsis* that shows the living to the living.

So it makes sense that although Carlotta's portrait and the painting by Midge may both find homes in a broad category called "art," Scottie fixates on one and flees the other. He reads the portrait of Carlotta as a mystic token, either genuinely sacred or sacralized by Madeleine's veneration. The portrait enters a Madeleine-world in which trees narrate lifespans and dreams lure souls into graves. It becomes an *eidôlon*, as the shade of Patroclus is in the *Iliad* and as dreams and *kolossoi* are, effecting communication between this world and the other.[13] No wonder Scottie rushes away from Midge's painting. Its subject is visible things and it only makes emotional sense as a picture of what is visible; it is Midge saying "Look at my face, the one in front of you, turn your attention away from that higher world of spirits to see the world in front of you."

As a signpost showing the way back to "this world" Midge's painting not only is mimetic but also advocates *mimêsis*. As if the time that passed between Carlotta's life and Midge's sufficed to secularize art, the painting that Midge tries luring Scottie with represents a new world containing only what remains after magic powers have receded.

Aside from the light it will shed on the two portrayals of Madeleine, the scene with Midge's painting marks the distance Scottie has traveled since first seeing Madeleine. Well after representing skeptical rationality in Elster's office, he still puts himself forward as a skeptic. No ghost stories for him. "I'm not telling you what I think" (to Midge in the car, about Elster's story of Carlotta), "I'm telling you what he thinks." Kissing Madeleine for the first time on the beach, he tells her he wants to find the key that will release her from her morbid obsessions – not just a line to seduce her with, even if he is misrepresenting himself to himself. Only minutes before she apparently flings herself from the bell tower to die he is showing her the stable at San Juan Bautista, explaining her dream away as childhood memory. Those scenes could make you believe he is the same hard-headed Scot. But the way Scottie recoils from Midge's painting betrays his attraction to the ghost world that he claims to scoff at. William Rothman understands him rightly: Scottie falls in love with Madeleine because of her connection with a ghostly underworld.[14] As in certain ancient comic plots (such as the plot of Plautus's *Mostellaria*) a man has been hoaxed into believing a ghost story, and the hoax

overpowers him.¹⁵ Scottie wants to use that key he speaks of to enter Madeleine's world, not to let her out of that world into a place of mere likeness and artistry.

Drama

Fleeing Midge's mimetic artistry Scottie calls back "Let's make that movie some other night," as if the desirability of a movie bore some relation to the effectiveness of a painting. The conceptual distance between *Vertigo*'s two portraits suggests a vocabulary for the difference between dramatic performances that might appear even more alike than the paintings are: Judy Barton's performance as Madeleine before her (Madeleine's) apparent death, and her encore performance in the film's second half leading up to her (Judy's) real death.

Part of the vocabulary for describing those performances will be Platonic again, as Scottie's language is when he grabs Judy in the bell tower and accuses her.

> You were the *counterfeit* . . . You *played* the wife very well, Judy. He *made you over*, didn't he? He *made you over* just like I made you over, only better. Not only the clothes and the hair, but the looks, and the manner and the words, and those *beautiful phony* trances . . . Did he *rehearse* you? . . . I was the *setup*, wasn't I? I was the setup; I was a *made-to-order* witness.

The word "setup" unites the two aspects of Scottie's accusation, that Madeleine played a part and that she lied. Plans to frame an innocent person are setups; but a setup can also be the arrangement of props and scenery for a dramatic performance, and in filmmaking the position from which a scene is being filmed, the camera setup. (Scottie watched the performance from the spot where the camera would go.) The word is as much at home on stage as in the criminal mind, which makes it the perfect word for a criminal dramatic performance.

To similar double effect Scottie says of the tower's top landing, "This is where it happened," meaning the crime, but with a word that conjures up the famous etymology of the Greek word *drama*, its root in the verb *dran* "to act, to do"; so that drama is a thing that happens even if its enemies complain that drama is a trick, something that never happened.

The erotic theater that Madeleine played in really was a lie and did arouse Scottie's lower passions, as Plato could have told him it would. Scottie fell in love with his client's wife, then mourned her without restraint. But Scottie also says, "He made you over just like I made you over, only better." Elster did not confine himself to what Judy/Madeleine looked like but gave her lines to speak and that breathy vague manner, and he "rehearsed" her, as Scottie says; Judy was his "pupil."

Scottie is bringing the two performances together into a single category. And yet in all the fury and sorrow of his accusation there is no self-reproach, as you might expect to hear from someone equating his behavior with someone else's conspiracy and murder. If anything, Scottie seems released from ambivalence. Goading Judy into dressing like Madeleine and putting her hair up, he had acted from unseemly desire. He stopped apologizing for his desire, but he did continue glimpsing Judy inside the impersonation sacrificing herself for him and hopeful that he would finally love her. Now he has nothing to apologize for. He did no harm. His outrage comes with his liberation from guilt.

Discussions of *Vertigo* vary in how severely they take Scottie to task for remaking Judy into Madeleine, and how closely they equate Scottie with Gavin Elster. Judy disappears both times under a man's direction in order to serve that man's desires. You might temper this accusation by conceding that Hitchcock recognizes what Scottie is doing and censures rather than exonerates Scottie.[16] But even the tempered accusation creates a problem for the bell-tower scene and Scottie's lack of self-reproach. Despite comparing himself to Elster, Scottie still does not find himself complicit in violence against Judy. This refusal to share the guilt he deserves ought to make his offense worse and leave him beyond sympathy.

You might reply that Scottie fantasized about performing a rescue, as Elster never imagined doing. Rothman presses the claim that Scottie acts on Judy's behalf in returning her to the role of Madeleine, a role that her first performance made a possibility for her.[17] Coming at Scottie from a different direction, a psychoanalytic reading looks for the wish to *be* rescued that drives Scottie's rescue fantasy (as it generally drives such fantasies) and again differentiates him from Elster (Berman 1997).

Without disputing any interpretations of these kinds, it is also worth coming back to the bell-tower speech not simply as Scottie's identification of himself with Elster but also for his statement of the difference between

their methods. Criticisms of Scottie take up his "made you over just like I did" and look away from the "only better," but Scottie thinks the "better" matters enough to spell out: "Not only the clothes and the hair" – what the two acts of direction have in common – "but the looks, the manner and the words, and those beautiful phony trances." What outrages Scottie is this improvement over what he did, somewhat as it horrifies James Stewart's character Rupert Cadell in *Rope* (1948) (but also implicates him) that his students bettered his easy talk about murdering the weak with an actual homicide. Elster made Judy speak and move. Scottie requested her words of consent (see below), but that is the opposite of giving her lines to deliver. In the final confrontation Scottie demands that Judy speak for herself, if only to tell him what she and Elster had done. Scottie's Madeleine-making confines itself to clothes and hair, which means that he made her without a voice or movement, therefore like a statue. The presence or absence of voice is essential: Greek mythology (to return there for a minute) contains stories about statues coming to life, and what sets those enchanted statues apart from ordinary sculpture is both their motion and their *phônê* "voice."[18]

Scottie's own comparison between the two directorial acts muddies the waters if viewers neglect the vital difference. Elster practiced *mimêsis*. Plato's most specific definition of *mimêsis* dwells on the sounds and speeches that come from parts and literary characters and from actors in tragedy and comedy.[19] Scottie was making a *kolossos*, something that, like Carlotta's portrait and her headstone, and like the felled redwood or the McKittrick Hotel, would let him reach back to the lost shade of Madeleine – in a way something as silent as those grave markers too, so he wouldn't hear Judy's remaining protests that the one who loves him is still alive.

Alcestis

Communication with the dead can be misleading, if it suggests an interpretation according to which Scottie plays Orpheus revisiting Hades to bring back his lost love Eurydice. That interpretation makes an inexact fit with *Vertigo*'s setting and story and stands in the way of a reading that says more about what Scottie hopes to do with Judy.

Since Hellenistic Greece, and unforgettably in the Roman Empire's poetry,[20] the tale of Orpheus has ended with his leading Eurydice up

from the underworld only to turn for that look that sends her shade back down again. Orpheus comes to be the one who loses his lover twice; that is certainly the Orpheus that interpreters of *Vertigo* who develop this reading of the film have in mind (Brown 1986; Poznar 1989). But in the original story Orpheus may have succeeded in bringing Eurydice up with him.[21] (Among other things, a happy ending for Orpheus would explain much better than the frustrated ending does why people joined the Orphic cult in pursuit of their own immortality.) By that standard Scottie is not much of an Orpheus.

More to the point, Orpheus's most important attribute disappears explicitly from *Vertigo*. Orpheus makes music. But when Scottie hears Mozart playing in Midge's studio it gives him a "dizzy spell" – and for Scottie dizziness spells mean acrophobia, which refers to falling and dying. The effect could not be more unright for an Orpheus whose music brings life. Later, catatonic and mourning, Scottie does not respond to Mozart at all; it does not restore him to life.

Nor does Scottie do anything worthy of being called descent into the underworld. Take that figuratively or allegorically, it still falsifies his pursuit of Madeleine after he thinks he saw her die. Rather than seek Madeleine among the shades, Scottie remains above ground and in mourning. With the exception of the fleeting moment in which he sees Judy finally done up just right, he mourns Madeleine for the remainder of the film. For that matter the other participants in the Orpheus story are absent here. *Vertigo* has no Persephone capable of giving Madeleine back to Scottie. Nothing about Judy Barton belongs in a realm of the dead. She is nothing but worldly, hailing from Kansas and talking tired slang.

Judy's nature shows where reading Scottie as Orpheus most mistakes him. Scottie loved Madeleine as he cannot love Judy yet because spirits haunt Madeleine and she does not really belong among the living. Orpheus wants Eurydice returned to life; Scottie wants returned to Judy the touch of death that will make her Madeleine.

If Scottie possessed Orpheus's persuasiveness and musicality he could control the spirits that grip Madeleine. The mere wish to control them makes him only a man who would *like* to be Orpheus. But Greek tragedy already contains a character who wishes he were Orpheus, who tells his dying wife, "If Orpheus's tongue and music were present in me, so that by charming Demeter's daughter or her husband with songs I could grab

you out of Hades, I would have gone down there." Those are the words of Admetus saying goodbye to his wife Alcestis, the wife who volunteered to die in his place and is now dying (Euripides, *Alcestis* lines 357–60). Change a few words and it could be Scottie's line.

Unlike Orpheus, Admetus matches Scottie well. 1. An unlucky fate threatens to end his life early. 2. A woman who loves him dies instead, or in his place. 3. Incapable of bringing her back to life as Orpheus had brought Eurydice back, he mourns her extravagantly. 4. The woman seems to return from the dead, but so ambiguously as to leave it undecided whether or not his mourning has ended.

Scottie experiences a reprieve like Admetus's in that he does not fall and die when death by falling seems to be the unlucky fate cutting his life short. Madeleine's falling death makes her an Alcestis inasmuch as that is how people die when they die in Scottie's place, on his behalf.[22] When Scottie thinks he sees Madeleine fall, the woman he meant to rescue has rescued him: close enough to dying in his place, dying the death marked out for *him*, to leave him with the guilt complex that the doctor diagnoses.

The extravagant mourning in the *Alcestis* is announced in the goodbye scene. Alcestis asks Admetus not to remarry (305–19). Judy Barton says no such thing, but her sour remark about the stepfather back in Kansas suggests that she has not known remarriage to succeed.[23] In the *Alcestis*, Admetus replies with all the pledges and pieties that a dying spouse could want. He begs Alcestis not to go as Scottie begs Madeleine not to run into the church. He promises Alcestis he will never marry again. There will never be another feast in the palace, nor music from his lyre. Maybe Alcestis will visit him in dreams and prepare a home in Hades for the two of them to share someday. He will have himself buried beside her (329–68).

The refusal to make music fits Scottie's mourning. Madeleine seems to send him dreams too, not just because Scottie dreams about scenes connected with her but because they are *her* dreams, the ones she had seen, complete with that vision of the open grave that Madeleine had told him about, a vision that now depicts the grave they share.

Finally there is a promise from Admetus, in the midst of all these others, that he will have skilled craftsmen make a *demas* "figurine, body-double" of Alcestis and lay it in her place on their marital bed. He will

lie beside this body embracing it and calling it "Alcestis." It will seem like holding his dear wife. "A chilly pleasure but the burden on my soul would lighten" (348–56).[24]

It is misguided to read the bed-statue as objectionable.[25] Admetus is not saying, "After you die I'll have intercourse with a doll and pretend it's you," despite one interpreter's disapprobation of "odd behavior even to the Greeks" (Heath 1994: 171).[26] Instead Admetus is envisioning a future in which he will yearn for Alcestis and attempt re-connections with her. The *demas* is supposed to be a consolation insofar as it provides for communication between visible and invisible realms.

Later in the *Alcestis* Heracles comes to the palace of Admetus. He learns about Alcestis and waylays Death when Death comes to collect her soul, and he leads her veiled and silent back to Admetus. "Your *demas* is almost like my wife's," Admetus tells this mystery woman, equating her bodily form with the sculptural form he was planning to have made (1063). Even after realizing Heracles has returned Alcestis to him, Admetus finds the same word the most natural one to use. "O face and figure [*demas*] of my beloved wife!" (1133).

But just *before* that cry of joy, upon seeing Alcestis's unveiled face, Admetus asks Heracles whether this is some kind of *phasma* "phantom, apparition." Heracles answers, a little offended, "Your houseguest is no *psuchagôgos*" (1127–28), no necromancer who uses a sculpture to control the movements of ghosts.[27] Heracles sounds put out because Admetus is wondering whether his guest just performed that kind of trick, conjuring a shade into coming to the palace. Admetus sees a *demas* of his wife or what looks like a *demas*, and he senses her spirit's presence, though she says nothing during this scene and scarcely moves, and he thinks he is still mourning her in the way he had planned to. The happy ending resembles mourning when mourning is magical reconnection with the aid of an effigy. Happiness becomes the continuation of mourning by other means.

Not just as a latter-day Admetus but as a desperate mourning lover, Scottie creates a replacement-figurine[28] and embraces her, even though he comes to find this new embrace a frosty pleasure. The process is not mimetic inasmuch as it is not deceiving anyone, more fundamentally because it does not simulate one sensory experience by means of another but rather creates a stand-in that will link a present sensory experience with someone beyond experiencing.[29]

Does this make Scottie another Pygmalion? But reading the story as that of Pygmalion does not imply a rival interpretation. Even Ovid's version of Pygmalion, however updated for sentimental effect, presupposes the tradition of magic in statues. Pygmalion fawned over the Galatea statue, *ornate quoque vestibus artus* "and decorated her limbs with garments" (*Metamorphoses* 10.263), his act conflating "the traditional, ritual act of clothing a statue, and . . . the 'modern' form of amorous behavior" (Stoichitz 2008: 40).[30] The final union between Pygmalion and Galatea speaks the language of the ritual tradition, and to the degree that *Vertigo* taps into Pygmalionist fantasies it looks back to the same tradition.

The haunted woman

Scottie gets Madeleine back and continues to mourn her. What he finds returned to him is a phantom. His magical fantasy is a compulsion in which the ritual that was designed to bring love back instead ensures that what returns is the desire without the satisfaction. For magic contains its own disadvantages. *Kolossos* rituals bespeak a sacred power that withered away and was replaced by the *mimêsis* of mere appearance; and yet the magic from a time before *mimêsis* comes with dangers that *mimêsis* does not know.

Scottie loves Madeleine, to paraphrase Rothman, not in the hope that some rational explanation will account for her haunting, but on the condition that it does not. He loves her because she is haunted. Madeleine already is the scene of communication between waking life and the ghost world, and that in-between state seems to be what is required for someone to be Scottie's love. But in that case, for Judy to recreate Madeleine for him she will have to connect herself to the world of ghosts too. The potential for becoming Madeleine that Scottie has discerned in Judy is the potential for being haunted.

Scottie's predicament is also more tortured than that, because his erotic fantasy begins in contradictory wishes. Being haunted is a passive state. Scottie lost Madeleine, as he understood things, because forces she could not control compelled her to revisit Carlotta's life and then to visit Carlotta in the grave. Madeleine's mysteriousness enchanted him but the enchantment also took her away. A Judy-figurine that conjures up Madeleine's spirit will control her, as legend says that Actaeon's wandering ghost was finally controlled when townspeople set up a bronze effigy of him.[31]

But how can Judy/Madeleine come under Scottie's control and continue to enchant him? If he likes he can keep Judy and lose the magic; then her performance reduces to the *mimêsis* that her first performance had been, under Gavin Elster's tutelage. Then instead of a godly *kolossos* Scottie is looking at a hodgepodge like the one that sent him running from Midge's apartment, partly a deceptive portrayal of Elster's actual wife Madeleine and partly Kim Novak's face stuck on her. He will have Judy as willing as ever but will not be able to love her.

The alternative is magic, but magic obeys a strict economy. Scottie calls Judy's original performance "counterfeit" and counterfeits bring value at very little cost. The supernatural is expensive, every life-saving paid for in true coin. Thus the back story to the *Alcestis* lurches from death to death, each step paid for with a fresh exchange between mortality and immortality. Apollo's mortal son Asclepius uses his medical powers to resurrect corpses, whereupon Zeus strikes him down with a thunderbolt, whereupon Apollo kills the Cyclops who made that thunderbolt and is sentenced to serve a human master. That master, Admetus, treats his slave decently, for which Apollo rewards him with a way to live past his fated death. An immortal pays back the good treatment he received when tasting mortality with a taste of immortality. The cost is fair but high: to undo a sacrifice calls for another sacrifice.

Carlotta's story traded lives at the same high price. Her daughter was taken away, her great-granddaughter dies to right the balance. To bring the great-granddaughter back Scottie sacrifices Judy.

A magician could have identified the moment that condemns Judy. This is an allegorical point about magic but also a literal observation. Scottie does not force Judy into being his Madeleine. He tells her everything and asks for her consent. Even for those viewers who find Scottie merciless, such moments mitigate his offence. Scottie wants Judy to join him in a fantasy. If fantasies force their way into both disastrous and harmonious love affairs, a difference between those two kinds of love may trace back to the willingness to know the other's fantastic wishes and to acknowledge them as mutually binding; to accept the other's errant subjectivity as a condition of the love and live in one another's dreams. This is a willingness to make "to know" a euphemism for sexual intimacy.[32]

But to a degree that common talk about consent does not always recognize, saying yes incurs risk. You will not know every implication

of what you are consenting to. You might put yourself in a position of losing your future power to consent or withhold consent. Not all agreements can be taken back; sometimes the power of consent leads to consent to the loss of power. In the language of magic: the rites that depend on consent are sacrificial rites. Many ancient peoples staged a "comedy of innocence" (the phrase originates with Konrad Lorenz) with animals led to the altar, whether by pretending that the animal had eaten something taboo or by inducing the beast to nod, a willing victim (Burkert 1983: 4, 46n.46, 140). Scottie grants some power to Judy when he asks her to wear Madeleine's clothes and again when he asks her to change her hair color. She is free to turn him down. By saying yes she consents to being sacrificed. (Scottie sees a rescue afoot there too, letting Judy be haunted. But then ancient sacrifices could see a benefit to the ox or goat, the dumb animal now sanctified, even if the beast in its ignorance does not feel itself blessed.)

The cost to Scottie is the loss of a real love that Judy's consent made possible. The first time around he lost someone who did not really exist, a mere imitation. The second time he traded *mimêsis* for magic, making a replacement-figurine that brought Madeleine back to him. This time he lost his love not because magic boils down to phony counterfeit play-acting but because his magic worked. His magic paid for the return of someone he could not afford to lose; and the proof that the magic worked was that he lost her. He knew this was a ghost he'd conjured up by the way she slipped out of his embrace as Patroclus's shade escaped Achilles, proving the reality of the haunting while also renewing the mourning.

The art of *Vertigo*

Alfred Hitchcock makes his cameo appearance in *Vertigo* on the sidewalk outside Elster's shipyard. He walks left to right across the frame carrying a black horn case, and as he exits the frame Scottie walks in from the right and enters the company office. Does Hitchcock's appearance identify him with Elster, saying that he occupies a place in the world that is close to Elster's; or with Scottie because the two of them crossed paths?

Both Scottie and Elster act as directors. But letting their identification with Hitchcock remain at that level invites generalizations about acting and falsehood, or about (Hitchcock's kind of) directing and violent control over women. Suppose that the function of Hitchcock's cameo is

not to call Elster and Scottie directors but to force the question, which one of the two is the real director? Elster imitates a visible reality by making Judy Barton recite lines, dress, and move as if she were his wife, a wife all too present to Elster. Scottie conjures up an invisible reality by dressing Judy and arranging her hair, until she can be the channel between him and a would-be wife who is absent. Which of them makes a better image of the film director?

The question partly asks about motives, whether filmmaking is more a deception serving violent purposes or more like yearning and tribute. But it is better not to limit the question to directorial psychology, when what a director is able to desire in the act of making a film depends on the possibilities present in the medium – some of these possibilities already implied by the nature of the photographic process, others discovered during film's history. Does filmmaking succeed by reason of technique and artistry, to the point of creating a world that the audience marvels at as so like the world they know? Then Elster exemplifies the directorial art, and his murderous motives are among the motives that film can satisfy. But what if film's success consists in some other effect, thanks to which viewers glimpse a world they pine for and do not know, populated by otherwise unseen shades? In that case Scottie represents what filmmakers do best as well as what they most want to do.

This is the question whether anything about film can function as a *kolossos*.[33] One place to look in considering that question is in the nature of film actors as they differ from actors on stage. Film celebrates certain people as more than actors; thanks to the photographic medium and to the tradition of film viewing that has grown up around that medium, there seems to be something about film actors not accounted for by the fact that they act or by their talent at acting (Cavell 1971, 1984). It feels as natural to refer to their persons on screen by the actors' names as by the names of the characters they play; this is one sign that a movie star appears in a film as a *presence*, that film is a medium by which their presence is conjured up. You go to the movies to see James Stewart as you would probably not go to see a drawing of him or an actor's impersonation. Something about Kim Novak in a film cannot be explained by appeal to her acting alone.

All this is to say, still loosely and only by way of introduction to the thought, that the film persona of Kim Novak evokes not *mimêsis* but a *kolossos*. The film she appears in promises magical entry into a world

containing her. It is a magical entry insofar as human skill does not account for it. The film works as a surrogate to her presence in the moviegoer's world. Unlike the actor on stage who shares the same air that the theater audience is breathing, the actor in a movie moves through an air that the audience has no access to, and might not even still be breathing when the audience is.

If this is a theoretical proposal about film, then *Vertigo* participates in the theory of its own nature by measuring the distance between magical *kolossos* and dramatic *mimêsis*. Scottie is the director who lets his actor be a star[34] while Elster is the type who makes his actors perform at his command. Elster uses dramaturgy as a trick suited to his desacralized world. Love does not go looking for tricks. Scottie explores the other possibility that film unearthed in itself, of standing fixed and upright, and communicating with beings who are otherwise all but invisible. Films call on the immaterial beings known as stars, practically mourning them during their lifetimes, because they cannot be found in the ordinary world.

Notes

1. Special thanks to Katalin Makkai and Mary Clare McKinley for their comments on earlier versions of this paper; and to Alex Neill for his remarks about another paper that led to the writing of this one.
2. "The gentleman seems to know what he wants," says a saleswoman, evoking the commonest saying about art.
3. This discussion will consistently refer to the transliterated Greek word *mimêsis*. In many contexts in and outside of philosophical aesthetics people speak of "mimesis," a word used often enough in English by now not to require italics. For most purposes it counts as an English word. But precisely because the English word "mimesis" has taken on meanings that were not present in the Greek word as Plato and Aristotle spoke of it, the word here will always be introduced as a quote, as it were, from the ancient authors.
4. The word has been translated "mimicry" and "emulation" as well as "representation" and "imitation."
5. Some similarities between the two works are worth calling to mind. After the attack on poetry Socrates recounts a story about the afterlife: *Republic* 10.614b-10.621b. This Platonic myth purports to come from Er, who stirred on his own funeral pyre and told the startled mourners around him about his adventures in the underworld: *Republic* 10.614b. The *Republic* begins with the word *katebên*, "I went down," as *Vertigo* begins with Scottie's threatened descent; here it is ending with the report of someone who

appeared to die but returned to deliver an outlandish confession. In between Plato pays tribute to a beautiful city, Callipolis, as Hitchcock will memorialize San Francisco's beauties. On Hitchcock and San Francisco see Aulier (1998: 70–71).

6 But note that Socrates acknowledges (10.603b) that his comparison of poetry to painting is only an analogy.
7 Spoto describes *The Picture of Dorian Gray* and *The Strange Case of Dr. Jekyll and Mr. Hyde* as "popular works during Hitchcock's adolescent years, and works he had read several times before beginning his film career" (1983: 264).
8 *The Picture of Dorian Gray*, chapter 19, paragraph 15. See, e.g., Wilde (2008: 178). The passage is partly quoted in Aulier (1998: 72).
9 Herodotus tells of a trip to Aegina just before the battle of Salamis to pick up figures of the sons of Aeacus to aid the Greek side (*Histories* 8.64.2, 8.83.2). Contemporary scholars have catalogued such practices (Tanner 2001; also Faraone 1992); others caution against over-interpreting the rituals in question, e.g. on the grounds that the gods were not really thought to come into the statues (Johnston 2008).
10 Collins cites Herodotus 6.61 as one example.
11 The phrase "figurines de remplacement" comes from Charles Picard (1933).
12 In the script Elster calls them "pillars on the far shore."
13 After his death Patroclus returns to Achilles in a vision, i.e., a dream (*Iliad* 23); he is called *psuchê* at lines 65, 100, and 105; *eidôlon* at 104, cf. 72. See Vernant on the *eidôlon*: "As well as the *psuchê*, which is a shade, and the *kolossos*, which is a crudely formed idol, this category includes the dream-image (*oneiron*), the shade (*skia*), and the supernatural apparition" (2006b: 325).
14 "Scottie is intent on denying the Carlotta in Madeleine, but what if it is Madeleine's fatedness that really draws him . . . ? Is Scottie, untutored in the ways of the heart, embracing her mystery, not denying it?" (Rothman 2004: 223).
15 The plot of *Mostellaria* (third century BC) probably derives from a Greek original *Philemon's Ghost* (Felton 1999: 50–61). That the clearest single forerunner to *Vertigo*'s story first appears in comedy says something about the way this film resolutely shuts out the opportunities for happiness. It refuses to let itself become a comedy and end in marriage even though that possibility has been established for this story.
16 Laura Mulvey uses scopophilia and fetishism to indict Hitchcock *and* Scottie for reducing the woman to spectacle and then punishing her for the man's curiosity (Mulvey 1975); but see Marian Keane's response (Keane 1986).
17 Having become Madeleine once, Judy cannot remain who she had been. "She may act the part of Judy, but only by repressing the Madeleine within her, only by theatricalizing herself." Scottie cultivates something in Judy's nature when he presses her to become Madeleine again; he does not violate her nature (Rothman 2004: 230).

MAGIC AND ART IN *VERTIGO* 41

18 Athenian drama repeatedly touches on phônê ("voice") as the difference between statues and living beings: Aeschylus, *Theoroi/Isthmiastai* fragment 78, line 7; Euripides, *Hekabe* 836–38; cf. Plato Comicus fragment 204, "I am Hermes, possessing a voice because of Daedalus" (1992: 217–21). Sarah P. Morris thus writes specifically of "the discourse on voice and animation in the inanimate" in the fifth century (1992: 220).
19 See *Republic* 3.393a-3.398c but also, e.g., 3.396b.
20 Ovid, *Metamorphoses* 10.1–105; 11.1–66; Virgil, *Georgics* 4.453–527.
21 There is a debate over whether some original version of the Orpheus story had a happy ending, later replaced by the tale of twice-lost love. One proponent of this view offers a reconstruction of the original poem (Bowra 1952); another argues against the consensus that presumes the story always to have ended sadly (Heath 1994).
22 It is how the uniformed policeman dies in the film's prologue so that Scottie can live.
23 Another Barton that Hitchcock must have known about did plead against a remarriage. Elizabeth Barton was the English Catholic ecstatic saint who warned Henry VIII not to remarry; she was committed to the Tower in 1533 and executed the next year.
24 The translation of "pleasure" is quite literal, from the word *terpsis* "pleasure, delight."
25 Heath summarizes commentators' (not invariably negative) reactions to Admetus (1994: 171n.12, 172n.13).
26 For Heath's fuller discussion of this passage and its connections with this play's reference to Orpheus (at 357–62), see Heath (1994: 172–75); also see Stieber (1999).
27 See Scholiast to *Alcestis* 1128 for gloss on *psuchagôgos* (Faraone 1991: 185–6).
28 Sophie Trenkner was an early reader to detect a reference to the Greek ritual of making funeral *kolossoi* in Admetus's words (Trenkner 1958: 69; Heath 1994: 172n.13).
29 Despite the obvious differences there are correspondences between this description of Scottie's behavior and passages from Keane, such as this:

> When he finds Judy, his suffering is not over. He will not be satisfied until the ghost is made flesh, until he has created a living woman out of the dead one . . . Stewart/Scottie is not reconstructing a fetish; he is creating a woman in fulfillment of his vision.
>
> (Keane 1986: 236)

30 Later in the book Stoichitz connects *Vertigo* with the Pygmalion story, as others have done; but he does not even look as far into the Pygmalion story (for its religious meanings) as his own comments on Ovid invite him to.
31 So Pausanias, *Description of Greece* 9.38.5 (Felton 1999: 27).
32 *Vertigo* calls this Biblical euphemism to mind in the conversation between Scottie and Judy after their first date. "Let me take care of you, Judy," he

says. "Thanks very much but no thanks." "No Judy, you don't understand"; then her reply snipping off the end of the exchange, "I've been understanding since I was 17," which equates acquiescence to men's sexual demands with "understanding."

33 Mary Clare McKinley has begun exploring these connections in her paper, as yet unpublished, "Art that Embodies the Disembodied." Much in this last section is indebted to McKinley's paper and to conversations with her. McKinley draws on Jonathan Gilmore's work on photography, in particular his paper "Public Curiosity: Ethics, Aesthetics, and Pictorial Representation," presented at the Aesthetics Reading Group, Columbia University, Fall 2007; McKinley has added an important element to Gilmore's discussion by introducing it and Vernant's work on the *kolossos* to each other.

34 When he looks at Judy finally transubstantiated, Stewart's role in *The Philadelphia Story* (1940) resurfaces, with the young James Stewart as Mike Connor drunkenly telling Katharine Hepburn, "There's a magnificence in you . . . in the way you stand there, in the way you walk." One reason the hackneyed description "everyman" stuck to Stewart with some plausibility was that despite his own stardom he could venerate the women he shared scenes with as every man in the movie theater also did. Being a star did not prevent him from experiencing those women as a fan did.

References

Aulier, D. (1998) *Vertigo: The Making of a Hitchcock Classic*, New York, NY: St. Martin's Press.

Berman, E. (1997) "Hitchcock's *Vertigo*: The Collapse of a Rescue Fantasy," *International Journal of Psychoanalysis* 78: 975–88.

Bowra, C. M. (1952) "Orpheus and Eurydice," *The Classical Quarterly* n.s. 2: 113–26.

Brown, R. (1986) "*Vertigo* as Orphic Tragedy," *Literature/Film Quarterly* 14: 32–42.

Burkert, W. (1983) *Homo Necans: The Anthropology of Ancient Greek Sacrificial Ritual and Myth*, trans. P. Bing, Berkeley and Los Angeles, CA: University of California Press.

—— (1985) *Greek Religion*, trans. J. Raffan, Cambridge, MA: Harvard University Press.

Cavell, S. (1971) *The World Viewed: Reflections on the Ontology of Film*, Cambridge, MA: Harvard University Press.

—— (1984) "What Becomes of Things on Film?", *Philosophy and Literature* 2: 249–57.

Collins, D. (2003) "Nature, Cause, and Agency in Greek Magic," *Transactions of the American Philological Association* 133: 17–49.

Faraone, C. A. (1991) "Binding and Burying: The Defensive Use of 'Voodoo Dolls' in Ancient Greece," *Classical Antiquity* 10: 165–205.

—— (1992) *Talismans and Trojan Horses: Guardian Statues in Ancient Greek Myth and Ritual*, Oxford: Oxford University Press.

Felton, D. (1999) *Haunted Greece and Rome: Ghost Stories from Classical Antiquity*, Austin, TX: University of Texas Press.

Graf, F. (1997) *Magic in the Ancient World*, trans. F. Philip, Cambridge, MA: Harvard University Press.

Heath, J. (1994) "The Failure of Orpheus," *Transactions of the American Philological Association (1974–)* 124: 163–96.

Johnston, S. I. (2008) "Animating Statues: A Case Study in Ritual," *Arethusa* 41: 445–77.

Keane, M. (1986) "A Closer Look at Scopophilia: Mulvey, Hitchcock, and Vertigo," in M. Deutelbaum and L. Poague (eds.) *A Hitchcock Reader*, Ames, IA: Iowa State University Press, pp. 231–48.

Morris, S. P. (1992) *Daidalos and the Origins of Greek Art*, Princeton, NJ: Princeton University Press.

Mulvey, L. (1975) "Visual Pleasure and Narrative Cinema," *Screen* 16: 6–18.

Picard, C. (1933) "Le cénotaphe de Midéa et les 'colosses' de Ménélas," *Revue de philologie* 59: 343–54.

Poznar, W. (1989) "Orpheus Descending: Love in Vertigo," *Literature/Film Quarterly* 17: 59–65.

Rothman, W. (2004) "Vertigo: The Unknown Woman in Hitchcock," in *The "I" of the Camera: Essays in Film Criticism, History, and Aesthetics*, 2nd edition, Cambridge: Cambridge University Press.

Spoto, D. (1983) *The Dark Side of Genius: The Life of Alfred Hitchcock*, Boston, MA: Little, Brown.

Stieber, M. C. (1999) "A Note on A. A. 410–28 and E. Alc. 347–56," *Mnemosyne* 4th s. 52: 150–58.

Stoichitz, V. I. (2008) *The Pygmalion Effect: From Ovid to Hitchcock*, trans. A. Anderson, Chicago, IL: University of Chicago Press.

Tanner, J. (2001) "Nature, Culture and the Body in Classical Greek Religious Art," *World Archaeology* 33: 257–76.

Taylor, S. (1991) "A Talk by Samuel Taylor, Screenwriter of Vertigo," in W. Raubicheck and W. Srebnick (eds.) *Hitchcock's Rereleased Films: From Rope to Vertigo*, Detroit, MI: Wayne State University Press, pp. 287–99.

Trenkner, S. (1958) *The Greek Novella in the Classical Period*, Cambridge: Cambridge University Press.

Vernant, J.-P. (2006a) "From the 'Presentification' of the Invisible to the Imitation of Appearance," in *Myth and Thought among the Greeks*, trans. J. Lloyd and J. Fort, Cambridge, MA: MIT Press, pp. 333–49.

—— (2006b) "The Figuration of the Invisible and the Psychological Category of the Double: The Kolossos," in *Myth and Thought among the Greeks*, trans. J. Lloyd and J. Fort, Cambridge, MA: MIT Press, pp. 321–32.

Wilde, O. (2008) *The Picture of Dorian Gray*, Oxford: Oxford University Press.

Further reading

Berman, E. (1997) "Hitchcock's *Vertigo*: The Collapse of a Rescue Fantasy," *International Journal of Psychoanalysis* 78: 975–88. (An insightful psychoanalytic reading of the film that goes much further with an exploration of its rescue fantasy.)

Brown, R. (1986) "*Vertigo* as Orphic Tragedy," Literature/Film Quarterly 14: 32–42. (Much more on the Orphic reading of *Vertigo*.)

Collins, D. (2003) "Nature, Cause, and Agency in Greek Magic," *Transactions of the American Philological Association* 133: 17–49. (A recent amplification of Vernant's insights into ancient art and its action-at-a-distance.)

Faraone, C.A. (1992) *Talismans and Trojan Horses: Guardian Statues in Ancient Greek Myth and Ritual*, Oxford: Oxford University Press. (A full-length study of effigies and other efficacious objects in Greek culture. This work, too, goes further with Vernant's ideas.)

Halliwell, S. (2002) *The Aesthetics of Mimesis: Ancient Texts and Modern Problems*, Princeton, NJ: Princeton University Press. (A broad and deep exploration of the issues that underlie Plato's assessment of the arts, but also of the ancient and modern tradition that understands the arts through the concept of representation or picturing. Not introductory reading, but essential.)

Pappas, N. (2003) *Routledge Philosophy Guidebook to Plato and the* Republic, London: Routledge. (Plato's *Republic* is the reading most relevant to this chapter's discussion of *Vertigo*; see especially the first half of Book 10, where Plato presses his most relentless attack against poetry, emphasizing its mimetic nature and comparing it to painting. There one finds the two works' joint concerns over painting and poetry, but also pathology and mourning. This *Guidebook* is an introductory discussion of the *Republic* as a whole, including Book 10, that might help readers unfamiliar with Plato's work.)

Rothman, W. (2004) "*Vertigo*: The Unknown Woman in Hitchcock," in *The "I" of the Camera: Essays in Film Criticism, History, and Aesthetics*, 2nd edition, Cambridge: Cambridge University Press. (The work of criticism that most informed and inspired this one with its reassessment of how Scottie sees and treats Judy.)

Segal, S. (1971) "The Two Worlds of Euripides' *Helen*," *Transactions of the American Philological Association* 102: 553–614. (This article explores the concept of the *eidôlon* "idol, image" in *Helen*, in ways that bring that play to bear on the issues at stake here, namely the issues of death and the communication between visible and invisible realms.)

Vernant, J.-P. (2006) "The Figuration of the Invisible and the Psychological Category of the Double: The Kolossos," in *Myth and Thought among the Greeks*, trans. J. Lloyd and J. Fort, Cambridge, MA: MIT Press, pp. 321–32. (Along with the other reading cited by Vernant, this is the most relevant secondary source that is not itself about *Vertigo*. These articles contributed to inspiring fruitful new ways of thinking about ancient Greek sculpture. This one in particular contains vivid examples of ritual thinking by means of statuary, along with new interpretations of that behavior.)

Chapter 3

William Rothman

SCOTTIE'S DREAM, JUDY'S PLAN, MADELEINE'S REVENGE

AT THE END OF *VERTIGO*, Scottie, like Stefan at the end of *Letter from an Unknown Woman* (1948), awakens – too late – to his failure to recognize the woman he loved. *Vertigo* is not a "melodrama of the unknown woman," as Stanley Cavell (1996) calls the genre that also includes such films as *Stella Dallas* (1937), *Now Voyager* (1942), and *Gaslight* (1944). And yet, as I observed in "*Vertigo*: The Unknown Woman in Hitchcock" (2004) (an essay published several years after *Hitchcock – The Murderous Gaze* (2012, first published 1982)), an "unknown woman" plays an essential role in *Vertigo* and in a number of other Hitchcock thrillers.

As I argued, the villainous Gavin Elster separates *Vertigo* from the "unknown woman" melodramas. Absent Elster, *Vertigo* could be a melodrama like *Letter from an Unknown Woman*, a comedy of remarriage like *The Lady Eve* (1941), or a member of an adjacent genre, like *Random Harvest* (1942), about a woman in love with a man who fails to recognize her. If *Vertigo* were a member of such a genre, the film would not call for the panoply of curtain raisings, eclipses, white flashes, frames-within-frames, profile shots, symbolically charged objects, and so on – through which, as I demonstrated in *The Murderous Gaze*, Hitchcock declares his authorship.

Embracing the progressive New Deal spirit, those classical American genres are Emersonian. They understand the camera to be endowed with the power to transfigure human beings, to enable them to become more fully who they are. Hitchcock is no Emersonian. In the Hitchcock thriller,

I argued, the camera kills, metaphorically, or reveals its subjects to be fated to die, or already dead. Then again, Emerson understood that for one's "unattained but attainable" self to be born, the old self must die (1979: 5). Remarriage comedies and unknown woman melodramas, no less than Hitchcock thrillers, acknowledge the camera's death-dealing power, apart from which it could not effect a transformation so traumatic as to be tantamount to death and rebirth. But Hitchcock thrillers do not share their faith. Hitchcock envisions the camera as an instrument of taxidermy, not transfiguration. Hitchcock's camera deals death, even – or especially – to those he loves, and it breathes into these ghosts only the illusion of life.

The specific circumstance that provoked me to revisit Hitchcock's masterpiece was coming across on the internet a brilliant if perverse essay on this, his favorite film, by the great filmmaker Chris Marker (1994). Marker offers an audacious twist on the idea that Hitchcock designs *Vertigo* to deceive us, and that Gavin Elster is his stand-in. The present paper uses Marker's interpretation as a springboard to look closely – and I do mean closely – at Scottie's dream sequence. The second half of the paper offers a new way of thinking about Judy.

Scottie's dream

Marker interprets the last third of *Vertigo* as Scottie's wish-fulfillment dream or fantasy. According to his interpretation, our last glimpse of reality is a shot of Scottie sitting in his hospital room, as Midge plays

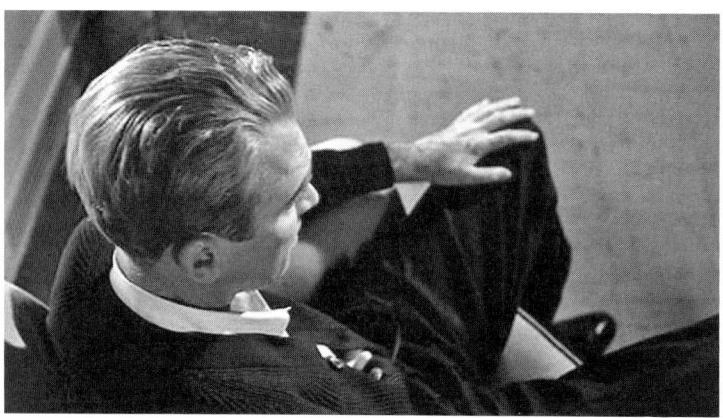

Mozart to "chase the cobwebs away" (although she knows his aversion to the composer) and assures him that (in her chilling words) "Mother is here." In reality, Scottie never leaves his chair, Marker argues; he is absorbed in a fantasy designed to assuage his unbearable guilt for causing the woman he loved to die by denying that she did die. During the last third of the film, nothing the camera presents is reality. Everything – Elster's plot to murder his wife; Scottie's project of changing Judy into Madeleine; indeed, Judy herself – is a projection of Scottie's subjectivity. Like Norman Bates's efforts to breathe life into the mother he murdered, Scottie's dream is a broken mind's way of denying a reality it finds intolerable. What began as wish-fulfillment turns into nightmare. The repressed returns – shades of *Mulholland Drive* (2001)! – as Scottie, within his fantasy, again causes the woman he loves to die.

Marker's claim that *Vertigo* deceives us into mistaking Scottie's fantasy for reality has the virtue of recognizing a fundamental Hitchcockian principle: on film there is no inherent difference between what is objectively real and what is real only subjectively. That is what makes possible the signature Hitchcock practice of employing his powers as author to make the innermost wishes of his characters – wishes they are not even conscious of harboring – "magically" come true. In using his powers as author to make reality coincide with fantasy, his aim is not to deceive us into mistaking one for the other. As I argue in *The Murderous Gaze*, it is one of his strategies for declaring in a modernist spirit, as well as exploiting for emotional effect, the capacity of the "art of pure cinema" to overcome or transcend the opposition, which we ordinarily take for granted, between reality and fantasy.

Because on film there is no inherent difference between what is objectively real and what is real only subjectively, filmmakers instituted conventions (cueing the beginning and ending of a flashback by making the screen go wavy, for example) in order to assert, against the grain of the medium, as it were, a real separation between them, and to provide viewers with criteria to distinguish one from the other. In segueing to Scottie's dream sequence, for example, Hitchcock invokes one such convention by having Scottie look toward the camera as if a point of view shot (and, in turn, a reaction shot) were to follow. But Hitchcock complicates this transition between "outer" and "inner." Instead of asserting a clear division between objective and subjective, the sequence is awash in ambiguity and paradox.

Scottie's dream sequence begins with a dissolve to Scottie lying alone in bed, fitfully tossing and turning. Hitchcock cuts in to a closer shot, Scottie's head framed by his white pillowcase. Without warning, the image turns blue, the blueness gradually intensifying, then subsiding. Next, the image turns purple. Then, in waves or pulses, the purple begins switching on and off.

We know, or think we know, these color shifts are not real. We take them to convey expressionistically the nightmarish quality of Scottie's dream. We are not seeing what Scottie is seeing in his mind's eye, the reality that exists only in his imagination. But we do take the pulsing colors to stand in for what Scottie is dreaming. Partly because they are anxiety-producing to view, they convey the sense that Scottie is being assaulted by them, as if they originate from outside, not inside, his subjectivity. Like the spiraling camera in *The Wrong Man* (1956) that at once expresses and causes Manny's vertigo, they seem to be causing Scottie's suffering, as if he would be able to dream peacefully – and not be afraid of waking – if they stopped.

Scottie seems to be struggling to open his eyes, as if waking might make the pulsing colors stop. At the same time, he seems to be struggling to keep his eyes closed, as if he feared waking up to find that his nightmare was real. When he does open his eyes and looks searchingly toward the camera, he seems wide awake. Yet the pulsing colors go on. Are they real, then? Or is it only in his dream that he is no longer dreaming?

When Hitchcock first cut to this close-up, wrinkles in Scottie's pillowcase visibly placed him as lying in bed. By the time he opens his eyes, the wrinkled pillowcase has morphed into a featureless background that offers no clue where he is. Visually, he could be anywhere. He could be lying in bed, or sitting in a movie theater viewing *Vertigo*. And, as I said, he could be awake, or only dreaming he is awake.

In the world of the film, which of these states "really" obtains at this moment is not decidable even in principle. Like Wittgenstein's "duck/rabbit," we can see Scottie at this moment in two incompatible ways, either as awake or as dreaming. But we cannot see him in both ways at the same time (except, perhaps, by splitting hares). Both interpretations, both ways of seeing, are equally valid. In the "real" world, either a man is dreaming or he is not. He cannot be both and cannot be neither. There is a fact of the matter, an underlying truth or reality, even if in a given

case we may not know what the truth is. But whether Scottie is awake or dreaming is not something we simply do not know, nor even something we cannot possibly know. In the world of the film, there is no "fact of the matter." This does not mean that in the world on film there is no reality. The question is what becomes of reality, what reality becomes, when it is transformed or transfigured by the medium of film. When reality undergoes such a metamorphosis, *Vertigo* is declaring, what is "real" has neither more nor less reality than what is "dreamed." What is "real," within the world on film, is also unreal; what is "unreal" is also real. The projected world itself is at once real and unreal. That the world on film does not exist (now), as Stanley Cavell puts it in *The World Viewed*, is its *way* of being real. Simultaneous with the birth of film is Freud's intuition that, to invoke another of Cavell's formulations, the reality of consciousness is unconsciousness. In the world on film, the reality of reality is unreality; everything that is, is not; everything that is not, is.

Although Scottie is looking at the camera, his gaze is unfocused. This cues us that the next shot does not represent his literal point of view. If this is what he is seeing at all, it is what he is seeing in his mind's eye. The image that materializes is a stylized representation of the nosegay (great word!) Scottie saw Madeleine buy at the flower shop, a perfect replica of the one in the portrait of Carlotta Valdes. This cluster of flowers, each like the facet of a jewel, framed against a smooth background, is linked, visually, to the jeweled necklace that will play a crucial role in the film.

Hitchcock does not cut directly from Scottie to this "flower/jewel," however. He fades out the former and fades in the latter. For a moment the screen is empty, withholding access both to objective reality and to Scottie's subjectivity. This vision of nothingness endures only a moment, but we have no standard for translating this moment of screen time, as we experience it, into its equivalent in "real time" within the world of the film (whether that be chronological time as a clock might measure it, or subjective time as Scottie experiences it). The moment of blankness, however brief, opens a temporal gulf that isolates Scottie, turned inward, from the "flower/jewel" that appears before us, born out of nothingness, calling into question whether this is what he sees, or is specifically what he does not see, even in his mind's eye.

A Freudian would see this "flower/jewel" as a symbol of female sexuality. I see it as an eye staring unblinkingly at Scottie. Viewed this way, the image of the "flower/jewel," which seems to represent Scottie's inner vision, retroactively reveals the shot of Scottie that preceded it to represent what this eye is seeing. Like the shower head that oversees Marion's murder in *Psycho* (1960), or the diamond that all but winks at us at the end of *Family Plot* (1976), this "flower/jewel/eye" is a stand-in for Hitchcock's camera. Emblematic at once of the "unknown woman" fated to die and the perfect jewel, the "cold and lonely, lovely work of art" that is the film itself (to borrow from the lyrics of *Mona Lisa*), this image invokes the mystery at the heart of *Vertigo*.

The "flower/jewel/eye" thus resonates with the film's opening title sequence, in which the title "IN ALFRED HITCHCOCK'S" is superimposed over an extreme close-up of a woman's eye, looking at Hitchcock's invisible camera, which is looking at her looking. Within this eye's black pupil, precisely centered in the frame, the title "VERTIGO" appears, a pinpoint of light that expands until it spans the width of the eye. Then this title is replaced by a spiral shaped like a galaxy that emerges from the eye's pupil and expands until it fills the frame, its spiraling motion, like a whirlpool, pulling our gaze into the blackness at its own center, from within which a new spiral is born, and so on . . . It is as if the chase sequence that ensues (which ends with Scottie suspended over an abyss with no conceivable way of being rescued) and, indeed, the entire film for which this chase sequence serves impossibly as a prologue, is envisioned, or conjured, by this eye. Or as if the universe of *Vertigo* is born out of the mysterious black hole at its center.

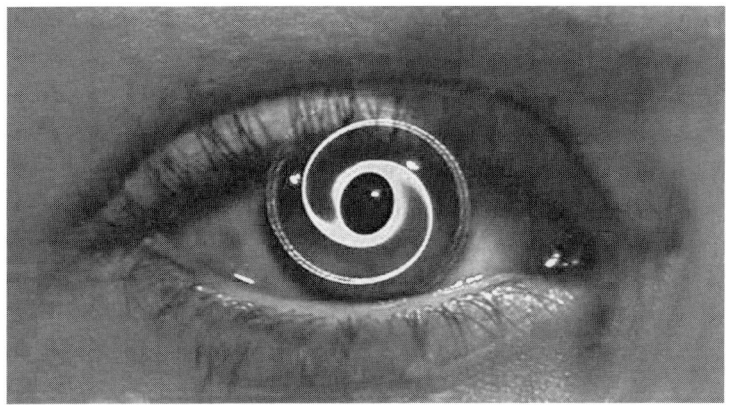

No sooner does the "flower/jewel/eye" materialize out of the blank frame than it is subjected to, or subjects us to, the pulsing colors. It is at this point that Hitchcock begins to animate the image. To me, the Disneyesque animation undercuts, rather than enhances, the gravity of the moment. (I am no fan of *Spellbound*'s (1945) dream sequence, either.) But whether or not the animation "works," it is important to grasp the thinking that underlies it.

First, the outer fringe disappears. Then the petals drop away, causing the image to fragment. I had never noticed this before, but there is a moment when at the center of this jumble there appears a form, at once a circle and a spiral, that is like a miniature "flower/jewel/eye" and at the same time seems to resonate with the spiral "galaxy/eye" of the opening credits.

Both associations are confirmed, I take it, when the petals part, opening a yawning hole that draws the camera into it, engulfing the frame in blackness. From this blackness emerges the most enigmatic shot in the film. It duplicates the framing in which Gavin Elster, after the inquest, has the chutzpah to say to Scottie, "Only you and I know who really killed Madeleine."

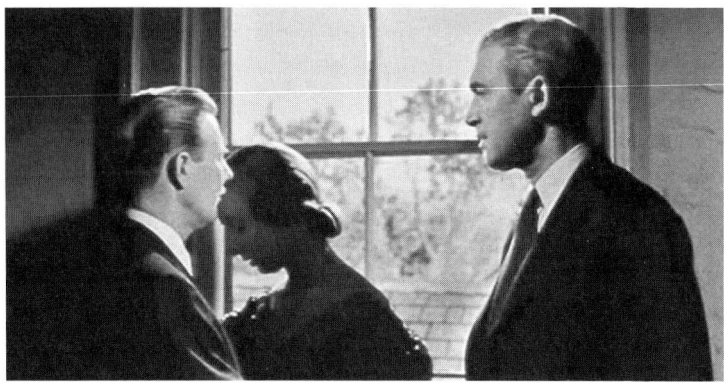

What makes the present shot different is the woman standing next to Elster. Silhouetted against the window, more shadow than flesh-and-blood, looking at neither man, she is turned inward, like the ghost at the end of *Ugetsu* (1953), mindful that she must return to the dead as soon as she completes her business on earth. Then a color shift reveals this woman to be, or seem, real. Plainer than Kim Novak (who isn't?), she is a woman we have never seen before. As she turns her head to cast an accusing gaze at Scottie, we see that she is dressed like Carlotta in her portrait.

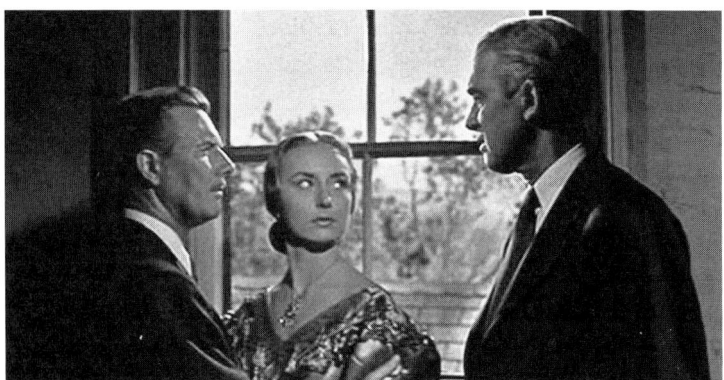

The shot that follows presents a painted image of this woman, viewed from Scottie's perspective, looking toward the camera out of the corner of her eye. Because this painted image has no visible frame, it seems to be the "real" woman's gaze, not the painted one, that solicits the camera, still seeming to represent Scottie's point of view, to move in and center her jeweled necklace.

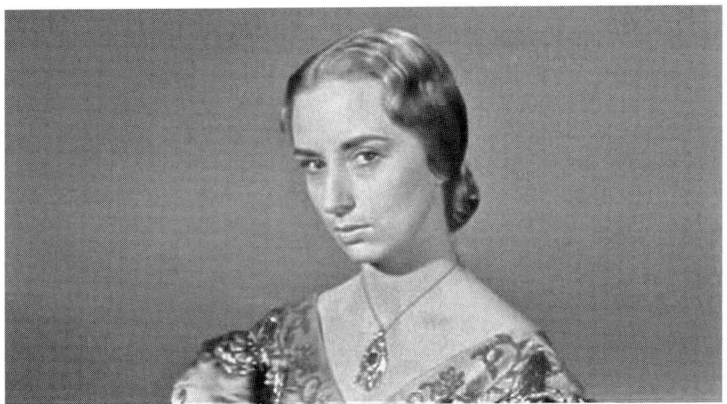

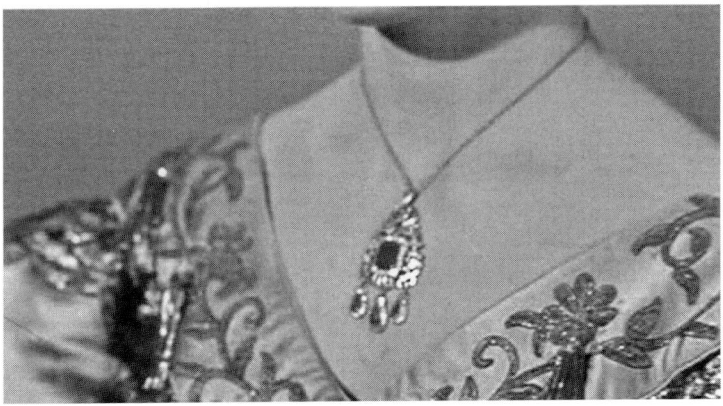

Like the "flower/jewel/eye," this necklace seems to have a gaze, one the camera's movement links with this mysterious woman's gaze. Thus the shot of Scottie that follows, which seems to present Scottie's reaction (or non-reaction) to what he is seeing, at the same time seems to represent what this "necklace/eye" is seeing, or conjuring.

As Scottie walks zombie-like toward the camera (but without getting any closer), it is as if this woman's gaze, relayed by the "necklace/eye," is drawing him by its hypnotic power. Even when the black background is replaced by one that places him in Carlotta's graveyard.

Hitchcock cuts to a shot in which the camera is moving toward an open grave. The darkness within the grave looms larger until the frame is again engulfed by blackness. In this shot the vision alone, and not also the subject whose vision it is, commands the camera's attention. But whose vision is this? I am moved to ask this question because the preceding shot of Scottie – which cued us to take the present shot as from his point of view – began as a representation of the vision belonging to the "necklace/eye." Our view of the open grave seems to have its source, or origin, in the mysterious woman's gaze. Has she by some unnatural art planted her own vision inside Scottie's dream, or raised it from the darkest depths of his soul? Does that even make sense? Who or what would she have to be to possess such power? Some commentators have suggested that she is the real Madeleine Elster. I am persuaded of this. But this is not who Scottie thinks Madeleine Elster is. How could a dead woman Scottie does not know so much as gain entrance into his consciousness? He cannot have invited her in, since he doesn't know she ever existed. Ghosts don't have to wait for an invitation. If this is Madeleine Elster, it is her ghost. Why would this ghost haunt Scottie? Is it because he took no notice of her, failed to keep her safe, did not prevent her murder from happening?

The shot of the open grave also aligns Scottie's "inner vision" with the scene the woman he knew as "Madeleine" described when he pressed her to say what she remembered after awakening from one of her trances. We will soon come to know – or think we know – that she was acting when she told Scottie she remembered standing before her own freshly dug grave. In the present view of the open grave, Scottie's vision fuses with the scene he believes she believed she remembered.

The moment the camera descends into the open grave, there emerges from the blackness an image that is vertigo-inducing to view.

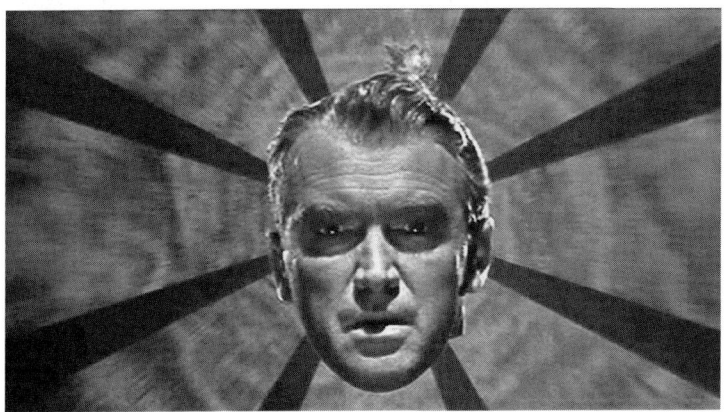

The shot frames Scottie's disembodied face, staring at the camera, against a receding spiral. This surrealistic frame strikes me as an inversion of the image in the title sequence of the twisting spiral emerging from the black pupil at the center of a woman's eye. Is this what Scottie is envisioning in his mind's eye, or are we only seeing him seeing whatever he is envisioning? If Scottie is dreaming, is the camera inside, or outside, his dream? Scottie's eyes are wide open. If he is dreaming, is he dreaming of himself dreaming? Is he dreaming of himself dreaming of himself dreaming?

Scottie's face now disappears, leaving only the vertiginous background. Then it reappears yet again – this time almost filling the screen. The shot that follows begins with the screen yet again engulfed by blackness, as if this emblem of nothingness is what Scottie was seeing in his mind's eye in the previous shot. That Scottie *is* this blackness is revealed as his stylized, silhouetted figure falls from the region of the camera,

whose view he had totally eclipsed, casting the world in shadow. Visually, this figure, which is its own shadow, seems at once inside the world on film and outside looking in, as we are. (This is underscored by the fact that the lines of the roof form a textbook example of what I call, in *The Murderous Gaze*, Hitchcock's "////" motif.) In retrospect, we may recognize in this figure's posture, at once scarecrow-like and Christ-like, a premonition of the shot that closes the film, in which Scottie looks down from the tower from which Judy has just fallen, or jumped, to her death.

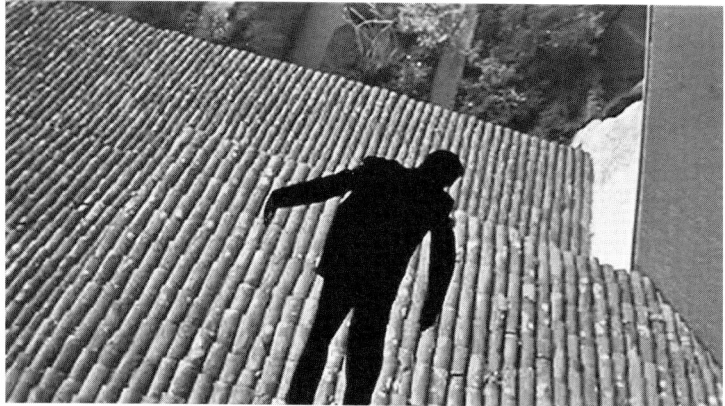

In the present shot, the background suddenly vanishes, giving way this time not to blackness but to whiteness, with the shrinking figure of Scottie suspended in infinite space.

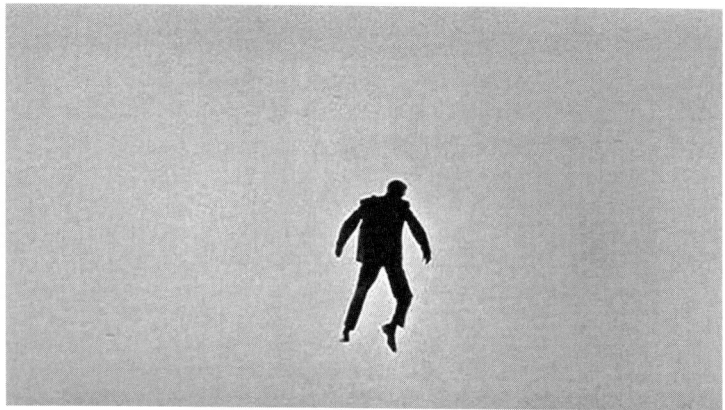

And it is this vision that makes Scottie sit bolt upright in his bed and stare in terror at the camera.

From this shot, we do not know whether Scottie's awakening is real, or whether he is only dreaming that he is awakening. (Within the projected world, there is no "fact of the matter.") The sequence has come full circle.

It is the remarkable way Hitchcock designs this sequence, and *Vertigo* as a whole, for that matter, that makes Marker's interpretation possible – that makes it possible to interpret almost everything we view from this point on as a continuation of Scottie's dream (if that is what we take this sequence to be). Marker errs only when he claims that in *reality* Scottie is dreaming everything that happens in the last third of the film. Hitchcock has gone to extraordinary lengths to make Scottie's so-called dream sequence demonstrate that the world on film is not reality but a projection of reality, and that as a projection it is at once real and unreal. That Scottie is dreaming this part of *Vertigo*, and that he is not, are two possible ways of viewing the film, two possible ways of understanding what reality is – what reality becomes – within its world. Neither interpretation is more valid than the other. Both "possible realities," like the world on film itself, are at once real and unreal. "Possible realities" within the projected world are "impossible realities" within the one existing world.

Judy's plan

Scottie is an open book to Hitchcock's camera. His thoughts are legible even when we find ourselves increasingly unwilling to endorse them. The mystery at the heart of *Vertigo*, the mystery that attracts Scottie himself, is not a mystery *about* him. It is a mystery *to* him. But it is a mystery the "hard-headed Scot" does everything in his power to deny. Scottie himself is a mystery to Hitchcock only insofar as he illustrates the fact about being human that it is possible for others to know us better than we know ourselves. The camera's relationship to the woman projected on the movie screen, in her various guises, is more ambiguous, but also more intimate. She is an object of desire to Scottie, to us, and to Hitchcock. Yet she and Hitchcock's camera are mysteriously attuned.

My earlier essay drew the conclusion that, no less than the villainous Elster, this "unknown woman" is a stand-in for Hitchcock. Hence the title I gave my essay: "The Unknown Woman in Hitchcock." And yet I

had no doubt that this "unknown woman" was known to me. Ah, the foolishness of youth!

I seem always to have known that it cannot be a simple mistake when Judy, saying "Can't you see?," asks Scottie to help her put on the necklace. (Freud was a genius, after all.) I said as much in "The Unknown Woman in Hitchcock":

> The deepest interpretation of Judy's motivation for "staying and lying" is that she *wishes* for Scottie to bring Madeleine back (which means that it is no accident when she puts on the incriminating necklace). Judy wishes for Scottie to lead her to the point at which she can reveal [that she is Madeleine] – but without losing his love.
> (2004: 230)

I understood that "deep down" Judy wished for Scottie to "change" her. But I still assumed, as has every commentator on *Vertigo*, that in the last third of the film it is Scottie who is leading Judy, not the other way around, hence that putting on the necklace is at most a slip. At least I recognized it as a Freudian slip, one that revealed an unconscious wish for Scottie to know the truth about her. But I clung to the belief that Judy cannot be conscious of harboring such a wish, hence that putting on the necklace cannot be a deliberate gesture, cannot be part of a plan calculated to make that wish come true. Nor did I ask myself why I resisted questioning the assumption – an assumption, and a resistance, common to all who have written about the film – that Judy cannot be conscious of wishing for Scottie to know the truth. Evidently, I wished to believe I knew this woman better than she knew herself. Evidently, I wished not to know this about myself. Why?

One answer is that it is vertigo-inducing to think that Judy consciously plans for Scottie to discover the necklace. One reason I find this thought so vertigo-inducing is that it calls for me to recognize that Hitchcock has deceived me. I trusted him to reveal the border separating what is real from what is not, but he betrayed my trust. Why would Hitchcock do this to me? "Why me?" is a question Scottie poses (to Judy? to Madeleine? to whatever God there may be?) on top of the tower. "I was the made-to-order witness, wasn't I?" is his answer to his own question. In my wish to believe I knew what I did not know, and in my wish to believe I did not know what I knew, was I Hitchcock's made-to-order witness?

Was I no different from Scottie in Hitchcock's eyes? I did not wish to think that of myself – nor to think that of Hitchcock.

It is also vertigo-inducing to think that in *Shadow of a Doubt* (1943) Uncle Charles plans for young Charlie to kill him. Or that it is Norman, not the mother who is her son's creation, who grins at the camera at the end of *Psycho*. Yet in *The Murderous Gaze*, I found the nerve to think those thoughts, just as in *Contesting Tears* Cavell found the nerve to think the vertigo-inducing thought that Stella Dallas deliberately makes a spectacle of herself at the soda fountain, that she is already carrying out a plan to free her daughter – and herself – to accept the necessity of their separation.

And yet long after I had found the nerve to think those thoughts, I continued to resist thinking that the woman in *Vertigo* knew herself better than I knew her – and better than I knew myself. Like Scottie, I loved this woman and wished to go on loving her. I did not wish to think that I was *her* made-to-order witness.

It is Judy's letter to Scottie, together with the flashback that shows us what "really" happened, that sets us up to believe that we always know what Judy is thinking.

The passage is prefaced by the moment when Scottie, who has just walked back into Judy's life, exits her hotel room and the camera pans to Judy, framed from behind, staring at the closed door, like Stella Dallas after Stephen departs with their daughter Laurel.

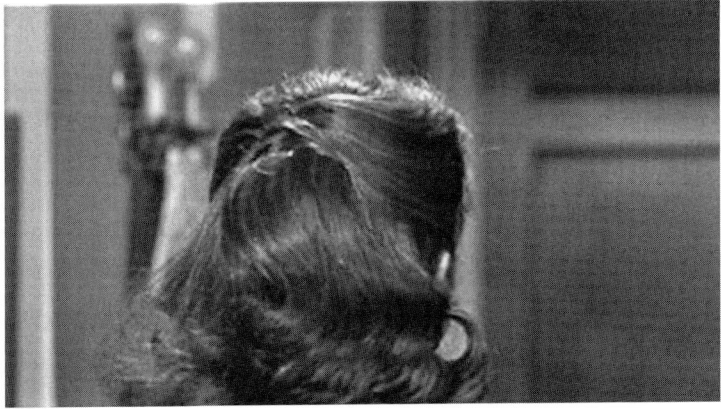

In this framing, this woman and Hitchcock's camera are in complicity, as they are at Ernie's in presenting to Scottie – and us – the vision that

makes Scottie fall in love. But this shot is so emphatic in hitting us over the head with the fact that Judy's hair is different from that of "Madeleine" that it distracts us from registering its deeper revelation, which is that this woman is thinking her own private thoughts.

A few moments later, the flashback itself is initiated by another close-up of Judy, this time staring toward the camera, a signal that the views to follow will grant us access to what she is seeing in her mind's eye.

Scottie, in his dream, seemed unaware of the source of the images assaulting him. Judy, by contrast, seems to be marshaling the images the camera presents to us, authorizing the camera's presentation, in effect. This flashback is designed to secure our trust in Judy – and in Hitchcock's camera.

We trust that Judy's letter, which she reads in voiceover as she is writing it, proves that she loved Scottie, that she still loves him, and that if she had the nerve she would "stay and lie" in the hope of making him "forget the other, forget the past" and love her, as she puts it, "as I am, for myself." And we are moved when she admits to herself – by now, she has stopped writing; what began as a letter to Scottie has become an interior monologue – that she does not know whether she has the nerve to try.

Having confessed this self-doubt, still in close-up, Judy, expressionless, stares again in the direction of the camera, this time without meeting its gaze. Still facing the camera, her gaze still averted, she rises solemnly, her movement synchronized with the camera's as it pulls back to frame her, in eminently Hitchcockian fashion, between a lamp on the left of the screen and a mirror on the right. Steadfastly meeting the camera's gaze, acknowledging its power to bear witness, she purposefully – perhaps there is a trace of violence in her gesture – tears the letter to pieces. She has come to a decision. Whatever the risk, she will "stay and lie" and prove she has the nerve to make Scottie love her "as she is, for herself." We silently applaud her.

This passage sets us up to think that we know what Judy is thinking. We have her own words as evidence. Yet at the decisive moment she is silent, absorbed in her private thoughts. The camera, which moments before had revealed Judy's vision of the past, now refrains from revealing her vision of the future. Lacking her clairvoyance, we have no access to her thoughts at this all-important moment. And yet we think we know what she is thinking. We think we know what she means by "staying and

lying", what she thinks it means for Scottie to love her "as she is, for herself", and what she thinks her "self" is – what it is "for herself."

In "The Unknown Woman in Hitchcock" I wrote:

> When Judy writes the note she never sends to Scottie ... she contemplates "staying and lying" and making him love her "for herself" ... She may think that the Judy persona – Judy's way of dressing, making herself up, carrying herself, speaking – is her self ... Yet ... [o]nce she is transfigured into Madeleine, there is no bringing Judy back. She may act the part of Judy, but only by repressing the Madeleine within her, only by theatricalizing herself.
> (Rothman 2004: 230)

I understood that "Judy," no less than "Madeleine," is a role she is playing (just as this woman herself, in both guises, is a role played by the actress we know as "Kim Novak"). I also understood that the fact she has made these roles her own means that both "Judy" and "Madeleine" are expressions of who she is. But I assumed that these were facts I knew about her that she didn't know about herself. I continued to cling to the assumption – as all critics have done, as Hitchcock sets us up to do – that in wishing for Scottie to love her "as she is, for herself," she was wishing for him to love "Judy," that slightly slutty dark-haired hard luck story who wears too much makeup and speaks not in Madeleine's near-British English but rather pronounces "Salinas, Kansas" with a whiny, exaggeratedly lower-class Midwestern twang. (In her voiceover, Kim Novak reads Judy's letter in a voice more neutral, more natural, than either of those.)

I had not yet found the nerve to think that she wishes for Scottie to love her as the actress she is, not the "Judy" who is one of her roles – a role that so perfectly denies her "inner Madeleine" that it is as if she created it for that purpose. I am not claiming that in the world of *Vertigo* the *reality* is that Judy is always acting, never "being herself," that there is nothing she is "for herself." My claim is that Hitchcock designs the film so every moment sustains this as a *possible* way of viewing her, a possible way of interpreting what reality is, what reality becomes, within a projected world in which there is really no "fact of the matter." (I might add that we don't know that "Judy" and "Madeleine" are her only identities. She keeps as many suits and dresses in her closet as Marnie (*Marnie* (1964)).

For all we know, each is a costume, a memento of one of her roles. We don't even know that "Judy Barton" is her real name. That is what it says on her Kansas driver's license, but she might have as many phony licenses as Marnie does, or as Van Dam's cohort Leonard assumes George Kaplan does when he contemptuously says, "They provide you with such good ones" in *North by Northwest* (1959).)

It would seem that Judy (as I will continue to call her) has set herself an impossible goal. How, by lying, can she make Scottie love her "as she is, for herself"? Then again, if she has no identity apart from the roles she plays as an actress, how can she make Scottie love her "as she is, for herself" *except* by "lying"? Insofar as she knows that there is nothing she is "for herself," hers is the knowledge possessed by the heroines of such melodramas as *Stella Dallas*, *Now Voyager* and *Letter from an Unknown Woman* (all films intimately related to *Vertigo*). It is the knowledge, the self-knowledge, that, as Cavell puts it, her identity is ironic, that her "self" is not fixed, that everything she is, she also is not, that in the condition in which she finds herself – Emerson would call this the human condition – she stands in need of creation.

Terrified of death, longing to become someone "for herself," she stakes her quest for selfhood on winning Scottie's love. Why Scottie? For one thing, both as "Judy" and as "Madeleine," she loves him. As she writes in her letter, she wants him to find "peace of mind." Unless she saves him, she cannot be saved. If she lets him "change" her so he can love her as "Madeleine" again, or, for that matter, if he falls in love with "Judy" and forgets his love for "Madeleine," she would not win his forgiveness, apart from which she cannot be saved. She cannot tell him the truth without making him stop loving her, but his love cannot save her unless he knows the truth. Neither she nor Scottie is saved if Scottie loves her as "Madeleine" but not as "Judy," or as "Judy" but not as "Madeleine," or even if he loves her in both of her roles but without recognizing that they are "positively the same dame," as Muggsy puts it in *The Lady Eve*. Only if Scottie finds "Madeleine" in "Judy" and "Judy" in "Madeleine" can his love heal the rift in her soul and enable her "unattained but attainable self" to be born. How can she make this happen?

Judy's unfinished letter to Scottie began, "And so you've found me." His finding her is one of those "accidents" Hitchcock is wont to arrange to bring reality and fantasy into alignment. But I view this "accident" as also arranged by Judy. It is the first step in her plan.

Scottie is standing in front of the flower shop where he saw "Madeleine" buy the nosegay – he haunts all the places "Madeleine" used to frequent – when Judy "happens" to walk by, chatting with friends. She "happens" to pause in full view of Scottie, "happens" not to see him; "happens" to turn her face so that he views her in profile, exactly as "Madeleine" had done that fateful evening at Ernie's.

After Scottie follows her to the Empire Hotel, the camera slowly tilts to an upper floor window she "happens" to open. Then she "happens" to stand framed in that window. Scottie now knows exactly where to find her.

Even if we think it is only by chance that Scottie finds her, Judy – like Félicie in Éric Rohmer's *A Tale of Winter* (1992) – gives the man she loves every chance of finding her by chance. Unlike Rohmer's heroine but very much like Paula in *Random Harvest* – having watched that film a couple of nights ago, I have no doubt that it provided the inspiration for *Vertigo*'s necklace – Judy knows where to find the man she loves. But her plan is to let herself be found.

Judy's next step is to lead Scottie to believe that "changing" her is his idea, not hers. When she finally gives in, as Scottie thinks of it, and lets herself become "Madeleine" in his eyes, they kiss. Hitchcock expresses Scottie's rapture in that celebrated camera movement in which the background changes from Judy's hotel room to the livery stable where they had kissed before. The camera is registering a change in Scottie's subjective experience, we take it, but one he has not (yet) consciously registered. He does not see – even in his mind's eye – the change in his

surroundings the camera presents to us. We know, or think we know, that Scottie hasn't really gone anywhere. He has been transported metaphorically. What has transported him is this woman's kiss. (He is not a necrophiliac, as some commentators have suggested. Chris Marker is on target when he insists that in this kiss Judy is anything but dead to Scottie; she is "Madeleine" very much alive.)

But then Scottie opens his eyes and turns his face almost to the camera, so we see his perplexed expression. We also see that he is hiding his perplexity from the woman in his arms. Our impression is that he now sees what we are seeing, and is at a loss to explain it, just as he is at a loss to explain how it can be that this woman not only looks like "Madeleine," but also kisses like her. But what causes the background to change? Scottie's perplexity makes clear that it is not his doing. Of course, we can say that it is Hitchcock's camera that effects the change. But it does so by way of registering a change in Scottie's subjective experience, the fact that he has been transported. And it is Judy who makes that happen – deliberately, I am suggesting – with her kiss.

Like a man awakening from a pleasurable dream and willing himself back to sleep, Scottie abandons himself to Judy's embrace, choosing not to question the miracle, or black magic, that has brought his love back from the dead. I view Scottie's fateful decision, too, as internal to Judy's plan. Although the kiss resumes, it is not the same as before. The camera's continuing circling has led it to frame Judy from behind. We no longer see her face, only the spiral twist of her hair, an image that will be echoed, uncannily, in *Psycho*.

Judy is no longer the kisser but the kissee. Neither resisting nor responding, like Marnie in Mark's arms on their honeymoon cruise from hell, she has become, visually, a lifeless body.

And this change in the image does not register a change in Scottie's subjective experience. That he does not feel he is kissing a corpse is confirmed, I take it, when, after the fadeout that signifies that they have sex, Scottie relates to Judy – who expresses the wish for a "big, juicy steak" – in a way that makes it clear that he sees her as full of life. If Hitchcock's camera registers anyone's subjectivity, it is Judy's, when it intimates that Scottie's kiss drains her of life. She feels deadened in Scottie's arms, for he hasn't yet come to see her as she is "for herself." This kiss takes her closer, but it does not get her to her goal. She has yet to take the most dangerous step. She takes it when she asks Scottie, seemingly in all innocence, to help her put on her necklace – Madeleine's necklace. The necklace opens his eyes, as it had in his dream.

Once Scottie knows – or can no longer deny to himself that he knows – that she is "Madeleine" or, rather, that the "Madeleine" he loved never existed, Judy "lets" him return her to the scene of the crime and drag her to the top of the tower, enraged enough to kill her. All this is part of her plan. When she declares her love for him, falls into his arms and pleads with him to keep her safe, he says, "It's too late, there's no bringing her back," but does not resist her embrace. And he responds to her "Please . . ." by kissing her with overwhelming passion. And this kiss completes Judy's plan, I take it. Everything has unfolded as she had scripted it. All is fulfilled. She has succeeded in leading Scottie to this point at which he forgives her, and himself, and loves her unconditionally. For Scottie, this kiss is forever. Then why is it the kiss of death for Judy?

At the end of *The Wrong Man*, Manny visits his wife Rose, who has suffered a breakdown, in the hospital. He brings her glad tidings that the police have caught the man who committed the crimes of which he was accused, and that his trial is over. "That's fine for you," she says, rebuking him for assuming that her life revolved around his. In "The Unknown Woman in Hitchcock," I viewed the ending of *Vertigo* as such a rebuke to Scottie. Yes, this woman is his dream come true. But how can she achieve her "unattained but attainable self" in the embrace of a man for whom it makes no difference who or what she is, whether she is "Judy," a human being of flesh and blood; "Madeleine," a woman

who never existed; or even the ghost of "Carlotta," a madwoman who took her own life?

I now have a more charitable view of Scottie. When Judy declares her love and pleads with him to keep her safe, he rebukes himself for having been a "fat-headed guy full of pain" (as Devlin describes himself at the end of *Notorious* (1946)) who had failed until this moment to recognize who she is "for herself." For Scottie, this kiss is not like the kiss in Judy's hotel room. His vertigo is gone. He holds in his arms the key to the mystery. It is not, as I had thought, a matter of indifference to him who or what she is. Judy is now Madeleine, and Madeleine Judy, in his eyes. He forgives her for the suffering she caused him. What more is there for Judy to ask of Scottie? Nothing more, as there is nothing more for him to ask of her. Like the couple at the end of a remarriage comedy, he has forgiven her, she has forgiven him, and they have both forgiven themselves. And if they have forgiven each other, what standing have we – or Hitchcock – to rebuke one on the other's behalf? Then why does Judy have to die?

When I wrote "The Unknown Woman in Hitchcock," I believed that Judy chooses to die when she recognizes that Scottie's kiss has changed nothing, that in his eyes she is still nothing "for herself." If Scottie does acknowledge her with this kiss, as I now believe, who, or what, does kill her? What makes her pull away from Scottie's kiss, as she had pulled away at the livery stable, her gaze drawn in the direction of the camera? That Judy sees no one when she looks toward the camera is made clear when Hitchcock cuts to a shot, from her point of view, in which human figures are conspicuously absent. What Judy sees, we might say, is a vision of nothingness. Only after a moment does a shadowy figure, more an absence than a presence, emerge barely perceptibly out of the dark void.

Judy seems to know what she will see before she sees it, as if she envisions it in her mind's eye before her gaze and the camera in concert conjure this specter into being. When she does see this shadow, her eyes widen. The fact that what she had imagined is real takes her by surprise. That this is not something she has planned is significant, because it implies that if she sees this shadow as Death coming to claim her – as I do not doubt she does – Death is not coming at her conscious bidding. And yet she immediately knows, or thinks she knows, what this apparition is. She *recognizes* it. But how can she recognize this specter unless

it has appeared to her before? While in character as "Madeleine," Judy had described to Scottie a scene she said she remembered in which she stood before what she knew was her freshly dug grave. She now knows, in the same way, what this shadow is – that it is, in effect, her own freshly dug grave. Is it, then, that she really did dream the scene she had only pretended to remember, that she is only now remembering that dream, which has returned to haunt her?

Scottie, not granted her vision (although it is one that he might well have recognized from his own dream), remains absorbed in embracing Judy until, with a heartbreaking "Oh no, no!" she steps back in terrified awe and slips silently out of the frame. Only when it is too late does Scottie turn, and we hear a woman's off-screen voice say, "I heard voices." There is a chilling scream and Scottie wheels around in horror. As Hitchcock films this scene, we know we do not know whether in her terror Judy accidentally steps over the edge, or whether she deliberately jumps. Does she scream as she is falling because she wants to live, or because she has chosen to die but finds herself terrified as the void is about to engulf her?

Judy's scream still reverberating, the silhouetted figure steps into the light. It is a nun, and she is looking straight into the camera. Crossing herself, the nun intones, "God have mercy" and begins tugging on the bell rope, ringing down the final curtain on Hitchcock's deepest and most disturbing film, and his only tragedy.

In discussing the shot of the open grave in the dream sequence, I was motivated to ask whose dream this really was. The vision of the open grave seems to have its source, or origin, in the gaze of the woman I took to be the ghost of Madeleine Elster. And I found myself wondering whether Madeleine's ghost, with the complicity of Hitchcock's camera, was the author of that vision. I now find myself wondering whether Madeleine's ghost – again with the complicity of Hitchcock's camera – also authors the vision that kills Judy.

It hardly seems just for Madeleine's ghost to make Judy die screaming while letting her deceitful husband get away with murder. But Judy is vulnerable to being haunted, as Gavin Elster is not, because she is already haunted, as Scottie is. I am not suggesting that Judy sees the shadow that frightens her *as* the ghost of Madeleine Elster. Judy sees it as a vision of her own death, the way Scottie sees his death in his vision of the open grave. If the vision of her death Judy sees when she looks in the direction

of Hitchcock's camera emerges from the depths of her soul, has the dead Madeleine conjured it into wakefulness, or planted that vision – perhaps Madeleine's vision of her own death – in Judy's soul in the first place? That this death-dealing vision metamorphoses into a flesh-and-blood nun suggests that if it is an unnatural art that raises the specter that kills Judy, it is also God's will that she die. In the nun's judgment, this is divine justice.

Judy's lies to Scottie, and the psychic violence of his efforts to change her, are venial sins. If there is such a thing as a mortal sin, Gavin Elster surely commits one when he murders his wife. Murder is not, in principle, forgivable. No living person has the power to forgive the murder of another person. Scottie can forgive Judy for the suffering she caused him, but he has no standing to forgive her for the part she played in the murder of Madeleine Elster.

Do we believe that Judy's complicity in Gavin Elster's diabolical plot makes her guilty of a sin morally equivalent to his? Because we love Judy, we do not wish to think she is a murderer. But our judgment must hinge on whether we believe that when she breaks away from Scottie's kiss at the livery stable, tells him there is something she must do, and runs up the tower, she is still playing her role in Elster's script, or trying to keep the murder from happening. It is internal to Hitchcock's design of Judy's flashback, I take it, that it does not settle this question. Nor does her later telling Scottie that she tried to stop it. No matter how well she knows herself, that is something only God can know about her.

A few pages ago I was moved to ask myself, as I often have, why Judy has to die. But that is a prejudicial question. It presupposes that Judy's death *is* necessary, that Hitchcock has no choice but to kill her, that it is not in his power to keep her safe. If her death had no necessity to it, it would mean that Hitchcock chooses to kill her, that, like the arch misogynist some still foolishly take him to be, he wishes Judy to die. Would that make the creation of *Vertigo* the moral equivalent of murder?

What, if anything, legitimizes killing, and how, if at all, the act of killing changes the person who performs that act, are questions to which the Nazi menace gave special urgency in Hitchcock's British films of the late 1930s, such as *Secret Agent* (1936), *Sabotage* (1936), and *The Lady Vanishes* (1938), and the films he made in America during the Second World War, such as *Shadow of a Doubt* and *Lifeboat* (1944), and in its immediate aftermath, such as *Rope* (1948). But every Hitchcock thriller has its own way of

posing and addressing these questions, and of thinking through their implications for the "art of pure cinema" of which he was both master and slave.

If there were no Gavin Elster in the world of *Vertigo*, this woman would not have to die. But if there were no Gavin Elster, there would be no *Vertigo*. Elster is Hitchcock's accomplice in artistic creation. But Hitchcock is Elster's accomplice in murder. Madeleine has to be murdered for *Vertigo* to be created. And Judy, too, has to die.

I wish to believe – and I do believe – that there is a difference between Elster and Hitchcock. I wish to believe – and I do believe – that Hitchcock is not indifferent to Judy's fate, that he loves her as much as Scottie does, as much as I do. *Vertigo* is a tragedy because Scottie's love fails to keep Judy safe. I wish to believe – and I do believe – that the tragedy is also Hitchcock's. Not only does he fail to keep her safe, he finds it necessary to kill her himself, as Marnie finds it necessary to kill her beloved Forio. Hitchcock was fond of quoting Oscar Wilde's line, "People always kill the things they love."

And what of Madeleine Elster? Is she, even more than Judy, the "unknown woman" in *Vertigo*? There is no *Vertigo* without her murder, yet except for those two pivotal shots in Scottie's dream sequence, Hitchcock's camera takes no notice of her, seems as indifferent to her fate as her murderer is, as Judy is, as Scottie is, as we are. When Judy looks toward Hitchcock's camera and sees the shadow of her own death, I have finally found the nerve to think, this death-dealing vision is the murdered woman's revenge. If Hitchcock is Gavin Elster's accomplice in Madeleine's murder, he is no less an accomplice in Madeleine's revenge against Judy. Judy's death is Madeleine's revenge against Hitchcock as well. It forces the film's author to recognize at once the limits of his own power – the dark fact that he cannot keep Judy safe even though he loves her – and the murderousness of his unnatural art – the even darker fact that Hitchcock kills Judy not only because he has to, but because he wishes to. Hitchcock wishes for this woman he loves to die so that his greatest work of art, in all its perfection, can be born.

References

Cavell, S. (1996) *Contesting Tears: The Hollywood Melodrama of the Unknown Woman*, Chicago, IL: University of Chicago Press. (Following up on his seminal *Pursuits of Happiness: The Hollywood Comedy of Remarriage* (Cambridge, MA: Harvard

University Press, 1981), Cavell explores an adjacent genre of melodrama in this challenging but important book. The present chapter reflects on *Vertigo*'s intimate relationship to this genre as Cavell understands it.)

Emerson, R. W. (1979) "History," in J. Slater, A. R. Ferguson and J. F. Carr (eds.) *Collected Works of Ralph Waldo Emerson*, vol. II, Cambridge, MA: Harvard University Press.

Marker, C. (1994) "A Free Replay (Notes on *Vertigo*)." Online. Available at http://kit.kein.org/files/kit/Chris%20Marker%20Talks%20About%20Hitchcock's%20Vertigo.pdf (accessed August 1, 2011); originally published in *Positif* 400: 79–84; reprinted in J. Boorman and W. Donohue (eds.) (1995) *Projections* 4½, London: Faber and Faber. (The great filmmaker Chris Marker's brilliant if eccentric take on *Vertigo*, his favorite film.)

Rothman, W. (2004) "*Vertigo*: The Unknown Woman in Hitchcock," in *The "I" of the Camera: Essays in Film Criticism, History and Aesthetics*, New York, NY and Cambridge: Cambridge University Press, pp. 121–40.

—— (2012) *Hitchcock – The Murderous Gaze*, 2nd edition, Albany, NY: State University of New York Press. (Originally published in 1982, this expanded edition, incorporating over 800 frame enlargements, is a detailed study of six characteristic Hitchcock films. The book introduced the method of close reading the present chapter exemplifies.)

Further reading

Rothman, W. (2004) *The "I" of the Camera: Essays in Film Criticism, History and Aesthetics*, 2nd edition, New York, NY and Cambridge: Cambridge University Press. (Originally published in 1988. Contains, in addition to the essay on *Vertigo* discussed in some detail in the preceding pages, three other essays that stand in close relationship to the present essay: "*North by Northwest*: Hitchcock's Monument to the Hitchcock Film," "The Villain in Hitchcock: Does He Look Like a Wrong One to You?" and "Thoughts on Hitchcock's Authorship.")

Chapter 4

Noël Carroll
VERTIGO: THE IMPOSSIBLE LOVE

Introduction

VERTIGO IS AN IMMENSELY COMPELLING film, perhaps Hitchcock's greatest achievement. And yet, as I've noted elsewhere (2007), it cannot be the mystery and suspense elements that hold us in thrall. For they are too forced to warrant a second view.

Upon re-viewing, the absurdity of Gavin Elster's plot to kill his wife is hard to ignore. It is far too ingenious to succeed – too many things could have gone awry. What if Scottie hadn't been smitten by the phony Madeleine? What if Scottie had been just a little more probing – wouldn't he have easily discovered the whereabouts of the real Mrs. Elster? How could Elster be so sure that there would be no one else in the church? There was a nun nearby the second time around and that was in the middle of the night! And, of course, how could Elster be certain that Scottie couldn't climb to the top of the bell tower? He almost gets there during the murder and he makes it on his second attempt. Elster's stratagems click together smoothly in a way that is only possible in a fiction. In reality, the probability of Elster's plan working would be close to zero. Reflecting upon it after seeing the film, it can only strike you as remarkably silly.

Nor can much be said on behalf of the mystery element of *Vertigo*. After all, Judy divulges the "secret" in a flashback (followed by the letter

she never sends to Scottie) almost immediately after Scottie finds her. Nor is there much suspense at the end of the film, since we have no idea of what Scottie intends to do to Judy. We have no sense of where the scene might be headed, but that would be necessary for suspense to take hold. Instead there is only surprise when the nun emerges from the dark and Judy plunges to her death.

Perhaps there is some suspense in the second half of the film over the issue of whether Scottie will figure out that Judy and *his* Madeleine are one and the same. But it hits him in the scene just after Judy's final "transformation." That is, he realizes everything almost as soon as Judy is done up as Madeleine once again. Moreover, on a second viewing this element in the plot – Scottie's initial failure to recognize that Judy is his Madeleine – also seems wildly improbable. How could a man whom we presume made love to Judy-as-Madeleine fail to notice that the body of Judy-as-Judy is the same as Madeleine's in every respect, save for the platinum blonde hair? It strains credulity to the breaking point, especially given the body at issue (Kim Novak's!). The plot of the film, in short, is as stupendously unlikely as Gavin Elster's plot to kill his wife. Sitting through the film a second time would seem to invite a chuckle at its expense.

Like many detective stories of the classic age of mystery fiction by people such as Agatha Christie, the plot of *Vertigo* is very clever and inventive, thereby stoking the audience's curiosity. But once we learn the secret of these stories and see how we have been tricked, we rarely reread such mysteries. However, *Vertigo* is a film that many revisit. Yet if it is not the thriller elements that compel, what does?

Part of the answer, of course, is that the characters in classical detective fictions have next to no depth, whereas the characters in *Vertigo* are psychologically intriguing, especially in terms of their perversely convoluted amorous relationships. But *Vertigo* is not just a thriller. More than that, it is a love story. Indeed, it is the story of an impossible love, and by limning what makes the love between Scottie and Judy impossible, Hitchcock and his collaborators are able to draw from reflective viewers a recognition of some of the essential conditions that make love possible. That is, *Vertigo* provides the philosophical resources that can enable thoughtful spectators to develop insights into the nature of love.

A twice told tale

Vertigo is a twice told tale both in the sense that it tells the same story twice, revealing in the distributed second telling what really happened on the day when Elster's wife died, and also in the sense that it is made up of what appear to be two different, albeit overlapping, love stories. Indeed, the fact that there are two love stories is part of what gives Vertigo its philosophical traction, because by encouraging comparison between the two, the creators of Vertigo help the viewer pinpoint what is impossible about the relationship between Scottie and Judy/Madeleine.

The film opens with the famous rooftop chase sequence, ending with Scottie dangling from the drainpipe and looking down at the street way below where the body of his police partner is crushed against the pavement, a situation recalled with variation in the last shot of the film, where Scottie stands on the parapet of the campanile, looking down in the direction that Judy has fallen.[1] The next scene opens in his friend Midge's apartment. We see Scottie, played by Jimmy Stewart, on a chair with his leg propped up on a hassock. Presumably he has trouble walking. Perhaps this reminds us of the beginning of Rear Window, which also opens by establishing the leading character's injury.

Most of the scene with Midge is devoted to dispensing the information we need to follow what ensues. Scottie has vertigo, which has led him to resign from the police department, but this is not a financial problem because he is independently wealthy (which explains how it is that he can spend all his time wandering around San Francisco). Scottie's vertigo, it is said, cannot be cured, except possibly by another traumatic event (a hint of things to come?). But apart from being brought up to speed with respect to the plot, we also learn something important about Scottie. There is something suspect and maybe unstable about his relationships with women.

He reminds Midge that they were once engaged in college, but that she broke it off. He then tells her that he is still available. Both of his statements are greeted by strangely angled shots of Midge's frozen stare. Her silence speaks volumes. We take it that she sees through Scottie; she doesn't believe him. There is a strong suggestion that he is afraid not only of falling, but also of falling in love. Perhaps this is connected to the allusion to Rear Window, since the character played by Stewart there

also resists marriage. But, as gradually becomes apparent, Scottie's slightly veiled, almost boyish skepticism about love is a fragile defense against his own scarcely controllable romantic tendencies.

From the scene with Midge, we go to Gavin Elster's shipping company. Perhaps we should be on the lookout for some trickery here, since Hitchcock himself, the great manipulator, makes his appearance outside Elster's offices. Scottie enters Elster's office; they catch up on what each has done since their college days together. Then Elster attempts to enlist Scottie's help in investigating his wife, who he suggests is either being taken over by, or imagines she is being taken over by, her distant ancestor Carlotta Valdes, a woman who committed suicide and who, Elster insinuates, may be driving his wife to the same end. At first, Scottie turns down the assignment, but then relents, agreeing to start by observing the Elsters at dinner at a restaurant called Ernie's.

One thing that is striking about the meeting with Elster is the décor. It is very brown in a wood-paneled, manly sort of way. This color scheme reappears on other occasions, such as the men's club where Scottie reports to Elster. It also dominates the lobby of the McKittrick hotel which, in retrospect, we should probably regard as Elster's territory. But apart from its cinematic function as a narrative marker for Elster, it is one of the panoply of recurring elements that imbue *Vertigo* with a sense of highly obsessional unity that encompasses every dimension of the film: narrative, visual, and musical; costumes and characters; and so forth.

When Scottie scans the dining room at Ernie's, the faux Mrs. Elster pops out of the visual array, since she is virtually the only person in the room wearing something colored, which is an arresting, loud green dress.[2] It is important that when Scottie first sees her she is in green, since when he initially spots Judy in the second part of the film, she is also in green. And when Scottie awakens the supposed Mrs. Elster – who drives a green Jaguar – in his apartment, he has on a green sweater.

Moreover, green is, of course, the color that floods Judy's apartment in the Empire Hotel from the neon sign outside; after their famous prolonged kiss, when the camera makes the room spin, they end up hugging against what is an effectively abstract field of green. This repeating color motif has a unifying function. One wonders whether the production designers also knew that green is the color of Advent, since each of these occurrences signals a new beginning.

As the phony Mrs. Elster leaves Ernie's, she is the object of Scottie's point of view. She stops, almost frozen, on her way out, her stasis indicating Scottie's instant fixation. She is shot in profile, her nose pointed screen right. Later when Scottie first glimpses Judy, she too is in profile, her nose pointed screen-right. In fact, throughout the film, there are a number of very studied profile and silhouette shots of Judy/Madeleine and Judy, such as the shot of Judy sitting on her bed, swathed in green light. These rhyming profile shots visually underline one of the most important themes of the film in terms of the philosophy of love – namely, the question of whether one lover can be replaced by another lover who has (or is made to have) the same properties as the original.

Throughout *Vertigo*, events and images from the first love story are echoed in the second story. Sometimes these repetitions may be quite subtle. Scottie seats "Madeleine" in front of the fire at his apartment, after her supposed suicide attempt; later, he has Judy sit in front of the same fireplace as once again he ministers to her. Scottie sees the fake Madeleine in the upstairs window of the McKittrick Hotel; he spies Judy at her window in the Empire Hotel. In addition to these visual rhymes, there are the very overt narrative repetitions. Scottie follows the imitation Madeleine Elster in his car; subsequently, he stalks Judy on foot.[3] Judy/Madeleine goes to Podesta Baldocchi's, the florist where Scottie's infatuation literally blossoms in a burst of color as he opens the backdoor of the shop; later he buys Judy flowers. He first sees the woman he thinks is Mrs. Elster at Ernie's; Ernie's is the restaurant where Scottie and Judy first dine.

These repetitions are given a special significance by a short segment of the film between the two love stories. After Scottie has been released from the sanitarium, he roams San Francisco, haunting the various places that figured in his relationship with the alleged Mrs. Elster. First he goes to her apartment building, the Brocklebank, where he began tracking her. He sees her green Jaguar and, for a moment, we think that he thinks he sees his Madeleine walking toward it, because from afar the blonde woman who now owns the car is wearing a white coat just like one that Scottie's beloved wore. Next he goes to Ernie's, where he is taken aback by a couple who, for a split second, look as the "Elsters" did on the first evening Scottie saw his Madeleine.

These false Madeleines are what we might call *cinematic revenants*. They are very carefully designed by Hitchcock to look like Judy/Madeleine

from a distance. They are blonde and wear outfits reminiscent of Judy as Madeleine, and they are often not in sharp focus. They constantly conjure up the idea of Scottie's Madeleine by echoing her visual properties and emphasize his obsession with finding her again. But as they come into focus, the illusion dissolves and Scottie must continue his search.

In short order, he arrives at the art gallery of the Palace of the Legion of Honor, where he observed "Madeleine" studying the portrait of Carlotta Valdes. There is a young woman, a student perhaps, examining the painting, seated in exactly the same posture in which Judy/Madeleine "composed herself" and dressed in gray (which by that time was "Madeleine's" signature color). Scottie stares at the young woman; one feels that he wishes it were his Madeleine, but then realizes she is not and breaks away. Clearly Scottie is searching for his beloved. It seems impossible that he will find her.

But . . .

Standing outside Podesta Baldocchi, and looking at a bouquet just like the one that his Madeleine favored, Scottie turns only to see Judy – dressed in green and in profile – and her friends walking up the street. He is immediately drawn to her and follows her to her hotel. He has found his beloved or, at least, a simulacrum thereof. He goes to her apartment, and, strangely enough, is able to convince her to go out to dinner with him. Judy is very different from Scottie's Madeleine. Her hair and her complexion are far darker than those of the platinum-haired, pale "Mrs. Elster." She looks as though she might be part Latina, whereas the faux Madeleine Elster was echt WASP.

Judy speaks very straightforwardly and colloquially; Scottie's Madeleine spoke in something like the standard American stage accent popular in films of the 1930s.[4] Judy's glance is very direct and her facial expressions are animated. As Madeleine, her face was often frozen, affectless, as if she had daily Botox treatments; often she looked away when she spoke, her words drifting off; her eyes were frequently blank and popped wide open – as if she were elsewhere or in a trance, as if possessed, perhaps by the ghost of Carlotta. There is something a bit vulgar about Judy, whereas the Madeleine Scottie fell for was decidedly upper class. Yet Scottie says he sees something "in her" that attracts him. What he doesn't say is that what that is consists of the properties of his putatively dearly departed, which he discerns in Judy.

At first, the budding romance between Scottie and Judy proceeds normally. They stroll together past the Palace of Fine Arts, where they observe young lovers on the lawn; they go dancing at the Fairmont Hotel. Standing at the main entrance of Gump's, Scottie buys a bouquet for Judy from a streetside vendor. But at that very moment, the love story takes a scary turn. Scottie wants to buy Judy clothes at Ransohoffs. She is apprehensive, and rightly so. She senses that he is going to attempt to recreate his Madeleine using Judy as a platform. Scottie sees something of his Madeleine already in Judy and imagines that by further investing Judy with Madeleine's properties, he can reanimate her. Nowadays we might say that Scottie wants to clone his Madeleine using Judy's body to do so. Putatively, he thinks of the Madeleine he loved as a cluster of properties that can be transferred to Judy.

The scene at Ransohoff's is emotionally harrowing. There is an angry, intemperate tone in Scottie's voice. He barks at the salespeople. Judy is very upset. She realizes that he is attempting to dress her up as Madeleine. He keeps sending back gray suits until the shopkeeper locates the model that his Madeleine wore. Judy pleads with him to stop. They argue in front of a mirror, interestingly, where two Judys are visible.[5] She wants him to love her as she is, but she apparently realizes that she can only have him on his terms, so she surrenders.

She'll wear the clothes if he wants her to, she tells him, but, she adds inconsistently, only if he will love her (meaning Judy). Judy is so compliant, one surmises, because on their first date at Ernie's she saw Scottie looking yearningly at a blonde, the last cinematic revenant in the film, who, from a distance, looked fleetingly like a doppelgänger for Scottie's Madeleine. Judy appears to conclude that she must give in to Scottie's desire to reconstruct her if she is to hold on to his affection. What she does not quite realize is that it is not she, in the way she hopes, whom he will be loving.

After the debacle over the gray suit, Judy caves in on the evening dress and then the shoes he wants to buy for her. Had Scottie not learned of Judy's complicity in Gavin Elster's scheme, he would probably have gone on to sign her up for voice coaching and deportment lessons (and maybe some Botox injections too).[6]

The last battleground is Judy's hair. He wants it dyed platinum blonde. Via a montage, we see Judy transformed at the beauty parlor,

Elizabeth Arden's, which at first looks more like a hospital. Indeed, the transformation scene itself reminds one of an experiment from a horror film. Judy is being remade; Scottie's Madeleine is being reanimated.

Although Judy agrees for the most part to the make-over, she essays a final attempt at resisting; she leaves her hair down, rather than pinned up in a French twist. Scottie protests. He wants to replicate all his Madeleine's properties on Judy. Judy finally capitulates. She goes into the bathroom. When she returns, she first appears in an overexposed area within the shot; she appears illusory, ghostlike, recalling the previous cinematic revenants. Then she steps forward and becomes solid, concrete. Those ethereal properties have become incarnated cinematically. Whereas Madeleine's earlier doppelgängers never quite come into focus as the alleged Mrs. Elster, as Scottie's beloved, Judy does.

Judy has metamorphosed, at least visually, into Scottie's Madeleine. The fake Madeleine's properties and Judy's are now the same, at least as far as the eye can see. She and Scottie embrace and the room turns around them like a gyre. Scottie has replicated his Madeleine to his own satisfaction, by investing Judy with her properties.

In the next scene, there is another repetition. Judy puts on the necklace she wore as Madeleine, which, in turn, is identical to the one worn by Carlotta in her portrait. Scottie recognizes it. Interestingly, he seems to make the connection while looking at Judy's mirror image. This prepares us for the last and most fateful repetition in the film – the return to the Mission at San Juan Bautista. Once again they ascend the stairway of the bell tower, this time with Scottie, seething in rage and sarcasm, narrating the true story of what happened that day when Gavin Elster's wife supposedly committed suicide. The tale told once more – their love has died; and this is then deftly symbolized by Judy's literally dying. They could never have gone on from there. Their love was impossible.

Impossible love, part I: Scottie's project

Vertigo is philosophical not because it recounts the impossibility of the love between Scottie and Judy, but because it supplies reflective viewers with the resources to discover for themselves why that relationship *necessarily* – given the nature of couple-love – never had a chance of success. Underlying Scottie's behavior, it would appear, is a very commonplace view

about love – namely, that what we love by way of amorous romance are the properties of the beloved. Asked why we love our significant other, we say things like "because of her intelligence" or "because of his laugh," or maybe "because of her generosity." That is, we offer a list of properties in order to account for our love. Upon what else could our love be based? It cannot be that we love some bare particular.

This view of love – which is sometimes attributed to Plato by way of Socrates's rehearsal of Diotima's theory of the *scala amoris* in the *Symposium* – has, it would appear, several curious consequences.[7] One is that since properties are general and can be instantiated by different particulars, the cluster of properties we prize in our beloved could obtain in someone or something numerically distinct from our significant other, *and*, were that the case, we would have just as much reason to love the double as we do to love our partner of many years. In fact, if it is really a certain cluster of properties that grounds our love for the other, then if someone were to possess those admired properties to a greater degree than the one we are with, it would make perfect sense for us to trade up.

In short, if it is the beloved's properties that are the object of our love, then were a clone of, say, our spouse contrived, and our spouse incinerated, we should have no cause for distress, since we would still have access to the cluster of properties we so value. In *Vertigo*, Scottie's behavior indicates that he believes something like this. He has lost his Madeleine. However, he hopes to recuperate that loss by transferring her properties to Judy. That is why he is obsessed with remaking Judy in the image of his beloved. He is like those people who have their pet dog cloned in the hopes of literally replacing it in their affections.[8] The difference is that Scottie is attempting to do this with a human being.

The idea of a transfer of one person's properties to another is introduced in *Vertigo* in terms of ghosts, not clones.[9] Specifically, Gavin Elster plants the idea that Carlotta Valdes's properties – not only her looks, but her suicidal tendencies – are being transferred by supernatural means to his wife Madeleine. Whether or not Scottie accepts this account of the alleged Mrs. Elster's behavior is unclear; nevertheless, he attempts a parallel operation in his effort to remake Judy in the image of his beloved. Judy, of course, protests. She wants Scottie to love her for herself and not for some cluster of properties that she shares or can be made to share with the counterfeit Mrs. Elster.

Although Scottie's view of love appears based in common sense and has, in fact, an ancient pedigree, the way in which it is represented in *Vertigo* strongly indicates that it is flawed. This is especially apparent in the conflict over the new clothes in Ransohoffs. It is difficult to miss the suggestion that there is something very wrong with what Scottie is attempting to do. His very demeanor seems cruel, out of control, and at times tyrannical. And when he pleads for Judy's compliance, one senses that he is asking for something that no one should ask of his/her beloved. He is asking her to abnegate her haecceity, her status as a unique or individual being. Judy herself articulates this when she beseeches Scottie in these words: "Couldn't you like me, *just me*, the way I am?" (emphasis added).

In this way, *Vertigo* illuminates what is questionable in the properties-view of romantic love that Scottie seems to embrace. Previously, we noted some of the stranger consequences of the properties-view. On that conception of love, we should be willing to trade up at the prospect of obtaining more of the properties we covet by allying ourselves with a more richly endowed object than our present lover. But, I suspect, most of us think that a "love" so fickle is hardly worth the name. It rubs the wrong way our intuitions about what counts as love.

Similarly, few of us would feel loved if we were convinced that our lover would be just as happy with a clone as he or she is with us – that if I died, for example, I would not be missed, so long as my partner had a replicant available. I, that is, would not feel loved. I might even say that my partner just doesn't understand what love truly and essentially is if he or she would be as satisfied with my doppelgänger as with me, because I would not feel that my lover loved *me* – me just as I am, as Judy says, or, better yet, as who I am.

Judy's protests capture these intuitions, which the audience may interpret as the basis for objecting to the philosophy of love that Scottie presupposes. Indeed, by riling our intuitions in this way, *Vertigo* induces the conscientious viewer to probe even more deeply the issue of that which is dubious in the philosophy of love that Scottie exemplifies.

One essential element of genuine romantic love that Scottie's relationship to Judy lacks is a desire to benefit Judy for her own sake (Brown 1987: 27–8). Judy sounds this alarm by constantly asking Scottie

to love her, to attend to her. Instead, he is attending to himself and his own needs. In fact, he makes this clear by asking her more than once to transform herself for him. He does not treat her as an autonomous agent who is valuable for her own sake and whose needs and desires merit respect. Rather, he treats her as an instrument for satisfying his desires. He is obsessed with recreating his Madeleine by *using* Judy as his basic building material. His attitude toward Judy is not one of disinterested care. It is self-interested. Scottie is using Judy to salve his own spiritual wounds.

At least with respect to Scottie's portion of it, the first love story in the film – the one between Scottie and his Madeleine – initially offers us a foil to the second love story with Judy, a contrast that clarifies what is amiss with what Scottie is doing to Judy. For, the first time around, Scottie's concern for his Madeleine is authentically disinterested. He has become her self-elected champion or guardian; he will protect her and attempt to free her from inner torment *because he loves her*. But he does not love Judy as such ("just as I am," as she puts it); he loves the properties of his Madeleine as they are instantiated in Judy Barton. And that is what makes his bullying and pleading so very reprehensible.

However, *Vertigo* does not only reveal that Scottie's conception of love is flawed because of the insufficient extent to which he treats Judy as an autonomous individual – with her own needs and desires – who should be valued for her own sake and not merely as a means. In addition, something else that is essential to loving is also missing from their relationship. Love is a historically constituted bond – a bond between this person and that person that evolves with unique specificity over time. Evidence that love is a historical relation between individuals – rather than a matter of valuing a certain cluster of properties that just happen to cohere in one's lover – is the fact that we continue to love even when the properties we cherish in the beloved begin to wane, when they lose their looks, their cheery disposition, their wit, their intelligence, and so on. This is because love is a historically developing relationship with a particular person. That is why there is something peculiar about attempting to replace one's beloved with a clone. We do not share a historic bond with the clone. We cannot, because the clone was born yesterday. The presupposition that love is a historical relationship, moreover, underwrites the distress we feel at the preceding thought-experiments involving our replacement by a replicant.

As Robert Nozick noted:

> Apparently, love is an interesting instance of another relationship that is historical, in that (like justice) it depends upon what actually occurred. An adult may come to love another because of the other's characteristics; but it is the other person, and not the characteristics, that is loved. The love is not transferrable to someone else with the same characteristics, even to one who "scores" higher for these characteristics. And the love endures through changes of the characteristics that gave rise to it. One loves the particular person one actually encountered.
>
> (1974: 167–68)[10]

Because love is a historical bond, the lovers in question are unique and irreplaceable. Scottie cannot expect to have a relationship with Judy on the basis of the relationship that he thought he had with Madeleine Elster. That happened at another time and place, and, as far as he is concerned, with another person. From his perspective (that is, up until the end of the film), Scottie does not have a historical relationship with Judy-as-Judy and, because of that, love between them is impossible. When the couple begin dating, it appears as though they are starting to develop the kind of historical relationship that is necessary for love. But Scottie interrupts that process with his campaign to transform Judy into his Madeleine. Thus, he abrogates the possibility of evolving a history with Judy in favor of a history (that he does not know to be fictional) with someone effectively other. But the failure to forge a historical bond with Judy as Judy is a recipe for romantic disaster.

The notion that love is a historical relation should not seem mysterious. Love relations grow over time. The partners in such relations share experiences, projects, and memories. Lovers shape each other in terms of desires and concerns. They are invested in each other and this investment is historical. It was not someone else with whom you brought up the children, suffered through their teenage rebelliousness, and struggled to pay for their college education.[11] Lovers teach each other things and spur each other to being better selves. Lovers are touchstones for each other – "Remember the time that we . . ." That is, they confirm each other's historical identity as it is constituted by their collective activity and memory.

All of this happens within a historically evolving relationship. And that relationship can only be had with a unique, irreplaceable person. It is not the sum of a cluster of properties that could fit somewhere else. The love relation is infungible; it cannot be transferred to a clone or a replicant. It is not that properties don't matter to love relationships. It is just necessary that they be embedded in a history. But since Scottie refuses to develop a historical bond with Judy as Judy, their love relationship is impossible; in fact, it is self-destructive, as *Vertigo* asserts.

Furthermore, even had the relationship with his Madeleine been genuine, Scottie could not have mapped it onto his relationship with Judy, for, in the way that Scottie understands that relationship, it was not in fact, historically speaking, a relationship with Judy. There is – as far as Scottie knows and to the extent that Judy must dissemble – a historical disconnect between their two "romances." But without a historical link, genuine love is impossible, as *Vertigo* encourages us to appreciate. Why is the love between Scottie and Judy a non-starter? Because Scottie wants to ground it on his history with someone other than the person he believes Judy to be, someone whom Judy cannot acknowledge to have been.

There is a point in the film that readers might feel I have failed to notice. Right after Judy relents about her hairdo and the two embrace in their room-swirling kiss, Scottie hesitates momentarily. In the background, we see the carriage house where Scottie last kissed his Madeleine. Is he aware, if only dimly, that he has had a relationship – a historical relationship – with the woman now in his arms? The shot is certainly ambiguous. But my interpretation of it is not that Scottie has an intimation that Judy was Madeleine, but rather that he has secured his wish to re-animate Madeleine. When he returns to kissing Judy, it is extremely vigorous, as if he were marking the culmination of his desire. Furthermore, would he be so taken aback when he later sees Judy wearing Carlotta's necklace, if he were already suspicious?

In short, Scottie and Judy have no effective history together before the moment when they intersect in front of the florist's shop. Scottie's attempt to erect his relationship with Judy upon some other history is doomed. His terms of endearment are metaphysically impossible, as Hitchcock and his collaborators invite us to recognize.[12]

Impossible love, part II: What about Judy?

Judy Barton's relationship to Scottie is, of course, very different from Scottie's relationship to her. She knows from the get-go that she has had a past with Scottie. However, the nature of that relationship does not constitute the kind of historical bond that is essential to couple love. There are at least two initial ways of comprehending Judy Barton's history with respect to Scottie. On the one hand, she is related to him as the ersatz Mrs. Elster. On the other hand, she was related to him as the actress playing Scottie's Madeleine. There can be no historic bond between Scottie and the counterfeit Mrs. Elster, since the latter is a fictional being. Whatever relationship Scottie imagined to have been evolving between him and his Madeleine was a false one, a mirage. Theirs was not a relationship between two actual persons, because the relationship was one person shy; Scottie's Madeleine was really a cluster of properties, invented by Gavin Elster. Scottie could no more have a historic bond with her than I could make love to Moll Flanders. Moreover, *Vertigo* makes this abundantly clear by underscoring the futility, not to mention the injustice, of Scottie's attempt to transfer the properties of his Madeleine to Judy Barton.

Of course, the actual (in the world of the fiction) Judy Barton has had a relationship with Scottie, but that relationship is also problematic in at least two ways. In the first relationship, she is basically an actress playing a part. But in that role, Judy Barton could not establish a historic bond with Scottie because she was ostensibly Madeleine.

But what of the actual Judy Barton? She has had a relationship with Scottie since the time she was the phony Madeleine Elster. Yet that was not the right kind of historical bond, because it was based on a lie. Scottie and Judy were not embarked upon a mutually shared project. Hers was an agenda altogether different from his; her agenda was basically Gavin Elster's. Any sense of self that Scottie derived from the relationship that he believed he was in sundered when he became aware of the true nature of his association with Madeleine/Judy. Undoubtedly, that is why he is so furious in the bell tower at the end of the film. He behaves like an injured animal in pain. He feels as though a part of himself has been torn out of him.

Vertigo also encourages reflection on infidelity. Whereas in most relationships betrayals occur after they are up and running, the narrative

of *Vertigo* places Judy's before Scottie follows her home and their "second" romance commences. I think that this inversion of the usual order of things functions to guide us by defamiliarizing a familiar situation. It emphatically draws our attention to the harm faithlessness inflicts upon the *historical* nature of a romantic relationship.

Scottie realizes that Judy tricked him by pretending to be Mrs. Elster, but he also surmises that she was romantically unfaithful to him as well (referring to Elster, he snaps, "You were his girl, huh?!"). The historic bond that is essential to genuine love depends upon a converging history's being shared by both members of the couple. Sexual infidelity – betrayal – implies that one half of the couple is operating on a misconception concerning the ongoing nature of the relationship. And insofar as one's sense of who one is is at least partially based on a self-narrative, to discover that an integral component of that narrative is false presents a deep and often literally felt wound to one's ego.

Infidelity is not wrong simply because it is based on lying; it constitutes a harm that is wrong because it shatters one's conception of who one is by destroying the historical foundation of that conviction. That is why Scottie is so hysterical in the last moments of *Vertigo*. He hasn't just lost his Madeleine. He's lost a piece of his own self-image, the piece that was based on what he supposed was his shared history with her. That is, infidelity constitutes a harm, beyond lying, insofar as it forces the former lover to give up parts of his/her identity. Phenomenologically, it feels as though a part of oneself has been ripped out of one's body.

Scottie's love for Judy is impossible, *Vertigo* suggests, because it is rooted in the notion that the object of love is a set of properties transferrable from one vessel to another rather than a unique particular with whom one has forged a historical bond. But Judy's love for Scottie is also impossible because Judy does not realize that the historical bond that love requires must be a true one. It cannot be fictional or false or deceptive, if love is to survive.

Concluding remarks

Vertigo tells the story of love haunted by and finally destroyed by the past, and in doing so it reminds thoughtful viewers of the importance of history to the marriage of true minds. On the one hand, it suggests that the object of love cannot be – as Scottie seems to think – a cluster of

properties; those properties have to be anchored in a concrete individual with whom the lover builds a life and, in the process, a self. Love without that historical tether is impossible. If the past is not properly acknowledged, love will be destroyed, as Scottie risks destroying his relation with Judy. On the other hand, that history must be a true one, for if it is faithless, if it is rent with betrayal, love, along with part of the beloved, will dissolve. *Vertigo* is an opportunity to contemplate philosophically the nature of the historical bond that is essential to love. If we return to it again and again, it is not because we find the mystery elements so compelling, but because we are fascinated by the nature of love.

Notes

1 Interestingly, this is not the last shot in the script as it was revised on 9/12/57. (That draft of the screenplay by Alec Coppel and Samuel Taylor was converted to a PDF by www.screentalk.org.) In that version, the movie ends in Midge's apartment with Scottie staring out at the city. It seems especially fitting that the film now concludes by echoing the shot at the end of the first scene. For the film is made of repeating motifs, not only of places, events, costumes, and musical leitmotifs, but also of colors and compositions. The film is highly unified by all of this multidimensional repetition. Indeed, the film is a virtual repetition-machine. Call this unity obsessional, a mirror, perhaps, of Scottie's mentality.
2 Green is Judy/Madeleine's color, at least in the opening phases of both love stories. Green also figures in a number of compositions in Judy's apartment, including not only the scene in which she pins her hair up, but also the scene in which she argues with Scottie while sitting in profile on her bed by the window. The color composition in *Vertigo* is very, very carefully designed.
3 Trailing someone is, of course, a wonderful objective correlative for obsessional behavior.
4 Perhaps the fact that Judy/Madeleine was speaking in an affected accent (along with the patently dyed hair) should have alerted the astute, first-time viewer to the fact that she was a phony.
5 Scottie also first recognizes that Judy is wearing Carlotta's necklace by looking at her image in a mirror. Once again we see two Judys, reinforcing the film's doubling imagery. In the mirror we see Judy reflecting, in a manner of speaking, the image of "Madeleine."
6 It bears noticing that the properties Scottie wants to transfer to Judy are fairly superficial – clothes, makeup, and hairdo. But this I think is less a comment upon the depth of his desire to recreate his Madeleine than a function of the way in which these can serve as efficient, visual markers for his intention to

secure a total transfer of properties. That is, these are just the most effective ways to cinematically signal Scottie's intentions.
7 See Plato's *Symposium* (1991) and, for commentary, Nussbaum (1991).
8 An anecdote of such an attempt is summarized by Grau (2004: 111–13).
9 There is a theme of ghosts that runs throughout *Vertigo* in several dimensions. In addition to Carlotta, there are what I have called the cinematic revenants of the counterfeit Madeleine. Also, as I seem to recall from my first viewing of *Vertigo* eons ago, at least initially I took the nun at the end of the film to be the ghost of the real Mrs. Elster – that is, until she stepped into the light. Moreover, this way of handling the scene visually recalls the strategy whereby the cinematic revenants step from perceptual obscurity – owing to the camera-to-subject distance, the focus, the lighting, etc. – to clarity. Call this cinematic device in this context *ghosting*; it is a recurring technique in the film, and it is meant to underscore the ways in which properties can be shared by different individuals.
10 Further authors, among others, who defend the view that love essentially involves a historical bond include Rorty (1986), Kraut (1986), Brown (1997), Grau (2004), and Kolodny (2003).
11 See Nozick (1991).
12 There is the lingering question of what we are to make of Scottie's initial love of his Madeleine in the first part of the film. In retrospect, my suspicion is that in one sense Scottie did not truly love even *his* Madeleine, in all her uniqueness, for the simple reason that there is no Madeleine to love, but only the cluster of properties invented by Gavin Elster. Further evidence that Scottie loved a cluster of properties rather than a historical person is Scottie's campaign to transfer those properties, most notably the most apparent ones, to Judy. Lastly, there is the way in which Scottie's Madeleine is treated as an artwork, specifically as an *idealization*, rather than a real person. For a discussion of Madeleine-as-an-artwork, see Carroll (2007).

References

Brown, D. (1997) "The Right Method of Boy-Loving," in R. E. Lamb (ed.) *Love Analyzed*, Boulder, CO: Westview Press, pp. 49–64.
Brown, R. (1987) *Analyzing Love*, Cambridge: Cambridge University Press, pp. 27–28.
Carroll, N. (2007) "*Vertigo* and the Pathologies of Romantic Love," in D. Baggett and W. Drumin (eds.) *Hitchcock and Philosophy*, LaSalle, IL: Open Court, pp. 101–13.
Grau, C. (2004) "Irreplaceability and Unique Value," *Philosophical Topics* 32: 111–29.
Kolodny, N. (2003) "Love as Valuing a Relationship," *The Philosophical Review* 112: 135–89.
Kraut, R. (1986) "Love De Re," *Midwest Studies in Philosophy* 10: 412–30.

Nozick, R. (1974) *Anarchy, State and Utopia*, New York, NY: Basic Books.
Rorty, A. (1986) "The Historicity of Psychological Attitudes: Love Is Not Love Which Alters Not When It Alteration Finds," *Midwest Studies in Philosophy* 10: 399–412.

Further reading

Auiler, D. (1998) *Vertigo: The Making of a Hitchcock Classic*, New York, NY: St. Martin's Press. (Background information about *Vertigo*.)

Baggett, D. and Drumin, W. (2007) *Hitchcock and Philosophy*, LaSalle, IL: Open Court. (A useful source for articles about the relation of Hitchcock to philosophy.)

Nozick, R. (1991) "Love's Bond," in R. Solomon and K. Higgins (eds.) *The Philosophy of (Erotic) Love*, Lawrence, KS: University Press of Kansas, pp. 417–32. (An argument in defense of the notion that love is a historical relationship.)

Nussbaum, M. (1991) "The Speech of Alcibiades: A Reading of Plato's *Symposium*," in R. Solomon and K. Higgins (eds.) *The Philosophy of (Erotic) Love*, Lawrence, KS: University Press of Kansas, pp. 279–316. (Challenges the properties-view as an interpretation of Plato and as a position on love.)

Plato (1991) *Symposium*, in R. Solomon and K. Higgins (eds.) *The Philosophy of (Erotic) Love*, Lawrence, KS: University Press of Kansas, pp. 13–32. (Often cited as the *locus classicus* of the view that the appropriate objects of love are certain properties or clusters thereof.)

Chapter 5

Charles Warren
OFFENSIVE

> "Madness is like intelligence. You can't explain it. Just like intelligence. It comes over you, consumes you, and then you understand."
>
> <div align="right">Hiroshima mon amour</div>

"...NIGHT TRAINS, air raids, fallout shelters..." Near the beginning of Chris Marker's essay film *Sans Soleil* (1982), these words emerge to sound the theme of remembered war, and feared and anticipated war, that is so important to the film. Explicitly, things other than war are talked about most of the time, but war keeps coming back, and the film gives the sense of war's memory, or anxiety about war, as hovering just behind everything, or lying just below the surface – "small fragments of war enshrined in everyday life," as this early passage of the film puts it. While we hear these words, we contemplate the ordinary-seeming faces of dozing commuters on a ferry in contemporary Japan. Can we imagine, can we see, these people as holding within themselves, with some sense of the sacred even – "enshrined" – small fragments of war?[1]

Two-thirds of the way through *Sans Soleil*, the film takes a surprising turn into discussion of *Vertigo*, looking at its locations, bringing up some of its images, making terse comments on its events. Surprising because Marker turns attention to an old romantic Hollywood film, after spending so much time on contemporary Japan and its social rituals and politics, on Guinea-Bissau and its history of decolonization and civil war, and on meditation upon history. Surprising that with *Vertigo* Marker goes into the story of a couple, a man and a woman (is she that? – more of this

later), their affair and their problems, the area of personal psychology, after *Sans Soleil* has so de-emphasized the individual, going for the broad historical view. And suddenly we see San Francisco up on the screen, after being so long in Asia and Africa, no interest taken so far in the United States. Does *Sans Soleil* bring *Vertigo* into relation with the issues otherwise so important to it? Even war?

The turn to *Vertigo* feels abrupt, and one does not get over this with re-viewings of Marker's film. The abruptness is a shock into thought, like the juxtapositions of a John Donne poem. What we have, on reflection, is not a simple turn from history, anthropology, philosophy, to film. Not even a simple turn from essay and documentary to the world of fiction. Up to the turn, *Sans Soleil* has been widely concerned with the ephemerality of things, with loss and the melancholy of irretrievable loss, with the sense of an extra-human or super-human destructiveness that seems to rise up and overwhelm human happiness – all of which is pertinent to *Vertigo*. Moreover, film and its relation to other forms of human creativity has been a subject of *Sans Soleil* right from the start. The whole work is framed as the memories and comments of cinematographer "Sandor Krasna," whose words are read in voiceover by a supposed woman friend to whom he wrote letters and, presumably, sent the film footage that we watch as we listen to her. The world of *Sans Soleil* and its concerns comes to us explicitly – openly and admittedly – as the rendering of an artist, a filmmaker – perhaps two, the woman friend serving as verbal and visual editor. "Krasna" identifies himself with the medieval Japanese woman writer Sei Shonagon, a poetic documentarist in prose; also with a friend in modern Tokyo who transforms the world on a visual synthesizer; and with many forms of folk or popular culture – old African myth-making, television, street festivals in Japan.

"Poetry is born of insecurity," the voiceover says in a summary way at one point, and the phrase seems to give a key to the whole film. All of culture, for Marker, is poetry. Filming and fashioning a film are a form of this. In face of the destructive forces of nature and of humanity, people create – beautiful prose, ritual, the lights of Tokyo, films . . . People create in order to have and hold, to fix something for contact or contemplation, to give the urge of life, make a gesture of life, again and again. Memory and creation, for Marker, are inextricably tied together. We want to hold on, and memory is our way. But memory is a creative act – not the thing itself. Memory does not really hold on, and is thus "impossible." It is

gloriously "insane," leaving reality in a sense. With *Sans Soleil*'s turn to *Vertigo* we hear the words, "only one film had been capable of portraying impossible memory – insane memory: Alfred Hitchcock's *Vertigo*."

It is not surprising to think of Hitchcock films as "born of insecurity," even as being "poetry" born of insecurity, gestures of forming and shaping, rising from a deep anxiety. In the many films from the 1930s to the 1960s with spies and a background of war, personal relations are played out in consciousness of the world's treachery and uncertainty, consciousness of the forces greater than the individual that seem to determine how life will go. Some characters take an active role in the world's affairs, some are made to be involved in spite of themselves. All are *aware*. The world affects people, and its catastrophes also seem to mirror or symbolize something already inside them. A few years after *Vertigo*, back in San Francisco and its region, *The Birds* (1963) gives an image of "the end of the world," as one of its characters puts it.

Vertigo portrays insecurity and the counter-moves people make in face of it. It gives us characters deeply rattled and making their impossible, insane creative/memorial gestures and constructions. Does their disturbance have consciousness of the world's broad chaos and ruin? This needs pondering, though one might feel right off that James Stewart's Scottie bears traces of the other and earlier Stewart characters in Hitchcock, who link pretty plainly to the wider world: *Rope*'s (1948) false Nietzschean, a figure of the times; *Rear Window*'s (1954) frustrated, injured news photographer, longing for the world stage that he has known and from which he is now being kept back; the controlling husband of the second *The Man Who Knew Too Much* (1956), paired with a blonde woman who hankers for theater and performance, their equilibrium, such as it is, upended in the currents of international spying and power plays.

Sans Soleil identifies its own filmmaking work with all the memorial/creative gestures it sees about it in the world. And *Vertigo* does something similar. *Vertigo*, like *Sans Soleil*, portrays disturbance giving rise to insane, impossible poetry – poetry is *making* – and this poetry is seen to be like film. Scottie remembers the dead – as he thinks her – Madeleine, and creates her again in Judy. When he realizes that his Madeleine did not die, but that Judy had acted the role of this Madeleine, even up to pretended death, Scottie angrily compares himself to the villain Gavin Elster, Judy's first master, who had costumed and coached her and given

her lines – in short, directed her. Elster and Judy made a film for Scottie. Scottie and Judy make a film for themselves.

Elster's motive is some kind of disturbance we cannot fathom – the motive to do away with his wife and cover it by bringing to life the elaborate scenario with Judy as Madeleine. Elster tells Scottie that he longs for the "power" and "freedom" of the settlers of old San Francisco; if he is sincere, this would link him to the ruthless strain in American expansion west. Yet his elaborate plot is more notable for its stickiness and pervasiveness than for any sense it makes. For this film it is simply a fact of life, to be accepted, that there is such murderousness about as Elster's, such force of will to project schemes.

"Madeleine" in the first part is clearly torn or split, and after what we eventually learn of her, we see Judy behind this figure, insecure in a vertigo of her own – under the spell of Elster as a lover and powerful man who has raised her above her origins, and also, increasingly as the scenario plays out, drawn to Scottie and to being Madeleine because he likes her to be, and, perhaps, because she is herself liking it. Scottie is the audience for the scenario of part one, but he starts to become involved and to become the author too, in a way, as any film audience will, in its way, and as Judy/Madeleine starts to become its author in a way, as the scenario changes from what was intended. The scenario starts to take on a mind of its own, as many a film does. "I tried to stop it," Judy will say. She could not stop it.

In the second part of *Vertigo* Scottie, of course, tries to recreate the remembered Madeleine, directing Judy, the woman before him. The stronger plan in this may be Judy's, deciding to enable Scottie once they have met (again), having her flashback and going forward with him instead of running away, perhaps intending and performing all things that ensue with her – her resistances that give way; even, as William Rothman suggests in his essay in the present volume, intending her revelation of her role in the earlier plot, by putting on the necklace near the end; perhaps intending even her death, while desperately hoping she can "stop it" and be reconciled. She is, to say the least, some kind of co-author in this later as-it-were film.

Everybody's imaginative constructions in *Vertigo* come with visions and projections calling attention to themselves as such – altered images, dream, events seen in the mind's eye, and more. Hitchcock knows well what Marker points out, that film is tied up with the way we live life.

Fairly early in Sans Soleil "Krasna" spends a lot of time with Japanese television, its animation and horror shows, its documentary material on Rousseau and on the Khmer Rouge; and Krasna remembers Brando in Apocalypse Now (1979) (recreating Kurtz from Joseph Conrad's Heart of Darkness): "Horror has a name and a face. You must make a friend of horror." Krasna continues the thought, "To cast out the horror that has a name and a face, you must give it another name and another face." And he soon comes to the formulation "poetry is born of insecurity." Japanese television and its real-world and fantastic content make a gesture to cast out horror by giving it a new name and face. At the center of Sans Soleil is an extended section on Tokyo's underground shopping arcades and on commuter trains with dozing passengers, where horror and fantasy images come back from the earlier television material to suggest the passengers' dreams. Krasna speaks of "a gigantic collective dream of which the entire city may be the projection," and says, "the train inhabited by sleeping people puts together all the fragments of dreams, makes a single film of them – the ultimate film" – words Krasna will virtually use of Vertigo.

Just before coming to Vertigo, Sans Soleil gives its account of the decolonization of the Cape Verde islands and Guinea-Bissau under the idealistic leader Amilcar Cabral, and of Cabral's assassination and the ensuing cycle of rupture, dissension, plots, and counterplots. "History," one finds, "doesn't care . . . She has only one friend, the one Brando spoke of in Apocalypse: horror." And the camera, in found footage, contemplates a corpse on the ground, seemingly the corpse of an African soldier, some of the skin torn away, maggots swarming. The film finds horror itself, and in a sense gives it a new name and face by making it into a film image and thinking about it.

With a cut, the voice says, "I'm writing you all this from another world, a world of appearances," and we see the image of a woman on the synthesizer screen of Krasna's friend in Tokyo who calls his screen world "the Zone" as "an homage to Tarkovsky." In Tarkovsky's Stalker (1979), the Zone is the region where faith is aroused and wishes come true, a refuge from the world's general collapse. Earlier, Jean Cocteau in Orphée (1949) had called the region beyond death "the Zone," where the characters play out their lives – and we remember that Vertigo's source is the novel D'entre les morts. The region of imaginative gestures is a region of death and new life.

The woman in the synthesizer image is singing softly what soon becomes recognizable as Ophelia's mad song from *Hamlet*: "He is dead and gone, lady/He is dead and gone . . ." Ophelia herself will soon be dead, a suicide. It is as if the image and song of Ophelia grieve, maddened, for the dead African soldier. The image and song are another gesture in the film, and a climactic one, and unmistakably filmic – using the synthesizer – of giving horror a new name and face. As the camera moves over the controls and apparatus of the machine, with cuts away to marvelous altered images of other women – perhaps fragments, alter-egos, of the shattered Ophelia – the voiceover tells us, "Legends are born out of the need to decipher the indecipherable. Memories must make do with their delirium, with their drift. A moment stopped would burn like a frame of film blocked before the furnace of the projector. Madness protects . . ." Memory, delirium, drift, madness – the flow and projection of film is declared to be mad, in a necessary way. And just here *Sans Soleil* turns to *Vertigo* – "He wrote me that only one film had been capable of portraying impossible memory – insane memory: Alfred Hitchcock's *Vertigo*" – as we look at abstract spiral images from Saul Bass's credits sequence for *Vertigo* – the very images of madness, if one likes, here altered by Marker with changes of focus, as if to compound *Vertigo*'s creative gesture with *Sans Soleil*'s own.

Both *Sans Soleil* and *Vertigo* portray a way of mind giving rise to action, or delusion – the forming of creative gestures out of disturbance – which the films declare to be film-like, to be, virtually, film. And the films call this way of mind, this film, mad. *Sans Soleil* and *Vertigo* are themselves films – poetry born of insecurity – and they identify themselves with the gestures they depict and comment on. Are they mind, and mad? *Vertigo* raises the idea of a film taking on a life of its own ("I tried to stop it"), as many works of art can seem to do. *Sans Soleil* strikes one as more than the *representation* of thought, of an active mind; it seems, itself, to think, to think on its feet, we might say, like a Montaigne essay. How does an essay, wandering, spiraling about its subject and showing its feelings, matter as thought? Does it matter to philosophy? *Is* it philosophy, a way of doing philosophy, thinking at as radical a level as possible and in a necessary form? – in *Sans Soleil* with flowing film images as well as words. *Vertigo* is a drama, or poem, not an essay – though perhaps the boundaries between these categories ought not to be taken as hard and fast. *Vertigo* reflects on disturbance giving rise to creative gestures, as-if films, and

finds a unique form for its reflection – dramatic film – but then there is no film quite like *Vertigo*. If it thinks about something, and finds its own way to think, thus offering thought unlike any other, will this not matter to us? How do we get close to it?

"Krasna" gets close to *Vertigo* by merging with the film, losing himself a bit in it, playing out the parts. Then he moves on to speak of a fiction film he would like to make, about a man who has "lost forgetting" and who will fail to understand and to connect to what he is touched by – a version of Scottie, we might say – a film to be called "Sunless," underscoring that *Sans Soleil* with all its concerns *is Vertigo* in a sense – and implying that *Vertigo* is an essay, a philosophical venture. Krasna and *Sans Soleil* then turn abruptly to the World War II offensive in Okinawa. "Fragments of war" thrust their way forward, reminding us that they were always there.[2]

* * *

Vertigo at first contemplates a woman's face – not that of a known, recognizable film actor, and not, as it turns out, someone who will appear in the film again. The face perhaps points to the mystery of the Kim Novak character's identity – Madeleine or Judy, or something that is more than or beyond either. Credits begin to appear, and the film's title comes soaring toward us from the depths of the woman's eye, as does an abstract drawing, a spiral, and then we seem to be taken inside the woman's eye, or head, as we see more spirals come and go against a dark background, and we read more credits. One spiral is wonderfully asymmetrical, almost ugly, like a blob of organic matter, and suggests, like the sharp dissonance heard in the musical score when we see the word "Vertigo," that something is amiss, that there is some unexpected complexity, some unexpected twist, embedded in the general order of things. Eventually we come back out, as it were, to see the woman's eye again, before the film moves on to the rooftop chase that begins the narrative. As if the woman – herself in a dreamlike space – dreams or projects what follows.

James Stewart appears at a run – a peculiar being, a film star. As suggested earlier, he carries traces inevitably of his former Hitchcock roles, which tie him to the wider world and the chaos of history. And there are the many other roles going back to the 1930s that help make up, or present, this star figure compounded of idealism and charm, but

also frustration, volatility, and anger. Things often do not work for Stewart, and he lashes out. Think of outbursts in Mr. Smith Goes to Washington (1939), The Philadelphia Story (1940), and It's a Wonderful Life (1946). Think of his hurting his girlfriend, Liz – the camera clearly showing her hurt – when he proposes marriage to Tracy Lord (Katharine Hepburn), for whom he has gone a little mad, at the end of The Philadelphia Story.

The rooftop chase that opens Vertigo presents, in essence, James Stewart undergoing trauma. The plot specifics – the chased man – do not matter. The night-time sequence, with churning music and vivid colors, has a nightmare quality; and Hitchcock does all he can to bring us close to Stewart's subjective experience of suddenly slipping – as if falling out of the world – clutching desperately to a sagging gutter, looking down and experiencing vertigo, as the camera and zoom lens work in opposite directions to give the sense of quickly moving down and drawing back at the same time. Stewart takes shock as his colleague reaches down to him and also slips, pitching to his death, screaming. We see the agony and surprise on Stewart's face. All that he will now do rises from this essential, in a way abstract, disturbance.

The transition to the next scene, down to earth and indoors, is as if waking from a dream. Yet the relaxed and sophisticated Stewart character we see here is a man marked by trauma, by physical ordeal and paralyzing fear in facing the horror that underlies all existence and is always ready to surface or break out. And, of course, at the end of the scene John Ferguson, as we now know him, goes up a kitchen stepladder and looks out the window, and the horror and vertigo come back. Stewart/Ferguson has died in a sense, and is going on nevertheless. Gavin Elster will soon tell him that he fears harm may come to his wife from "someone dead" – that will be Scottie (as Elster now calls him), if we think of what he does to the Kim Novak/"Madeleine"/Judy figure.

Hitchcock's stunning image of lunging forward and flying back, falling and retreating at once, is the essential facing of the horror. It is conspicuously a film image. Film is death. Its nature is to kill – the world becomes those shadows on a screen. But also to bring to life – death and transfiguration. The abrupt move – the very transition – from Vertigo's opening to the interior scene with its particular look and mood, allowing Stewart's performance to blossom, is a filmic act, a filmic gesture. Film brings to life, and here at the beginning of Vertigo enters with unusual self-assertion and self-awareness – but this is Hitchcock – into the

offensive and counter-offensive of death against life. *Sans Soleil* remarks at one point, admiringly, that the barrier between life and death is thinner in the East than in the West – and surely the film knows that it is pointing to the thin barrier between life and death in film – thinner than what we are used to acknowledge, but thin in a way that needs to be acknowledged. Film is interested in life and death together, as we all are deep down. *Vertigo* deals with a man who at first seems to have died and come back, and who is brought to a woman who may be possessed, may be mad – are they the same? – is called a ghost at one point, is an actress in someone's script, seems to die and to be reborn, is a kaleidoscope of identities with thin barriers between them.

The scene in Scottie's friend Midge's apartment is the first of a series of interiors real enough and down-to-earth seeming, but which are nevertheless carefully designed to start, or follow, this marked, restless, and somewhat rebarbative man on his spiritual journey from discontent to a grand new effort at escape or at remaking of his state of things. The interiors are after all as purely imaginative as the film's opening. Midge's room has walls painted pale yellow, and large windows at the back look onto the bright white buildings of San Francisco and the sky – it is actually, and fairly clearly, an artificial image of the vista. Midge is blonde and wears a yellow sweater blouse. She has tepid music playing on her phonograph, about which Scottie complains at one point. Midge is a former painter and now a commercial artist – romantic ambitions given up – and during the present scene works steadily at her drawing table on the left, as he sits opposite her on the right. For the most part the film cuts back and forth between Scottie and Midge as they talk, the back-and-forth cuts suggesting antagonism. Many of the shots feature a can of brushes and other artist's paraphernalia in the foreground. The atmosphere is one of an artificial brightness or cheeriness, stifling in a way, certainly to Scottie. And Midge is an artist, a contriver, who has Scottie, in a sense, caught in her web, or wants him caught, in a way that will not succeed.

Scottie is at loose ends, having resigned from the police force because of his acrophobia and vertigo, and Midge is both his comfort and a provocation to him. When she suggests that he take a trip, he replies with a certain hardness in his voice, "You mean to forget. Oh now, Midge, don't be so motherly," and the film cuts to Midge looking up from her work and looking partly hurt by the response, partly pitying of the man's

situation and attitude. When she says after a bit that "Johnny-O," as she calls him, is the only man for her, Scottie recalls lightly that they were engaged once in college. The film cuts to Midge intensely close – quite shocking on a big screen – as her eyes snap up and then down and she says with a forced smile, "Three whole weeks." Back to Scottie, deliberately at ease and playing with her, saying, "But you were the one that called off the engagement, d'ya remember?" – and the film cuts again to Midge in intense close-up, this time thinking a bit before raising her eyes, then lowering them more slowly, no words, no smile. Scottie spends time with Midge, but the woman and her ambience make him want to escape. He hurts her and gives offense. The cuts to intense close-ups of Midge are violent acts. They are the violence upon Midge of Scottie's remarks, and the violence of her reaction, subtly "looking daggers." The violence of the film gesture seems to catch Scottie and Midge up in something greater than themselves, and yet to be provoked, or engendered, by the dynamic of their feelings. Film is what we are.

Scottie has brought up a call from an old college acquaintance, whom he will go to see at an address on "skid row." We get a brief shot of an industrial area street, drab in color, and Alfred Hitchcock walks by carrying a case for an engineer's or carpenter's instrument, or possibly a musical instrument, reminding us that planners and executors and artists are at work everywhere. And we move into Gavin Elster's office, that of a shipbuilding magnate, it turns out, another world of plans, constructions, and fantasies, a big room with walls lined with pictures opening out into other dimensions – such as old San Francisco, as they note, with its power and freedom for men – and behind Elster's desk a huge picture window giving views of the shipyard with moving cranes and other industrial apparatus, all as if a projection or imaging of Elster's plotting mind. After Midge, Scottie is caught in yet another person's web of designs.

Scottie grudgingly accepts Elster's plan that he follow his wife, in an uncomfortably close shot of both men together, as if Scottie is being physically forced. And with a dissolve, suggesting dream or projection, we move into almost total darkness out in a street at night, and then into the last of this opening series of interiors, the restaurant Ernie's, where Scottie is to see Madeleine for the first time. This brief intense – and wordless – scene amounts to the taking of the bait, or infection, of romantic love on the part of Scottie, this man with a history.

Scottie sits at the restaurant bar, facing us, and turns to look into the dining room to his side and behind him, and the camera backs away from him and moves left and out into this room, extending his point of view, taking in much more than he can possibly see, projecting his interest, drawing him out of himself into something bigger, dissolving him into the room. We see a busy, elegant restaurant, with people dressed formally for evening, eating and talking quietly at every table. The walls are covered in red flock wallpaper, surrounding everything as if by the walls of a womb – a space to conceive and make ready for birth. Elster had said that he and Madeleine would be dining here before going to the opera – and in a sense the rest of the film is an opera that Scottie and Madeleine enter and play out. A plausible restaurant scene, yet striking in its artificiality, a show-off moment for Hitchcock, insinuating reality and at once asserting "I am false – just playacting" – with all the carefully chosen and carefully dressed "extras," marvelous to look at, doing their best to impersonate conversation, perhaps saying no real words at all, as is often the case with extras. As long-lined romantic film-score music begins, obliterating conversation and other sounds of the room, the camera moves slowly in toward Elster and Madeleine's table near the back – along the way revealing two late-middle-aged men in military uniform, army and navy, part of a larger table – they would likely be veterans of World War II or Korea – "fragments of war enshrined in everyday life." Elster and Madeleine are chatting like everybody else – just as artificial.

The film begins cutting back and forth between Scottie and views of Madeleine as she rises with Elster and walks up to the bar area, past Scottie, and out of the restaurant. She is magnificent in her long dress and cape of purple-black and green. And there is something of the transvestite about her – the facial expression, the eyebrows, the makeup. Difficult to pin down – one can say only, look at this face here and scene after scene – see the boy there. The cutting now between Madeleine and Scottie stands forth as an elaborate filmic device like the camera movement we have just seen go deep into the room, fusing Scottie's state of mind – and his destiny – with film. In views of Madeleine there are frames within frames – doorways and a great mirror – suggesting her status as a work of art, or an image, a film image. Scottie's union with her – film spectator and film image, in a sense – is suggested most powerfully in the film's few concentrated cuts between her seen fairly close in profile, turning to her right, and Scottie also seen fairly close, turning to his left, away from her and

back towards the bar. The mirroring turn and counter-turn catches both up in the same rhythm. As Madeleine and Elster walk out of frame in the bar area, there is a momentary view of nothing but the red wallpaper in the distance, slightly out of focus, before cutting back to Scottie. The red, fuzzy blankness – somehow an image of Scottie's mind at the moment – suggests madness.

The film fuses with what it projects in the characters, suggesting that human experience is itself filmic – and that film is itself in a strange way inescapably, fallibly human. Does the film have a mind of its own? Does even the super-controlling Hitchcock, with the Hollywood apparatus that he oversees, yield ground to the film itself? One would want to feel that the film gets out of control, while still commanding attention, making some new kind of sense – that it thus thinks. To go out of control, to go over boundaries, is in a sense to go mad. Is to have a mind of one's own to be mad – mad in a way that might command attention, offering thought that ought not to be neglected? The image of the red, out-of-focus wall is not dwelled on. It is so brief, one might feel that Hitchcock and his editor overlooked it, cutting as soon as possible once the main actors leave the frame. One cannot be sure. But the image seems not *meant* by the filmmakers so strongly as it in fact comes through. It seems meant by the film itself.

The super-realization of the Ernie's scene – the grandeur, the rhythms, the detail, the hypnotic quality, the saturated color, the possibly out-of-control assertion of the red wall – all seem an over-reaching – on the film's part – to avoid insecurity, nothingness, death, even as the scene propels Scottie and Madeleine, Hitchcock and the film itself, and all of us absorbed in the film, toward a new destiny of insecurity and nothingness. Scottie and Madeleine meet their own destiny. The film ends and its tail flickers through the projector. We have nothing – it was all an illusion. Were we mad to be absorbed? Would we not be deprived not to be absorbed?

After the scene at Ernie's, the film goes outdoors as Scottie, in his car, begins to follow the supposed Madeleine, in hers, driving about San Francisco, visiting sites associated with Carlotta Valdes, who Scottie will be told is the tragic great-grandmother of Madeleine, a woman long ago "thrown away" and driven mad, who now haunts Madeleine and may lead her to harm herself. As they drive, music pulses quietly and spins out romantic lines. The outdoors, with its music, is an indoors, another imaginative realm.

Scottie becomes fascinated with a woman who knows the way into a beautiful place through a dark alley and even darker, ugly back hallway; fascinated with her visit to a grave and with the atmosphere of the church and graveyard itself, suggesting a breakthrough from this life to something beyond, like the dark alley and hallway leading to the beautiful flower shop. He becomes fascinated with her museum visit to contemplate a portrait, where she has made herself resemble the portrait in various ways, aspiring to the world of the image; and fascinated with her visit to a small, old hotel in midafternoon, perhaps like an adulteress.

The two first speak as a result of her leap into San Francisco Bay and his taking her home to his apartment. He first sees her standing on the shore, the sublime, red Golden Gate Bridge arching above her off into the distance as if toward another world, another life, repeating and expanding the mood of her earlier appearances, or stagings. She plunges into the water, and he after her, both as if entering another world. The water here is black like death, but gives them back to life at a new stage. Water, with its reflecting surface, its transformative property, its flow and motion, is a ready image for the screen and for film – and has often been found, or used, as such by film and filmmakers from Flaherty and Eisenstein and Murnau to Renoir and Bergman and Tarkovsky. Scottie and Madeleine enter a film here, in this water, or become film, more intensely than ever yet.[3]

The experience is erotic – Scottie touching and clinging to her for the first time; getting her to his car where we view them very close and hear only heavy breathing; stripping and drying her and putting her in his bed – this the film elides, as if it were obscene. This attention is given to an apparently unconscious woman, as if to a corpse, but it brings her to life, emerging from the bedroom in his robe, barefoot, her hair falling. And they have their first talk, he kindly, concerned, animated; she kindly but aloof. And she runs away while he takes a telephone call. Of course, her unconscious state has been an act – or has it, quite? – playing a game of necrophilia. *Sans Soleil*, thinking of the San Francisco Bay incident and then Madeleine's later apparent fall from the tower owing to Scottie's inability to follow her up, comments, "he had saved her from death before casting her back to death. Or was it the other way around?" With the leap into the Bay, Scottie in a sense casts Madeleine to death, in that the role, the plan, which he is so far answering to, so that it must go forward, brings her to this action, which, as it turns out, is a leap into

a new phase for them, their film, where she takes an interest in Scottie, and in his view dies to her role as Elster's wife, and known only to herself dies to her role as Elster's mistress and actress and collaborator – coming into something new with Scottie, which, more and more, is new life. "Or was it the other way around?" She saves him from death, focusing his desire, bringing him out of a death-in-life, and yet she eventually casts him to the death of catatonia in the mental home. At the end of the film she leaves him, casts him, to the nothingness she had for a time brought him out of.

Once Scottie and Madeleine have met and talked, the misprisions and provocations develop apace, as well as the ecstasies. The start of their interaction is marked by reminders of the wider world and its tensions. Shortly before the leap into the Bay, Midge had taken Scottie to see Pop Leibel at his bookstore, and he had told Scottie all about Carlotta Valdes. Leibel speaks with a vaguely East European accent. He may be Jewish. His age and accent suggest someone displaced from the European turmoil of the 1930s and the War. After the Bay episode, Scottie and Madeleine meet the next day and decide to "wander" together, and drive out to the forest of thousand-year-old trees where they look at the cross-section of a cut down tree, tagged with indicators of historical events occurring during the tree's life: Battle of Hastings, Magna Carta, Discovery of America, Declaration of Independence – invasions, contests over rights, births through violence. And Madeleine indicates her own life in this timeline. Scottie and Madeleine exist in a nexus of contestations and displacements, which in a sense they ignore – as we viewers may do – and which in a sense they extend into their own private affairs.

Scottie and Madeleine talk in the ancient forest, and talk more in a scene by the ocean, culminating in a passionate kiss. Scottie is relentless, even bullying, in his questions about her state of mind and dreams. In his apartment after the leap into the Bay, she had called him "very direct," and he had apologized for seeming "rude." Now he is rude in a way, but of course determined to help this woman he is attracted to and who seems, to him, to be in danger of psychological collapse. Through all this dialogue Madeleine treads the line between being someone troubled and in need as Scottie thinks, acting a part to draw Scottie on, and beyond this acting, being in a deeper way troubled and in need, striving against the confines of her role in Elster's plot. Where is Novak herself in this complicated performance? She is not an established film figure, who may

be inflected, like James Stewart. Perhaps the film gives us, or indicates, a woman beyond all the film's plots, even Hitchcock's.

A shot of Madeleine walking away into the great trees in the distance transitions to a similar shot of her walking toward the sea, in a new location. Some greater force – her plot, her madness, the power of film – has her step over time and enact a doubling, a pattern, of moving away toward the primeval, forest or sea, that may swallow her up. Scottie follows her to the sea's edge and elicits an account of her bad dreams and fears. Her "please don't ask me, please don't ask me" of the forest scene – which *might* be taken in part as resistance toward giving up the Elster plot, which in a way she would like to do – gives way in the ocean-side scene to a full telling out of "Madeleine's" inner life, of all that haunts her. Pure performance? Even the desperation in her voice? The scene is filmed/presented in a highly manipulative manner, with alternation of location shooting and back projection, and meddling with the sound – on the verge of the kiss at the end, we hear the crash of a wave on the rocks, piercing through the background music for the first and only time. Scottie and Madeleine are caught up in a world of performance and manipulation not to be disentangled from reality. Upon the kiss, the turbulent musical score resolves itself on a bright inappropriate major chord – false and offensive, like the treacly, three-quarter-time tune we will hear much later when Scottie and Judy walk outdoors by the Palace of Fine Arts – so unlike the rest of Bernard Herrmann's canny (and genuinely moving, seductive) score. Perhaps these are cases of the film's meaning, and saying, more than Herrmann and Hitchcock mean – a suitable going over borders, out of bounds.

The close view of Scottie and Madeleine kissing moves to a view of Midge painting at an easel in her apartment – it is the imitation of Carlotta's portrait, with Midge's head and face, which will send Scottie into an immediate black mood, exiting the apartment and calling off their plans for dinner and a movie. The apartment is very different now than earlier – full of shadows, with the color yellow hardly in evidence, the view out the picture window all but black. Film realization is reality, what people experience. Midge's taking offense at Scottie's involvement with Madeleine, and her desire to goad him, issue in the joke art work that gives him offense and drives him away. She is left pulling her hair and cursing herself – or something – "Stupid! Stupid!" Plot gone awry. Scottie had come in relaxed and good-natured – but it seems a little strange, his being ready for an evening on the old terms with Midge, who he knows

loves him, after his illicit kiss with Mrs. Elster. Some double-dealing here, and perhaps being deeply uneasy about it, drives Scottie into his over-reaction and sudden departure – lashing out at Midge.

The film is cast into the negativity of a prolonged, nearly black shot of a street intersection at night – meaningless. And then in the morning at Scottie's house Madeleine arrives, upset (apparently), to tell of having dreamed more, revealing enough detail of location to have Scottie recognize the San Juan Bautista mission to the south and insist on their going there. He enters a mania of conviction that he can solve everything, urging his plan on Madeleine, "Don't you see? You've given me something to work on now" – the mania perhaps a result of, a counter-move to, the bad feeling of the night before with Midge. This scene, centered on Madeleine's dream and the plan to drive south, is as if itself a dream born out of the dark night of the street shot just previous, born out of that horror. The sense of being in the grip of something beyond themselves is enforced by Hitchcock's use of a table lamp incongruously huge in the foreground in shot after shot as they talk (it recurs when Judy writes her letter later in the film), and then by the incongruous overhead view of them with the camera moving with them, looking down, as they walk to the front door, all as if they are choreographed and caught in someone's plan. But Scottie opens the door toward the camera, creating momentarily a white screen, reminiscent of the momentary red wall at Ernie's, and anticipating the sudden white screen, which in a real film theater shocks and hurts the eyes, that occurs during Scottie's madness-inducing dream, or whatever it is, following the supposed Madeleine's death. Scottie is disruptive, opening the door and whitening out the shot in the living room – as he is himself already disrupted, and to be further disrupted.

Scottie and Madeleine drive to San Juan Bautista, at times clearly and incongruously driving on the left side of the road, as will happen again when they (Scottie and Judy) drive there near the end of the film – the film throws out disruptions of its own style and consistency and basic way of making sense, as if compelled by the incongruities and misunderstandings and provocations of its material. San Juan Bautista – Saint John the Baptist, performer of baptism, whereby one dies and is reborn to a new life. Thus the dry, bright setting of this old mission – product of the Spanish invasion of America – recalls the black water into which Madeleine and Scottie dove earlier, a breakthrough into a new stage of

existence for them, or new existence, like entering a film. In the old forest, then by the sea, in Scottie's apartment just now, and here at the mission, Madeleine seems alternately withdrawn, loving, and wrought up by her inner demons. If we have seen the film once, we see her in these scenes as moving in and out of performance, of rhetoric – as being "herself" at one moment and being direct with Scottie, then entering into her act, talking about her dreams and fears – though one is never sure; she may indeed be full of dreams and fears. This is how Scottie and whoever she is relate – and this relation will go on in the later part of the film, with the supposed Judy.

Madeleine runs away to climb the tower, which appears more massive and ominous than phallic, though it recalls the decidedly phallic Coit Tower seen from Scottie's living room window, and on which he and Madeleine remark (it was seen too in the film's opening pan across the city skyline, part of the setting of that trauma). The tower images suggest a mix of desire, excitement, fear of going too far, and impotence in a broad sense, all endemic to their relationship and remaining as unclear as the nature of this relationship's perverse conversation.

The struggle up the tower, Madeleine's supposed fall, the return of the film's opening trauma and its falling/withdrawing image, give way to the hearing where Scottie is humiliated by the coroner's words – "unfortunate choice," "weakness" – and we see the agitation and suffering on his face. The provincial, superior, droning official is offensive. Scottie remains hurt and mute even after the hearing breaks up and Elster tries to talk to him. The scene had opened, and now closes, with a large view of the room, the shadowy ceiling bearing down like the black cloud in Scottie's soul. Briefly we see him visit Madeleine's grave, as she had visited Carlotta's. Then we are given a black city street shot, a descent into nothingness and meaninglessness, a grave of sorts, as occurred after offense was given and taken at Midge's over the parody Carlotta portrait. And as that gave way to Madeleine's reported dream and Scottie's dream/plan for driving down to the mission, so now the black street shot gives way to Scottie's traumatic dream, or the film's image for his mental unraveling.

This dream/breakdown sequence is gauche, with its color filters, animated cartoon bouquet falling apart and spiraling outward, Scottie's disembodied head flying through space, and the habanera motif Herrmann had used so subtly during Madeleine's monologues, when she

refers to Carlotta, now blaring out full and simple – one does not want to hear it like this and to such an extent. And there is the inspired image at the end, of Scottie as a silhouette cut-out falling from the tower and then, very tiny, falling against the bright white screen that hurts the viewer's eyes – Scottie as shadow, as film figure, projected onto or into the film screen in its bright purity, according with the leap into the Bay and with all *Vertigo*'s intimations of life entering the filmic.

One thing everybody notes about the dream sequence is that it identifies Scottie with Madeleine. He visited her grave, as she visited Carlotta's, and in the dream he too visits Carlotta's grave, and it is open and waiting for him, just as Madeleine said that in *her* dream there was an open grave waiting for her. *He* now approaches the grave. *He* falls from the tower. If Scottie in part loved a boy in Madeleine, now he becomes a woman.

At the end of this, he lurches up erect in bed, terrified, eyes wide open. And we next see him sitting mute and unresponsive in the mental hospital. Could the film not have gotten us here without the full gaucherie of the dream? Breakdown. We seem close to what the old New Critics, in their wisdom, called the fallacy of imitative form. The ungainliness of the psychic material seems to break out in the film, breaking its balance and deftness and sureness of artistic judgment, just as Scottie's relations with Midge and with Madeleine/Judy break out into offensiveness. There are torques and twists deep down – fault lines, like those that lie below San Francisco – that will come to the surface and flare out. The path between people, and between each one's surfaces and depths, their present and past, mind and memory, is not direct and clear – nor is it between the film, as a form, and what it offers to treat of.

A pan across the city skyline, this time left to right, opposite to the one in the film's opening chase scene, and this time in bright daylight and lustrous color with long-lined orchestral music sparkling with harps, introduces the final portion of the film, and does suggest – as Marker suggests in an article separate from *Sans Soleil* (Marker 1995) – that this portion of the film is a dream or fantasy of some kind, a re-play or reversal of what began with the opening trauma and its pan across the city. In this view, the fantasy punctures itself, defeats itself, as fantasies will. At the least, we feel an ambiguity about what is being experienced. Scottie meets Judy – Kim Novak with reddish-brown hair and shop girl attire, but still with a transvestite look. He remakes her into Madeleine, and

discovers that she is Madeleine, precipitating a brief plot on his part to return to the tower, and a final ugly scene on the stairs, with physical and verbal abuse, giving way to a fright that provokes death, as if out of nowhere.

Rothman's notion that the final part of the film plays out a plan on Judy's part (Chapter 3, this volume) is strongly suggested by her first opening her hotel room door to Scottie and showing not the least sign of surprise or recognition. Perhaps she had shown herself to him in the street, baiting him to follow her. Then again, maybe she spotted him looking at her and prepared herself for his appearance. After he talks to her a bit and leaves, she is dismayed and plans to pack and run away, leaving him a note exonerating him and explaining Elster's plot – but changes her mind and will stay, hoping to develop a relationship with him as he continues laboring under the burden of thinking he has lost Madeleine to death and is responsible for this. Maybe the dismay and impulse to leave are just a momentary loss of nerve in carrying out a plan that had already been formed. Scottie has just said to her, "I just want to know who you are." He, and we, will never know.

In her not-to-be-delivered letter, Judy insists on her love for Scottie, conceived during the Madeleine days (how? owing to his looks, his concern, his warmth?), and she insists on this love even at the end of the film. But does she know who *he* is? From here on he will constantly surprise and disconcert her. At any rate, they enter on a course of making requests or demands of each other, and meeting frustration. They fight. In the hotel room Scottie presses himself on her and she seems offended and resists this "stranger." Of course, this is an act – or is it entirely? There *is* something to resist. At dinner at Ernie's she is made uncomfortable when he is distracted by the entrance of a blonde woman who looks like Madeleine. There is the falsity of the walk by the Palace of Fine Arts, with the false music – the film offending us to make a point. Then the clothes shopping to recreate Madeleine, with Judy clearly upset and Scottie rude to salespeople and to her, firm and beside himself. "Scottie, what are you doing?" "Judy, it can't make that much difference to you." "I want to get out of here." "Judy, do this for *me*" – these last two lines uttered by both with clenched teeth. Back at Scottie's house, desk lamp in the foreground again, she is distraught and is given brandy, like Madeleine here after her bad dream. "I want to go away" – but she relents, she does not want to. They start to become more at ease – it is

not just that she reminds him of Madeleine – "It's you, too. There's something in you that . . ." – incomplete sentence. She speaks to him hopefully about getting to like her – then he takes on an obsessed, distracted look, music starts, and he brings up changing the color of her hair to Madeleine's, and presses it – again, "It can't matter to you." She has had tears in her eyes, and as they walk together to the fire, viewed close in a moving camera shot, a bit delirious, she shows hurt and agitation as well as hope – a great complicated bit of playing on Novak's, or the character's, part. She has just, and finally for now, said, mostly to herself, "I don't care anymore about me."

The beauty salon transformation scene, with its mysterious music from the opening credits sequence, not heard since – even-note arpeggios down and up at the slow pace of a practice exercise, readying for something – takes us back to the film's beginning. There we saw an anonymous woman's face and eye – now we see no whole woman or face, but lips being wiped, hair being rinsed, nails being painted.

For Scottie back at the hotel Madeleine seems to emerge, at least after one more exchange of pressure, resistance, and giving in, to do with her hair needing to be pinned up. The prolonged kiss is a film kiss, the lovers impassive as the set turns and the camera revolves, and the colors and images change. The lovemaking is elided – as if it didn't really happen. Then some friendly banter about going to Ernie's and about being "mussed." Then his alarm at the necklace, and a quick assault of a remembered image – the Carlotta portrait with this necklace – an attack from within. Is the point of this no more than Scottie's discovery of a highly improbable murder plot and the complicity in it of the woman before him? Is it the discovery of the common human stain, intolerable to one so lately wrapped up in an ideal and in bringing the ideal into reality, at least on the level of appearance? – though with a sense of that "something in you." The human stain opens to the horror; sin is death. Scottie draws back, as with an attack of vertigo. The film wants to talk about the intimacy and trials of lovers, and its mad and awkward way is by means of an improbable murder plot with here, near the end, the intrusion of the portrait image. Judy asks him, "Can't you see?" as he fumbles with the necklace clasp to help her put it on, just before the recognition – the desiring woman pointing the man in the direction of revolt back from her – unless it is an offer to see and know all, hoping he will live with it, abide with her.

Scottie keeps his composure, induces her to drive out of town instead of going to Ernie's, and maintains a sinister smug manner as they drive and she becomes uncomfortable. His notion of taking her back to San Juan Bautista and making her climb the stairs up the tower seems almost a calculated ploy to kill her, as it ends up doing. What else did he expect from the climb to the high place, the yelling at her, the pushing and dragging of her? It is an act of revenge. Scottie senses he has been "used," and lashes out (as does the James Stewart figure in many films). Is it a cover for a deeper confrontation with mortality?

While she – Judy – tries to apologize, he calls out madly, "I loved you so, Madeleine" – and we believe him, he is full of feeling. There is a final embrace and kiss, where she says, sincerely we feel, "Keep me safe," though it is like Madeleine earlier by the sea, where, in retrospect, the feeling is more ambiguous. He now replies, "Too late," as Madeleine had said when he first tried to stop her going into the church and up the tower. The phrase epitomizes the profound and perpetual mistiming and misconstruing of their relationship. Why too late? Because they cannot be free of sticky plots?

Her wandering eye shows alarm. The film cuts to the image of a black form rising up at the top of the stairs – a little as if summoned up by Judy, in a self-contradictory and self-destructive gesture, perhaps in reaction to Scottie's abuse and final pronouncement. Madeleine had spoken of "someone within" who says to her she must die, and to whom (or to which) Scottie ironically and unconsciously – is it? – refers when he tells Judy, "There is something in you that . . ." The someone or something within emerges as the black rising form, at once a product of the psyche, and the imposition on the human of the ultimate horror that we befriended by forming our desires and longings, our plans and creations, and in the process finding ourselves mistaking and misconstruing, taking offense and finding ourselves warped into offensiveness.

The film cuts back to Judy, further alarmed and turning out of the film frame into nothingness, her scream indicating that she has gone off the tower. In a discovery worthy of Buñuel, the Angel of Death turns out to be a nun. She now begins to ring the tower bell. A bell accompanies, or constitutes, ritual, which means transformation, death to one life or state of being and entrance into another – is it a mockery here? The nun's most immediate thought is likely that the bell be a call for

help. Could anyone help? Can we who view this help ourselves, or help the world, by virtue of viewing this?

The camera backs away from the nun and Scottie, out into space off the tower, giving a point of view beyond the human – as the camera backed out to sea earlier to watch Scottie and Madeleine drive along its edge to the spot where they would stop and then leap into the Bay. Something bigger than they seems to draw them on their way. And Scottie now emerges onto the ledge, alone, extending his arms out as if reaching down toward Madeleine/Judy, and a bit as if crucified, seen in long shot, a picture of loss and bewilderment and nothingness.

Scottie and Madeleine/Judy, very drawn to each other, nevertheless take very peculiar approaches to each other and do very wounding things to each other. To be direct seems all but impossible. Or, the way that they do relate to each other seems courted by them. This is who they are. This is how they go about it. This is, at some level, what they want of each other – ecstasies entailing being wounded and being annihilated (it is no accident that Herrmann's musical score is so reminiscent of Wagner's *Tristan und Isolde*). The picture is like that of Heidegger's view of Greek tragedy, where Being has withdrawn from us and we proceed without seeing (Heidegger 1992). The eye is prominent in *Vertigo*, but it cannot see directly – it projects, it distorts, it agonizes. This is modern tragedy, film tragedy, like *The Birth of a Nation* (1915), *The Rules of the Game* (1939), *Monsieur Verdoux* (1947). We are caught with one another in a labyrinth of our own making and of the making of something beyond our power – a labyrinth of projections, mistakings, mistimings, with perhaps an impulse to sadism, certainly one for reactive violence, at least the minor violence of the everyday. In the case of *Vertigo*, the mad voice of Hollywood melodrama – with overripe color, overripe music, crazy plot, stars, theatrics, artistic lapses, offenses – amid all its perfection – speaks our state, if only we will lose our bearings a bit and be drawn into this lurid film. Our state is a film state.

Notes

1 Howe (1996) offers a profound discussion of war, loss, and memory in *Sans Soleil* and other films of Marker, Tarkovsky, and Vertov.
2 Marker's fiction film *La Jetée* (1962) quotes *Vertigo* (the scene with a large cross-section of an old tree) and seems in a way a commentary on it, setting, as it were, *Vertigo*'s tragic romance explicitly in a world of war, the only world we have.
3 Water as an image for film is discussed further in Warren (2012).

References

Heidegger, M. (1992) *Parmenides*, A. Schuwer and R. Rojcewicz (trans.), Bloomington, IN: Indiana University Press. (Lectures dating from 1942–43.)
Howe, S. (1996) "Sorting Facts; or, Nineteen Ways of Looking at Marker," in C. Warren (ed.) *Beyond Document: Essays on Nonfiction Film*, Hanover, NH: Wesleyan University Press/University Press of New England.
Marker, C. (1995) "A Free Replay (Notes on *Vertigo*)," in J. Boorman and W. Donohue (eds.) *Projections 4½*, London: Faber and Faber.
Rothman, W. (2012) "Scottie's Dream, Judy's Plan, Madeleine's Revenge," this volume.
Warren, C. (2012) "Self-Reflection in American Silent Film," in R. Grundmann, C. Lucia, and A. Simon (eds.), *The Wiley-Blackwell History of American Film*, Hoboken, NJ: Wiley-Blackwell Publishers.

Further reading

Aristotle, *Nichomachean Ethics*. A good modern translation is that of Terence Irwin, Indianapolis, IN: Hackett Publishing Company, 1985. (Aristotle's discussion of friendship, where one and one's friend provide instructive images of and for each other, relates interestingly to *Sans Soleil*'s dictum, "One must make a friend of horror." Stanley Cavell in *Cities of Words: Pedagogical Letters on a Register of the Moral Life* (Cambridge, MA: Harvard University Press, 2004) makes a great deal of Aristotle on friendship in relation to possibilities within romantic couples, in film and in life – possibilities decidedly not realized in *Vertigo*.)
Heidegger, M. (1971) "The Origin of the Work of Art" in A. Hofstadter (trans. and ed.) *Poetry, Language, Thought*, New York, NY: Harper and Row. (This essay from the 1930s is a philosophically searching consideration of the art work as having a mind of its own, so to speak, a mind not co-optable by author, history, or anything else. The essay ought to be a starting point for film studies. Other essays in this collection of Heidegger make a case for the philosophical interest of works of art, here poems, blurring the distinction between art and philosophy. Daniel Frampton's *Filmosophy* (London: Wallflower Press, 2006) is a rough-hewn but serious and thorough approach to the notion of film as mind, as thinking. Thomas Wartenberg's *Thinking on Screen: Film as Philosophy* (London: Routledge, 2007) proposes various ways in which film may be seen to "do philosophy." Both Frampton and Wartenberg lead the reader to further material.)
Wood, R. (1965) "*Vertigo*," reprinted in *Hitchcock's Films Revisited*, New York, NY: Columbia University Press, 1989. (There is a large worthwhile literature on *Vertigo*, but nothing better than Wood's inspiring essay, showing how extended critical engagement with the film – listening to it, allowing it its own voice – can yield philosophical insight.)

Chapter 6

Gregg M. Horowitz
A MADE-TO-ORDER WITNESS: WOMEN'S KNOWLEDGE IN *VERTIGO*

Hitchcock's knowingness

IN THE PERIOD that begins with *Spellbound* (1945), in which Ingrid Bergman plays a psychiatrist with a seriously unmastered countertransference problem, and runs through *Marnie* (1964), in which an epistemologically rapacious Sean Connery sadistically helps Tippi Hedren to shrink her kleptomania and sexual frigidity back to a childhood trauma, Alfred Hitchcock's movies unmistakably trade in psychoanalytic themes.[1] In the latter part of this period, from *Rear Window* (1953) to *Marnie* (1964), Hitchcock goes a step further, as his movies come to exhibit a conspicuous presumption of psychoanalytic awareness on the part of his audience. Psychoanalytic *topoi* such as unexplained sexual anxiety, raging repetition compulsion, abrupt returns of the repressed, the uncanny commingling of Eros and Thanatos, and a general pall of mother-hauntedness are rife in *Rear Window*, *The Trouble with Harry* (1954), *The Man Who Knew Too Much* (1955), *Vertigo* (1958), *North by Northwest* (1959), *Psycho* (1960), *The Birds* (1963), and *Marnie*, but these movies rip from the headlines of psychology textbooks more than their thematic material. The self-understandings, or at least self-accountings, of the characters in the movies of this period are expressed in psychoanalytic language and, in their conversations, Hitchcock's characters blithely take for granted that everyone, including the audience, is intimately familiar

with the concepts and protocols of self-disclosure and communication characteristic of the Freudian consulting room. All in all, it would understate matters to say that Hitchcock's movies of the 1950s are informed by psychoanalysis. With an odd ingenuousness, they clamor for psychoanalytic interpretation. And Hitchcock sometimes provides them with it on his own, as when, for instance, the narratives of *Vertigo* and *Psycho* grind to a halt so that psychiatrists can come on stage to deliver depth-psychological explanations of plot developments and diagnoses of leading characters.

In light of Hitchcock's use of psychoanalytic themes and material, it should come as no surprise that his movies have been the subject of a steady stream of psychoanalytic interpretations. Most famously, Laura Mulvey's essay on visual pleasure and narrative cinema, the ur-text of feminist psychoanalytic film theory, halfway rests its argument on a brief interpretation of voyeurism and sadism in *Rear Window*, *Vertigo*, and *Marnie* (Mulvey 1975). There can be no doubt that to understand Hitchcock we must appreciate that these themes are at work in his movies. That, however, is where my worries begin, for where there can be no doubt, there something is being shielded from inquiry. I begin, in other words, with a sense, which is weaker than a conviction but stronger than a hunch, that the very aptness of psychoanalytic interpretations to Hitchcock's movies should give us pause about whether, or at least how, to believe them. For, notwithstanding their genuine insights, most psychoanalytic interpretations of Hitchcock accept an invitation to read his movies that is issued by him so openly and calculatingly that psychoanalytic inquiry, its self-understanding as a hermeneutics of suspicion notwithstanding, runs the risk of becoming an agent of an authoritative understanding that is partial, if not misleading, insofar as it is authoritative. Precisely because Hitchcock's pitch to psychoanalytic ways of knowing is so utterly self-aware, we might do better to maintain the suspicion – the meta-suspicion, really – that he is appealing to his audience's enlightened predilections for the sake of a more rigorously systematic misdirection.

The suspicion that multiple strata of meaning are sedimented beneath or within the licensed and self-licensed psychoanalytic edifices of Hitchcock's movies was my original justification for undertaking to add one more essay to the stream of writings about him. My focus here will perforce be narrower, as I aim to show only that *Vertigo* in particular is

formed and deformed by anxiety about what women know, how that knowledge shapes the visible world pre-historically, so to speak, and how the psychosexual roles played by women grow uncertain and unstable when women lay claim to knowledge. But as my own interpretation remains psychoanalytic, a methodological preamble is in order. While it may seem ungrateful, if not perverse, to trade in well-warranted psychoanalytic interpretations of Hitchcock for what, in the end, will remain a speculative psychoanalytic interpretation, skepticism about off-the-rack interpretive insight is, in fact, an expression of the fundamental psychoanalytic suspicion about authoritative interpretations and self-interpretations of human motivations, by which I mean interpretations the grounds of which are so epistemically forceful that they appear to be above suspicion. Such skepticism is characteristic of psychoanalytic thinking, especially when the interpretations in question smell of incuriousity about how the possessor of supposedly authoritative knowledge came to be authoritative in the first place. Indeed, immediate and untroubled intelligibility, intelligibility untroubled by its own history, is singled out by Freud for special critical treatment as knowingness in the service of the evasion of interpretive insight into unconscious meaning. In *The Interpretation of Dreams* (Freud 1953) and *On Dreams* (Freud 1989), Freud argues that dreams as reported – dreams as remembered – are more coherent than dreams as dreamt. Freud names the process that produces this excess of cogency "secondary revision," which is undertaken by the dream-work when waking is anticipated in order to give the materials of the dream a "first, preliminary interpretation" (Freud 1989: 48), a nip-and-tuck with an eye toward satisfying the hunger to understand that is characteristic of approaching consciousness. During secondary revision, the unkempt dream material is made to seem more familiar, hence less epistemically and affectively challenging, which allows the dream-thoughts to be secreted within a façade of narrative plausibility. Like the obstinately proud psychoanalysts whom Freud criticizes elsewhere in *The Interpretation of Dreams* for too neatly translating the messages that would disturb the dreamer, secondary revision allows the dreamer to stay asleep to the meanings of his dream even after he awakens.[2] What makes it necessary to single out secondary revision for criticism is that, unlike condensation and displacement, which are the other main processes of dream construction, secondary revision does not conceal the dream's latent meaning by adding layers

of confusion to it. Instead, it obscures unconscious meaning by giving the dream an intuitively *intelligible* façade that pre-emptively satisfies the dreamer's curiosity.

> Considerations of intelligibility are what lead to this final revision of the dream; and this reveals the origin of the activity. [Secondary revision] behaves toward the dream content lying before it just as our normal psychical activity behaves in general toward any perceptual content that may be presented to it. It understands that content on the basis of certain anticipatory ideas, and arranges it, even at the moment of perceiving it, on the presupposition of its being intelligible; in so doing, it runs a risk of falsifying it, and in fact, if it cannot bring it into line with anything familiar, is a prey to the strangest misunderstandings. As is well known, we are incapable of seeing a series of unfamiliar signs or of hearing a succession of unknown words, without at once falsifying the perception from considerations of intelligibility, on the basis of something already known to us. Dreams which have undergone a revision of this kind at the hands of a psychical activity completely analogous to waking thought may be described as "well-constructed."
>
> (Freud 1989: 49)

Freud's advice not to take well-constructed meaning at face value is like the strategic warning that Godfather Vito Corleone offers to his son Michael: the turncoat will reveal himself not by openly switching sides but by offering to broker a mutually beneficial deal and appearing thereby to remain loyal to those he is preparing to betray. Secondary revision is, like the Don's treacherous associate Tessio, a double agent. As an archive of prior achievements of interpretation, it serves the interests of the conscious mind in cogent and coherent experience. But precisely because it is on such intimate terms with the needs and satisfactions of consciousness, secondary revision can also be turned by unconscious thinking to hide its own "demonic" ends in plain sight. The same processes that produce intelligibility, in short, make their own unique contribution to the preservation of obscurity. The thought that interpretation can be oblivion's co-conspirator frames my supposition that the "first, preliminary" psychoanalytic interpretation of Hitchcock's films might serve also as a defense against insight, and prepares me to

decline Hitchcock's offer to us, his audience, to claim interpretive authority merely as long as we satisfy the condition of being ourselves psychoanalytically informed (Cousins 2003; Lear 1998). To comprehend some of the deeper mysteries of *Vertigo* requires that we venture out with a map less determined in advance – venture out less knowingly, that is – for, as a contrast between *Rear Window*, interpreted from a Mulveyesque perspective, and *Vertigo* will show, Hitchcock brings the dynamics and dangers of the pre-historical hunger for authoritative knowledge under extraordinarily systematic scrutiny in the later film. In the struggle over the body and image of Madeleine Elster/Judy Barton (Kim Novak) between the protagonist John 'Scottie' Ferguson (James Stewart) and two secondary characters with suggestively subjunctive names, Gavin Elster (Tom Helmore) and Margaret 'Midge' Wood (Barbara Bel Geddes), Hitchcock gives expression to the idea that aspiring to interpretive authority is motivated not, or not only, by the fear of female sexuality but by a more corrosive fear, of women's knowledge.

Rear Window: Reconciled to knowing

The most significant psychoanalytic insights into Hitchcock's movies have been gained by training psychoanalytic concepts on his conspicuously rigorous use of subjective point-of-view narration.[3] In its focus on the erotically charged aspects of looking and story-telling, psychoanalytic film criticism has illuminated the role in Hitchcock's movies of the scopic dimension of masculine sexual fear and desire in shaping the images of women as objects of desire or fearsome phallic mothers (or, as in *Psycho*, objects of desire *and* phallic mothers). In short, it is as a theory of sexual difference and erotic power, of romance and terror, that psychoanalysis has been put to work. As I have noted above, Hitchcock was one of the two leading examples (along with Josef von Sternberg) of the cinematic male gaze in Laura Mulvey's invention of that concept in "Visual Pleasure and Narrative Cinema." Mulvey there brings Jacques Lacan's development of Freud's idea about the scopophilic dimension of the ego, its intertwining of looking and knowing along an axis of desire, to bear on the relation between the domineering, sadistic component of masculine specular identity (the eye/I of sight) and the submissive, masochistic image of the woman who is its target, and

sometimes its casualty. Mulvey's most general aim is to demonstrate that images of women in film provoke castration anxiety in the male spectator and thereby set in motion pictorial and narrative operations geared to allay that anxiety – to reaffirm masculine authority beyond the shadow of a doubt – by bringing the threat of castration back under perceptual control. Her deep cinematic point, however, is that the male protagonist in classical Hollywood narrative cinema serves, in virtue of his power to control the direction of the gaze and the trajectory of the narrative, as the idealized surrogate for the male audience members who have come to the theater to gaze desirously at images of women but who are at the same time made anxious by the prospect of looking at s/he who is castrated or castrating. By means of identificatory mechanisms that Mulvey explains in classical psychoanalytic terms, the moviegoer can both suffer and master the anxiety attendant upon his scopophilic desires by imaginarily taking on the agency of the idealized protagonist. The movie screen, in this light, becomes the shield of Perseus on which the fearsome image of woman can be both gazed at and protected against.

Rear Window, made five years before *Vertigo*, is exhibit A in Mulvey's argument. Lisa Fremont (Grace Kelly) is wooing L. B. Jeffries (James Stewart), a middle-aged adventure photographer who bears the stump nickname "Jeff." Since Lisa is beautiful, funny, and smart, Jeff's inexplicable commitment to evading marriage to her suggests some underlying sexual anxiety on his part. The castration anxiety at the core of Jeff's ambivalence is symbolized by his cast-bound leg, which is simultaneously helplessly erect and immobilizing. The emasculating injury that has put Jeff in a cast also sets the narrative of *Rear Window* in motion: because his broken leg makes him unable to flee from Lisa to photograph yet another adventure, it deprives Jeff's gamophobia of its characteristic defensive expression as restless activity and so unmasks the castration anxiety beneath for all to see.[4] In defense against, or at least distraction from, this anxiety, Jeff becomes caught up in a specular adventure, a gruesome murder (a dismemberment of a wife, as it happens, thereby distancing Jeff from his own dismemberment fears by one elemental step) that he has witnessed across his back courtyard. Because he is wheelchair-bound, Jeff cannot chase the murderer. The enormous telephoto lens through which he spies on his neighbors brings sexualized violence close to Jeff in the form of images only, leaving the physical space between

him and what those images show untraversed. Until the climax of *Rear Window*, his lens is Jeff's shield of Perseus, allowing him to remain untouched by what he nonetheless sees in vivid close-up.

Paradoxically, although Jeff's injury makes him more narrowly and intensively scopophilic, it simultaneously offers Lisa her best chance to land her man because, in his immobilized state, Jeff's scopophilia is on plain display. In observing Jeff's fascination with a scene of marriage turned to murder, Lisa sees that the way to trump his fear of marriage is not, as she had fruitlessly thought before, to turn Jeff away from adventure and toward her, as if she could entice him by standing before him as an emblem of the end of risk, but, rather, to insert herself into the only scene of adventure that remains available to Jeff in his unmanned state. Lisa gets Jeff to look at her, in other words, by taking up the part of the endangered woman in the scenario Jeff so avidly constructs. By recasting herself from the role of Jeff's pursuer into the prey of the wife-killer Thorwald, Lisa enables Jeff to transfer his anxiety to the scene of *her* endangerment and, now that it is under threat, to succumb to the lure of her beauty. Through this ruse, which turns out not to be a game, Lisa turns Jeff's scopophilia, which had been the enemy of their marriage, into the means to achieve it. It cannot be said, of course, that this reversal returns Jeff to a robust masculine *vita activa*, for his defeat of Thorwald leaves him with both of his legs broken. But since *Rear Window* ends with Jeff and Lisa reconciled, it succeeds in hopping genres at the last minute, turning from a thriller into a romantic comedy. Or, perhaps better said, in resituating the thrills of the adventurous life within marriage, *Rear Window* deciphers for us the thriller that is encrypted in romance. Either way: the transformation of *Rear Window* into a romantic comedy is made possible, at least at first glance, by shifting Lisa away from the position of, in Mulvey's psychoanalytic vocabulary, the bearer of the look to that of she who is to-be-looked-at, which shift navigates her safely and fatefully away from narrative authority. *Rear Window* thus returns mastery of point of view to its male protagonist and, crucially, objectifies this mastery in the image of the narratively well-embedded desirable woman.

Unreconciled knowledge

The interpretation of *Rear Window* sketched above, focusing on the male gaze, captures with great cogency Hitchcock's urgency to return

ownership of the governing point of view, in both its physiological and narrative senses, to Jeff. It is because Mulvey's is an unmistakably and emphatically psychoanalytic reading, which identifies authoritative control of the narrative with mastery of the castration complex, that it brings into sharp focus how the fixing of the image – its repair, its proper placement before the male protagonist, its reliable arrogation of final authority to him – is an erotico-narrative precondition that must be fulfilled to stanch the masculine anxiety that would otherwise forestall any hope of sexual reconciliation, hence of narrative fulfillment. In other words, from this psychoanalytic point of view, we can see why Hitchcock's final transformation of *Rear Window* into a romantic comedy must come at a price that Lisa must pay: of eroticizing her own objectification with a smile on her face.

The virtues of this interpretation of the reconciliation of anxious thriller and marriage comedy notwithstanding, something has gone wrong with it, for it relies on a massive neglect of the irony of *Rear Window*'s dénouement. While in the end heterosexual reconciliation reigns over the courtyard that functioned hitherto as a space of anxiety, this is not, or not entirely, the same as the reign of heterosexual happiness, as is attested glancingly by the newlyweds who had earlier drawn their shade to hide their amorousness but who now bicker openly, as did the Thorwalds before them. And this uncertainty about whether the attainment of marriage entails the comic achievement of "and they lived happily ever after" is equally at work inside Jeff's apartment. Lisa appears to be taking easily to her new role as an adventurer in the realm of romance; we see her in the final scene dressed in jeans and a casual blouse, as if having conceded to Jeff's taste, while passing the time by reading an adventure-travel book. But even if her transformation into a character in Jeff's narrative may seem complete, it turns out to be a disguise.[5] As soon as Lisa sees that Jeff is safely asleep (dreaming, we may suppose, of some private adventure), she puts down *Beyond the High Himalayas* and picks up *Harper's Bazaar* instead. The implication that risk and marriage have been happily reconciled is revealed to be not a manifestation of romantic reconciliation but a contrivance of Lisa's hardwon understanding, rescued from the accident of Jeff's having been right about Thorwald, of what Jeff's taste for mannish adventure means, an understanding which, in the nature of it, she cannot share with him.

This final depiction of Lisa takes back the attribution to her of masochistic submissiveness and substitutes for it secret, hence also dangerous, knowledge of how image and narrative work that can be revealed to us, and only partially at that, only while the man sleeps. The scene suggests, then, that marriage depends not on reconciliation but on perpetual asymmetry and non-reciprocity between men and women.

It would be an exaggeration to say that the comic tone of the final scene is canceled by this arrogation of woman's knowledge, but it is certainly unsettled for good when Lisa brings *Rear Window* to a close by drawing the window shade to conceal from us (as Hitchcock concealed Thorwald's dismemberment of his wife from us) the danger that subsists in the midst of reconciliation. As Jeff remains blissfully asleep, Lisa takes control of our gaze, too, to shield from our vision something in the scene of domestic happiness that cannot or must not be seen. The terror of castration that drove the narrative of *Rear Window* from the start is thus at best ambivalently allayed in its dénouement or, better, not allayed at all, but only withdrawn from sight. This blank image of terrors not evanesced but hidden is, of course, in patent tension with comedy, which accounts for why the final scene edges toward satire, as if it were drawing not on romance but on domestic farce, a genre several rungs lower. (One almost expects Lisa to wink knowingly at the camera.[6]) The demands of the romance genre do win out, however, albeit in the form of negation: the elements of farce struggle to keep at bay the full expression of the bottomless anxiety that remains at work in the midst of the sexual reconciliation that *Rear Window* figures. But for this reason, to take Mulvey's psychoanalytic interpretation of Lisa's masochistic objectification at face value – to overlook the fact that Hitchcock closes *Rear Window* with the authority over both the image and the narrative on Lisa's side – is to conspire with a form of intelligibility that will have nothing to do with knowledge of how it itself, as a form of intelligibility, came to be achieved and that thereby effaces – secondarily revises – the threat that emanates from the knowing woman. What Lisa knows remains, as a condition of marriage, barely approachable in *Rear Window*, but the sense that such knowledge is both essential and yet must be left unexhibited, unenvisioned, haunts the reconciliation that marriage figures.

Vertigo: Whose past?

What happens if we crack open the final scene of *Rear Window* to extract from it the kernel of knowledge that Lisa possesses but that she cannot share with Jeff? And what do things look like if we turn that knowledge against the forces of reconciliation? *Vertigo*, which is obsessively narrow in its focus on haunting female knowledge, is an answer to these questions and, in repealing the reconciliation of *Rear Window*, appears to be Hitchcock's recantation of the comic romance he clung to in the earlier movie. At the simplest level of narrative form, it is obvious that *Vertigo* is driven to display what heterosexual union cannot digest. Where reconciliation might be, in Scottie's liaison with Judy Barton (who is both too mute and too knowledgeable), there we find instead a second death of the beloved. Scottie gets his second chance at love, but it turns out to be nothing but the occasion to experience, in the full glare of the knowledge produced by the woman's forced confession, not reconciliation but the necessity of its failure. In *Rear Window*, the door to romantic comedy is kept open only on condition that what Lisa knows is kept from Jeff and, in that concealment, kept from us. By contrast, in the twinned deaths of Madeleine and Judy, *Vertigo* proposes – perhaps we should say affirms – that there is no escape from the narrative of wife-killing into a marriage built up out of, and as genre of, adventure.[7] In other words, *Vertigo* decisively cleaves adventure from marriage and closes the exit to romantic comedy. To invert Stanley Cavell's formula for certain Hollywood screwball comedies, *Vertigo* is a tragedy of remarriage (Cavell 1984).

We will not, however, get to the bottom of *Vertigo*'s fascination with the impossibility of comedy if we restrict our attention to its central couple. We must of course go through that relationship, since it is the door Hitchcock opens for us, but after all Hitchcock does not present it as a freestanding pairing but first as the outcome of a plot and then as a missed opportunity. I will argue in the concluding section of this chapter that this relationship is in fact a façade, and perhaps nothing but a façade, projected by the deeper forces at work in *Vertigo*. It is, however, enough to get us started to note that, unlike Thorwald and Stella in *Rear Window*, who are set firmly outside the romance narrative and act as, on the one hand, a vision of the worst in marriage and, on the other, a wryly comic perspective on the best in marriage, Elster, *Vertigo*'s wife-killer, and Midge, its embodiment of a desexualized female point of view, are

participants in the romance of Scottie and Judy/Madeleine. (Of Elster this is clear; of Midge there will be more to say.) There is a glimmer of this thought in the observation, common to the many psychoanalytic readings of *Vertigo* that do focus on Scottie and the perversity of his desire, that Hitchcock stages a romance not so much between Scottie and a woman as between Scottie and an image.[8] For as soon as Judy/Madeleine is acknowledged to be an image, the question naturally follows of how and by whom the image was made, or projected. In *Rear Window*, the answer to this question turns out to be Jeff, acquiescence to whose projections by Lisa turns out to be the key to marriage (although, as observed, Lisa keeps her knowledge of this acquiescence apart from the narrative that marriage is). In *Vertigo* the answer is emphatically not Scottie, which is why restricting our focus to the central couple is analytically insufficient. It is also where the vertiginous terror begins.

That Scottie is in the grip of images is clear from the start, by which I mean it is in the very nature of his malady. His vertigo makes him faint before a memory image. But the rule of images over Scottie also plays a peculiar role in getting the narrative of Scottie's love off the ground. When Elster first asks him to follow Madeleine, Scottie sensibly refuses. His "accident," as the preceding scene with Midge showed us, may not have him immobilized, Jeff-like, in a comically masculinizing cast, but Scottie's movement is still inhibited by the feminizing corset he must wear. This, in combination with his continued acrophobia, has led him to quit the police force, so that, again unlike Jeff, Scottie is not simply on a temporary reprieve from adventures he continues to covet but insufficiently recovered to think about work at all. In light of these considerations, Scottie offers instead to find Elster a professional firm ("they're dependable, good boys," Scottie says) better suited to the job. But Elster parries Scottie's effort to render the matter of Madeleine a professional – which is to say an impersonal – concern. Feigning a moment of panicky hysteria, Elster pleads with Scottie to let the case of Madeleine stay in the realm of male friendship. Feeling the force of Elster's plea, and perhaps hearing in it a version of his own mortification at a private condition having become public knowledge, Scottie's commitment to declining the request wavers. One more time, but with weaker conviction, Scottie mutters that this is not his line of work, whereupon Elster launches his final argument: Scottie should come see Madeleine. This is a colossal non sequitur, but Scottie agrees to go the

following night to Ernie's, where Elster stages an elaborate presentation of Madeleine, escorting her through the crowd until she is mere feet from Scottie. As Elster had anticipated, then, the mere act of seeing Madeleine serves to clinch his argument; with no further discussion, Scottie, in the next scene, begins to follow Madeleine. In short, an image completes the work that Elster's ghost story has left undone. Scottie's attachment, then, is not to a woman but to an image of one. As we and Scottie will later discover, of course, this turns out to be literally true.

But to say that Scottie is in the grip of an image does not tell us what in the image grips him. All we know from Hitchcock's emphatically odd editing of the encounter at Ernie's is that whatever Scottie sees when he looks at Madeleine, it is not something he can bear to look at while being looked at himself. In a delicately choreographed dance of faces and eyes, Madeleine first shows herself to Scottie in full profile, the form of presentation that (for humans, if not for fish and horses) prohibits eye contact. Madeleine slowly begins to turn her face toward Scottie, foretelling an exchange of glances, but before she can face the camera and Scottie head on, Hitchcock cuts to Scottie turning his gaze away – or we should say, to capture the force of the strange magnetic repulsion at work here, having his gaze driven away by the threat of meeting Madeleine's eyes. By the time Hitchcock cuts back from the shying Scottie to Madeleine, her face has passed beyond the point of eye contact. The danger avoided here cannot be, from Scottie's point of view, that Madeleine will recognize him, as they do not yet know one another. And, in any case, Scottie does not exactly hide his face from Madeleine, but only his eyes. With unaccountable anxiety, he averts his gaze from Madeleine's, very specifically avoiding an encounter with the thing in Madeleine that might, in looking back at him, see him looking at her.[9] Not, then, what is cut to the shape of Scottie's desire for images, but what might defeat that desire, is the intense center of the scene. What in the image threatens to look back and see him, which is also what in the image looms up as a threat to the authority of his gaze, is what traps Scottie in the obsessive narrative that begins here.

Of course, the official story is that it is Madeleine's beauty that sweeps Scottie off his feet and into his pursuit of her. We must, however, pause to note that there is nothing in the scene of Madeleine's presentation to require this supposition. In fact, there is evidence scattered throughout *Vertigo* that Madeleine's beauty is of no special interest to Scottie.

When Midge, Scottie's old girlfriend who remains his confidante, if not quite his intimate, senses the beginning of Scottie's obsession, she asks whether "she" is pretty. Scottie at first misses the point of the question and thinks that Midge is asking about Carlotta, the dead spirit that supposedly inhabits Madeleine. When Midge then clarifies that she is asking not about Carlotta but about Elster's wife, Scottie says only that he supposes she is pretty. His indifference to Madeleine's visual appeal could, in this context, be part of the persistently desexualizing banter that characterizes the conversation of Scottie and Midge. No such excuse is available, however, to explain Scottie's behavior after he rescues Madeleine from her plunge into San Francisco Bay. Madeleine awakens naked in Scottie's apartment, finding that he has removed her clothes and laid her in his bed. While these might ordinarily be two steps on the way to sex, Scottie nonetheless has no evident sexual interest in Madeleine (an oddity that Madeleine herself is struck by). Despite his obsession with her image, it is not at all Madeleine's beauty that interests Scottie. The woman's beauty may be *our* excuse for looking at her, but it is not *Scottie's* excuse. (Scottie's kinship with Jeff is nowhere more evident than in this regard, for neither one is moved by beauty nor by the thought that he ought to be.) Madeleine's beauty is, thus, an exemplary instance of secondary revision, a working-over by Hitchcock of a much uncannier thought. Something else is at work behind the mask of beauty, something that is deeply indifferent to the façade it wears. And that something, to return to the aversion of glances at Ernie's and the unconscious trances into which Madeleine falls, is a strange thing, a species of unknowingness, of helplessness before the forces of history, that subsists beneath or within the image. It is, we might say, the image of Scottie's private oblivion.

Put another way: that it is not Madeleine's beauty that compels Scottie alerts us to a mystery in his nature, but on its own it does not solve that mystery. This is not evasiveness on Hitchcock's part, for as *Vertigo* is shaped thematically and formally by the thought of love and death as intersecting in nothingness, at no point can he make visible what animates Scottie. Even though Madeleine's beauty does not move Scottie, it is nonetheless, in what appears to be its indifferent perfection, the best image we have, the ideal form of appearance for us, of his desire. The wellspring of Scottie's behavior thus remains a vacancy at the heart of *Vertigo*. This does not mean, however, that it remains simply unknown. Rather, as I will show in the next section, it is deeply, horribly known (by Midge),

but not such as to sustain a figuration of it. For now, though, let us trace out one more thread of the relationship of Scottie and Madeleine to see how Madeleine's unknowingness is the object of Scottie's desire.

The story that Elster tells Scottie, of how Madeleine is in the grip of her dead maternal ancestor Carlotta of whom she is also the living image, depends for its uncanniness on Madeleine's not knowing that she is a great-granddaughter of Carlotta. If Madeleine knew of this history of abandoned women and lost daughters, she would be understandably haunted by it, as Scottie observes, and returning to it in her recollections would be no mystery. Elster explains, though, that Madeleine's mother kept her in the dark about her past. As his story goes, in trying to protect her against knowledge of the danger of madness that Madeleine carries in her blood, her mother ended up giving that madness the specific flavor of melancholia, of a history not expressed by but buried under the forms in which it is undergone. Madeleine is in this respect exactly like Carlotta herself – she is Carlotta's simulacrum – since, as Pop Leibel, the patriarchally named but genial proprietor of the Argosy Bookshop and an authority on the history of California, explains, Carlotta too spent her final days wandering around madly lost in the history she moved in and of which she was a victim. (The power to move, and move in, history, which is in *Vertigo* called freedom, is attributed both by Elster and by Leibel to men alone.) To rescue Madeleine from her unconscious state, to free her from history, is Scottie's ambition. Like a psychoanalyst driven cure-mad by the thought that all one needs for liberation from the grip of history is his understanding of it, making the past explicit seems to Scottie an obligation of love. This conviction in the absolute asymmetry of knowledge, the unloosened grip of which makes for bad lovers and bad psychoanalysts alike, is Scottie's cardinal qualification to play his role in Elster's plot. It compels Scottie to compel Madeleine to return to San Juan Bautista, the scene of Madeleine's fictitious original trauma where Elster stages his wife-murder as an accident. To call Scottie's behavior a compulsion – of love or oblivion or whatever unites them – is, however, to say that it is not Madeleine's history that drives him, but his own. And in that light, we catch sight of what Madeleine is: not a woman, but Scottie's own unmastered past, massively displaced onto and disguised as the image of a woman who is herself a fiction constructed by another man.

One more point before turning to my final section. As has been noted by Charles Barr, it remains unexplained why *Vertigo* must end with Judy/Madeleine's second death (Barr 2008: 76). Once Scottie has discovered that Judy was Madeleine or, since he never met Madeleine, that Judy simply was the woman he loved all along, why is he enraged rather than grateful for his extraordinary dumb luck? Why is the fact that Madeleine was a counterfeit, as he puts it, an intolerable realization? *Vertigo* does not go as far as to directly blame Scottie for Judy's death; that her fall from the bell tower is caused by the sudden and startling appearance of the nun means the question of the extent of Scottie's rage remains suspended and he is saved from being tarred as a "wife"-killer, like Elster and Thorwald. But the uncertainty about Scottie's intention is, I think, less interesting than the fact that Hitchcock so emphatically, one might even say willfully, closes off the possibility of romantic reconciliation. Something has already emerged between Scottie and his beloved to which no romance can reconcile him, something that would kill love even were he to have the opportunity to refrain from murdering Judy. What is it that, even within the context of love, will remain forever unforgiven by Scottie, the persistent force of which makes a happy resolution of *Vertigo* so unimaginable? This is surely a real question, for despite Judy's plain complicity in the murder of the real Madeleine Elster, Scottie lingers at the climax of his vengefulness for not one moment in the world of moral and legal standards. Only in his final aria of pain and execration does Scottie name the unforgivable crime: Judy knew. She was, as Scottie puts it, Elster's apt pupil, and Elster taught her something about Scottie she ought not to know. It is that she was not innocent of knowing that for Scottie is the unforgivable betrayal. But what did Judy know that goes beyond forgiving? This is the question that inverts the end of *Rear Window*, in which Lisa was forgiven her knowledge (if not by, then on behalf of, Jeff). But it is clear that Judy knew nothing on her own initiative, and that she, too, is a casualty – a student, as Scottie insists – of Elster's plot. To answer the question of illicit knowledge, we must shift our focus away from the unhappy couple and ask the question that lies behind: what did Judy's teacher know?

What Midge knows

The romance of Scottie and Judy/Madeleine arises at the intersection of two centers of knowledge of and from the past: Elster and Midge.

As already noted, their knowledge is not choral, as was Stella's in *Rear Window*, but effective in the narrative of *Vertigo*. Exactly what they know is unclear, but that they know more than they say is indicated obliquely yet repeatedly throughout *Vertigo*, both in hints dropped into the dialogue and in Hitchcock's oddly paranoid way of filming them. Elster, of course, is the villain of the story, so his motive for keeping his knowledge to himself and ours for wanting it to be brought into the open are clear enough. In the end, though, what Midge knows will concern us more, for her knowledge, in both its force and its strangeness, is the deeply unreconciled woman's knowledge that *Vertigo* presents. But as the question left before us at the end of the previous section is what Elster knows, the teaching of which makes Judy a criminal to Scottie, let us start with him.

When Elster first explains to Scottie that he needs someone to find out where Madeleine goes and what she does as she wanders around San Francisco, he stands behind Scottie, who sits facing forward toward us while Elster tells his story. We can see Scottie begin to draw the inference that Elster is worried about his wife's fidelity, but just as Scottie is about to announce his suspicion, Elster denies it. Elster seems to know where Scottie's thoughts have raced, even though it is contrary to the facts of the composition of the shot that he could have seen Scottie about to draw the conclusion. Elster's counterclaim, delivered from behind Scottie just in the nick of time to pre-empt the inference to infidelity, betokens some prior knowledge on his part of Scottie's rhythm of thought. The very banality of worrying about a wife who wanders in that sense might make it plausible to think that Scottie and Elster have simply arrived at the same false conclusion at the same moment in the story, but in this scene there are other hints of Elster's foreknowledge. For instance, before he begins to tell his story about Madeleine, Elster says, "I was sorry to read about that thing in the paper. And you've quit the force? It's a permanent physical disability?" The story we heard Scottie tell in the preceding scene between him and Midge is that his recent near-fall (while chasing a criminal across the rooftops of San Francisco) revealed that he has long suffered from acrophobia. This is an obscure story, for it suggests that Scottie has had the condition for a long time without knowing it, has had it unconsciously, as it were, which means in a way that could be detected only by others and only by means of secondary symptoms. Elster's interaction with Scottie hints at some prior awareness of Scottie's weaknesses. Scottie brushes away the suggestion that his life is

meaningfully inhibited by his acrophobia by joking that while he can no longer go to the Top of the Mark, there are plenty of ground-level bars in San Francisco.[10] Hitchcock then cuts from Scottie to Elster asking, as if he were testing Scottie, whether Scottie would like a drink right now. Scottie grows momentarily reflective, as if the offer were coming to him from across a distance, and then declines it because it is too early in the day. How much and when Scottie drinks is a matter Elster seems to know something about. The matter plays no further role in Elster's plot (unlike in Scottie's relationship with Midge, where the offering, accepting and declining of drinks plays a charged role), but it functions here as a piece of mysteriously intimate knowledge. This prior knowledge is also signaled, more consequentially, in the exchange with which Elster closes the deal for Scottie's help, which has already been discussed in detail. Protesting that he is retired and doesn't want to get mixed up in this, Scottie gets ready to walk out of Elster's office. But Elster tells him that he and Madeleine will be dining that evening at Ernie's where Scottie can come to see her. Why seeing Madeleine would further or better entice Scottie's involvement is obscure, but in fact it is the clincher. As there is no further discussion with Elster between Scottie's seeing Madeleine and his starting to follow her, the logic of Elster's argument as a whole is governed by his knowledge that when Scottie sees something that he knows Madeleine will display to him, Scottie will be driven to pursue it.[11] Prior knowledge of Scottie's tendency to stalk, it turns out, is as essential to Elster's plot as Scottie's acrophobia.

How Elster came to know of Scottie's scopophilia is never explained. In fact, the exact nature of his and Scottie's shared history is vague. Despite Scottie's description of Elster as part of the college crowd, Midge cannot quite remember him. And, as we discover later when Scottie formally introduces himself to Madeleine, his friends call him John or John-O (this is how Midge addresses him) and his acquaintances Scottie; Elster, despite calling on Scottie's friendship, addresses him as Scottie. Whether they are friends or acquaintances we never really know, but this very indeterminacy makes Elster a center of authority over Scottie that remains historically inscrutable. Its unaccountability notwithstanding, Elster's authority over Scottie plays one more key role in the scene of their first meeting. After Elster pre-emptively rebuffs Scottie's near-inference that Madeleine is unfaithful, he describes her wanderings as more bizarre than the strayings from the norms of marriage Scottie is imagining. This

promise of an encounter with the uncanny is part of Elster's seduction, but it takes the form of a cunning imputation to Scottie of an unnamed attunement to bizarre impulses. Hearing this imputation to him of strange expertise, Scottie moves to redirect it. When Elster asks what Scottie would say were he to tell him that he believes someone dead has taken possession of his wife, Scottie replies that he would recommend consulting an expert in the field of mental disease (rather than turning to a detective-friend). But however reasonable this proposal, something in it makes Scottie nervous. "Well, I'd say take her to the nearest psychiatrist," Scottie says, "or neurologist or psychologist or" – and here Hitchcock makes use of James Stewart's trademark stutter – "psychoa— or maybe just a plain family doctor." Scottie plainly starts to say, or wants to say, "psychoanalyst," but despite his fluency in naming all the related medical specialties, something censors the word. That Scottie experiences something that makes the word "psychoanalyst" anathema to him, and that this anathema would be acted out in the presence of his old college friend Elster, suggests that Elster provokes in Scottie an old anxiety about being seen to be in the grip of unconscious impulses. (When asked by Elster whether he believes "that someone out of the past, someone dead, can enter and take possession of a living being," Scottie says "No." But his response is so immediate and incurious that it sounds more like a refusal of the thought than a disagreement with it.) Elster's knowledge of his old acquaintance is, it is intimated, asymmetrical.

Such asymmetry of knowledge – being looked back at while looking, being seen without comprehending the conditions under which he is seen – is, as I have argued in my discussion of Scottie's final indictment of Judy, the deepest stratum of his dread. That dread turns into melancholia at the midpoint of *Vertigo* is therefore textbook psychoanalysis, since Madeleine's death has stripped Scottie of his means of making amends to whatever persecutes him. The suppressed premise of this inference from broken-off reparations to open melancholia is, of course, that the injury for which Scottie seeks to make amends has been inflicted by Scottie himself and that it is an ancient – an archaic – one. That is, it is the sort of injury the asymmetric knowledge of which would enable Elster to manipulate Scottie to become a made-to-order witness. But, to make a contrast that will allow us to shift our attention now to Midge, Elster uses his knowledge entirely instrumentally. He knows Scottie only in order to use him for his own ends. Put another way, Elster

gains all the benefits of asymmetric knowledge and bears none of its costs, which is why he can disappear from *Vertigo* so weightlessly (to Switzerland?). Seen in this light, Midge is the inversion of Elster: she shares his asymmetric knowledge of Scottie, but she bears the costs of it. Her disappearance from *Vertigo* is gray and heavy. And it is also decisive: without Midge's knowledge, Scottie plunges into open, manic madness.

Midge is Scottie's old college friend. No general doubt hovers over her, as it does over Elster, as to whether her history with Scottie is as their conversation presents it. There is, however, disagreement between her and Scottie about the details and meaning of their shared history. The disagreements are not spoken aloud, to be sure. In fact, the banter between Midge and Scottie is carefully, cooperatively and wittily crafted to prevent the disagreements from emerging, but they do not, for all that, go unacknowledged within their conversation. There is much in Scottie's history that Midge is allowed to know, and even turn back into their conversation, as long as it is turned back with a lightness of touch. In their opening scene together, for instance, there is the repeated implication of an imbalance in their sexual experience. Midge knows more than Scottie about people's underwear – both that worn by men, many more of whom wear corsets than Scottie would suppose, and women, who, Midge jokes, Scottie seems not to know wear brassieres. The gentleness of this joking, and the fact that Midge's knowledge can also be taken merely as an aspect of her artistic work, leaves it unclear which of them is in fact the more experienced. They have both remained unmarried, but there is an implication that Midge is the sexless career woman, while Scottie ("available Ferguson," he calls himself, as if quoting a nickname others use to caricature his perpetual readiness to date) is the playboy. But that this is never sorted out makes the conversation of Scottie and Midge simultaneously flirtatious and non-sexual. It wouldn't be wrong to call it familial – which is to say, to treat Midge as a sisterly figure.

To treat "sister" as the only licit female position Midge occupies would, however, be partial at best, for what is non-sexual in her relationship to Scottie was not always so; not so, so to speak, by nature. She and Scottie were once engaged, but the romance is over and what remains is a conversation of familiars built atop its ruins. In a historical vein, then,

their relationship can be thought of not as non-sexual but as desexualized. But that paints their relationship in the present in a melancholy hue that is false to the vivacity of their talk. The combination of joint, if not fully shared, knowledge of each other's foibles, and tolerance for those weaknesses that runs so deep that it becomes its own kind of pleasure, suggests not a romance ended but a romance sustained only in and by speech. In fact, were this not *Vertigo* we were discussing, Midge and Scottie would be well treated as candidates for membership in the pantheon of great gabbers characteristic of screwball comedy. To look at Midge this way, however, as knowing Scottie's love life from the inside but as loving him nonetheless, is to see her not as sisterly but as wifely. And this perception is reinforced by the way they share domestic life. Midge mixes Scottie's drinks out of old, familiar habit, they share war stories from their past and their work, and Midge tends Scottie through his injuries. When, in the midst of Scottie's obsession with Madeleine, Midge puts a note under his door because she cannot raise him on the phone, Scottie interprets her "Where are you?" as an expression of desperation. He isn't wrong, of course, and when Scottie concludes their exchange by saying, with a *comme ci, comme ça* flip of his hand, that he continues to suspect despair in her note, Midge does not quite retreat to a defense of the innocence of her question. Scottie's interest in Madeleine, they both acknowledge, has an edge of infidelity about it, suggesting that their relationship is in part a marriage, even if also, or only, a marriage foresworn.

Midge is both sisterly and wifely, then. But that is not all. Repeatedly throughout *Vertigo*, she is also cast in a third licit female role, that of Scottie's mother. When Midge suggests, in the movie's second scene, that Scottie might travel for a while now that he's quit the police force, he responds, "You mean, to forget? Oh now, Midge, don't be so motherly." After a brief shot of Midge hearing this, Scottie concludes the thought: "I'm not going to crack up." There is an undercurrent in this response that Scottie is being pushed out of the nest. This is weird, and not the least non-sequential of Scottie's trains of thought, but it makes explicit other odd tics in his conversation with Midge, such as his refusal to arrogate to himself complete independence ("fairly independent" is how Scottie describes himself, in a small-scale retreat from his claim to complete independence of means) and Midge's joke that he must know

about brassieres since he's a big boy now. Further, all of these small brushes against the idea of Midge as Scottie's mother occur in the context of a larger anxiety about whether Scottie can stand on his own two feet, and, in light of Midge's explanation that the brassiere she is drawing is based on the principle of the cantilever bridge, about uprightness and the struggle against the fateful draw of gravity in general. Finally, Midge openly avows herself Scottie's mother when she visits him in the sanitarium after Madeleine's death, declaring, in a tone the despair of which is not at all hidden behind the façade of false cheer, that "Mother's here."

Midge, then, occupies all the normative positions of female authority in *Vertigo*: sister, wife/lover, and mother.[12] Although it might not be entirely beyond the powers of imagination to sort out, or seamlessly blend, these three different positions, in *Vertigo* this does not happen. Only with Midge's final appearance is there an open arrogation of one of the three positions, the maternal one, but the declaration that mother is here represents the end of all play among the positions, and also – hence also – the end of Midge's role in the narrative. In contrast to Elster, Midge's departure from *Vertigo* is drawn out and agonizing. After her retreat into the position of mother alone, Midge is able to tell Scottie's doctor what only she knows, that Scottie was and remains in love with a ghost (what Scottie bluntly and incuriously denied to Elster is possible). By what authority Midge knows this is uncertain, but that she knows it with authority is illustrated – better: validated – by the entire remainder of the movie. It is no exaggeration to say that, as the first half of *Vertigo* plays out Elster's plot, the second half plays out Midge's knowledge. But the validation of Midge's knowledge requires her exit, for it is a knowledge that cannot be embodied by any character in Scottie's narrative. Midge's is knowledge entirely outside of the narrative that is nonetheless the authority over the narrative. And if that is so, then the narrative of Scottie's "recovery" is nothing but a secondary revision of Midge's knowledge that nothing can help him any longer. In Midge's extended walk, after her conversation with Scottie's doctor, down the gray-on-gray hallway of the sanitarium, *Vertigo* gives us just enough time to feel the weight of this knowledge, hard won but even harder to bear.

The claims that (a) Midge is, alongside Elster, the other bearer of the knowledge Scottie cannot himself know to be had by anyone, that for

him can be had only if kept unconscious, but that is nonetheless authoritative, and that (b) bearing this knowledge is a kind of suffering that *Vertigo* cannot redress, suffering that makes it impossible for *Vertigo* to figure a happy reconciliation, find their validation in two moments of the movie, the analysis of which will serve as my conclusion. In the early scene when the relationship between Midge and Scottie is first laid out, Midge spends most of her time at her drawing table. Her gaze alternates easily between the two projects of prosthetic support before her, Scottie and the cantilevered bra. At a certain moment in this scene, Scottie puts to Midge the question whether she will ever get married. She responds that there's only one man for her. "You mean me," Scottie replies, and then he asks, as if this were something one might forget about one's history with a best friend, "We were engaged once, though, weren't we?" The answer to this question is a close-up of Midge from a slightly elevated angle, elevated enough, that is, for us to see a quick smile cross her face and her eyes flicker, twice, behind her glasses. But why do Midge's eyes flicker? Not because she remembers all of a sudden the engagement she has forgotten, for she answers readily, "Three whole weeks." The flicker represents the recognition of something else, some aspect of her relationship with Scottie that is not borne aloft by happy conversation, but is also, as the quick smile attests, not a weight on her. Scottie makes the next move: "The good old college days. But you were the one who called off the engagement, you remember? I'm still available. Available Ferguson." In the midst of this speech, right in-between Scottie's recollection of the end of their engagement and what is either a new proposal or an expression of the fatefulness of the non-consummation of their love, there intervenes a repetition of the high-angle close-up of Midge. Her eyes flicker again, but this time over a significantly darker expression. One wants to say that what Midge recognizes here, following on Scottie's thought that an engagement is something one can forget, is Scottie's deeper forgetfulness, his revision of the fact that it was he who ended the engagement. Midge does not say anything, however, and she does not correct Scottie. This opens up the possibility – just as likely, in light of what we later come to understand is the pathology of Scottie's eternal availability, as Scottie's having terminated their engagement – that it was in fact she who called it off in recognition of Scottie's essential unavailability. But what matters most is what Midge does not say. She keeps her knowledge of Scottie to herself. Whether this is sororal

affection, frustrated love, or maternal holding we cannot know with any certainty, for this is the knowledge that Midge must keep secret, from Scottie and from us, in order for Scottie to tell the stories that keep him in the world of which she is the boundary, and also the container.

Because this interpretation of Midge's silence entails that we cannot know on whose shoulders the responsibility falls for the breaking off of her engagement to Scottie, it is impossible to know what thought exactly darkens Midge's expression. This uncertainty gets a sharp, but still ambivalent, twist in the last scene in which Midge and Scottie speak with one another. (She will see him again in the sanitarium, but at that point Scottie will not speak.) When Midge gets Scottie to come to her apartment by leaving the "desperate" note under his door, she has prepared a surprise for him: a copy of the painting in the Palace of the Legion of Honor that has so captivated Madeleine and, in turn, captivated Scottie. In Midge's version, however, she replaces Carlotta's face with her own. Scottie's response is apt for a couple who rely on wit to keep them together, but it is darkly extreme, extreme beyond apparent motivation. "Not funny, Midge," mutters Scottie. Whatever his feeling here, Scottie has it inconsolably. He refuses Midge's apology, cancels their date for dinner and a movie, and leaves. But why exactly is the painting so frightfully unfunny to Scottie? In point of fact, the painting is a witty, self-ironizing pastiche of nineteenth-century portraiture and mid-twentieth-century commercial illustration. It acknowledges Scottie's infatuation without mocking it and also without quite making the case that Midge should be its object instead. I urge that we resist seeing the painting as a love letter to Scottie for the same reason that we ought to resist in general seeing Midge as a lovelorn career girl. Everything we know about her points to an alternative conclusion – that Midge understands that marriage is not for her an escape from the fault lines internal to authoritative female knowledge – and so our interpretation of the painting should not collapse it into a tool of seduction.[13] In putting herself into the picture of Carlotta, Midge puts on display not her availability to Scottie but her knowledge of him. The *emblem* of this knowledge is her eyeglasses – which, in this case, we really ought to call spectacles – which make her appear to Scottie's gaze as a seer, a knower, of his desire. But the *form* of this knowledge is the painting itself, a knowing image of a knowing woman. This Midge has been all along, but up to now only in a pool of quiet suffering drawn from the unfigurable

knowledge that women's knowledge has no prospect of proper figuration. Made visible, all it can do is puncture the illusions, the secondary revisions, it itself makes necessary.[14]

As Scottie leaves her apartment, his relationship with Midge having been mortally wounded by her open avowal of her knowledge of him, we stay inside with Midge. We then see her angrily, belatedly, slash at the painting with her paintbrush. We only see her attack the painting from behind the easel, however, so the damage she does to the image remains out of our sight. What we are left with, instead of a defaced image, is the aria of the knowing woman. Midge squints, winces – she does not cry, however – and masochistically pulls her own hair. "Stupid, stupid," Midge yells at herself, in the voice of accursed knowledge. And then, after a brief pause, once more: "Stupid." With the third iteration of Midge's self-slander, the screen fades to black, leaving her alone with and as the disfigured image of women's knowledge, and Scottie alone to the terror of asymmetrical knowledge, the encounter with which will cause him to kill what he loves.

Notes

1 In Hitchcock's final movies, *Torn Curtain* (1966), *Topaz* (1969), *Frenzy* (1972), and *Family Plot* (1976), the interest in psychoanalytic themes disappears almost completely. The replacement of an abiding concern with the travails of knowing by a fascination with obscene political and sexual violence deserves more analysis than it has received, but I will say no more here than that in Hitchcock's universe there is either too little information or too much, but nothing in-between.

2 "I used at one time to find it extraordinarily difficult to accustom readers to the distinction between the manifest content of dreams and the latent dream-thoughts. Again and again arguments and objections would be brought up based upon some uninterpreted dream in the form in which it had been retained in the memory, and the need to interpret it would be ignored. But now that analysts at least have become reconciled to replacing the manifest dream by the meaning revealed by its interpretation, many of them have become guilty of falling into another confusion which they cling to with equal obstinacy. They seek to find the essence of dreams in their latent content and in so doing they overlook the distinction between the latent dream-thoughts and the dream-work. At bottom, dreams are nothing other than a particular *form* of thinking, made possible by the conditions of the state of sleep" (Freud 1953: 506).

3 For rare and interesting exceptions, see Cohen (1999), Maxfield (1990), and Wood (2002).
4 It is the fate of Jeff's nurse Stella (Thelma Ritter), who is safely and unanxiously outside of sexual norms – she describes herself and her unseen husband as happy misfits – to be able to see Jeff's anxiety. When Jeff says of Lisa that "She's too perfect, she's too talented, she's too beautiful, she's too sophisticated, she's too everything but what I want," Stella, in a tone of amiable insinuation, asks, "Is what you want something you can discuss?" How Stella is turned, in *Vertigo*, into Midge, who is markedly not happily outside of sexual norms, is one of the key transformative links between these two movies.
5 There is a hint of this even before the scene unfolds, as Lisa's outfit is accessorized with a scarf she uses as a sash. As a decorative ornament, which is to say as something merely to be looked at, the scarf gives the lie immediately to her assumption of an unfussy ready-to-move aesthetic. Or at least it does so for those more attuned than I to the details of fashion, as I confess this stylish touch escaped my attention until my fifth or sixth viewing of *Rear Window*.
6 That Hitchcock is working with and against domestic farce is hinted at by the fact that the Bickertons across the courtyard are trapped in one.
7 I am especially grateful to Katalin Makkai for directing me to make this point clearer.
8 See, for instance, Cousins (2003), de Lauretis (1984), and Modleski (1988).
9 That Hitchcock edits this as a broken-off shot/reverse-shot encounter means that Scottie hides his eyes not just from Madeleine's gaze but also from ours. Scottie's fear of being seen looking by Madeleine is, in this sense, a fear of the anonymous spectator as well.
10 This is another sign that the sudden onset of Scottie's acrophobia is more alibi than explanation: had he been able to go to the Top of the Mark, despite his acrophobia, before his recent near-fall?
11 In the original screenplay, Elster's storytelling continues as voiceover narration in the scene of Madeleine's presentation at Ernie's. Had Hitchcock made the scene that way, it would have brought Scottie's first sight of Madeleine more firmly inside Elster's plotting. Without the voiceover, however, Elster's voice does not dominate the encounter, which means there is more room for the confusion between our first encounter with Madeleine's beauty and Scottie's with her hauntedness.
12 The female position Midge notably doesn't occupy is daughter. That position is monopolized, although not without its own admixture of other positions, by Madeleine/Judy, and, in any case, it is not a position of authority.
13 Like Stella from *Rear Window*, Midge's love life is, as she says, normal; unlike Stella, her normality is not vouchsafed by a happy marriage.
14 Under the skin, then, Midge and Judy are the same kind of criminal.

References

Barr, C. (2008) *Vertigo*, London: BFI/Palgrave Macmillan.
Cavell, S. (1984) *Pursuits of Happiness: The Hollywood Comedy of Remarriage*, Cambridge, MA: Harvard University Press.
Cohen, P. M. (1999) "Hitchcock's Revised American Vision: *The Wrong Man* and *Vertigo*," in J. Freedman and R. Millington (eds.) *Hitchcock's America*, Oxford: Oxford University Press, pp. 155–72.
Cousins, M. (2003) "The Insistence of the Image: Hitchcock's *Vertigo*," in P. Adams (ed.) *Art: Sublimation or Symptom*, New York, NY: Other Press, pp. 3–26.
Freud, S. (1953) *The Interpretation of Dreams* in J. Strachey (ed.) *Standard Edition of the Complete Psychological Works of Sigmund Freud*, vol. 5, London: The Hogarth Press and The Institute of Psychoanalysis.
—— (1989) *On Dreams*, New York, NY: W. W. Norton and Co.
Lauretis, T. de (1984) *Alice Doesn't: Feminism, Semiotics, Cinema*, Bloomington, IN: Indiana University Press.
Lear, J. (1998) "Knowingness and Abandonment: An Oedipus for our Time," in *Open Minded: Working Out the Logic of the Soul*, Cambridge, MA: Harvard University Press, pp. 33–55.
Maxfield, J. (1990) "A Dreamer and his Dream: Another Way of Looking at Hitchcock's *Vertigo*," *Film Criticism* 14: 3–12.
Modleski, T. (1988) "Femininity by Design," in *The Women Who Knew Too Much: Hitchcock and Feminist Theory*, New York, NY: Methuen.
Mulvey, L. (1975) "Visual Pleasure and Narrative Cinema," *Screen* 16: 6–18.
Wood, R. (2002) *Hitchcock's Films Revisited*, New York, NY: Columbia University Press.

Further reading

Freedman, J. (1999) "From *Spellbound* to *Vertigo*: Alfred Hitchcock and Therapeutic Culture in America," in J. Freedman and R. Millington (eds.) *Hitchcock's America*, New York, NY: Oxford University Press. (Freedman explores Hitchcock's relationship to therapeutic discourse in the era of popular psychoanalysis, with special emphasis on the relation of psychoanalytic forms of narration to detective fiction.)
Gordon, P. (2008) *Dial 'M' for Mother: A Freudian Hitchcock*, Cranbury, NJ: Fairleigh Dickinson University Press. (While orthodox in its emphasis on the latent content of Hitchcock's movies, Gordon's introductory pages are helpful in thinking about Hitchcock's manifest presentation of psychoanalytic themes and tropes as interpretive lures to be avoided.)
Horowitz, G. (2001) "Pompeii Beyond the Pleasure Principle: Death and Form in Freud," in *Sustaining Loss: Art and Mournful Life*, Stanford, CA: Stanford University Press. (My most sustained discussion of the relationship among death, memory and artistic form in a psychoanalytic perspective.)

Miller, D. A. (2008) "Vertigo," Film Quarterly 62: 12–18. (On the occasion of the release of the Universal Legacy Series DVD, Miller discusses *Vertigo*'s wandering narrative, commenting provocatively on what he calls its imposition of "bad spectatorship.")

Ravetto-Biagioli, K. (2011) "*Vertigo* and the Vertiginous History of Film Theory," *Camera Obscura* 25(3): 101–41. (Ravetto-Biagioli analyzes the fascination with *Vertigo* by film theorists of various stripes and explains it in terms of its resistance to firm narrative grounding.)

Chapter 7

Katalin Makkai
VERTIGO AND BEING SEEN

Scottie: "Where are you now?"
Judy/Madeleine: "Here with you."

*V*ERTIGO IS A FILM about time that itself defies situation in time, as if there were no viewing of it in the present. The first viewing reaches into the future, calling for a second. Not just for the pleasures of appreciating, or mastering, the work and the play of a plot of which we had been a set-up ("a made-to-order witness"); not only because everything in the first part will look, *be*, different, since on our first viewing we were as duped as Scottie. More: the moments preceding Judy's "revelation" will reveal the other side of an essential doubledness the film contained all along.[1] When Judy/Madeleine tells Scottie of the sense that haunts her ("It's as though I were walking down a long corridor" at the end of which lie darkness and death), she is – to the extent that this is purely performance of "Madeleine" – dissembling, saying words she doesn't mean. But tangled as she is at this point, having fallen for the intended dupe, she may (also) *mean* them. A second level of doubling beneath the first. And yet if the first viewing calls for the second, the second is inevitably a viewing of a *different* object. It is not really a re-viewing of what we saw the first time. *Vertigo* is, in a certain sense, impossible to view; it escapes grasp by viewing.

For the object of the first viewing is irrevocably lost in time. At the mention of *Vertigo*, a friend spontaneously lamented the fact that she could

never see it again for the first time. It is internal to the workings of the film, I think, that it is apt to awaken in its viewer an uncanny experience of loss and a paired desire: I want to see it again, but I cannot, and know that I cannot. I cannot see the same again: this is so not just in a trivial sense that applies to any film, indeed any experience, visual or otherwise (if only because of the difference in temporal location, the thing I experience now cannot be the same as the other then), nor in the sense of the non-trivial yet undeniable fact that innocence once lost can never be regained. What is at stake is more than a wish to recapture the first encounter with a beloved object, to repeat an experience already had. With *Vertigo*, the film itself seems to have slipped through my fingers. The feeling of loss gives way to a more disturbing feeling that I never had the lost object to begin with, and never will have it. So the loss is somehow total, or rather my condition is one of lack, the figure for which is that of a blank, a hole, or an abyss. The sense that the film eludes me, or that it eludes presentness as a whole (of it to me, of me to it) – since it is, or I am, always too late or too early; it is, or I am, always ahead or behind – is, I think, something the film seeks to produce in me, because that sense is central to what the film thematizes. So is the desire to see it again, colored by the awareness that this desire, as it stands, cannot be satisfied, since it is the desire to be new to the film while – impossibly – marked by my experience of it.

"Only one is a wanderer. Two together are always going somewhere." Madeleine says this in response to Scottie's wish that they wander together. Is the idea that the film eludes me, that I am too early or too late, that we missed each other, a self-serving fantasy? And if so, what need does it answer? Does it cover over a failure on my part, by substituting a distorting idea of presentness for that the conditions of which I seek to avoid or flee: presentness as involving a willingness to be seen? It all depends on what "seeing" is or means – and on what being seen is or means. These are questions that the film explores in some detail. The suggestion I am lining up is that the risks and open possibilities that are there for Scottie to take up or turn away as he goes places with Madeleine/ Judy echo those we meet in our experience of, or with, the film.

Scottie loses Madeleine to something deeper, more annihilating, than death, since she (what she was for him) never existed, was nothing to begin with. (The whorl of her hairstyle is her sign.) Now he can no longer take solace in memory; what it was meant to preserve has

evaporated. Thus the irony in her name, for Proust's madeleine houses memory. His idea or ideal has turned out to be empty, or was empty all along, not because it still awaits instantiation but because it is the marker of an emptiness in him. What Scottie has lost turns out to have been nothing all along – but then in a sense there is nothing that Scottie has lost. And this is what Judy pleads with him to accept. The situation is delicate, since the captivating idea was itself that of a kind of nothing. The problem from which Scottie suffers is that what he loved precisely for being a kind of nothing or no one turns out to have been something, or rather someone. And it is this someone, and (perhaps) his love for her, that Judy pleads with Scottie to accept.[2]

* * *

> "That hero there, who protects his gaze from mine, casts down his eyes in shame and fright. Tell me, how does he strike you?" – Isolde

Perhaps the most common starting point that one is likely to come across in academic and non-academic characterizations of *Vertigo* alike is the idea that its central theme is that of watching – or, more specifically, a kind of watching that is dubbed "voyeuristic": taking a certain pleasure in spying on the activity of someone who remains all the while unaware of being observed. Since that description may seem to line up irresistibly not only with Scottie's conduct (as far as he knows) in the first part of the film, but also with the situation of the moviegoer in the cinema, the implication is that *Vertigo* places the viewer in the position of voyeur. *Vertigo* is, in fact, regularly cited as *the* film taking up this theme, as taking it up, indeed, so wholly and sustainedly that it might more properly be called the film's governing idea. There is a range of ways of going on from this starting point. On one influential approach, the *locus classicus* of which is Mulvey (1999), Scottie's (that is, the main male character's) "voyeurism" is to be understood in terms of the "male gaze" and its objectification of women, where such objectification constitutes a form of "sadistic" visual control or mastery that, needless to say, is morally problematic, and that reflects the morally problematic nature of gender relations in the (real) patriarchical world of the film's viewer. Made by a film industry reflective of that world, *Vertigo* invites its (male) viewer to identify with Scottie and to enjoy a gaze mirroring Scottie's own, thereby

experiencing the pleasures and accommodations of anxiety that the voyeuristic objectification of the woman affords.

One might counter that Scottie is treated instrumentally (by Elster and Madeleine/Judy in the first part), complicating the position of "objectification" in *Vertigo*. And it has been pointed out that the film's engagement of spectator identification is also more complicated than Mulvey allows. If it frequently invites identification with Scottie, it also sometimes, and in crucial moments, invites identification with Madeleine/Judy, and so identification is "severely disturbed, made problematic" (Wood 1982: 35, quoted in Modleski 2005: 89). The film's dimensions of identification and objectification are complicated in further ways. Modleski argues that it presents Scottie's attitude toward the woman as deeply ambivalent, his "sadistic" desire to control and possess Madeleine – who is the "the fully fetishized and idealized, 'constructed' object of male desire" (2005: 98) – vying with his fascinated identification with her and with the "femininity" that she represents.

Such objections share the starting point I mentioned: the idea that what drives Scottie in his relation to others, particularly women and especially Madeleine/Judy, is a desire or need to look, to be the one who looks and who subjects the other to his look. But in broaching the subject of looking in *Vertigo*, I find that to speak of Scottie's desire or need to look I have to begin with his apparent desire or need not to be looked at. This is the starting point I follow out in this essay.[3] Along the way, I bring to bear some thoughts about the work of Jean-Paul Sartre.

I take up Sartre's work because it develops a notion of objectification that is different – or so I argue – from the notion of objectification at stake in talk, as above, of the objectification of women. When you "objectify" someone in the latter, more familiar, sense, you fail to regard and to treat her (or him) as a subject; you regard and treat her (or him), instead, as a mere object of some kind, the object (for example) of your desire or for the satisfaction of your desire. (This is a most preliminary gloss, but enough for conveying the contrast at issue.) Sartre's idea is that there is a form of objectification that is also connected with being seen, with what he famously calls "the look," but that (in and of itself) is not morally problematic, not a form of harm. In fact objectification in this sense articulates a basic truth about what's involved in living in the world with others, if one that – according to Sartre – we are inclined to repudiate.[4]

In the first section below, I draw from my (sometimes critical) reading of Sartre an idea of objectification the acceptance of which is a necessary feature of human relationship. I then suggest in the next section that the tragedy in *Vertigo* – the one that plays out before us, not the tragic murder of the "real" Madeleine haunting the film – stems in the first place (not from Scottie's objectification (in the pernicious sense) of others, but) from his unwillingness to be objectified, his flight from objectification, in this second sense of "objectification." Finally, in the last two sections, I qualify and complicate the thought that Scottie flees being seen.

Sartre and "the look"

Being and Nothingness is Sartre's phenomenological study of being – his study, that is, of the structures of being as they appear to consciousness. In this work, Sartre characterizes the human being as essentially doubled or split in two different (but related) ways. The first split is between the aspects of my being that Sartre calls "transcendence" and "facticity": as consciousness, I experience my freedom to step back from and take up an attitude toward (to "transcend") the given facts of the world, in particular the given facts about myself, such as my past, my character, my dispositions, my motives, and my physical attributes (my "facticity"). Sartre calls this "the human being's double property of being a facticity and a transcendence" (1956: 98, translation modified). What is of particular interest to Sartre is the way in which (as he claims) the human being is apt to acknowledge this split with "anguish" and to resist it through the flight into "bad faith": the (essentially unstable, futile) attempt to identify myself wholly with either side of this split.[5] When I attempt to identify myself wholly with my transcendence, I endeavor to be "pure" transcendence (rather than transcendence *of my facticity*); when I attempt to identify myself wholly with my facticity, I endeavor to be a thing, a piece of the world, exhausted by my standing qualities.

Sartre's treatment of what he calls "the look," over 200 pages later, brings to light the second split. The look articulates the ground of my relations with others. Through it I discover a (second) way in which my being as freedom is set against my being as given – in this case, my being as given over to others (my "being-for-others"). (As in the case of the first split, it would be better to speak of a balancing of my freedom with

my givenness; this balancing becomes a central theme below.) Sartre's famous example asks me to imagine that, in the grip of jealousy, I am peeping through a keyhole. At first I am entirely absorbed in what I am doing. My attention is directed outwards and taken up by the scene upon which I spy; it is not directed back upon myself and my conduct. I experience myself as unreflective transcendence: a free point of view on the world. This changes radically when upon hearing (or imagining that I hear) footsteps approaching, I am flooded with shame. Now I am thrown back upon myself in a new way: in my reaction of shame, my attention is turned to how I might appear to someone who came upon me, which is to say that I become aware of myself as a possible sight for another. According to Sartre, this means that I am revealed to myself as not just a point of view on the world but also an object within it, exposed to the point of view of the other. That is, I apprehend myself as a particular object fixed in space and time, with particular qualities, the nature of which the other, as transcendence, is free to interpret and evaluate: she may see my conduct as voyeuristic and myself as contemptible, for example. Because as object I am given over to the other as a being capable of exercising her transcendence in judging me, my apprehension of my objectivity is, simultaneously, an apprehension of the subjectivity of the other.[6]

The keyhole scenario is meant to be more than a piquant example, for Sartre claims that shame is the fundamental way in which we apprehend the look. Here Sartre's point seems to be that particular ways of apprehending the look, of experiencing being seen – even those of pride or of indifference – are to be understood as articulated in some relation to a more basic feeling of shame. (Thus pride is an attitude taken up in response to shame, according to Sartre.) Registered in this claim is the idea that the other's look is fundamentally *threatening*. Sartre's point is not merely that the particular ways in which the other sees me – the content of the particular properties and values she ascribes to me – may trouble me. Even if they do not – even if they are flattering – I am threatened by the underlying fact that her look fixes me as an object, however specified. My shame is in my being an object at all. Sartre glosses this threat in terms of my dependence on the other. (Or rather, to anticipate a thought to which I will return, it would be more accurate to say that the issue is the lack of a desired total independence from the other.) In the following passage, Sartre brings this circle of ideas together

and speaks of my shame-awakening objecthood in terms of my "fall," alluding to the Christian doctrine of the "fall of man."

> Pure shame is not a feeling of being this or that reprehensible [or objectionable] object but in general of being *an object*; that is, of *recognizing* myself in this degraded, dependent, and fixed being which I am for the Other. Shame is the feeling of an *original fall*, not of the fact of having committed this or that fault, but simply of the fact that I have "fallen" into the world, in the midst of things, and that I need the mediation of the Other in order to be what I am.[7]
> (1956: 384, translation modified)

I will, in a moment, question Sartre's characterization of "shame" as the fundamental mode of apprehending the look (and as an "authentic attitude" (1956: 386)). First I want briefly to elaborate his idea that the experience of being looked at is an experience of being exposed — that the look of the other is threatening and constitutes a form of dependence — in order to bring out the thoughts about "objectification" from which I will draw.

The train of thought with which I begin (i.e., this paragraph) is suggested to me by elements of Sartre's text; the question of whether he would accept it as a rendition of his views can be set aside for my purposes here. In a certain frame of mind, it can seem that not merely am I sometimes caught doing things I'd rather not be caught doing (such as peering through keyholes), but that everything I do is something I am or could be "caught" doing, in the sense that its meaning and value — its significance — is not up to me to decree but is, rather, a matter to be determined by looking at what I've done, upon which I have no privileged say. Whether my action counts as this or that is an "objective" matter, just as is the matter of whether a particular tree is a cypress or a cedar. In the case of my action as in the case of the tree, I *might* have more pertinent information than someone else, but not necessarily. In any event, a question about whether it is distorting or apt, or somewhere in between, to call what I did a "mistake" rather than an "accident" (for example), is answered (not by accepting whatever I say about it, but) by considering the evidence.[8] To put it another way, I can choose the name of my child, but it's not up to me to decide what my action shall be called — what it is to be called is a matter of what it in fact *is*.

Likewise for my qualities. What is brought home to me in the experience of the look, in other words, is the respect in which I am an object in the world, to be understood and appraised in ways and in terms of meanings that are not up to me to dictate, that are essentially "public."

It's not just that I don't have a privileged position with regard to the determination of my objecthood, however. In Sartre's view, there is a sense in which it is precisely the other who has, in this respect, a privileged position. For Sartre holds that I can be an object only for the other, not for myself, and this means that "beyond any knowledge which I can have, I am this self which another knows" (1956: 350). The point must be, I think, that as transcendence I always have to take up a practical attitude toward my givenness; I cannot adopt, toward myself, an attitude of (sheer) observation. So the position from which I am known, or anyway knowable, is essentially external to me. I elude myself. (In Sartre's jargon, the "foundation" of myself is outside of me (1956: 349).) I take this to be part of what Sartre records in speaking of my objecthood in terms of my "dependence" upon the other. And so what the look seems to mean is this: at the heart of my being I encounter the other, designating a split within myself that I cannot join or bridge, and a freedom external to my own upon which I am ineluctably dependent.

There are questions to be raised about these claims concerning self-knowledge and dependence, but that work may be left for another occasion.[9] It is the notion of objectification that is emerging from thinking about Sartre that I want to contrast with "dehumanizing objectification" (as I'll call it), the notion of objectification I identified earlier in talk of the objectification of women. We can begin to appreciate the difference by noting that the act of "dehumanizing" objectification – that is, the treatment as an object of the one it is directed toward – is a distorting piece of violence. For the one so objectified is precisely, properly, *not* an object, and indeed this fact is what such objectification trades upon: only a non-object can be thus objectified. Whereas in the sense I am inviting us to consider by reading Sartre, objectification reflects the articulations of being (as Sartre might say): it is true of me that I am an object (although that is not the whole truth about me). Otherwise put, to repudiate the aspect of my being that is my objecthood is falsifying: in Sartre's language, it constitutes bad faith. That's not to say, again, that I am bound by whatever way of seeing me someone might

have. The point, rather, is that I must acknowledge that I am an object in the world (if not only that), that, in other words, I am given over to the look of the other. This is how I suggest we take Sartre's claim that I *recognize* myself as the object seen: "Shame is by nature *recognition*, I recognize that I *am* as the Other sees me" (1956: 302). Recognition of oneself is internal to shame, for shame is shame *of* oneself, before – in the eyes of – another. In shame the other's view of me "touches me to the quick" (1956: 302), precisely because I acknowledge myself as the (shameful) object seen; if I could dismiss that view as the mere image that she *happens* to have, I would not be experiencing shame (but, say, annoyance or anger). Indeed, it is on the basis of this recognition that I take myself to be "responsible" (1956: 303) for this object, this self, even though its "foundation" is outside myself. Bracketing the language of "shame," we can say: it is insofar as I recognize the object the other sees as *me* that the other's look *matters* to me as revelatory of myself.

I adduced Sartre's notion of bad faith in connection with the repudiation of one's objecthood, but just how Sartre understands bad faith in the context of the look is difficult to assess. It is clear that he takes the reaction he calls "pride" or "vanity" to be a form of bad faith. In that mode of bad faith, I seek "to lose myself in objectivity" (1956: 491). I try to make the other feel "admiration" or "love" for me; in the latter case, I try to get her to make of me, with the qualities she confers on me (such as my strength or my beauty), a sort of "absolute object," dictating the point and the limits of what, for her, is the world (1956: 386). Reactions of bad faith are essentially futile efforts, as I said earlier in my brief mention of bad faith with respect to my transcendence/facticity split, and the futility in this case is clear. Since I am trying to *make* her have the feeling of "love," I am undermining my very project, for if her subjectivity is shaped by my aims, it no longer has the freedom needed for her regard for me to have the power I wanted it to have. So my effort to undertake a certain kind of retreat into objecthood in the face of the other's subjectivity has instead brought before me my own subjectivity and the other's objecthood.

Bad faith in the opposite direction, bad faith as a flight from my objecthood, which would be akin to the bad faith repudiation of my facticity – both, then, flights from my givenness – would be an attempt to "lose myself" in my subjectivity, to identify myself wholly with

looking. Sartre does talk about the "defensive reaction" (1956: 393) of turning my look upon the other and so making the other the object – avoiding my objectification by objectifying the other – but whether he thinks there's a form of bad faith to be found here is a question.[10] We find a picture of the attempt to distort or deny one's objecthood in *Vertigo*, or so I now want to suggest. I won't be worrying about whether it counts as "bad faith" proper, but we can say a bit about why such a form of bad faith would have to be futile: when I employ the strategy of fleeing from being looked-at by turning my look upon the other and thus converting her into the object, my attitude toward her must encompass not merely her being an object, but her having *become* an object and thus defused as a threat; she is for me the object-that-was-objectifying-me, that threatens to objectify me or that I am keeping from objectifying me, that I have for the moment tamed. Otherwise, I would seem to lose the motivation to maintain objectification once it is realized. So the reaction of objectification must, I think, be accompanied by a residue of dissatisfaction. I must remain aware of the threat of the look of the other, as a threat that is (for now) contained. Then there can be no genuine sense of *satisfied* desire to escape the look of the other.

Sartre's claim that the apprehension of one's objecthood is necessarily a feeling of or derived from shame is problematic, for he has not given us grounds for this claim, nor, more generally, for the claim that this dimension of one's being (one's objecthood) *must* appear as a threat. As I read him, Sartre holds that all forms of bad faith derive from a fundamental, but not ineluctable, desire. This is the (obviously hopeless) desire to overcome the two splits I've been discussing, to erase the fundamental division, of which they might be called aspects, between being free ("for-itself") and being given ("in-itself"). As freedom I always transcend my given self. The fantasy is to be released from the burden of that responsibility, to just *be* (be complete, whole) – but not to be a mere thing; to be, in this complete, whole way, *freedom*: to be freedom in the mode of givenness, to be identical with my freedom rather than having to exercise it. This paradoxical, contradictory, desire is, in Sartre's terms, the desire to be my own foundation and to exist justifiably and necessarily rather than contingently. Sartre's name for it is the desire to become for-itself-in-itself or to be God (to be what a God would be) (1956: 723–24). The implication is that by not giving in to that desire, it might be possible to avoid bad faith – to, for example, experience

something deserving the name of "love" (as opposed to the debased form described above). Whatever the merits of this account, it seems to me that Sartre ought to say not that the desire to be God is the basis for bad faith reactions to (supposedly unavoidable) shame, but that it is only for consciousness characterized by this desire that its "double property" of being subjectivity and objectivity will awaken shame, and so prompt one or the other bad faith reaction. In other words, bad faith reactions are "inauthentic" reactions not to *shame*, understood as the basic way of apprehending one's objectivity and the dividedness of which it is a part, but to one's objectivity itself, or to that dividedness itself. They stem, that is, from reacting with shame to one's objectivity, so to one's being split between objectivity and subjectivity. And that suggests that — if we are not just condemned to bad faith — a fitting attitude toward one's objectivity, so one's dividedness, an attitude that does not express bad faith, will be one that does not find it to be *simply* threatening.[11]

It's worth mentioning Sartre's famous appeal to the idea of "vertigo" in *Being and Nothingness*. Its central use is as a term for anguish "in the face of the future": anguish concerning the fact that my conduct at every moment requires and expresses my transcendence, that I cannot now lock down and "determine" my future doings. This is anguish before my own inescapable freedom. We've now seen another kind of apprehension of ineluctable dependence on a freedom. In the case for which Sartre reserves the name, this freedom is my own, or that of my future self. In the case to which I am proposing that we extend his term, the freedom is that of the other. The possibility I am trying to raise, in other words, is that of extending Sartre's categorizations so as to speak of "vertigo" as an experience of my dependence on the other's capacity to exercise her free powers of judgment to know me, to fix me as an object, and of thinking of Scottie's condition in terms of this extended version of "vertigo."[12]

Scottie unseen

What is it that draws Scottie to Madeleine in the first place? Is it her sheer beauty, displayed in the gorgeous setting of Ernie's, that hooks him? Or is it the ethereal quality of this beauty, playing to the idea of mystery Elster has already evoked, so that she represents a kind of ideal, the "eternal feminine," cut to the measure of male fantasy (Modleski 2005: 93)? The thought that Scottie is seeing something that Elster's words

have prepared is important, but it strikes me that those words give us something more specific to go on in thinking about *what* it is that he has prepared, and so what it is that Scottie sees. Scottie is attracted, in the first place, by a certain idea, one that is awakened in him – before he ever lays eyes on Madeleine – by Elster's particular description of her; and it is as the confirmation of this description that the sight of her is decisive. In the preceding scene at his office, Elster says that he believes her to be possessed by someone dead and that he wants Scottie to follow her. Scottie soon heads for the door, ready to leave; such nonsense leaves him cold – so it seems. It is now that Elster turns to describing Madeleine, focusing almost immediately on her powers of sight: "She'll be talking to me about something. Suddenly, the words fade into silence. A cloud comes into her eyes and they go blank." She becomes blind to this world, if she now sees another. "She's somewhere else, away from me, someone I don't know." Scottie has been hovering by the door. But now he walks over to an armchair – not the one he had occupied earlier but another that gives him a better view of Elster, as though taking up the position of spectator that Elster's performance invites – and settles in, listening with new concentration. He recommends a firm of "private eyes." When Elster presses him to take the job he protests ("Look, this isn't my line," with the ironic suggestion that his control over what he says, so what he means, is already in question) and then grumbles that he's "supposed to be retired," that he doesn't "want to get mixed up in this." But he does not refuse the job. On the contrary, his grumbling suggests that he has all but accepted it. (This man seems to have no general difficulty putting his foot down. Or does the moment expose terrain with respect to which he does? What exactly would that terrain be? The film leaves such questions open.) And indeed he follows Elster's suggestion that he come to Ernie's that night in order to "see her there." I take it that Scottie is attracted to the idea of a woman who, at least intermittently, is dispossessed of a gaze, and is lured by the hope of encountering her in the flesh – the experience, that is, of seeing her, and not being seen by her. And this is precisely the experience Madeleine provides for him, and for the viewer.

Madeleine's gaze never falls upon Scottie at Ernie's. A central sequence drives the point home. She has made her gliding entrance from the dining room into the bar where Scottie is seated and has paused before her exit, the whole movement presented from Scottie's point of view.[13]

The camera frames her, now standing just off Scottie's shoulder, in right profile. She turns her face toward us. The camera cuts to Scottie (moving his profile in the opposite direction, as though to avoid her eyes[14]) and then back, Madeleine's eyes now past the point of meeting the camera as she completes the arc to present her left profile. As she turns back to right profile, the opportunity for eye contact is again missed, now because she lifts her gaze away just in time. Here is a woman who does not see Scottie. The next scene finds him on the job. There is no pause, as there is evidently no need for further explanation. His enchantment has begun.

We enter into the long passage in which we watch Scottie following and watching Madeleine. There was no real dialogue at Ernie's (the score replaced, soon and conspicuously, the muddy murmur of the chatting diners), and there is none at all for around ten more minutes. Scottie and Madeleine do not exchange words or make physical contact for nearly the next half hour. Scottie trails her in his car and lags behind on foot. He peeks out from behind a slightly opened door at the florist's, hides behind a stone wall and tree at the cemetery, lurks near a column that he later ducks behind at the Palace of the Legion of Honor (in the second, briefer "following" sequence): but the initial tension – will he succeed in escaping her notice? – gives way to relief, a mounting realization that he is in no danger, for it is no accident that she does not see him. She is not in a position to see him; she is in that state in which "a cloud has come into her eyes." This realization is just what Scottie hoped for: it is the realization, at the same time, of his desire, the desire that is answered by the idea of a woman who does not see him.[15]

The woman's gaze is emerging as a threat, a danger to avoid. But this idea has been at work from the outset. Consider the opening credits. Bernard Herrmann's score has already begun.[16] The first image is a black-and-white close-up of a woman's mouth, somewhat off-center. The camera centers on her mouth, and then slowly moves up to her eyes. Surprisingly, perhaps, this woman is not Kim Novak, nor any of the women we will encounter in the film. She looks left and then right, fearfully – so it seems. The camera centers on her right eye and moves in. It moves in closer still, the eye now filling the screen, as the whole image is tinted red, and the eye widens, its pupil dilating, again in what seems to be fear. Thus far the credits ("James Stewart," then "Kim Novak," and then "in Alfred Hitchcock's") seemed to come from "our"

side of the screen, superimposing themselves over the woman's face.[17] But now "Vertigo," beginning as a tiny line of type, emerges toward us from her pupil, floating up and off screen. There are layers of suggestion here. To begin with, there is, as I've said, the woman's terror. But given what is to come, what shall we say is the significance of this terror? Perhaps it is the terror of a woman who finds herself to be a vessel for someone else. There are many whom Madeleine/Judy could be said to experience as possessing her or acting through her: Elster, Carlotta, Scottie, the persona or role of Madeleine, the "real" Madeleine (the spirit of the murdered wife), Hitchcock. But the sequence also seems to evoke the productive, creative power of motherhood, suggesting that the power here is woman's (which is not incompatible with its being terrifying); then we have a certain way of relating the creative powers of the film's "maker" to those of the mother. Next a stylized purple spiral, a kind of whorl, emerges from her eye, swirls toward the viewer, takes over the screen, and dissolves against a black background in which we see the next (blue) whorl following in its wake, evoking the unending succession of ocean waves or of moments of time. The music too has the rhythm of crashing waves. Credits now appear in conventional format, independently, so it feels, of the whorls. After more stylized spirals, now variations upon one another, the eye returns, a spiral separates into two, the offshoot moving in the opposite direction and disappearing into her pupil, and then with a final reversal the eye projects "directed by Alfred Hitchcock." If we are made uncomfortably aware of ourselves as looking, this awareness is complicated by the suggestion that we are being looked at, that we are the object of this woman's look (and that of Hitchcock; that of this film?). Being subject to that look and its powers is rendered here as vertigo-inducing. The sequence begins, I noted, with a close-up of the woman's mouth, for now closed and static. This beginning and the transition to her eyes lays the ground for a link that the film will underscore and a version of which we saw in Sartre, a link between seeing and saying, or – to be more specific – between seeing, judging, and knowing, hence between being seen and being known.

This link underlies the delicate yet familiar balancing act of Scottie's relationship with Midge, which depends on keeping, or regularly returning, to the surface with the help of a covering casualness and of leavening doses of easy, unchallenging humor. It depends also on Midge's controlling the extent to which and the ways in which she voices her

thoughts and lays claim to, and pursues, knowledge of Scottie – his state, his doings, and his plans. The camera's relation to her gaze echoes this sense of control. Her prominent glasses send back reflections that veil her eyes. In the first scene at her apartment, she (at first) keeps her eyes on her work while talking to Scottie, her attention manifestly divided, not fully trained upon him. When tension bubbles up, the close-up shots of her face emphasize her withholding of her gaze and her thoughts from Scottie and from us, her eyes nearly blocked from our view by the frame of her glasses. The mood of their interaction moves between friendship, mild or mock-flirtatiousness ("That's the kind of greeting a girl likes"), and domestic comfortableness, the invocation of the "mother" role serving as a kind of warning signal of transgression ("Oh now Midge, don't be so motherly"). Midge's being in possession of a "look" for Scottie – Scottie's awareness that she is in a position to know him, not only because they share a long history but also because she has insight into him and an interest in knowing him – places limits on their relationship. There are fault lines that they carefully navigate without making explicit. This is part of their intimacy, from which we are, to a degree, excluded.

Scottie seems to bring the conversation brushing up against these limits, as if he were testing them – like someone confirming the solidity of a barrier – with his strange remarks around their engagement in college. Midge has just handled his question about whether she'll ever marry by saying, "You know there's only one man in the world for me, Johnnie-O" – a playful line that allows the level of its seriousness to remain unspecified. "You mean me," he says, and then, most casually, "We were engaged once, though, weren't we?," as if wondering about some minor episode he's lost track of. Scottie may be going for a tone of levity, but the blunt incongruity of the suggestion that one could forget about a former engagement with a close friend is a sign of something forced. Apparently unaware of the strain in her tight reply ("Three whole weeks") – for Midge the topic is clearly charged, although we don't know in what ways – he drawls a lazy "Good old college days," the cliché dismissing it all as long outgrown, which is why his next words are stinging. "But you were the one that called off the engagement, d'you remember? I'm still available . . . Available Ferguson." One moment the engagement is long dead, the next it's back on if she says so: he doesn't mean his words; their carelessness is their point. With "Available

Ferguson," he seems to be repeating an old nickname (in some sort of mock (Scottish?) accent) and drifting for a moment into the nostalgia it inspires. But then he is reminded of something more interesting or more pressing, the call he's received from his old college friend Elster. He wants to know if Midge remembers him.

The limits approached here are transgressed in the scene with Midge's painting. From the start, Scottie is distant yet prickly. His terse greeting is soon followed by a question: "Since when do you go around slipping notes under men's doors?" He sits down on her couch; now he is shot from the side and from below, the length of the dark couch prominent in the foreground and emphasizing the inaccessibility he is insisting upon. He blocks her attempts to find out what he has been doing with hard non-replies ("Where do you go these days?" "Oh, just – wandering." "Where?" "'round about."), and pointed questions of his own. "What was this, uh" – he smacks his shoe – "what was this desperate urge to see me?" His hostility is obvious, as is his effort to keep it under control. When Midge lightly dismisses the charge of "desperation," Scottie replies that he detected an "undercurrent" in her note. Irritated by Midge's desire to know what he has been doing, he is asserting his knowledge of her. Trying, still, for lightness, Midge says she hoped he'd "be so grateful" for the drink and dinner she's offering that he'd take her to a movie. "What'll we talk about at dinner?" "Oh, this and that." "What I've been doing?" "Naturally we won't talk about anything you *don't* want to talk about." "Naturally," he repeats sarcastically.[18] A pleading, hurt note that she must have been trying to avoid breaks out as she asks, "What *have* you been doing?" He deflects, again: "Wandering. What have *you* been doing?" This brings them to the topic of her painting, her return to her "first love." In response to Scottie's question whether it is a "still life," she replies, "No – no, not exactly. You wanna see?" The original picture of Carlotta *is* a kind of "still life," a depiction of something that partakes of life yet is touched by its absence: these are ways of describing Carlotta and also Madeleine. (Hitchcock spoke of Scottie in terms of "necrophilia" (Truffaut 1967: 244). He is generally understood to mean that Scottie's erotic attachment to Judy is based on her looking like, his trying to pretend that she is, the dead woman who remains the object of his desire. But the phrase is more apt, it seems to me, as a kind of description of what Madeleine means to Scottie from the outset, and why that meaning so seduces him: he

understands her to be "dead" to begin with, insofar as her capacity to assume the look is in question, and perhaps in other respects as well.)

Midge has inserted her face and her direct, bespectacled gaze into what is otherwise a copy of the painting of Carlotta.[19] But by painting herself into the picture in this way, Midge undercuts just those elements that, for Scottie, give the picture, or what it depicts – Carlotta and also, through a kind of identification, Madeleine – its value. She has painted in something like a live gaze to replace what is crucially, for him, an empty pair of eyes. The force, violence perhaps, of her gesture is reinforced in the shot from his point of view as he looks at the painting. The shot does not center on the painting. Instead, it contains Midge, sitting on the coffee table, in the left half of the frame, doubling the painting in the right; even Midge's pose – hands clasped – mirrors the one in the painting. A doubled pair of eyes looks out at him.

Scottie leaves. This is the end of his interaction with Midge. At the sanatorium he shuts her out entirely. He has rejected the effort Midge was making in the scene as a whole and that her painting enacted, the effort to enter the space of Scottie's privacy, his fantasy – to force her way in or to get him to allow or even invite her in. Scottie makes a similar effort with Madeleine at San Juan Bautista, and Midge's effort at the sanatorium echoes both.

So far I have been sketching an interpretation on which Scottie's attraction to Madeleine and his relationship with Midge are understood in terms of his wish to avoid being, or to limit the extent or depth or explicitness of his being, the object of the knowing look. What I want now to suggest is that the film shows Scottie's relation to the look to be more complicated, and more ambivalent, in two ways.

Visions of seeing and of being seen

> "Gently enfolded in your spell, sweetly vanishing before your eyes . . ."
> – Tristan

I've been suggesting that Scottie flees from being looked at. But it would not be quite right to say that this flight consists of seizing the position of the one who looks while relegating Madeleine to the position of the one looked at. For one thing, Madeleine does not lack a look *tout court*. I don't mean just that "Madeleine" is a role. The deeper point here is that

even on Scottie's perception of her, Madeleine's trances come and go. She is better described as prone to being dispossessed of the look. But we miss something too if we say that Madeleine is the unseeing object of Scottie's look when she is in one of her trances. Two related dimensions of identification are pertinent here: Scottie's identification with Madeleine, and Madeleine's identification with Carlotta. About the former I will say more in a moment. Madeleine's "possession" by Carlotta is rendered in terms of her serving as a vessel or channel for Carlotta. She is taken over, swamped, perhaps to the point of becoming Carlotta. And when Midge asks, "Is she pretty?", obviously meaning Madeleine, Scottie's confused reply – "Carlotta?" – suggests that Madeleine and Carlotta have become conflated in his mind and in his attraction.

What I have in mind is most poignantly conveyed in the scene in the redwood forest, home of "the oldest living things." This is the only occasion on which Scottie, and we, are in Carlotta's presence (as it were). Elsewhere Madeleine's communion with Carlotta – at the graveyard and in the museum – is silent and held away from Scottie and from us. If here Scottie is not quite the audience to whom Carlotta is communicating, he seems nevertheless to be witness to her thoughts and feelings. They stand before the cross-section of a felled tree, some of its rings marked with the dates of major historical moments. For an instant we see, in a shot that doesn't feel like it's quite from her point of view but might be – an ambiguity internal to the scene – the cross-section left to itself, without any sign of its visitors, before Madeleine's (Carlotta's?) black-gloved hand enters the frame, slowly and strangely, pointing to one ring and then to another, disconnected from the rest of her. We hear her voice, it too somehow detached, seeming to come from elsewhere, saying, "Somewhere in here I was born. And there I died. It was only a moment for you, you – you took no notice." She turns around and past Scottie, and walks off as though he weren't there (or as though she weren't there with him: she "goes into that other world," Elster said).

The eeriness of this moment and of the scene as a whole derives not just from the experience of Carlotta as speaking through Madeleine, but also from the way in which Carlotta/Madeleine seems to speak outside time, and seems to address time itself, or nature or the world itself, aggrieved by its indifference. (For her addressee we are all "the small stuff, you know, people you've never heard of," as Scottie earlier

described the kind of history he wants access to.) It is as if Carlotta's "presence," her being "present," is tied to the timelessness of this moment. Is she standing outside time, or is the petrifaction of time allowing her manifestation? In any event, she is not merely a dead being, but one with enormous power, the power to move through time, to take over the living, and to overcome the forces that the mortal, finite human cannot escape: time, nature, space (recall that from Scottie's point of view Madeleine simply vanished from the McKittrick Hotel, as if dematerialized).

If in one respect Madeleine seems to be (prone to being) dispossessed of a look, in another respect she seems to be (prone to being) possessed by, and hence possessed of, an extraordinary look, one that takes up an extra-human perspective on our world and on the conditions of our existence. And if Scottie wishes to liberate Madeleine from Carlotta – more about this in a moment – his commitment to that project is conflicted: for he is also drawn to the idea of being seen by Carlotta, the figure of a (great-grand-)mother with an all-powerful look.[20] This attraction is not incompatible with what I have been calling Scottie's desire to flee the look. For it expresses the desire to disappear into objectness – not objectness in the eyes of an other (that is, another human being), but rather a sort of total objectness, objectness in the eyes of this transcendent mother figure. The prospect is that of being wholly known, or, better, of going beyond being known, merging into unity with her. (Then she is not more than other but less than other.) This is the fantasy of being the lost child, reclaimed even from time. Far from being at odds with the flight from the look, it represents a mode of that flight, since being the object of the look involves the recognition that a (real) dimension of my being lies outside me in a (human) other.[21]

The look Sartre theorizes is dangerous to the one seen. The other's look constitutes "the knowledge [of me] by which the Other touches me in my being" (1956: 385). When I turn the look back, asserting my capacity to wield the look and making the other the object, I neutralize this danger; the other's knowledge "no longer *touches* me; it is [merely] an image of *me in him*" (1956: 385). But whether Madeleine does not see Scottie, or whether she – as Carlotta – sees Scottie in this extra-human way, with her Scottie seems to avoid Sartre's danger, "the danger of *being-seen*" (1956: 484). To the extent that she has a look, he is "untouched" by it. And Scottie's look cannot really fix *her*; she eludes it like the ghost

she is (like). She is untouched or untouchable, in Sartre's sense, by Scottie's knowledge of her. Is this too part of her attraction?

And does Scottie think of looking as dangerous in a sense that Sartre does not broach? With Madeleine, Scottie does not have to look at (know) another human being. Perhaps knowing itself strikes him as a burden or danger, something to flee; perhaps Madeleine appeals by offering the opportunity for such flight. Here the look would be dangerous to the one looking (knowing), and to be untouched by this danger would require the avoidance of seeing. Madeleine too is "untouched" or "untouchable," in this new sense, by the knowledge of Scottie. She is safe, in other words, from the sight of him. If this is also part of her attraction for Scottie, the implication is that Scottie thinks of the sight of him, that is the knowledge of him, as vile or dangerous. Perhaps even fatal.[22] (This is a thought to which I return in the next section.)

I think we can say, then, that Scottie's demystification project, his attempt to recover Madeleine from possession by the dead, is doomed to begin with. Quite apart from the external hand of Gavin Elster, there is a kind of internal logic to (what Scottie takes to be) her fall from the tower, suggesting a corresponding explanation of his fall into "melancholia" and a "guilt complex." Madeleine – what she is for Scottie, the attraction she holds for him – cannot survive her rehumanization, and he knows this, however dimly. He wishes her dead rather than human, and he finds this hidden wish to be fulfilled: this is the source of his guilt, not his failure to keep her from dying at the bidding of the dead, nor the part he played in bringing about her death by trying to force her out of possession.[23] If he is an Orpheus, then the answer to the question "Why does he turn around?" is, for this Orpheus, because he *wants* her (to stay) dead.

But what about that attempt of his to "demystify" Madeleine? If we take it at face value, it conflicts, as I've said, with his desire for her to be "mystified." (I'll be bending this word to catch an elusive sense.) It may also mean effectively the opposite of what it seems to mean – it may be, in short, no demystification project at all. Another attraction that the idea of Carlotta as the (mother) figure with the all-powerful look holds for Scottie is pertinent here, the attraction of seeing what she sees. Scottie wants to find the "key" to Madeleine's other-worldliness. Cut out, excluded, from her dreams and visions, Scottie wants this key not so that

he can bring her out, but so that he can go in. So he drives her down to San Juan Bautista and tries to get her to "remember" when she was there. His wish to enter the space of her privacy is figured by his attempt to bring her back to this physical place where she once was (in some sense) without him, and to restage that earlier moment with himself now included. It is also, of course, figured in his attempt there to gain access to the internal or metaphysical space to which she again retreats. ("I have to know," he said by the ocean after they left the redwoods.) It is because Scottie associates the livery stable with the space of her privacy, the space he wants to enter, that it is what Judy's room morphs into as they kiss following her emergence from the bathroom, hair put up, looking "exactly like" Madeleine.

Now the inaccessibility of her privacy is insisted upon by the camera and by her. Having found the "gray horse" she recalls from a past that sounds like it might be Carlotta's, he says, "You see, there's an answer for everything." There is a cut to a shot from his point of view fairly deep into the stable. A carriage in which Madeleine is seated takes up half the frame. It and she are dark shapes against the brightness of the daylight outside. He sees, from behind, the view she faces; but her stiff and faltering voicing of fragments from the past has suggested that she is lost in a vision of something else. (Is she lost in fantasy or memory? Is she having Carlotta's memory or seeing or somehow living Carlotta's past?) The shot registers Scottie's and our exclusion from that vision, and the frustration it provokes. She is still and silent. "Madeleine, try," Scottie urges. He comes next to her and looks at her intently as she gazes ahead. "Try for me." As she slowly alights from the carriage, he turns her to face him and kisses her. She seems to have difficulty drawing and then keeping her eyes away from whatever they've been seeing. He is trying to secure her gaze or to force his way into her vision, to be part of her vision or to have that vision himself. He wants to be what she sees, or see what she sees – or be, with her, what Carlotta sees and takes over.

My reading of this scene involves the two identifications I mentioned earlier (Madeleine with Carlotta, Scottie with Madeleine/Carlotta) and suggests a third, that of Scottie with Midge. I spoke of Midge as trying, with her painting and in the whole scene in which it appears, to get Scottie to let her into his private world. In the sanatorium, in a shot

partially mirroring this one of Scottie and Madeleine, she looks at him as he gazes forward, incommunicative, apparently absent: "Johnny, please try. Try, Johnny. You're not lost. Mother's here." Just before leaving, she stands behind him and says, "John-O, you don't even know I'm here, do you?" She bends, kisses his face, and presses her own next to his, as though trying to take up his point of view, to see what he sees. "But I'm here."

On this train of thought, Scottie's goal is not the demystification or humanization of Madeleine, but his own mystification or dehumanization. If Scottie's desires are ambivalent or contradictory, as one's desires often are, they might, of course, also include the desire to humanize her by liberating her from possession or from her fantasy of possession. He might want to liberate her for his sake, insofar as he identifies himself with her. For the other side of Scottie's fantasy of being fully known by an all-powerful mother figure is threatening: the danger is that she will absorb the child (into a kind of nothingness more total than death brings). Carlotta seems, indeed, to be trying to reclaim the child she has lost to the world, trying to pull that child (or a substitute) into joining her in death and in identity. (Conferring with Scottie at the club, Elster says that Madeleine's mother never told her about her mad great-grandmother. The mother knows something fateful about her child but withholds that knowledge (so goes the story) – is she protecting or endangering her child?) According to Modleski, Scottie wants to "cure" Madeleine for his sake, so she can be his mirror reflecting back to him "'his own self sufficiency as a subject'" (2005: 96).[24] This would be of a piece with his pernicious objectification – his "dehumanizing" objectification (as I called such objectification earlier) – of her: "The very effort to cure her, which is an effort to get her to mirror man and his desire, ... destroys woman's otherness" (2005: 96). But does Scottie want Madeleine/Judy to be human, for her sake and for his? That would mean his being human too.

Seeing and being seen

> "Two together are always going somewhere."

Chris Marker (1995) makes a provocative suggestion. It involves the venerable "it was all a dream" interpretive gambit, on which the key to

understanding a work lies in recognizing part of it to be a non-obvious dream or fantasy sequence.[25] This approach to *Vertigo* has been taken before. It has, for example, been argued "that everything after the opening sequence is the dream or fantasy of a dying man" (Maxfield 1990: 3, quoted in Barr 2002: 32). What makes Marker's suggestion provocative is his unexpected carving up of dream and reality: Scottie's encounter with the mysterious, otherworldly Madeleine is reality; it is Scottie's discovery of and relationship with Judy that is dream – the fantasy of the man whom we last see languishing in the sanatorium in a state of total inward retreat. On this suggestion, then, the ethereal and dream-like is reality; the ordinary and pedestrian is dream. In particular, the ghostly Madeleine is real, while the "vulgar" and patently flesh-and-blood person with whom Scottie is involved in a difficult struggle is a creation of his dream. As is that struggle itself – a decidedly earthbound struggle, with none or few of the theatrical and mythical markings of the first part of the film, a struggle full of anger, frustration, demands (petty and extreme, some somehow both), pleading, misery alternating with mad hope, inelegant tears, inarticulacy, desperation, humiliation, and confusion, much of it oddly, probably dispiritingly, familiar to the viewer.

On Marker's proposal, what we witness in the second part of the film is the dream that Scottie constructs in order to support and provide imagined fulfillment of the impossible wish for the recovery of the dead woman. The dream says, "[T]his woman is not dead, I can find her again" (1995: 126).[26] One might wonder why a dream meant to stage the recovery of an unearthly woman lost in an extraordinary reality would not help itself to comparably extraordinary material – the very medium of dream, surely – rather than shift so emphatically (if not totally[27]) to the register of the ordinary. Marker, I think, wants to say that the "ordinary" setting of the dream is motivated by Scottie's desire to prove both that Madeleine is still alive (here in ordinary real life) *and* that she was really alive to begin with. In other words, the "ordinary" setting is meant to offset incipient doubts about the reality of Scottie's whole encounter with Madeleine, doubts that are understandable precisely because of the extraordinary tenor of that very encounter.

But might one take the provocation even further? Does Scottie dream of a demystified Madeleine, a fully human Madeleine, and of a reunion

set in the ordinary world, because this is what he longs for? In that case, the "ordinary" setting would be not merely an instrument in Scottie's battle of belief against skepticism, a shoring up of his memory, but a substantive object of Scottie's deepest desires. There is a thought here, independent of any commitment to a "dream reading" of *Vertigo*, that strikes me as registering something important about the second part of the film (and so the film as a whole). Its elaboration will serve as my closing.

The inclination to orient thinking about *Vertigo* around the idea of Scottie as fundamentally interested in looking and Judy/Madeleine as fundamentally consigned to being looked-at is perhaps all the stronger with respect to the second part, bent as he so manifestly is on seeing her as – making her look like – the Madeleine he remembers. Then much of the second part will look something like this: Scottie is trying to transform the disappointingly earthly Judy into a simulacrum of the otherworldly Madeleine. The recovery of the appearance of Madeleine, or as much of it as is possible (and she seems to hold the promise of more than he could dare hope for) won't be the same as getting her back, but it is the best he can do. The change of clothes leaves him dissatisfied. Judy is still detectable; her lingering presence renders impossible to sustain the fantasy, anyway already tenuous, of Madeleine returned. Only once her makeup, hair color, and, finally, her hairstyle have been restored to Madeleine's is he capable of embracing her.

Just as understanding Scottie's experience in the first part required interpreting him as fleeing the look, so (I now want to argue) does understanding his experience in the second part require interpreting him as reacting – reacting, now, to finding himself looked at more profoundly than ever before. For that is what happens in his struggle with Judy: as violent and as cruel as he is, he not merely suffers (as Marian Keane emphasizes (1986: 236)), but finds himself – and his perverse, pointless, hurtful desire – exposed before Judy. This is a position of vulnerability. Judy, meanwhile, does more than suffer only to eventually capitulate to his demands, effectively sacrificing herself. (It would be grotesque to say that he loves her for that, that what he feels for her then deserves the name of "love.") She also, and crucially, sees Scottie reduced to his most loathsome and humiliating, for she knows, and he knows that she knows, that his most desperate wish is to behold again the

hairstyle, the appearance, of a dead woman, his lost "love," and that he is willing and able to be a brute in order to realize it. Perhaps Scottie thinks she might know what this wish means for him – what underlying desires it bespeaks, what he wants from a woman, from others. Her knowledge, her willingness to bear that knowledge without contempt but *also* without foregoing protest ("No, I won't do it!", "Why are you doing this? What good'll it do?") – acquiescence which is pained, and which she lets him know is pained, and the cost of which she lets him know ("I don't care anymore about me") – must constitute, for Scottie, the most unrelenting experience he has ever had of being the object of someone's look, the object he recognizes himself as being. (Contrast his conversations with Midge, which skirt the question of the nature of his desires, which depend on the maintenance of control over what is revealed, and how rawly, about whom.) It is an experience of what is, in the term I'm adapting from Sartre, Scottie's *own* objectification. (I am emphasizing what Scottie knows Judy knows: there is of course the matter of her knowing more than he knows – as we learn in her letter-writing scene, so that we too know more than he knows. Later he learns that this objectification is even more total, or rather he experiences it as more total, to the extent that Judy knows who or what Madeleine is for him, what the content of his "love" for her was.)

What is important for Scottie about this experience is, I think, that it is not entirely horrifying. That is: it is horrifying insofar as it is revelatory of him and his desires. But it is also an experience of being seen and not turned away from; he is not, his desires are not, responded to as just loathsome, nor are they death-dealing (but are they, in the end?). Their intimacy in the moments following the elided sex scene is, I think, to be understood in terms of this shared knowledge, which makes such intimacy possible. Note, in this connection, that it is frequently said that the transformation is now complete, that Judy is fully (back) in the role or persona of Madeleine.[28] But that's not quite right. What we are presented with is something like the "still image" of Madeleine, but with the movement, the speech, and the mood of Judy.[29] Even her appearance is off, at least with respect to the necklace she soon has Scottie fasten, the same as, or a replica of, the one Carlotta wears in the portrait: for Madeleine would never have worn Carlotta's old-fashioned jewelry (as Elster remarked, and as we can see). Of course, the necklace is

precisely the clue that Scottie picks up, but (interestingly) only once he has gotten a view of it in the mirror. Until then he is not disturbed by it – it is inert, perhaps, until activated in some way the mirror is involved with. He seems newly relaxed and content, bantering and flirting with her and enjoying her expressions of love, satisfied desire, appetite and anticipated pleasure ("I'm gonna have – I'm gonna have one of those big beautiful steaks. Let me see, to start I think I'll . . .")

Once he has seen the necklace in the mirror, driven them both back to the mission, and forced her back up the tower with him, there is a moment in which Scottie, his rage and pain poured out, seems to unfocus his eyes or to suspend their gaze, as if unseeing or seeing something visible only to him – as if a cloud has come into his eyes – and chokes out, "I loved you so, Madeleine." Judy replies, ". . . Oh, Scottie, please. You love *me* now. Keep me safe." She is in his arms now: "Please." Scottie: "Too late. It's too late. There's no bringing her back." Again: "*Please.*" She is pleading with Scottie to break through his enchantment (self-enchantment?) and be present to her. He looks into her eyes, pauses, and then kisses her, as though taking a leap, plunging into something. How to understand this? Does one see the possibility of an undistorted connection between them, of reciprocity, even of genuine love?[30] Is this a delicate instant in which it seems that they might come through? How one reads it will be bound up with how one understands the struggle they have been going through together. Is it a mutual transformation?

In my response to Sartre, I said that the only "solution" (as it were) to being split between subjectivity and objectivity is that we "surrender" the desire for invulnerability or total self-sufficiency, that we accept or live with the tension that split entails. For what is at issue is a species of vulnerability that is essential to being with others, and hence, in particular, to the kind of being with others that is love – genuine love, not the distortion that Sartre calls "love." But this does not mean the overcoming of this desire, as if it could be surrendered once for all. (The idea of such total surrender itself constitutes a fantasy of evasion.) We *are* this split, this tension. Our lives with others constitutes the way in which we live it, the extent to which we accept or live with it.

As we saw, Sartre says that I recognize myself as the object of the look, but he does not imagine (and leaves no room in his view for imagining) that I might want to be seen by another human, seen not only in a

flattering light but as I am. But even if being seen is threatening in ways such as those Sartre has in mind, the prospect of not being seen at all – of being, or being treated as, invisible – is terrible in its own right. What this points up is the stake one has in being seen, in being acknowledged as part of this world.[31] What Sartre casts as the look's condemnation – "behold now I *am* somebody!" (1956: 353) – can be heard as its offer of redemption. The look might be said to bring me into the world. Scottie's distorted wish to be seen only by Carlotta is not accidental, picking up as it does on the creative powers of both a mother and a supernatural being.

Part of the charge of love has to do with its being a space in which the possibilities of seeing and of being seen are heightened. Here may be found the most intoxicating sense of being really seen and of really seeing, and the deepest pain of being unseen, or of finding that one no longer sees or knows the other – seeing as distorted or withheld, by seer or seen. In a passage in which he mentions Tristan and Isolde, just after having referred to the writing of Proust, Sartre says that to love is to want to be loved, and to want my beloved's love for me to flow from her freedom (not from her "enslavement," for example through a love potion, in which case she is an "automaton," but also not as a "free and voluntary engagement" she signs up for (1956: 478–79)). Sartre is talking about the project of "love," which, recall, is a development of a bad faith reaction to the look. But the thought seems true for genuine love too, at least so long as it's understood to say that wanting the beloved's love is a part of love (not what love consists in). To love someone is to want to be loved, hence seen, by her. I want the other to love me, to love me as I am – in the respects that are outside my control, that are given, not just those that express my will and my self-conception – and freely (not as the result of my, or someone else's, manipulation).

We can make no sense of the idea that Scottie loves Judy – that it is to this love that she tries to return him at the top of the tower – unless we see him as growing to love Judy, not as transferring to her his "love" for the Madeleine he thinks he has lost, and growing to love her not, as I said, for her sacrifices, but for (if not just for) her knowledge and love of him, gained and held as they've been going together down this path through a kind of hell. The promise of reciprocal love at the end, if that is what it is, depends upon Scottie's being up for accepting the experience of "objectification" that opens up in the struggle of the "re-creation" of

Madeleine — and, of course, on Judy's being up for it, and up for her accepting her experience of objectification. Given what I said above about such acceptance being an on-going matter, not something done once and for all, this means, I think, that if anything is achieved in their struggle, that achievement is to be found in the struggle itself, the going through it itself, not any goal or outcome it might have. (Ovid paints the following picture of Orpheus's rejoining of Eurydice upon his second descent into Hades, this one the natural consequence of his death: "Here now they stroll together side by side, and sometimes she leads the way, and Orpheus follows her, or sometimes he goes in front" (2001: 183).[32])

Whether Scottie is up for this is something the film does not determine for us — in this sense, it leaves *less* open to view in this second part than in the first. If he is, then rather than getting less than he wanted and thought he once had, Scottie discovers that in Judy he has more than he had, revealing (to him as well as to us) his earlier desires as incomplete. Then the tragedy hinges on the fact that this late realization does not prevent Judy's death. What Scottie has been calling his "vertigo" has been overcome, inasmuch as he has made it up the tower. But this is no victory. What the film calls "vertigo" is not to be overcome.[33]

Notes

1 Depending on the context, I use one of a range of names, including: Judy, Madeleine, "Madeleine," Judy/Madeleine, Madeleine/Judy, Madeleine/Carlotta. We know virtually nothing about the original bearer of the name "Madeleine Elster," never encounter her alive, and allow the film to direct our interest away from her. The film does not leave us an unambiguous or tidy way of naming her as-it-were successor(s). And like many others, I speak of two "parts" of the film. But it's worth noting that the film is also divided into thirds of nearly equal duration by the woman's (that is, Kim Novak's) voice, and specifically by her address to the man (James Stewart) — first as Madeleine emerges from his bedroom and asks what she's doing there, then as Judy asks him what he's doing there at her door, what he wants ("Well, what is it?"). In other respects as well threes are as important to this film as twos.

2 Scottie's wild idea is that if Judy is made to look like Madeleine then somehow, impossibly, she might *be* Madeleine. We know this "impossible" idea to be possible. At the same time we know that it is impossible in a way obscured from Scottie and deeper than the impossibility he has in mind. We know that he cannot get her back, not for the all-too-familiar reason that

we are mortal and there is no return from the dead (when it comes to that, "Madeleine" is *not* dead) but because there is nothing to recover: there is and never was a "Madeleine"; there is and never was, that is, anyone or anything corresponding to what Scottie calls Madeleine. And yet the very reason that we recognize to make Scottie's quest doubly impossible also makes it entirely realizable. "Madeleine" was a mere show. But that is to say that Scottie precisely *succeeds* in bringing her back: for *this* woman, approaching him in the green glow, *is* (all that) Madeleine is. An apparently obvious falsity turns out to be, at a deeper level, truth. This deeper truth is devastating, for it means a deeper falsity — a deeper wish or fantasy is exposed as unanswered and unanswerable. But this deeper falsity makes room, in turn, for a deeper truth.

3 Is it specifically or centrally the *woman's* look that Scottie seeks to avoid? And if so, why? These are pressing questions, but they require more space to pursue than I have here.
4 It is, for Sartre, a truth that holds equally for men and for women. One might argue that the objectification of women in the pernicious sense constitutes a paradigmatic case of its distortion.
5 What Sartre says, strictly, is that it is my freedom that I become aware of through anguish. But since this is not freedom *tout court*, not pure transcendence, but transcendence *of* facticity (and in particular *of my* facticity), my encounter with my transcendence is at the same time my encounter with my facticity. Thus it fits the spirit (if not the letter) of Sartre's view to say that in anguish I encounter my transcendence as well as my facticity; they are interlocking pieces of a whole structure. This, indeed, is why the ensuing variants of bad faith that Sartre explores take the form of seeking to repudiate my transcendence *or* my facticity.
6 Two important points that I can only note here: (1) Sartre thinks that even my freedom is objectified (so that as an object I am different from mere "things"). (2) The experience of the look does not require the actual "convergence of two ocular globes in my direction" (Sartre 1956: 346); it is enough that I imagine myself to be seen. (And perhaps Sartre does not mean to tie my possible apprehension to the mode of vision.)
7 See Sartre (1956: 352) for another allusion to the "fall." Sartre is drawing on Heidegger's notion of "fallenness" (which Heidegger explicitly dissociates from the Christian doctrine).
8 The example is from J. L. Austin (1962). Stanley Cavell's *The Claim of Reason* (Cavell 1999), which engages closely with Austin and with Wittgenstein, thinks about how one might come to feel such "publicity" to be threatening.
9 To start, one might press the claims upon which Sartre is here relying: to look, for Sartre, is to be a subject; to be looked at is to be an object; and one cannot be object and subject at the same time. Thus I can never look (subject) at myself (object). And I cannot look at, know, the other as subject.

10 Sartre calls this the "defense" of "objectivation" (1956: 359). Although it sounds as though it might count for him as a bad faith flight from my objectivity, he doesn't label it "bad faith" outright, and when he later discusses the bad faith of the "original reaction" that is "pride/vanity" he does not mention "objectivation" and indeed gives the impression that "pride/vanity" is the only mode of bad faith to be found in this context. (Part of the difficulty lies in figuring out the relation to "objectivation" of what Sartre calls "arrogance," which he clearly does not regard as bad faith.) However, in the later chapter on "concrete relations with others," he adduces an "original reaction" of "indifference" or "blindness toward others" and calls it bad faith (1956: 495–96). Perhaps this is a development of a bad faith flight from my objectivity? (Sartre describes this chapter as working out two "attitudes" or "attempts," one starting from "blindness" and the other from the project of "love" (the elaboration of which makes it sound like a development of "pride" or "vanity"), which form a circle such that "the failure of the one motivates the adoption of the other" (1956: 474). Then if "love" is itself bad faith, and if the other relation ("blindness"?) is an opposing bad faith flight from my objectivity, a "concrete" manifestation of bad faith with respect to the other would be the oscillation between a flight from my objectivity and "love." I mention all this only to point to a suggestive zone for further thinking about Sartre and *Vertigo*.)

11 Sartre says that transcendence and facticity are "two aspects of human reality [that] are and ought to be capable of a valid coordination" (1956: 98).

> But although this *metastable* concept of "transcendence-facticity" is one of the most basic instruments of bad faith, it is not the only one of its kind. We can equally well use another kind of duplicity derived from human reality which we will express roughly by saying that its being-for-itself implies complementarily a being-for-others.
> (1956: 99–100).

What I'm suggesting is a "valid coordination" of my being-for-itself and my being-for-others. (A question that would need to be pondered is how such "coordination" is related to what Sartre calls "authenticity.")

12 Sartre employs the word in several other contexts, himself extending this – his first – use of the term.

13 Pulling away from Scottie and into the dining room to center the seated Madeleine, as if drawn or summoned, the camera gives us our first sight of Madeleine from a point of view that obviously cannot be Scottie's. In the shots that follow, it is not clear that the point of view is strictly Scottie's. The profile sequence seems to show Madeleine from an indeterminate spot somewhere next to him. If so, this is a sort of idealized position with the double advantage of having a clearer view while leaving Scottie himself at a further remove from her eyes.

14 In one sense, the profiles move in opposite directions: Madeleine moves to her right, Scottie to his left. In another sense, they move in the same direction: for the viewer, both are movements from the right of the screen toward its left (since Madeleine moves toward the camera while Scottie turns away). The two experiences of motion – as opposite and as the same – coexist or overlap (as does the experience of moving forward and back in the famous zoom-in and track-back "vertigo" shot.) The effect is of a kind of disorientation or confusion essential to *Vertigo*.

15 A sequence at the florist's involves a particularly concentrated play between this anxiety and relief. We see Madeleine from Scottie's point of view, walking toward the door behind which he is hiding. With the cut to what would be her point of view, we are shocked to see Madeleine somehow, oddly, right next to Scottie – but something is off. We feel confused as well as vulnerable, exposed, reflecting our sense of Scottie's vulnerability and exposure. In the next moment we realize that what we are seeing is Madeleine's reflection in the mirror affixed to the door; this leaves us unnerved but relieved.

16 It accompanied the appearance of "VistaVision," the giant middle V separating the two parts of "motion picture/high-fidelity" beneath, and superimposed over the mountain, its visual inversion, of the Paramount logo – each of these elements as if punning on the film. Coincidences, of course; but this is a film interested in the sense that nothing is coincidence, the sense of mysterious connections binding the apparently unrelated.

17 There is an element of humor here: "James Stewart" lands above her lip like a mustache, and "Kim Novak" settles on the bridge of her nose like a pair of glasses.

18 This echoes, but inverts the mood of, Cary Grant/C. K. Dexter Haven's repetition of Katharine Hepburn/Tracy Lord's "naturally" in *The Philadelphia Story* (1940). George: "But a man expects his wife to . . ." Tracy: "Behave herself. Naturally." Dexter: "To behave herself naturally."

19 She worked from the picture in her copy of the catalogue, which she stashed, as Scottie entered, under a pillow atop the stepladder from which he fell into her arms. The stepladder was not in view – returned to its place in the kitchen, one imagines – in the intervening scene in her apartment.

20 At the same time Carlotta is a "mother" who is not powerful enough. At one level the vision that Madeleine recounts after she and Scottie leave the redwood forest represents her possession by a ghost who wants her dead ("There's someone within me and she says I must die"). At another level, it records a picture of life that not even this otherworldly mother can change. That is, the vision has a third register in addition to the doubledness I noted at the outset of this essay. For it can be heard as articulating a sense that *any* human being might have, and that our everyday distractions serve to forestall or cover over: a sense of life as leading inevitably and inexorably – and in an essentially solitary way – toward death, the dark unknown, with moments

that get fixed into memories, themselves broken up and displaced, coloring the journey and haunting it. Then the vision is a figure of birth as abandonment to a lonely journey to death, and Carlotta as a mother figure who is not powerful enough is an abandoning mother.

21 This is different from the attempt to disappear into objectness that Sartre calls "masochism," the project that, in his view, the failure of the project of "love" can prompt. As a project of bad faith, "masochism" is driven by the project of being one's own foundation, so being God. But what I am imagining in Scottie is closer to the desire to be an object for, and only for, God. Then my foundation lies outside. I deal with the "problem" of being "unjustified" (not by being my justification, but) by drawing justification from elsewhere, from God. This is dependence not on another human being, but on an ultimate source. It is a kind of ultimate dependence.

22 The rooftop chase scene ends with Scottie hanging from a rain gutter that his weight is rapidly prising loose. The policeman who turns back to help Scottie utters the first words of the film: "Give me your hand!" But Scottie does not (or cannot) give him his hand, and the officer, trying to extend his reach ever closer, finally loses his balance and falls to his death. Scottie's inability to accept a hand extended in support, as well as his horror of the consequences of his inability, are figures of his fear or dread of dependence upon another human being. To accept the policeman's hand, to depend from him, would be to hand himself over, but it would also be to allow the other to bear his full weight. Is his horror of dependence upon another human being a horror of his own humanity, his mortal, embodied self? (This moment emphasizes Scottie's body, his incarnate self, objecthood at its most thingly.) Which does Scottie imagine to be death-dealing: returning his hand or failing to do so? The next scene at Midge's apartment treats of his supporting corset which binds and humiliates, the self-supporting bra (its design by an aircraft engineer "a do-it-yourself type thing") and his self-sufficiency ("You know, don't forget, I'm a man of independent means, as the saying goes – fairly independent"). Then the power of Elster over Scottie is, surely, also a function of a wish to be like this man who is in certain ways another otherworldly, powerful figure (as Madeleine/Carlotta will be presented to be), who associates himself with the San Francisco of the past and who ties "power" and "freedom" to this association.

23 Then it is this wish that his episode of vertigo in the tower, so his failure to reach the top, signifies. (Is there a related sense of guilt toward the policeman? Did Scottie prefer, or does he wonder whether he preferred, the policeman's death to his being a human being upon – from – whom he depends?)

24 The phrase appears in Modleski as a quotation from Shoshana Felman (1975: 9).

25 If I look for the key to unlock *Vertigo*, does that align me with Scottie? On my reading, that would signal the fantasy of entering the film, becoming a part of its world, which is a fantasy the film strikes me as readily awakening.

26 On the question (which Marker does not address) of why Scottie's dream or fantasy would then include the second, total, loss of the woman, see Chapter 3 in this volume.
27 In important ways, of course, the extraordinary remains: it is there in the green mist enveloping Judy as she emerges fully transformed into the appearance of Madeleine, and in the metamorphosis of the "background" of Judy's room into the stable and then back as it rotates around Scottie and Judy in their own rotating embrace. And it is there in the way the "discovery" of Judy follows upon the false starts characteristic of a fairy-tale. But the moment of Judy's appearance is rendered so as to downplay, or offset, its mythic or fairy-tale magic. In the first two false sightings, the music swells promisingly, encouraging us to share Scottie's insane hope. In the third, the music ebbs and flows uneasily. But when Judy wanders into view, there is, at first, no music, just street noise. The moment begins with as little theatricality and fanfare as possible. This is part of its magic.
28 For example: "When Judy/Madeleine reenters after dressing for dinner, it is Madeleine we see moving, Madeleine we hear talking: Judy is quite submerged" (Wood 2002: 128).
29 A kind of pastiche to compare to Midge's portrait. Scottie is aware of this fact; later it is with rage that he describes how Elster's makeover of Judy into Madeleine was more complete than his: "Not only the clothes and the hair, but the looks and the manner and the words." And, of course, "those beautiful phony trances."
30 "They embrace, clearly renewing their love," says Sterritt (1993: 98).
31 I would call this recognition as an object, to distinguish it from the recognition as a subject that Kant and especially Hegel are concerned with. (The question of how these forms of recognition are or can be related deserves attention.)
32 Quoted in Silverman (2009: 52). Silverman continues:

> Death also clarifies Orpheus's vision, giving him a new kind of "hindsight." When he arrives in Hades, he "[sees] again all of the places he had seen before," and when it is his turn to walk ahead, "he can safely look back at his dear Eurydice."

33 I thank Rachel Zuckert, from whose suggestions and encouragement this essay and I have very much benefited.

References

Austin, J. L. (1962) *How to Do Things with Words*, J. O. Urmson and M. Sbisa (eds.), Oxford: Clarendon Press.
Barr, C. (2002) *Vertigo*, London: The British Film Institute.
Cavell, S. (1999) *The Claim of Reason: Wittgenstein, Skepticism, Morality, and Tragedy*, 2nd edition, Oxford: Oxford University Press.

Felman, S. (1975) "Women and Madness: The Critical Phallacy," *Diacritics* 5: 2–10.
Keane, M. (1986) "A Closer Look at Scopophilia: Mulvey, Hitchcock, and *Vertigo*," in M. Deutelbaum and L. Poague (eds.) *A Hitchcock Reader*, Ames, IA: Iowa State University Press, pp. 231–48.
Marker, C. (1995) "A Free Replay (Notes on *Vertigo*)," in J. Boorman and W. Donohue (eds.) *Projections* 4½, London: Faber and Faber, pp. 123–30.
Maxfield, J. F. (1990) "A Dreamer and his Dream: Another Way of Looking at Hitchcock's *Vertigo*," Film Criticism 14: 3–13.
Modleski, T. (2005) *The Women Who Knew Too Much: Hitchcock and Feminist Theory*, 2nd edition, London: Routledge.
Mulvey, L. (1999) "Visual Pleasure and Narrative Cinema," in L. Braudy and M. Cohen (eds.) *Film Theory and Criticism: Introductory Readings*, Oxford: Oxford University Press, pp. 833–44. Originally published in Screen 16: 6–18.
Ovid (2001) *The Metamorphoses*, trans. Michael Simpson, Amherst, MA: University of Massachusetts Press.
Sartre, J.-P. (1943) *L'être et le néant: Essai d'ontologie phénoménologique*, Paris: Gallimard.
—— (1956) *Being and Nothingness: A Phenomenological Essay on Ontology*, trans. H. E. Barnes, New York, NY: Simon and Schuster. (Cited page numbers refer to the 1992 Washington Square Press edition.)
Silverman, K. (2009) *Flesh of My Flesh*, Stanford, CA: Stanford University Press.
Sterritt, D. (1993) "*Vertigo*," in *The Films of Alfred Hitchcock*, Cambridge: Cambridge University Press, pp. 82–99.
Truffaut, F. (1967) *Hitchcock*, New York, NY: Simon and Schuster.
Wood, R. (1982) "Fear of Spying," *American Film* 9: 28–35.
—— (2002) "*Vertigo*," in *Hitchcock's Films Revisited*, New York, NY: Columbia University Press.

Further reading

Beauvoir, S. de (2011) *The Second Sex*, trans. C. Borde and S. Malovany-Chevallier, New York, NY: Random House. (Originally published in 1949, this landmark work is in dialogue with Sartre (1943, 1956). It explores both the (dehumanizing) objectification of women and objectification as a dimension of being with others, as well as the relation between them.)
Cavell, S. (2003) "The Avoidance of Love: A Reading of *King Lear*," in *Disowning Knowledge in Seven Plays of Shakespeare*, updated edition, Cambridge: Cambridge University Press, pp. 39–123. (A reading of *King Lear* that links the "avoidance of love" with the avoidance of being seen and with shame.)
Lacan, J. (2006) "The Mirror Stage as Formative of the I Function as Revealed in Psychoanalytic Experience," *Écrits*, trans. B. Fink, New York, NY: W. W. Norton & Company, pp. 75–81. (Delivered as a lecture in 1949 and published in the original (French) *Écrits* in 1966. An important source for Mulvey, although neither it nor Lacan is mentioned in Mulvey (1999). Lacan here

draws upon Freud, but he also makes a certain contact with Sartre's (1943, 1956) ideas: he invokes Sartre and his text without exactly mentioning either by name, and follows the bare suggestion that Sartre's text contains a pertinent insight with door-closing criticism. Aided, no doubt, by the impact of Mulvey's essay and the abundance of work it has spurred, Lacan has eclipsed Sartre as a source for contemporary thinking about the look and its connection with film.)

MacKinnon, C. (1987) *Feminism Unmodified*, Cambridge, MA: Harvard University Press. (A central work on the objectification of women.)

Chapter 8

Eli Friedlander
BEING-IN-(TECHNI)COLOR

*V*ERTIGO'S HYPNOTIC POWER is not least a function of its colors. Their splendor, a credit to that film's technical achievement, is at the same time a matter internal to its argument. The place of colors in *Vertigo* has not gone unnoticed, but interpretations of what their presence comes to, in terms of the logic of the movie, often sound disappointing. Color is either accounted for in terms that are too painterly (as though adding to the beauty of a scene's formal composition), or understood through a scheme that is too rigidly symbolic.

My interpretation of the character of colors in *Vertigo* is guided by, and makes contact repeatedly with, Stanley Cavell's chapter "The World as a Whole: Color" in his book *The World Viewed* (1971). In particular I wish to follow up the consequences of its opening claim: "A . . . major property of film which can serve to declare its recording of a total world is color" (80). Hitchcock's *Vertigo* is for Cavell "the great example of this combination of fantasy and color symbolism . . . The film establishes the moment of moving from one color space into another as one of moving from one world to another" (84). Specifically, Cavell recalls the scene in which Scottie, following Madeleine, enters through a dark alley and, as he opens the back door into the shimmering Podesta Baldocchi florist shop, is flooded by color.

Color, on Cavell's understanding, can have the function of revealing the unity of experience as that of a world. This pairing of worldhood

and film is evident already from the title of Cavell's book, *The World Viewed*. It thus takes film to be a world-disclosing medium. Cavell's work on the ontology of film inherits Heidegger's turn to fundamental ontology, albeit in relation to a form of art Heidegger might not feel completely at home with. For Heidegger the fundamental dimensions of experience are not to be accounted for in terms of a relating of subject and object, but in terms of the internal relatedness of man and world. *Dasein* is "being-in-the-world." The revelation of affinity with the world as such cannot be a matter of anything directly given to intentional consciousness (for that would blur the very distinction between world and objects or facts). Thus Heidegger famously argues that the world is originally disclosed affectively, in moods. Moods are distinguished from feelings or other emotional states in part by being affective manifestations of one's surroundings and one's being in them. Moods manifest our attunement or falling out of attunement with the world.

A mood of color, then, is not just a matter of the emotional ambiance that might be associated with certain colors (the soothing influence of light blue, say). Such rendering of the force of color in terms of its psychological effects would be like taking Mozart's music to be good for melancholia. Rather, color must be capable of bringing out the texture of experience as an interrelated totality. That is, there must be ways to experience color not simply as a surface property of discrete objects but as disclosing a mode of unity of reality. But even more importantly, being in color must reveal some of the fundamental dimensions of being in the world. And how would color partake in a projection of the fallen revealed as thrown?

Vertigo's prologue on the rooftops of San Francisco establishes guilt as the film's premise. Guilt preceding everything, associated as it is with falling, tempts, even dares, us to think of the film as addressing the issue of the Fall, of guilt associated with original sin, or with the exposure of the creaturely condition.[1] The underlying guilt is manifested as a fear of heights (acrophobia), and symptomatically as vertigo. But such experience of space becomes a schema for what Chris Marker has called a vertigo of time (1995: 123). One might also think of it as a vertigo of meaning. It is, namely, a form of essential ambiguity that derives from a condensation and identification of disparate times. In *Vertigo* identity is duplicity: Madeleine is Carlotta, Judy is Madeleine, but also both are, for Scottie, a "second chance," the occasion to redeem himself, to free himself from

the burden of guilt.² But to say this is only to scratch the surface of the vertiginous doubling of meaning. As Chris Marker aptly puts it: "*Double entendre? All* the gestures, looks, phrases in *Vertigo* have a double meaning" (1995: 125, emphasis added).³ The vertigo experienced in viewing the film is not so much the result of its famous "dolly effect," but rather has to do with the spiraling duplicity that makes meaning essentially ambivalent, or tragically ironic. Ambiguity is the essence of fate. It is the other side of a certain inflexibility of meaning, that is, an inescapable precision of meaning manifest in repetition. In that respect *Vertigo* opens up, in a stark, elemental, or skeletal way, something essential to the condition of being in the world, or being in meaning.

To suggest an initial connection between these themes and matters of color, consider that whereas vertigo is a matter of the intense awareness of heights or depths, color is ordinarily thought of as an experience of what lies on the surface. Colors are, moreover, often related to innocence or candor. Color is a schema for openness, so to speak. Color cannot dissimulate itself, or with color one can hardly draw a distinction between appearance and essence. Colors, one feels, just are what they seem to be. This is why certain epistemological projects intent on grounding knowledge in certainty turned to colors as paradigms of indubitable experiences. Without wanting to adopt such philosophical pictures of what skepticism or knowledge come to, we can nevertheless ask whether the register of color can play a role, or at least be a stage property, in the drama of fate. And how is film specifically suited to discover this function of color?

"Always green, ever living"

Color is at issue from the first time Scottie's gaze (and ours) comes to rest on Madeleine. He is seated at the bar of Ernie's, a chic restaurant with walls upholstered in deep red velvet. The camera pans around the dining hall, gliding over its well attired customers to come to a halt, lingering, as though spellbound, irresistibly drawn to the table at which Gavin Elster and Madeleine are seated. She is dressed in a black and green cape, the folds of which both echo the lush red of the walls and form the starkest color contrast with it. Madeleine appears straight out of a painting (one might think here of Ingres's all too ideal, stony yet at the same time pliant women in their velvety interiors). The immediate fascination that (since we experience, we are led to believe) Scottie

experiences, is thereby also immediately made ambiguous. For the color contrast of red and green is too stark, too painterly, that is, designed, hinting at the underlying presence of Gavin Elster's machinations. It is as though being taken in by the immediacy of the striking color contrast opens up the duplicity that will rule the unfolding of the film. (Elster is indeed confident that the very appearance of Madeleine will overcome Scottie's reluctance to take on the assignment, as no appeal of his would: "Look, we're going to an opening at the opera tonight. We're dining at Ernie's first. You can see her there." That Scottie is dumbstruck by this vision is only too apparent from the fact that the next brief dialogue does not occur until about ten (!) minutes later into the film).[4]

The contrasting reds and greens will be repeated throughout the film: as for instance with the colors of clothes worn by Madeleine and Scottie, as with the colors of her green car parked outside his red door. It is almost too tempting to take that scheme of colors in a strictly symbolic sense, that is, to take colors as signs indicating psychological characteristics (as in "red is associated with the erotic and desire, green with anxiety and envy"). Too tempting, since these associations are at the same time undermined by ironic echoes in the use of this color scheme: take, for instance, the fact that red and green are colors of traffic signals standing for stop and go. (Such a signal switch will figure in a scene of the film as Scottie crosses Union Square at dusk after an encounter with Madeleine.) In a film where driving often feels like being driven, where wandering is all too orchestrated, reference to traffic conventions must be taken with a grain of salt. Think of the other traffic signs, such as the "one-way" sign, which was always there, in front of Madeleine's apartment building, but the obtruding presence of which, as the second half of the movie opens, is a crudely comic representation, almost a cruel joke on the impossibility of any change of direction whatsoever. Punning is also part of the play of colors in a more natural environment: sequoias, which are also known as redwoods, are in their Latin name *Sequoia sempervirens*, that is, evergreens, "always green, ever living," as Scottie says.[5]

In other words, even though color is an essential content of *Vertigo* I doubt that specific colors constitute a clear signifying system that can be read consistently throughout. If anything, what seems important is that we start seeing those colors repeated, as though their presence threatens the very unobtrusive continuity of visual experience. That repetition of the pair of colors must be read, further, while bearing in

mind that red and green are complementary colors. If we stare at a red (green) object long enough and then turn our gaze to a light surface we will see a green (red) after-image. The paired appearance of red and green would then form repetition, as though following the logic of after-images. Their recurrence would signify the reversal and ambiguity that the afterlife introduces into the attempted ordering of the present.[6]

As Scottie begins to follow Madeleine, the wonder of the first striking appearance of color is replaced by a fascination with what I would like to call her discolored appearance. Madeleine is now dressed in a light gray suit, the like of which she will wear on the occasion of the supposed and (therefore) the real fall from the mission tower.[7] It is understandable that Gavin Elster would choose such gray to give Madeleine an appearance of aloofness, of distance, even something of a ghostly appearance. And it is understandable that Judy would insist on wearing her plain colored dresses (green, purple) as she tries to resist Scottie's attempt to transform her back into Madeleine. But to complicate the picture, consider one of the only exceptions to Madeleine's gray, black and white wardrobe, as Scottie takes it upon himself to provide the unconscious Madeleine with his own red bathrobe (to dress her, so to speak, after he has undressed her following her plunge into San Francisco Bay). This gesture is highly ambiguous, for it foreshadows his later attempt to transform Judy. Bringing Madeleine back to life and providing her with clothing would describe both what happens following the plunge into San Francisco Bay and what is perversely attempted in the second half of the movie. Therefore we might conjecture that colors partake in that ambiguity. That is, the gesture of animation by providing the red bathrobe would not be opposed to, but rather one with, the change of clothes that takes place in the second half of the movie as Scottie replaces back the colored with gray. It is because the "coloring" itself is an *attempt* to bring back to life that it will be not so much reversed as followed up. Re-enlivening will henceforth be a matter of design, intention, or obsession, from which the most drastic discoloration will ensue.

Indeed, discoloration should not be confused with the absence of colors. In the dark one does not see colors, but one can see discoloration. More importantly, we can think of discoloration not only in the absence of any color but also as an effect of color. Discoloration by means of uniform color is characteristic of the dream sequence, to which I will return. But it is even more striking in the scene at the Empire Hotel as

Scottie puts the final touch on Judy's transformation into Madeleine. This time the effect is achieved by the presence of a uniform green light (the fluorescent light of the Empire Hotel street sign). The green haze (halo) surrounding Judy as she emerges into the room, following the final transformation of her appearance, makes her all the more ghostly, transparent, as though the projection of an image. The fact that Judy acquires, in her final metamorphosis, the quality of an image on screen raises, I take it, the question of the relation of these issues of design to the fact of film itself. Throughout the film lines abound suggesting the identification of Judy's transformation into Madeleine (the first and the second) with the coaching of an actor made into the figure projected on screen. That is, the question is not only how Scottie sees Madeleine in Judy, or Carlotta in Madeleine, but what it is for us to see Kim Novak in Judy/Madeleine/Carlotta. And similarly, it is not only the effect of red and green on Scottie that is thematized, but also what color is for us, in the experience of film, as it is designed to be seen.

Color: Schemes and designs

We are made to pause over the appearance of Madeleine at Ernie's. The directorial hand of Elster is involved in having Madeleine strike a pose on her way out, standing in profile, right next to Scottie. Similarly, Hitchcock's choice of the striking color contrast of red and green has an effect that would be in line with the following statement of his from 1937, before he started to film in color:

> I should never want to fill the screen with color: it ought to be used economically – to put new words into the screen's visual language when there's a need for them. You could start to color film with a boardroom scene: somber panelling and furniture, the directors all in dark clothes and white collars. Then the chairman's wife comes in wearing a red hat. She takes the attention of the audience at once, just because of that one note of color.
>
> (quoted in Allen 2007: 221)

But how does Hitchcock further his designs with color?

The issue of design is developed in *Vertigo* by way of a contrast set between film and painting. Looking at paintings is central to that film.

In Elster's office at the shipyards, Scottie looks at an old print which he takes to illustrate Elster's Romantic imagination of the past of San Francisco: "I'd like to have lived here then. The color and excitement . . . the power . . . the freedom." As he evokes this nostalgic wish – the ironic echo of his design to recreate the past as a haunting presence – Elster is seated in front of a large windowpane with a view of the machinery, the cranes and pulleys, of the docks. Viewed in terms of the argument of the movie, we have here a glimpse of the machination of Elster's mind. But this can just as much serve to form a contrast between the old, painterly depiction and the modern, cinematic presentation of reality. The windowpane is easily recognizable as a figure for a screen, making the machinery into that technology of a film set necessary to produce the image on the screen. The scene thus raises the question whether the experience of movies is, in fact, ultimately a matter of design. Or, more precisely, whether design must be understood on the model of the control exerted by Elster's diabolical mind. Stressing that identification of the director's power, one tends to forget that no underlying scheme supports the second part of the film. There is some truth to what Elster tells Scottie: "I'm not making it up. I wouldn't know how." Design goes only so far, and Scottie moves all on his own, unawares, taken up by repetition itself. Scottie's exclamation "I made it" as he reaches the top of the stairs, suggestive as it is of "I made you," that is, Judy, in the image of Madeleine, is not the expression of power and the success of design but the surest sign of its miserable failure.[8]

 A further contrast between the art of painting and that of film is developed in the museum scene as Scottie is absorbed in Madeleine's absorbed (though very theatrical) contemplation of Carlotta's portrait. The focus on the painting serves to establish a contrast between the cinematic image and what it is of: by means of close-ups, the camera brings out details of the painting and juxtaposes them with details of Madeleine's appearance. The camera's power is here thematized, or allegorized, as allowing one to be struck by details or similarities. It records not only what the eye guides it to concentrate on, but also allows the emergence of similarities of details in memory. The identification of the eye with the camera makes the memory of movies something that can be striking. This is evident in the fact that the camera on that occasion does *not* focus on the detail that will only emerge for Scottie later on, the necklace. That piece of Madeleine's jewelry inherited from

her mad great-grandmother, which Judy has kept, would unintentionally betray the plot and at the same time enfold most ferociously the logic of the film.

Finally, Midge draws, not "creatively," but "instrumentally" for fashion design. In particular, she designs underwear (most notably bras). Her instrumental use of painting allows Midge to insert herself into the picture, painting herself as Carlotta, in a consciously ironic gesture as well as an unconscious sense of the truth of the matter. (Irony or undertone is present throughout the scene with its repetition of the word "under": slipping notes under a man's door, noticing an undercurrent, designing underwear.) To Scottie's remark that she is wasting her time in the underwear department, which implies that she should be painting instead, Midge responds, "It's a living." He echoes that last phrase by asking, as he turns to look at the painting, whether it is a "still life." Midge's down-to-earth reminder of the simple or true necessities of life wishes to deflate the mystery of existence taking over Scottie's mind: whether Carlotta is still alive in Madeleine. The sobering effect is part of a plan to go with Scottie to a movie after offering him a drink and dinner. But the painting turns out to be incompatible with the movies: "Let's make that movie some other night," he utters in self-pity as he leaves. Midge, furious at herself, grabs a paintbrush, defaces her portrait, and pulls her hair back in anger (in an impulsive gesture that itself does not escape the traps of irony, since it is duplicated by Scottie in the final transformation of Judy, as though what was wrong with the picture was the hairdo). She turns to throw the paintbrush out the window, but it rebounds on the pane of glass, leaving a stain next to her own reflection. Taking the reflection to have something to do with the mode in which images are captured on film, this can be read as yet another way of having the movies resist painting, or resist the modes of design of painting. In particular, what is emphasized is the difference between the function of the painting implement and the role of the instrument in the experience of film.

One might sum up these instances by saying that in film the problematization of design has to do with the nature of the instrument itself, with the way the apparatus of film is itself involved in the projection of reality. It is in the automatisms of film that the non-intentional can be disclosed by that medium.[9] The inflection of the question for us would concern finding in film a discovery of the dimension of color that

reflects that transformation brought about by the medium. We can approach the matter by aligning *Vertigo*'s concern with color with the problem of the emergence of color film from the past of movies in black and white. That is, insofar as gray would relate Madeleine to her haunting ancestry, one might take the question of color and discoloration in terms of the relation of the medium of film to its black and white past. What did color do to film? To what extent were the expressive powers of film developed in relation to its origins in black and white and only extended in range by color? Given that *Vertigo* comes ten years after Hitchcock's first Technicolor film, *Rope* (1948), can it still be seen as a struggle of the director to reveal the power of color in film?

In his book *Hitchcock's Romantic Irony*, Richard Allen argues that "Hitchcock's use of color must be understood as an extension and transposition of his black-and-white expressionist aesthetic into the domain of color, in a manner consistent with his prior embrace of sound as an expressionist idiom" (2007: 218). In a 1972 interview with Charles Thomas Samuels, from which Allen quotes, we find support for this view, as Hitchcock aligns the issue of the transition from silence to sound with that of the introduction of color into film:

> Color should start with the nearest equivalent to black and white. This sounds like a most peculiar statement, but color should be no different from the voice which starts muted and finally arrives at a scream. In other words, the muted color is black and white, and the screams are every psychedelic color you can think of, starting, of course, with red.
>
> (Allen 2007: 221)

How is the transition of film from black and white to color compared with its other major transformation, namely from silent film to talkies? Consider that muteness is a pressure on the characters in silent film. It brings out, in some films, the saturation of these films with gestures of excessive vocality.[10] The same cannot be said of the lack of color. For no matter how one gesticulates, color cannot be imitated. There is no way to mimetically identify with color. We do not experience a lack of color in black and white films. That is, the origin of film in black and white does not give us an experience of discoloration. If anything, it is the introduction of colors into film that makes for unease in their

presence. Initially, colors related to the medium of film not in their function in painting so much as like the watercoloring of illustrations in old children's books. In early films colors were introduced as tinting or coloring, superimposed over the image.[11] As a result colors were experienced as transparent (as well as artificial). In later Technicolor or Eastman-Color techniques, one cannot quite speak of transparency in the same way (since one does not perceive black and white behind the colors). And yet, one feels that the colors *exceed* the image. They feel too good to be true, as it were. The artificial look of color remains even with the new techniques: Hitchcock has been criticized for the "postcard" looks of the Riviera in his *To Catch a Thief* (1955), made three years before *Vertigo*.

Without wanting to dwell here in any detail on the complex issue of the nature of expressionism, bringing together the expressionist aesthetic and color in *Vertigo* loses something essential to that film's power. We tend to conceive of expression as the externalization of an emotional state of mind whose extreme, uncontrollable paradigm is the scream. Yet one of the exhilarating experiences of film is the release from the need to think in terms of the projective capacity for self-expression of the subject. Film avoids a certain picture of what character comes to (of where and how one recognizes the manifestations of human spirit in experience).[12] Just as conversation, so central to the emergence of the Hollywood "talkies," does not stand midway between muteness and screaming, but rather displaces the relevance of that scale for the experience of movies, so, I would argue, is film's aesthetics transformed (or brought into its own) in the light of color. Some cases of color use in Hitchcock intrude on the continuity of experience, like screams. I think in particular of the function of red in *Marnie* (1964). But colors can do many other things in his films. In particular, they can relate characters to their surroundings: the note of color in the green dress of Miss Lonelyhearts in her lighted window brings out her solitude, her enclosure in her world, her monadic existence (*Rear Window* (1954)). The spots of red of the red caps in *North by Northwest* (1959) suggest a species of birds, relating the swarming human scene to the animal or creaturely world. If we construe the function of colors as indicating the intrusion of hidden drives upon everyday reality (as leitmotifs, so to speak), we are liable to miss a fundamental possibility of the economy of fantasy and reality opened up by film.

Color and fantasy

> Vertigo is just a movie, but no other movie I know so purely conveys the sealing of a mind within a scorching fantasy.
>
> (Cavell 1971: 86)

With color film has found one of its (by no means negligible) modes of animating the world. There is in film a magic of the photographic reproduction of reality, a magic of the moving image, but also a magic of color. An indirect indication of the enlivening power of color can be gleaned from the black and white homage to *Vertigo* in Chris Marker's *La Jetée* (1963). In that film, for Marker, animation is essentially movement (i.e., is understood in relation to the medium of film through the figure of stills that produce movement). In order to bring about the ephemeral intensity of the blink of an eye, Marker foregoes any other enlivening powers of the medium, in particular color.

Is the animation film brings to the world through color the semblance of life? And what fantasy is satisfied by this semblance? How do colors partake in the space of fantasy opened by film projection? In order to assess such question we might start by considering the dream sequence of *Vertigo*. Dream sequences have been for Hitchcock an occasion to pay homage to artists, most famously Dalí, who designed the dream sequence of *Spellbound* (1945). (John Ferren designed the dream sequence in *Vertigo*.) But at the same time this enclosing of the painterly within the narrative bounds of the dream sequence opens a distance between it and the new possibilities of the medium of film.

The marked presence of color in the dream sequence is primarily the result of the imposition of a Color Throb or "rhythmed beat of colored light which swells from and recedes to darkness" (Auiler 1998: 148). Its overall effect is to produce a condensed experience of discoloration. If color space is related to the presence of flowers at Baldocchi's, then the dream shows the disintegration of the bouquet into hovering shapes turning to gray. Similarly, color is broken into the separate components of the spectrum, each time coloring the whole image uniformly, thus giving it its spectral effect.[13] The discoloring effect of the uniform colors has the dream end in the black silhouette of Scottie's body on a white background, as though sprawled at the foot of the tower.

The dream sequence is almost cartoonish (especially as we see Scottie's head free-falling against a background of animated stripes). The film

itself, one wishes to say, or at least its second part, is more intensely dream-like than anything in that sequence. Chris Marker adopts Cabrera Infante's characterization of *Vertigo* as "the first great surrealist film" (1995: 125). Marker further argues in favor of a "dream reading of the second part of *Vertigo*" (1995: 126). It is important that such a dream reading be compatible with taking the second part of *Vertigo* to be a narrative unfolding of the reality continuous with the first half of the film. That is, in contrast to earlier surrealist film, in *Vertigo* dream is present in experience without making experience itself look extra-ordinary. As Cavell points out, "It is a poor idea of fantasy which takes it to be a world apart from reality, a world clearly showing its unreality. Fantasy is precisely what reality can be confused with" (1971: 85). Certainly *Vertigo* raises questions concerning trauma, repetition and defensive reactions. Yet one can form certain fetishized pictures of what a surrealist aesthetics presenting them must look like. In particular, certain deformations, or instances of the formless, are taken to be characteristic, symptomatic manifestations of the unconscious in the perceivable. This is a question to be raised specifically in relation to the role of colors in *Vertigo*. For color is not something unknown in the world. And it need not "indicate" another world beyond appearances to effectively transform the everyday.[14] How are we to conceive of the transformation of the everyday by the everyday fact of color?

One would have to distinguish here two senses of dream or fantasy: first, in terms of something that looks out of this world. (And film has proved on ample occasions its attraction to the fantastic as the otherworldly). Color too can be thought of as partaking in representations of fantasy in this first sense. But it would often involve color substitutions or making color follow strange, out of the ordinary, shapes. (The psychedelic effect in lines in the dream or credit sequences of *Vertigo* needs such strange shapes). But there is a second sense of fantasy in which color as it is, in the world, can be the occasion to experience the transformability of this world itself, its pliancy or playfulness. To take color to be one of the clearest manifestations of fantasy in that latter sense would allow one to conceive of fantasy not by way of bizarre, grotesque, or ironic deformation.

In other words, one would not be able to appeal with color to the freedom of the imagination in constructing new and unheard of beings. One would speak here of a mode of the imaginative closer to

contemplation. It would involve the sense of things losing their rigid limits, color being the manifestation of the possibility of change. Think of how colors can provide us with the occasion of experiencing a continuity of change that does not involve loss or destruction. Color combinations just form another color, and the countless continuous transitions it affords, its nuances, even when minimal, can be immediately and utterly clear. This is why color *can* be experienced as a fluid medium of delicate change occurring of itself. It is not so much the mixing of saturated colors but rather the contemplation of transparent colors that often provides the occasion to experience differences of intensity, shimmering light, subtle and shifting nuances and continuous merging. "In their illumination and their obscurity," Goethe writes, "the transparent colors are without limits, just as fire and water can be regarded as their zenith and nadir ..." (quoted in Benjamin 1996b: 443). In other words, colors can provide the sense that there is room for change in our experience of the world, that boundaries and limits are fluid or soluble. It is a realm in which individuation and change occur painlessly, presenting the world as a place in which everything is soluble. It is thus a paradisiacal vision that opposes the inflexibility of fate, the image of a world in which there is no tragedy. Walter Benjamin identifies this mode of experience in the absorption of children with colors, in the child's view of color. Watercolors, soap bubbles, pieces of jewelry, decals and the magic lantern all provide the child with an opportunity for "pure imaginative contemplation" (note the expression), "Their magic lies ... in the colored glow, the colored brilliance, the ray of colored light" (1996b: 443). Among such phenomena he singles out the rainbow as a "pure childlike image." It is an image of boundaries solely defined by color: "In it color is wholly contour" (1996a: 50). In the rainbow, color is not limited by the form of the object, but solely by another color with which it can easily be imagined to be merging.

Color, like space itself, can provide a unity to experience. The unity that makes experience whole in color is not the expression of lawfulness in experience. Color involves the highest receptivity to experience, but its order does not parallel or merely reflect the *facts* of experience. It inheres in experience but at the same time can be dissociated from causal, temporal, spatial, or conceptual determinants. The self-sufficiency of color allows discrimination in an order whose internal relatedness is both endless and immediate.[15] It is by this sense of unity that the world is

deformed. Such deformation of fantasy would not be an external change, such as substances undergo, but would occur in the intensification of the inner relatedness of experience by way of color.

The unity the world acquires in color is thus very different from the anxious, sublime, or ecstatic emotional states in which we imagine ourselves to experience the world as a totality.[16] With color, totality involves no temptation to transcendence. The mood of color is created, Benjamin writes, "without thereby sacrificing the world" (1996a: 51). There is pleasure in color, involvement with experience, but its appearance is not seductive, as it promises nothing beyond itself. Color can intoxicate in a most ordinary and prosaic manner without occasioning any display of emotion, hinting thereby at its spiritual nature.

I would like then to think of the transparency, fluidity, and wholeness that color brings to experience as a possibility brought out by film. Colors in film acquire something that is typical of the experience of light, namely fluidity. The attraction to light and the fluidity of color is something film no doubt shares with, say, impressionism, but there are characteristics of film that make this involvement its own.[17] To return to the scene at Baldocchi's florist shop, color is there essentially a play of color, a fluid and all-encompassing play of impressions. The change from darkness into color is surprising and therefore color is all the more experienced as given. It evokes wonder, or constitutes, so to speak, a moment of grace in the visual field. One might argue that this is one more attempt designed at captivating Scottie. (One could after all imagine Elster coaching Judy to enter the florist shop from the dark alley, etc.) But here, I take it, it is crucial to insist on the moment as standing for a constant possibility of film experience, of the experience of color in film, as, indeed, produced by something inherent to film technology as such. Color does not function in such moments as a property of what is represented. The peculiar power it has is released in the cinematic image.[18] Film can detach color from its objects and make of it the basis of the experience in which the world as a whole comes to life. This detachment is not to be formulated in spatial terms, as a distance between representation and the reality it depicts, for this would make color present us with a veil of appearance that separates us from reality. Rather, this enlivening capacity of color is experienced in relation to the temporal detachment constitutive of the cinematic image. The power of color to make the world whole would feed off the sense of the

photographic image as being of a world passed. The epiphany in the vision of the wholeness of color can be seen as part of *Vertigo*'s reflection on the enlivening of the past in the present. The condition of the cinematic image, its being an image of light of the past, finds powerful resonance in the enlivening provided by color. The scene at Fort Point in which Madeleine distractedly throws flowers into the water, as colors already acquire the tint of dusk, most strikingly makes the wholeness of their presence as much a matter of their transience, ephemerality or imminent loss. (The identification of Madeleine with Ophelia is the staged theatrical evocation of this melancholy mood.)

The sense of wholeness in the ephemerality of color (or the ephemerality of the sense of the whole) can degenerate if one thinks of actively holding onto it, or producing it. The fascination with the fluidity of color is what can degenerate into the destructive fantasy of the pliancy of appearances to one's will, that is, of the power to fashion appearances to fit one's fantasy.[19] It is what eventuates in the aggressive draining of life from the object that is typical of melancholy. It leads to holding onto unreality, onto Judy as a figure of light, utterly fascinating yet lacking all material consistency. Color is dimly sensed as providing the unifying mood of the world, its mode of being alive. Yet introducing color intentionally, designedly, epitomizes the violence in the desperate attempt to reproduce that relation to the world, to keep one's hold on the passing.

The final moment of the film, just like the end of the dream sequence, reduces to a stark contrast of black and white. Judy's recoil from Scottie's embrace and her fall to her death are triggered by the appearance at the top of the tower of a nun dressed, as some nuns are, in black and white. The phrase the nun utters – "I heard voices" – is taken, colloquially, to be the expression of madness specifically of someone who believes herself to be addressed by higher powers. One might also say that the shift from the perceptual register of vision to that of hearing marks the final disappearance of color. The pattern of repetition that rules the film would make this a moment of recognition, that is, a moment in which Judy catches a glimpse of herself, coming up the stairs, in the image of the emerging nun. The fright that provokes the fall is not only the result of the surprising appearance of a shadowy figure, but of the nun's being for Judy a figure of herself, drained of all life, of all color, by Scottie's obsession. She is as unknown to Scottie as the real Madeleine was.

Notes

1 Martin Scorsese provides something of an X-ray of the film's core in terms of the creaturely condition as he relates the final moment of the film: "Morality, decency, kindness, intelligence, wisdom – all the qualities that we think heroes are supposed to possess – desert Jimmy Stewart's character little by little, until he is left alone on that church tower with the bells tolling behind him and nothing to show but his humanity" (Foreword to Auiler 1998). I note that this is not the only film of Hitchcock's where the question of original sin and Eden is thematized. In *North by Northwest* Eve (Eva Marie Saint) will be the one to eat first as well as the reason for the bruise in the man's ribcage. The exposure and barren existence of the human creature on the face of the earth is, arguably, another central theme of this film.

2 Both Preston Sturges's *The Lady Eve* (1941) and *Vertigo* are allegories of the Fall. In both cases there is an issue of repeating the same behavior toward what turns out to be the same person. In one case the repetition can be redeemed in comedy, in the other it is fatal.

3 The ambiguity is so pervasive that even when writing about the film it is difficult to decide what the characters are called. Not only does Scottie, as he drags Judy up the tower, switch to calling her Madeleine. We are at a loss as to how we should refer to her. Should we speak, in the first part of the film of the relationship between Scottie and Madeleine, or between Scottie and Judy, or between Scottie and Madeleine/Judy turned into Judy/Madeleine in the second half? And what kind of anxiety is hidden by the attempt to be precise in distinguishing these names? I have chosen to retain the ambiguity in the reference to the characters throughout the paper, instead of resorting to such expedients as inverted commas, double names, or parentheses.

4 Is it only Madeleine's face to which Scottie is irresistibly drawn? And what is the relation between the openness of a face and the candid in color? The fatefulness of the glimpse of a woman's face, its irresistible attraction beyond the bounds of time, and its connection to the revelation of one's own death, are themes of Chris Marker's moving homage to *Vertigo*, *La Jetée* (1963). I will suggest later on why the absence of color in that film is significant. (See Friedlander (2001).)

5 Hitchcock often lays traps for us to fall into all too easily. The self-assured, ironic mastery is evident in his use of the psychoanalytic register, particularly as its complexities are liable to collapse into a dirty joke. The fact that Scottie's apartment has San Francisco's Coit Tower in the background is an occasion for such a joke in the movie. Hitchcock himself refers to it as a phallic symbol. Coit Tower is named after Lillie *Hitchcock* Coit, adding to the reflexive irony of the moment.

6 The idea of color as after-image is developed in the dream sequence in *Vertigo*. It is precisely in the dream that images appear tinted in such colors, that is,

in a condition in which the eyes are closed. I note that such after-effects of vision are also a theme of *Rear Window* (1954), in relation to the blinding exposure to a flash of light.

7 On the occasion of the trip to the redwood forest, Madeleine wears a white coat and black dress, and when she comes over to Scottie's apartment at night to tell him about the recurrence of the dream, she wears a gray coat and that black dress. (Matters of fashion are made to matter or to fashion the film by way of the character of Midge). The following anecdote, told by the costumer Edith Head, makes clear how important the color of the dress was to Hitchcock:

> I remember her [Kim Novak] saying that she would wear any color except gray, and she must have thought that would give me full rein. Either she hadn't read the script or she wanted me to think she hadn't. I explained to her that Hitch paints a picture in his films, that color is as important to him as it is to any artist . . . As soon as she left I was on the phone to Hitch, asking if that damn suit had to be gray and he explained to me that the simple gray suit and plain hairstyle were very important and represented the character's view of herself in the first half of the film. The character would go through a psychological change in the second half of the film and would then wear more colorful clothes to reflect the change. "Handle it, Edith," I remember his saying. "I don't care what she wears as long as it's a gray suit." When Kim came in for our next session, I was completely prepared. I had several swatches of gray fabric in various shades . . .
>
> (quoted in Auiler 1998: 67)

Edith Head is tempted to equate the work of the director with that of the painter who creates compositions with colors, or to understand Hitchcock to be thinking of colors as the extensions of character. There is a striking misrepresentation of the film's logic in this description of the relation of psychological character and external appearance. But it can be attributed to Head's recollection of things, rather than to Hitchcock's intention.

8 The gradual disappearance of the support is to be traced to the first scene with Midge and Scottie, in which both the woman's bra and the man's corset are at issue. The casual innocence with which Scottie, unsupported, gradually attempts to habituate himself to heights by climbing up a stepladder is almost too painful to watch, in retrospect, after we see him taking pride in climbing for the last time the stairs of the mission tower. Whether or not the supporting actress Barbara Bel Geddes is absent from the second half of the movie owing to circumstances of her private life, her disappearance parallels the disappearance of the directorial hand of Elster. Given that Midge designs bras, this lack of support should explain the often noted fact that Kim Novak does not wear a bra when playing the role of Judy.

9 The transformation brought to the very idea of the aesthetic by the involvement of technology in the creation of cinematic experience is a central theme of Cavell's *The World Viewed*. It is also the crucial issue in Walter Benjamin's "The Work of Art in the Age of its Technological Reproducibility" (2003).
10 See Grover-Friedlander (2005).
11 Tinting was achieved in earlier times by literally dipping black-and-white film in a dye. The gradations of grays thus seemed to be transformed into variations of the dye color; areas which were white in the original film took on the over-all dye color also. In toning, which is usually achieved by printing black and white footage on color stock with a filter interposed, the gradations of gray are replaced by varying tones of the color, and white areas remain white. Thus toning usually has a more delicate effect than tinting.

(Johnson 1996: 16)

Color film contains the equivalent of three layers of black-and-white film, which record the amount of red, blue and green in each object color. In the final print, the monochromatic tones in each layer are replaced by red, blue and green dyes.

(1996: 7)

12 This is related to Cavell's understanding that film is attracted to types that can nevertheless not be experienced as lacking individuality. Cavell relates the constructed nature of the expressionist environment to its existence in black and white:

The Cabinet of Dr. Caligari serves another manner of creating an artificially unified environment. But it competes with reality by *opposing* it . . . with images that compose a conventional expression of madness . . . Its feeling of constriction, of imagination confined to the shapes of theater, is a function of its existence in black and white . . .

(1971: 82)

13 I only point here to the question arising from the connection between the spectrum and the spectral, in particular as it bears on the possibility of conceiving of color as a living phenomenon. To go into this issue would mean entering Goethe's challenge to Newton's view of the color spectrum in terms of the refrangibility of light.
14 Surrealism has in common with expressionism the suggestion that a deeper reality lies behind the world of appearances, or the ordinary. However, surrealism displaces the hierarchy of surface reality and shadow world by rendering the unconscious or dream world coextensive or continuous with reality itself. Hitchcock's color aesthetic affords this world a sense of complete realization that is absent from the rhetoric of black and white, precisely because the colors that are indicative of this

world can entirely supervene upon an everyday reality depicted on the screen.

(Allen 2007: 219)

15 The distinct colors of the rainbow and its geometrical shape might tempt us to think of the order of color on the model of harmony (and Newton did try to form an analogy between the seven colors he thought he perceived in his prismatic experiments and the octave in music). But the existence of rainbows makes all the more evident the obvious: that whereas color is so much part of the space of experience, the sounds we hear do not form the harmonies of music. This is why music can often feel out of this world. Moreover, the possibility of arranging colors on a wheel or a solid need not imply that they form a quasi-mathematical or geometrical order. The experience of color does not, for the most part, reflect in its appearance the mathematical armature of its description by way of physics. (More generally, it does not feel like a symptom of something else: sounds or smells lead back to an independently characterized source, tastes and tactile qualities can hardly be separated from the substances they are qualities of.) But color can retain the quality of a pure appearance, thereby forming "an order consisting of an infinite range of nuances" (Benjamin 1996a: 50). Harmony demands separation, but color allows countless continuous transitions. In that context it is instructive to think of the relation between Bernard Herrmann's music and Saul Bass's hypnotic shapes in the credit sequence. The curved shapes are the result of a harmonograph, a device consisting of two coupled pendula, usually oscillating at right angles to each other, which are attached to a pen. One might argue that the shapes are such as to illustrate inflexible physical law, whereas the experience of colors can be dissociated from their basis in physics.

16 I am thinking here of, for instance, Heidegger's concentration on moods in which Being as a whole is revealed by the retreat of beings (such as anxiety, boredom).

17 Black and white films certainly also have ways of bringing out the affinity of cinema with light, but it is more often by making the image crisp and scintillating, by its silvery appearance.

18 This is distinct from the autonomy of color conceived in terms of a self-enclosed mediumal form (such as would be the case if we considered, say, color in painting).

19 Cavell writes:

> The featurelessness of [Kim Novak's] presence and nonexistence of her acting allow full play to one's perversity; the lax voluptuousness of her smooth body – which Hitchcock insists upon as upon no other of his heroines, in the scene in which she is wrapped in a sheet, after her leap into San Francisco Bay – declaims perfect pliancy.
>
> (1971: 86)

References

Allen, R. (2007) *Hitchcock's Romantic Irony*, New York, NY: Columbia University Press.

Auiler, D. (1998) *Vertigo: The Making of a Hitchcock Classic*, New York, NY: St. Martin Press.

Benjamin, W. (1996a) "A Child's View of Color," in H. Eiland and G. Smith (ed.), *Walter Benjamin: Selected Writings Volume 1: 1913–1926*, Cambridge, MA: Harvard University Press, pp. 50–52. (A fragment investigating the sense of the world of children absorbed by color and its implications for our understanding of the structure of the imagination and the medium of painting.)

—— (1996b) "A Glimpse into the World of Children's Books," in H. Eiland and G. Smith (ed.), *Walter Benjamin: Selected Writings Volume 1: 1913–1926*, Cambridge, MA: Harvard University Press, pp. 435–43.

—— (2003) "The Work of Art in the Age of its Technological Reproducibility" (final version), in H. Eiland and G. Smith (ed.), *Walter Benjamin: Selected Writings Volume 4: 1938–1940*, Cambridge, MA: Harvard University Press, pp. 251–83.

Cavell, S. (1971) *The World Viewed: Reflections on the Ontology of Film*, Cambridge, MA: Harvard University Press. (To my mind, this work is the most important philosophical investigation into the nature of the cinematic medium. Its understanding of the medium in terms of "automatisms," of "world projections," as well as in relation to the problematic of acknowledgment, provides the framework for the present essay.)

Friedlander, E. (2001) "*La Jetée*: Regarding the Gaze," *Boundary 2* 28: 75–90.

Grover-Friedlander, M. (2005) "The Phantom of the Opera: The Lost Voice of Opera in Silent Film," in *Vocal Apparitions*, Princeton, NJ: Princeton University Press, pp. 19–32.

Heidegger, M. (2010) *Being and Time*, trans. J. Stambaugh and rev. D. J. Schmidt, Albany, NY: State University of New York Press.

Johnson, W. (1996) "Coming to Terms with Colors," *Film Quarterly* 20: 2–22.

Marker, C. (1995) "A Free Replay (Notes on *Vertigo*)," in J. Boorman and W. Donohue (eds.) *Projections* 4½, London: Faber and Faber.

Further reading

Goethe, J. W. von (1995) *A Theory of Color* in D. Miller (ed. and trans.) *Goethe: The Collected Works*, vol. 12 (*Scientific Writings*), Princeton, NJ: Princeton University Press. (Goethe's ordered presentation of the space of color phenomena. Set in opposition to Newton's account of color, this text has been of interest to philosophers such as Schopenhauer and Wittgenstein.)

Wittgenstein, L. (1978) *Remarks on Color*, G. E. M. Anscombe (ed.), trans. L. L. McAlister and M. Schättle, Berkeley, CA: University of California Press. (A manuscript Wittgenstein wrote in 1950, devoted to the investigation of the grammar of color concepts. The issue of color had been of concern to Wittgenstein mainly in the middle period, as he assessed the difficulties with the view of his *Tractatus*.)

Chapter 9

Andrew Klevan

VERTIGO AND THE SPECTATOR OF FILM ANALYSIS

Introduction

Both *Rear Window* (Alfred Hitchcock, US, 1954) and *Vertigo* (Alfred Hitchcock, US, 1958) are famous examples of films where the spectator is aligned, or orientated, around the viewing that takes place *within* the film (mostly by the central character, in both cases played by actor James Stewart). Their skill in managing this orientation, and other aspects of viewpoint, is thought to be one source of their power over a spectator. These films have become central in discussions concerning the role of the film spectator primarily because, for many spectators, they naturally and effectively bring forward questions of involvement and identification. For this very reason, they are staples of film courses throughout the world, in schools and universities, and many students will encounter *Vertigo* for the first time within the curriculum under the heading of Film Spectatorship. Indeed, for these students it is difficult to view the film, or conceive of it, outside this paradigm.

For most of these students, the film will be accompanied by Laura Mulvey's seminal essay 'Visual Pleasure and Narrative Cinema', perhaps the most studied and cited in the history of film scholarship. For Mulvey, our viewing of *Vertigo* is channelled through Scottie's (James Stewart) 'gazing' at Madeleine (Kim Novak), and the essay cemented the importance, within a psychoanalytical framework, of the relationship between the viewing that takes place *within* the film and the viewing *of* the film.

The idea that the viewing of this film, and indeed film viewing in general, is orientated around 'the look' and in particular 'the male gaze' became a significant one. This idea is currently less prevalent but its vocabulary has filtered into casual critical parlance and the word 'gaze' is still used to describe a variety of forms of looking in films. Since Mulvey's essay, there have been many conceptions, more or less complexly elaborated, of the film spectator.[1] Explicitly or implicitly, they often use Mulvey's ideas as a starting point and then nuance or reject.[2]

These conceptions, even the more sophisticated, flexible and illuminating ones, tend to be abstractly constructed. Therefore, I thought it would be worthwhile to take a different route and examine how individual pieces of film analysis – each an individuated instance of how *Vertigo* is viewed – conjure or reveal, either explicitly or not, different types of spectator. In most cases, I work through segments of the prose because this allows me to track the moment-by-moment development of a writer's viewpoint.[3] One reading of Ludwig Wittgenstein's work is that philosophical problems might be usefully tackled by linguistic clarification rather than theoretical, scientific or empirical investigation. The philosopher's goal is to produce a 'perspicacious representation' of the use of our words in specific contexts (Turvey 2001: 472–3; quoting point 122 of the *Philosophical Investigations*). Malcolm Turvey has argued that 'film scholars . . . have typically opted for constructing theories of film and our responses to it, instead of investigating the language people use . . . in their response to film' (2011: 474–5). The writing on *Vertigo* is particularly helpful in aiding our understanding of spectatorship. Given that the film potently addresses, confronts even, many spectators as a spectator, attending closely to the writing on *Vertigo* is a way of understanding how, and appreciating the methods by which, the writers manage to *articulate* the experience of being a spectator of it. We can also observe how this most visually and aurally vivid of films exists, and extends its existence, in a medium without image and sound.[4]

Analysing the work on *Vertigo* shows that far from producing or revealing one type of spectator, the film encourages a variety. Given the reasonably tight associations that *Vertigo* establishes between the viewpoints within the film and the viewing of the film one might expect a definite or circumscribed way of watching it. Instead, it inspires or provokes different responses, perhaps because it cleverly compels us to grapple with its proposed identifications, and these may be instructive in opening our eyes

to alternative modes of viewing, and understanding. The film skilfully continues to stimulate different views of it – hence the volume of writing – different ways of viewing it and different ways of being a viewer of it (even if these views overlap or are complementary). One purpose of the piece is to provide a little caution to those students coming to study *Vertigo*, and spectatorship, for the first time: not to presume that the film, and by association any film, has one type of spectator. It is through examining various responses to it – rather than presenting one view of it – that we can see perspicaciously that *Vertigo* has a special capacity for teaching us about the complexity of film spectatorship. This is possibly because *Vertigo* is so concerned to make the act of viewing an active part of viewing it.

The fixated spectator

Like most people who have gone before me, I will start with Mulvey's essay, 'Visual Pleasure and Narrative Cinema'. In it, Mulvey famously gives an account of Hollywood cinema as structured around 'looks' with the spectator identifying with the male 'look':

> The man controls the film phantasy and also emerges as the representative of power in a further sense: as the bearer of the look of the spectator . . . This is made possible through the processes set in motion by structuring the film around a main controlling figure with whom the spectator can identify. As the spectator identifies with the main male protagonist, he projects his look onto that of his like, his screen surrogate so that the power of the male protagonist as he controls events coincides with the active power of the erotic look, both giving a satisfying sense of omnipotence.
>
> (Mulvey 1985: 310)

An important consequence of this is that the spectator is 'prevent[ed] . . . from achieving any distance from the image in front of him' (Mulvey: 314). Disconcertingly, however, when Mulvey comes to discuss her Hollywood case study, *Vertigo*, she seems to imply that the spectator is not quite so fixated. Far from locking the spectator into the limitations of the male 'look', *Vertigo* does allow for 'distance', and knowingly '*focuses on the implications* of the active/looking, passive/looked-at split in terms of sexual difference and the power of the male symbolic encapsulated in the hero' [my emphasis] (1985: 313, and all further references are from

this page). One wonders then whether *Vertigo* is an exception to the rule, and if so, why it receives the most attention in the essay (the essay briefly mentions *Only Angels have Wings* (Howard Hawks, US, 1939) and *To Have and Have Not* (Howard Hawks, US, 1944) to support the main argument, but does not discuss them).[5] As Tania Modleski writes:

> Interestingly . . . Mulvey's essay, which uses Hitchcock films as the main evidence in her case against Hollywood cinema, actually ends up claiming that *Vertigo* is critical of the kinds of visual pleasure typically offered by mainstream cinema, a visual pleasure that is rooted in the scopic regime of the male psychic economy. In her reading of the film, Mulvey thus unwittingly undercuts her own indictment of narrative cinema . . .
>
> (Modleski 2005: 13)

Indeed, for Mulvey, *Vertigo* is aware of the perils of 'visual pleasure' so that 'the spectator . . . finds himself exposed as complicit, caught in the moral ambiguity of looking'. Now 'the spectator . . . sees through his look', where 'sees through' is primarily meant to express, given the essay's current line of argument, that Scottie is 'exposed' by the spectator who is no longer 'complicit' with him. The sense roughly is 'previously deceived, I now *see through* you', but it also permits another meaning: 'he guides me, I *see through* his eyes', and preserves the trace of Mulvey's earlier and overarching claim that the male protagonist in Hollywood cinema is the spectator's 'screen surrogate'.

There might be a third meaning if one drops the presumption that 'his' refers to Scottie. The full sentences reads, 'Hence the spectator, lulled into a false sense of security by the apparent legality of his surrogate, sees through his look and finds himself exposed as complicit, caught in the moral ambiguity of looking', and 'his' could refer to the spectator – 'sees through his [own] look' – rather than the 'surrogate' (i.e. Scottie). A similar inconclusiveness occurs elsewhere. After explicating the behaviour of the characters, the essay states, 'In *Vertigo*, erotic involvement with the look is disorienting: the spectator's fascination is turned against *him* as the narrative carries *him* through and entwines *him* with the processes that *he* is *himself* exercising' [my emphasis]. Are 'him' (three times) and 'he' and 'himself' referring to Scottie, who has been the subject of the previous sentences, or the spectator, because 'him' is the customary way Mulvey characterises this entity, or one then the other as

the sentence progresses? When Mulvey writes, 'the spectator's fascination is turned against him', has the 'spectator's fascination' turned against Scottie or turned back upon 'himself'? The repetition of 'him' compounds and emphasises the referential ambiguity, and the possibilities for substitution conflate the identities of Scottie and the spectator. For some readers, these may be troublesome confusions with regard to *Vertigo*, film and grammar but they do peculiarly enact, within the syntax of the sentence, Mulvey's general thesis about the merging of spectator and protagonist (and psychoanalytic concerns about the instability of subject and object). The sentence, like the audience's 'erotic involvement', is 'disorientating'. Not unlike the film, as one tries to get a grip on the (sentence's) meaning, one ends up going round and round, somewhat queasily. It is vertiginous.

Mulvey's essay sets out to provide a categorical thesis on the viewing experience of Hollywood cinema that is complicated by the effort to put in writing the specific viewing experience of *Vertigo*. Perhaps the essay is deconstructing itself, betraying its contradictions, and the strength of the film's complexity ruptures and insidiously manipulates the writing. The polemic of the thesis is 'exposed' by the prose to reveal the more suggestive and less definite aspects of it. The analysis releases the spectator, and the writer, formerly fixated by the theory, into a fluctuating drama of attachment *and* detachment. Indeed, the film sometimes sets up the 'gaze' only for the camera to depart from it, as it does when Scottie turns to spy Madeleine in Ernie's Restaurant and the camera goes wandering off at a tangent to the direction of his 'gaze', stalls to mark a quite different viewpoint, and *then* approaches her. Mulvey's sentence, 'The audience follows the growth of his erotic obsession and subsequent despair precisely from his point of view' is once again deceptive and slippery. On the one hand, if we were 'precisely' in his 'point of view', it would be as if we had become him, and it would make it hard, impossible even, to follow him, which is to come after him. 'Follows the growth of [Scottie's] obsession' suggests a more clinical position – 'I've been following his progress carefully' – that is 'precisely' not his 'point of view'. On the other hand, the sentence conveys the experience of Mulvey's 'audience' (is this the same as a 'spectator'?) vacillating with regard to Scottie's point of view, or simultaneously sharing, or coming very close to, his point of view *and* following it. After all, *Vertigo*'s story is concerned with following and becoming (another).

The medium-conscious spectator

Like Mulvey, both David Thomson and Stanley Cavell give reasonably brief accounts of *Vertigo* in their books *Movie Man* (Thomson 1967) and *The World Viewed* (Cavell 1979). In these books, they generalise about a wide range of films, about genre, about directorial oeuvre, and about the medium in general, and they are alert to how they inform each other.[6] One puzzling aspect of Mulvey's essay is that her brief account of the sophisticated mechanisms of *Vertigo* does not provide the example for her overarching understanding of Hollywood cinema. Thomson and Cavell proceed in a different direction in that their feelings about *Vertigo* feed into their conceptualisation of (Hollywood) cinema. For Cavell, the good film will discover and explore the possibilities of the medium and the spectator will not realise them in advance of their realisation in the film.

Thomson writes, 'Essential to every Hitchcock film is this awareness the director has of his spectator. It conceives of the spectator as an economic generalisation and there is an element of sadism in the devices inflicted' (Thomson 1967: 150). The films of this specific director, especially *Vertigo*, conceive of a particular sort of spectator, 'an economic generalisation', and inflict 'sadism' on them (partly by encouraging them to view sadistically). Yet, the use of 'conceives' means that the spectator is not necessarily 'an economic generalisation' but rather that this is how they are imagined by Hitchcock's films. The spectator may be amenable to this conception and to other conceptions: agreeably chameleonic from director to director and from film to film. Further, if Hitchcock's 'awareness' is an 'essential' aspect of his films, then Thomson, as a spectator, is aware of Hitchcock's 'awareness' and the 'devices'. The spectator is susceptible and conscious of their susceptibility. 'In watching Hitchcock films', Thomson writes, 'one becomes conscious of issues of freedom, not only to the extent that the characters in the film enjoy it but in how far the spectator in the cinema is deprived of it' (149). For Thomson, like Mulvey, the spectator of Hitchcock's films may get trapped in the male character's 'look' and 'find ... himself exposed as complicit' but this spectator also 'become[s] conscious' of the very 'issues of freedom', and more importantly *conscious of the way these 'issues' manifest in films and the viewing of them*.

Like Mulvey, Thomson conjoins character, director and spectator but in Thomson's case this leads to a spectator sensible to the mechanisms of the art form:

> Just as Helmore has deceived Stewart, so Hitchcock has misled the spectator by ensuring that he gains information in exactly the same way as Stewart. Stewart's assignment to follow and the subsequent attraction he feels towards his object are the equivalents of cinematic method. Because the central character is a detective and because the movie's main purpose seems to be the solution of a mystery, which on the available evidence presupposes a supernatural intervention in man's affairs, *Vertigo* progresses by what appears to be a factual gathering. The facts can be related to the ideal of pure cinema: what a person looks like, what she does, the manner of her gestures. It is in these terms that Stewart watches Novak and the entire visual material is directed to this information; cuts separate fact from fact rather than allowing them to elide with each other so that their certainty might be undermined by context. And, of course, Novak is behaving to the order of this method through her conspiracy with Helmore, which is the equivalent of her co-operation with her director . . . Why, in fact, do the most old-fashioned plots work in his hands? Basically, the effectiveness lies in the paradox that Hitchcock's films purport to be a sequence of factual statements, but that these 'facts' are subsequently revealed to be false. Because the method filters a continuum of experience into discrete items, the real source of disorientation is the insinuation of the film's form with the natural processes of watching a movie . . . His reliance on the conclusive 'story' form is such that he has concentrated on making all its connections plausible, so that the story has become more and more isolated from a spectator's sense of external reality.
> (Thomson 1967: 152–54)

The spectator follows the 'facts' *and* the 'cuts'; and is involved in the 'story' *and* '"story" form'. Stewart's 'assignment' becomes an equivalent of 'cinematic method', and 'factual gathering' in the film is 'related to the ideal of pure cinema'. Thomson refers to performers *not* characters – Helmore, Stewart and Novak rather than Elster, Scottie and Madeleine. For Mulvey, 'erotic involvement with the look is disorientating' but for Thomson 'the real source of disorientation' results from 'the *insinuation* of the film's form' [my emphasis]. The spectator attends to the 'visual material', the handling of the material, and the materiality of the medium, and all three merge.

The philosophical spectator

Rather than moving us through a specific example, Thomson's writing generalises and distils. Stanley Cavell's book *The World Viewed* is even more sharply condensed as one profound exclamation follows another. On *Vertigo* and fantasy:

> I speak of 'establishing a world of private fantasy'. . . . More specifically, [it] is *about* the power of fantasy, and in particular about its power to survive every inroad of science and civility intact, and to direct the destiny of its subject with, finally, his active cooperation . . . *Vertigo* seems at first to be about a man's impotence in the face of, or faced with the task of sustaining, his desire; perhaps, on second thought, about the precariousness of human verticality altogether. But it turns out to be about the specific power of a man's fantasy to cause him not merely to forgo reality – that consequence is as widespread as the sea – but to gear every instant of his energy toward a private alteration of reality.
>
> (Cavell 1979: 85)

There is a prevalence in film discourse (in all its various guises) to assume to know too quickly and straightforwardly what a film is 'about' and how it works. Critics who trust to close reading may be concerned that Cavell does not sufficiently analyse instances to validate and substantiate his points with detailed evidence. However, although close reading may authorise, it will not ensure the reader's engagement. I practice and advocate close reading, but one danger of the close reading approach is a list, more or less sophisticated, that straightens out the film, exhaustive perhaps (for the time being), but also exhausting. Even deft and delicate analysis cannot avoid, indeed it more insistently lays bare, the fact that someone else has done the work. Highly accomplished pieces of exact close reading may apparently seal up the film or lay it to rest: they overwhelm and over impress, they leave us with little room for our own engagements or they satisfy us that we know everything there is to know. Let us take the clause that understands the film to be 'about the precariousness of human verticality'. Cavell's clause suspends a thought and indicates further potential for viewing: it prompts the reader to think through the instances of 'verticality' in the film, to elaborate for herself.

The proposition does not require (a) proof but invites conversation.[7] How much can the writer safely leave unsaid? He trusts in his reader – his fellow spectator – and the film, and there are no assurances (but trust is itself an encouragement). Cavell's writing here, like 'human verticality', is thrillingly precarious.[8]

Cavell's spectator is stimulated to contemplate a range of ideas and concepts while viewing the film: 'fantasy', 'science', 'civility', 'destiny', 'impotence', 'desire', and 'reality'. For Cavell, a good film such as *Vertigo* stretches the mind and inevitably encourages the spectator to challenge their presumptions about the meaning of ideas or concepts. He continues:

> It is a poor idea of fantasy which takes it to be a world apart from reality, a world clearly showing its unreality. Fantasy is precisely what reality can be confused with. It is through fantasy that our conviction of the worth of reality is established; to forgo our fantasies would be to forgo our touch with the world.
>
> (Cavell 1979: 85)

'Fantasy', for Cavell, is not only inseparable from 'reality' or 'confused' with it; the inseparability and the confusion are integral to its conception. Furthermore, the medium of film is especially suited to showing the reality of fantasy, especially if it juxtaposes reality and fantasy without necessarily marking the boundary between them as it might, say, by explicitly indicating a change in the status of the image.[9] We have here not simply a moral ambiguity or an inescapable human tension but, for good or ill, something essential to our experience of the world, perhaps to our ability to experience it at all: fantasy establishes 'the worth of reality', and without it, we would 'forgo our touch with the world'.[10] It is unsurprising to read interpretations that consider *Vertigo* a critique of sexual or romantic fantasy or alternatively a perverse, Romantic celebration of fantasy's destructive intensity,[11] but *Vertigo* prompts Cavell to focus on the fundamental standing of the concept because the film dramatises the depth of fantasy's effect upon our grasp of the world.

Cavell is concerned not simply with announcing what the film means but with the approach to meaning, and the journey through meanings. Returning to the initial quotation, Cavell seems initially to announce what

the film is about – 'the power of fantasy' – but then he refines the idea to be about 'a man's impotence in the face of . . . his desire' or slightly differently, 'a man's impotence . . . faced with the task of sustaining . . . his desire'. In turn, this leads to a 'second thought' that the film might be about 'the precariousness of human verticality altogether'. The move to this point of general importance is stimulated by, and simultaneously allows, a tactful elaboration on the problems of impotence – 'precarious . . . verticality'. Just after his 'second thought' the film 'turns out' to be about something else: 'the specific power of a man's fantasy . . . to gear every instant of his energy toward a private alteration of reality'. Cavell is not simply providing alternatives, he is, with 'perhaps, on second thought' and 'But it turns out', explicitly marking the stages of alteration and adjustment. He is expressing how ideas come to us as we view, one prompting another in the mind, the train of thought. Even if we consider the prose to be a literary contrivance, there is nevertheless an attempt to recreate or evoke the viewing experience as a series of developing impressions. It conveys film spectatorship as a thoughtful process.

The aphoristic line, 'Fantasy is precisely what reality can be confused with', strikes us like an admonition, sternly conclusive: *surely, you realise that* 'Fantasy is precisely what reality can be confused with'. Yet, Cavell is not arrogantly rebuking his reader; he is reproducing the film's rebuke (to him), writing under the influence of its mood – still in shock. The force of *Vertigo* dragged me to this *point*; it compelled me to see that 'fantasy is precisely what reality can be confused with'. Cavell's philosophical spectator is not a cool rationalist sitting back, aloof, carefully clarifying concepts. The drama of the film stimulates the drama of thought. For Cavell, the film is a philosophical melodrama, but so is viewing it – and writing about it.

The camera-conscious spectator

For Mulvey, the cinema spectator should not be conscious of the camera, but rather see the film world through the (male) character's eyes. She writes:

> There are three different looks associated with the cinema: that of the camera as it records the pro-filmic event, that of the audience as it watches the final product, and that of the characters at each other

within the screen illusion. The conventions of narrative film deny the first two and subordinate them to the third, the conscious aim being always to eliminate intrusive camera presence and prevent a distancing awareness in the audience.

(Mulvey 1985: 314)

For William Rothman, however, the spectator is ever so conscious of the camera; and some directors, like Hitchcock, far from denying the camera, are eager to make them conscious of it (hence the moment, in Ernie's, of the diverting camera that I remarked upon earlier). Rothman is a camera-aware spectator, and much of his experience of films is down to experiencing the camera, rather than seeing the screen as simply a window through which we view the fictional world. The camera does so much more than 'record . . . the pro-filmic event': it has a 'presence', like a character, and although it sometimes allies itself with a character, it has its own character. It is often a vehicle of authorial intervention and commentary (sometimes 'intrusive').

At first appearance, the following example from Rothman would be in keeping with Mulvey's understanding:

> Judy [also played by Kim Novak] . . . turns to him for help with her necklace. 'How do you work this thing?' 'Can't you see?' Finally he *does* see, and we cut to his view, the camera moving in on the necklace reflected in the mirror. This provides an occasion for another of Hitchcock's virtuoso declarations of the camera. There is an 'invisible' cut to the portrait of Carlotta, the camera continuing its movement in, then pulling out until it frames Madeleine in the museum, spellbound in front of the painting. As the image slowly dissolves back to the present, the painting frames Scottie's eyes, a perfect Hitchcockian declaration of the camera.
>
> (Rothman 2004: 231–32)

The spectators see the necklace from Scottie's point of view, and as the camera takes them deeper into his viewpoint, they will have a sense of it taking them there. For Rothman, the spectators do not simply see what he sees, they see that he sees – 'he *does* see' – and 'we', the spectators, 'cut to his view'. The cut to the portrait of Carlotta is disguised so as not to disrupt the alignment with Scottie's vision, but the '"invisible"' cut

is visible, visibly invisible (and hence highlighted in speech marks). When the film dissolves from the museum and the 'painting frames his eyes', the spectators have been brought back full circle, tightly locked into Scottie's mind and thoughts. Yet they also see that his eyes are isolated from the rest of his face, his vision circumscribed, delimited and dominated by a vision of Carlotta/Madeleine. They see that what he sees is locked within a frame and that Hitchcock *frames* Scottie as surely as Elster.

The famous dizzying shots that express Scottie's vertigo are 'another invocation of the film frame . . . [an] intimation that he is condemned to the gaze of Hitchcock's camera' (233). Similarly, the final shot of the film:

> The nun, pulling on the rope, rings down the final curtain, signifying the end of the performance. Yet Hitchcock's final virtuoso turn remains to be completed. The movement continues, now revealing the camera to be – all along to have been – outside the tower chamber, occupying a position inaccessible to any human being on Earth. The camera keeps pulling out until it frames Scottie, looking down, his hands at his sides in mute anguish and supplication, as the bell continues to toll. It is with this declaration of the camera that Hitchcock ends his film.
>
> (Rothman 2004: 236–37)

The movement is 'revealing' the camera 'all along to have been . . . outside the tower chamber' and as such is 'revealing' the camera. The spectators are aware of it 'pulling out' so that they *come to see* him from this 'position'. They not only see Scottie 'in mute anguish and supplication', but are conscious that they (are able to) see him from this peculiarly 'inaccessible' view.

George Toles writes that 'Hitchcock . . . invents a visible action whose highest purpose is to reveal the camera's nature – in effect, giving the camera reflexively back to itself as the "power behind all things"' (Toles 2001: 175). While discussing Hitchcock's overt declarations of the camera at the beginning and ending of *Rear Window*, Toles writes about the 'arresting strangeness of the camera's way of positioning itself in relation to this environment, its manner of taking possession' (174). He is referring to when the 'camera actively asserts its independence

from a character's point of view' as in the prologue. The camera passes through the window and conducts a 'survey of the courtyard, the apartment dwellings opposite, and their tenants, returning twice in a kind of circling motion to James Stewart, the sleeping occupant of the room whose windows were the starting point for this guided tour' (173). For Toles, 'Finding the camera and questioning its purpose in declaring itself is equivalent to being briefly released from the spell of James Stewart's . . . presence' (178).

The camera can make explicit declarations but it may also provide an unobtrusive 'point of view' that does not compel us, and yet is revelatory. Toles writes of *Rear Window*:

> The film presents us with a narrative structure that is serenely intact, yet at the same time authorizes endless rupture. The rupturing process begins when the spectator recognizes that the perfect order of the film's surface story is a 'blind' for another story in which the camera's point of view is at variance with that of the characters. The same images that make it seem reasonable to view *Rear Window* as a self-sufficient, 'naïve' genre film also invite us, without compelling us, to see through the devices that hold us captive to the story. A mystery whose solution has seemed to depend on the gathering of external data conceals, but also discloses (to those moved to attend to it) a more basic mystery of perception: how our window on the world 'out there' ceaselessly transforms into a mirror of our desires and perceptual habits.
>
> (Toles 2001: 172)

The 'narrative structure' is simultaneously 'serenely intact' and full of 'endless rupture' and this apparent paradox goes against the grain of a commonly held assumption that a film either remains 'intact' (mainstream, Hollywood) or generates 'rupture' (independent, experimental, avant-garde).[12] Moreover, it is the 'serenely intact' 'narrative structure' that 'authorizes' 'rupture', and 'endless rupture'.

It is a technological matter of fact that the camera is always making itself known because it is producing the image, but the experience of the camera in fiction films is not easily known. The camera is always there *and yet* we (normally) never see it. We experience it moving about

in the environment of the fiction *and yet* we (normally) do not see it in the fictional world. We depend upon the camera, frequently aware of the *direction* of the image (as Rothman is) *and yet* we are prone to forget that it is providing these views. We see that performers depend on the camera too and they cannot forget it, so they look to it but (normally) do not look at it. For Toles, Hitchcock's films show us that the camera is a 'window' *and* ('ceaselessly transforms into') a 'mirror', an instrument that opens out *and* reflects back, that 'discloses' and 'conceals', that clearly perceives *and* poses the 'mystery of perception'. The camera ensures that film is equivocal and unresolved at the core of its being, and it encourages a spectator that is fluctuating and indeterminate.

The camera also accommodates multiple perspectives within its single vision. For example, the camera is able to show us simultaneously what it knows and what a character knows (feels or experiences). It may make available a crucial object, a glance, a gesture, which remains unacknowledged within the fiction. The camera-conscious spectator judiciously engages with the surveying camera and is the opposite of the spectator conceived by Mulvey. The survey takes on a more distinct character when it is felt that, as it is in Hitchcock's films, the camera's viewpoint strongly aligns with that of the director. Indeed, the camera-conscious spectator is often an authorial-conscious spectator. The director's eye refines the camera's in-built propensity for perspicacity. For Rothman the camera is not merely a tool of the director, it is his main vehicle of authorial intervention. Hitchcock sees through the camera to speak through the camera: in Rothman's formulation, the 'eye' of the camera is the 'I' of the camera.

The worry for the camera-conscious spectator is that they may over invest in what they take to be the all-seeing, all-knowing camera and become over-impressed with the ironies it provides. For Rothman, the camera intervenes, but to complicate rather than confirm. The camera's capacity to see the bigger picture does not mean it is the source of truth. Toles writes about the moment at the end of *Rear Window* when Thorwald (Raymond Burr) confronts Jefferies (James Stewart):

> Thorwald and Jefferies confront each other in a mutual blindness, culminating in Jefferies dropping out of the window (the rigorously controlled frame of the film's world) and Thorwald disappearing

into the darkness inside. Jefferies's fall, in allegorical terms, is the final severance of the idea of the privileged, justified spectator from the 'window'; the film decisively shows the window as something not belonging to him, something whose capacity to reveal is *not* predicated on his presence behind it. I would like to think that Hitchcock is also acknowledging here the drastic limits of the *camera's* power to image truth. Significantly, it is the camera that Jefferies instinctively seizes as the protective barrier between himself and Thorwald's 'reality'. . . . The camera . . . will proclaim itself part of the 'empty' fiction rather than attempt to *show* what is real. Hitchcock may be suggesting that the camera's truth *always* resides in what, at the last instant, eludes capture, never in what can be made literally visible.

(Toles 2001: 179–80)

The camera captures the 'visible' but does not 'show what is real'. The camera lets us see everything that is before it and simultaneously asks what it is that we see. *Searching* films recognise that this recording instrument is also a tool of inspection and perusal: it brings the spectator close to, and entices them with, the meaning of surfaces. This is why any worthwhile image, and not just transparently beguiling or puzzling ones, invites interpretation. Stewart and Novak's very presence, their bodies, their faces, their clothes, their gestures and their movements ask questions of us. Hitchcock is the 'Master of Suspense' and this most commonly refers to his handling of anticipation and expectation within the plot, but he also keeps us in suspense about people, their identities and their behaviour.

Good films need not be insistently questioning, however: their simplicity or ordinariness is deceptive and significance passes without notice. Some films, like *Rear Window* and *Vertigo*, are insistent *and* deceptive. In almost every image, they compel us to interrogate the status of what we see and yet Toles is still correct when he writes that 'The extraordinary imaginative resonance of a Hitchcock film derives . . . from his matchless ability to hide things in plain sight – to create "open" stories that are entirely taken up with subtle acts of concealment' (176). This line evokes point 89 in Ludwig Wittgenstein's *Philosophical Investigations*, and a favourite touchstone of Stanley Cavell:

[I]t is ... the essence of our investigation that we do not seek to learn anything *new* by it. We want to *understand* something that is already in plain view. For *this* is what we seem in some sense not to understand.

(Wittgenstein 2001: 36)

In its ability to make aspects available but not necessarily apparent, the camera seems peculiarly suited to this 'investigation'. It keeps the spectator on the case.[13]

The experiential spectator

For an experiential spectator, absorbed in the moment-by-moment encounter with a film, the camera, although fundamental, is only one aspect of the whole experience. The experiential spectator responds to the intricacy of a film as it unfolds and wishes to articulate this intricacy. He or she evokes the experience most often by way of an involved and intimate description. In the following passage, James Harvey describes the period after Scottie has found Judy. The prose recreates the dramatic momentum of the scene and is disposed towards shifts in mood and tone:

> They have their first "date," and he takes her (no surprise) to Ernie's, where she looks rather out of place. It's not a successful evening. Nonetheless, when he brings her back to the hotel and they are saying goodnight in the hallway, he asks her to quit her job, to let him "take care of" her. She treats this disdainfully, as a conventional, if extreme, make-out move – though she knows better, of course. Like Midge, she knows very well – just as much as he does not – what's going on between them. She walks away from him into the darkened room and sits on the arm of a chair near the window. From outside it, the big "Hotel Empire" electric sign gives off an eerie aqueous blue-green glow that floods her corner of the room. But she is in darkness, as she removes her glove – her face turned in profile, a black outline, like a silhouette cutout, against the green unearthly light. Scotty stands in the doorway, talking to her across the room, uncomfortably. His intentions are honourable, he tells her

– he only wants to see more of her. 'Why?' comes her voice from the darkness. 'Because I remind you of her?' (pronouncing it 'remind-juv'). At this, Scotty looks pained, the music rises, and the camera sweeps suddenly forward, right up to the black, unreadable profile, where it stops – the movement an almost visceral register of Scotty's longing and frustration. The next shot, however, is Judy's – inside the darkness: a frontal close-up, her face half in shadow, half in the sea-green light. She is gazing out the window into the light: one of those moments when Novak's unmediated, cornered-animal quality seems most vivid and moving. The unearthly light makes the misery in her opaque dark eyes look almost luminous. She shifts her gaze from the window: maybe, she says, she could get the day off from work.

(Harvey 2001: 35, 37)

The passage is colloquial and idiomatic, knowingly in with the sequence's ironies. Laconic understatement captures the underhand (black humour) and the uncanny. Taking her to Ernie's is the ominous beginning of Scottie's obsessive re-creation but here appears simply as '(no surprise)' with the parentheses standing in for raised eyebrows; and 'It's not a successful evening' is deadpan, as if this was any old blind date unworthy of further particulars. Vernacular locutions express the attitudes of movie characters – real, moving characters – especially ones that are modern, twentieth-century, urban and American. Correct formalities of academic prose do not necessarily faithfully evoke their physical and emotional energies, and dynamics. The lack of an 'and', for example, between 'quit her job,' and 'to let him "take care of"' her' means the latter clause appears abruptly and conveys Scottie's anxious pleading.

The sentence 'She walks away from him into the darkened room and sits on the arm of a chair near the window' does not start with a 'Because' or a 'When' or any other word that will lead to an interpretation or explanation of her movement. This risks boring the reader with what is plainly evident although we should take care because, as Toles writes, Hitchcock has the 'matchless ability to hide things in plain sight'. Harvey is not afraid of telling us what happens because he is interested in drawing attention to telling; this sentence deliberately sets the scene and begins a sequence of descriptive moves. The vocabulary of the 'eerie aqueous blue-green glow' appears more colourful and describing what is in plain

view now seems less straightforward. In the next sentence, the efforts to describe are further fore-grounded with the explicit simile of 'like a silhouette cutout'. Harvey's writing shows that the experience of a film includes a consciousness of experiencing it, and the articulation of that consciousness. The writer will be especially aware of translating the images and sounds into written language, but any spectator thinking about what they see and hear will be involved in an act of construal, forming descriptions in the mind, gathering the experience into words.

Harvey plays out the drama again but this time in words, and each sentence rebuilds the scene. The method is quite the opposite of encapsulation and generalisation employed by Thomson and Cavell. For Harvey, it is perhaps a way of *coming to terms* with the scene, a therapeutic process, where even if it is immediately in front of him, *recalling* it, or learning to call it (something), becomes revelatory. For the reader, it is perhaps a way of understanding how Harvey comes to see (how one thing leads to another) because of the opportunity to experience it through his eyes. Rather than simply giving *a* view of what happened, the writing conveys the drama of viewing as it happens and the reader, rather than checking (off) discrete observations, follows the progression. The writing recognises the unfolding of meaning in time, instead of conflating it, after the fact, into a brief summation that reduces instance to example.[14]

Sentences replicate cinematic movement. Scottie 'looks pained', the 'music rises' and 'the camera sweeps suddenly forward', like the sentence, right until 'it stops –' with a dash. On the other side of the dash lies the interpretation of the movement but the dash does not so much separate as bridge, or more accurately it drives and directs us, with the momentum previously achieved, into the interpretive clause '– the movement an almost visceral register of Scotty's longing and frustration'. Harvey's writing is not merely emoting about story and character because technique and meaning equally affect. The experience of the fiction is inseparable from the experience that this is a fiction. The vibrant and poetic close to the paragraph – 'The unearthly light makes the misery in her opaque eyes look almost luminous' – is inspired not simply by Judy, the fictional character, but by Novak at her 'most vivid'. Judy's submission is an appropriate climax to the paragraph as Scottie may now begin to create his fantasy. The crescendo into the 'unearthly' and the 'luminous' makes possible a sudden drop back down to earth – 'maybe, she says, she could

get the day off from work'. The bathos created by the syntactical arrangement generates, and incorporates, the interpretation – about the ordinary's capacity suddenly to subsume intensity – without needing to state it. Rather than transferring to an alternative discourse, the interpretation is expressed *within* the language that describes the film.

It is rare enough for commentaries to point out accent or pronunciation, but rarer still to impersonate a voice in order to provide an *impression*. For Harvey, what Judy sounds like ('remind-juv') is as important as what she says: 'Because I remind you of her?' In just that 'remind-juv', he distils the character and suggests class and upbringing (and performances of class and upbringing by character and performer) without elaboration – as Kim Novak does. Later in his chapter on *Vertigo*, Harvey draws attention to Scottie's final dialogue:

> 'Carlotta's necklace,' says Scotty. 'There's where you made your mistake, Judy. You shouldn't keep souvenirs of a killing,' he says – and the anguish in Stewart's face and voice is nearly as terrifying to us as it is to her. Then he adds, 'You shouldn't've been –' and stops, choking up at the bitterness of what he's saying. He starts over: 'You shouldn't've been – that sentimental' – both swallowing that last crucial word and coming down on it at the same time . . . Judy . . . who has just connived at a killing for money . . . is capable of appropriating even a murder . . . It's the pain of this recognition that Stewart – remarkably – gets into this word 'sentimental' when he says it, with all his bitterness and grief. And his next words, different as they are, are even more searing. 'I loved you so, Madeleine,' he says, in tears, raising his head. No longer looking *through* the insufficient Judy, but upward and away. But, of course, there never was a Madeleine . . . Madeleine is a phenomenon both impossibly specific and finally transcendent, so that Scotty's cry of love for her in the bell tower feels not only moving but oddly heartless – like this movie itself.
>
> (Harvey 2001: 40–41)

Stewart's 'terrifying' intensity ruptures *Vertigo*'s 'heartless' surface, and so the film gives his outburst a sense of bursting. It is 'terrifying', and confusing, for the spectator not least because 'there never was a

Madeleine': how did fakery elicit this raw sincerity? Scottie's moments of suffering, like the moment in the bell tower, are vital for many spectators ('terrifying to us'), but difficult to handle within the conventions of academic analysis without seeming aloof and dispassionate, and neutralising their force. It is greatly to Harvey's credit that he confronts them on their own terms and dwells upon them. Acknowledging Scottie's behaviour will take more than understanding (his character); it will require adequately experiencing his *being*. This entails an encounter with the urgency of the performance: the spectator experiences not only Scottie's emotions but also Stewart's expression of them. It may be '*Scotty*'s cry of love', but it is the 'anguish in *Stewart*'s face' and 'the pain of this recognition that *Stewart* – remarkably – gets into the word 'sentimental' [my italics]. For Harvey, the 'audience' is as emotional, empathetic, and sympathetic about a performer as they are about a character.[15]

The context-conscious spectator

The nakedness of Stewart's outburst in the bell tower is similar to his distressed tirade at the children in *It's a Wonderful Life* (Frank Capra, US, 1947), and his frantic cries as the filibuster collapses in *Mr. Smith Goes to Washington* (Frank Capra, US, 1939), and his glowing tribute to Tracy's magnificence in *The Philadephia Story* (George Cukor, US, 1940). Indeed, for Cavell, Stewart's performance in *Vertigo* joins hands with his other films:

> I think it cannot be an accident that the actor in both films is James Stewart, that both Capra and Hitchcock see in Stewart's temperament (which, of course, is to say, see in what becomes of that temperament on film, its photogenesis) the capacity to stake identity upon the power of wishing, upon the capacity and purity of one's imagination and desire – not on one's work, or position, or accomplishments, or looks, or intelligence. Call the quality Stewart projects a willingness for suffering – his quality Capra records in *Mr. Smith Goes to Washington*, and that John Ford used in *The Man Who Shot Liberty Valance*.
>
> (Cavell 2005: 6–7)

Cavell is alert here to Stewart's relationship to his other films and his relationship to the medium and asks what becomes of his 'temperament on film'. This allows him to see *Vertigo* as another chapter in Stewart's explorations 'on film' of 'wishing', 'suffering', 'imagination' and 'desire'. Indeed, performer and director are involved in exploring these concepts, or seeing different aspects of them, from film to film. Cavell *sees Vertigo in these terms* and as V. F. Perkins writes:

> The star performers influence what the audience expects and therefore how it reacts. The familiar styles and personalities . . . necessarily contribute to the total style of any film in which they appear . . . Hitchcock is able to absorb the strong personalities of [Cary] Grant and Stewart into the textures and meanings of his movies.
>
> (Perkins 1972: 182)

Anything in a film may trigger an association to something outside it that then affects the view of it. Raymond Durgnat is responsive to the elements in films that rhyme with other films and other aspects of the cultural terrain:

> Hitchcock must take the credit . . . for prefiguring the '60s sextet of blonde heroines whose smoothly perfidious responses to their victimisation or confusion catch a more generalised mood of disjuncted psyche: Tippi Hedren in *Marnie*, Catherine Deneuve in *Repulsion*, *Belle de Jour* and *Tristana*, and the two heroines of Ingmar Bergman's *Persona*. *Vertigo*, like *L'Avventura*, is built round winding journeyings after a missing person.
>
> (Durgnat 1982: 296–97)

Durgnat is a context-conscious spectator and he has an unrestricted range of reference that liberates a variety of meaning. He lets the vividness of imagery and his descriptions of it – 'smoothly perfidious', 'mood of disjuncted psyche', 'winding journeyings' – lead him to other films and the wider culture. He makes several contextual connections in one paragraph, each one condensed into individual words and phrases. He writes:

> The mixture of archaic and contemporary elements makes the beauty of this necrophiliac tale which, with its sugar-coating of glamour, remains a poignant lyric about what David Reisman in *The Lonely Crowd* called 'false personalization' and the alienations of modern life – including that deodorisation, depilation and depersonalisation of womanhood, the secret meaning of whose apparently optimistic perfectionism is a terror of the vulnerabilities which distinguish a woman from a pin-up or a high heeled machine. No doubt the film's own surface expresses an acquiescence in it.
>
> (Durgnat 1982: 296)

Durgnat's cultural references wind around each other and the film: coiled, tense, sparking to other points of contact. His descriptions simultaneously evoke the film and the wider culture. The rhyming of 'deodorisation, depilation and depersonalisation' and the alliteration of 'd's is more than a stylistic flourish. The words fold into each other, losing their individual identities, and starting with the same letter, they all have the same face. These words are 'smoothly perfidious' so they speak to *Vertigo*'s style and content and, at the same time, they are a sinister little mockery of an advertisement catchphrase where all the 'ations' reveal the clinical science buried under the 'glamour'.[16]

Durgnat doesn't simply write that *Vertigo* is a film about necrophilia; rather, it is a 'necrophiliac tale' where 'tale' evokes the 'archaic', and specifically brings out the film's meta-narrative aspects ('I have a tale to tell'), its deceptions ('telling tales') and its capacity to provide a lesson like a parable or fable ('it tells a tale'). The film is also 'lyric', a short poem of songlike quality, with its patterns of circularity, literally musical or otherwise. 'Lyric' and 'tale' link the film to prior artistic forms, and establish a spectator – a welcome antidote to the perpetually affected and implicated one customarily conceived – who dispassionately, perhaps admiringly, looks upon its form and sees it as an art object situated within a distinguished tradition.

The evaluating spectator

One spectator may feel *Vertigo* to be penetrating, another may find it silly, and these aspects may color their whole experience. Yet, these reactions are often regarded as less important than their other identifications and

involvements. The fact that spectators may disagree over the qualities of the presentation does not alter the fact that they may be an integral part of the viewing experience. A spectator feels a work to be deft, tender or delicate, or perhaps condescending, smug or arch as much as they feel for a character or their situations (indeed, whether the fiction affects them will depend on these qualities of expression). This is the evaluating spectator, perhaps the most prevalent and yet the one least acknowledged in academic treatments of film viewing.

The spectator's attachment to a performer, for example, will be crucial to their engagement, but it need not be sentimental. When Harvey describes Stewart 'both swallowing that last crucial word and coming down on it at the same time', he indicates how the actor's delivery achieves the emotion, and how the delivery might earn the spectator's involvement. It is not only Scottie's plight that is at stake for the spectator but Stewart's handling of it. The spectator senses the risks for the actor – exaggeration, embarrassment, earnestness – in pushing the fervency. The tension between *Vertigo*'s aspiration or potential and its actual achievement is as palpable as that generated by plot or narrative. The spectator monitors the success with which the film handles its elements; and this is not of supplementary interest, but of pressing importance every step of the way. It affects the moment-by-moment viewing of the film.[17]

Furthermore, for the evaluating spectator, aspects of aesthetic value are properties of the work, and not simply subjective projection.[18] Unfortunately, these aspects seem not to be materially present in the way that Midge's apartment *is*, or the way that the small stepladder *is*, or the way Scottie's walking stick *is*. However, the apartment, steps and stick are not simply present, they have a presence *and* they are *presented*, to us, in a particular way.[19]

Different elements of a film sometimes may be of varying quality, and a spectator may be alive to the imbalance or incoherence: for *Vertigo*, she might feel a powerful performance is carrying an otherwise crude drama, an intrusive score is overstating significance or a hitherto shrewdly arranged plot is let down by a wilful dénouement. The evaluating spectator entertains hypotheses about these matters as she views and she verifies or adjusts them as the film progresses. She may change her mind on a second viewing, or after learning of an alternative justification. Some spectators may believe, for example, that on an initial viewing *Vertigo* is less than convincing or credible, but they might eventually see that the

film is testing the limits of such notions, perhaps after reading Harvey who argues that the film is about a 'romantic passion [that] survives disbelief' (42).

This critical spectator constantly questions the film's way of doing things often against the background of alternative options and possibilities. Robin Wood discusses Judy's flashback when the film reveals to the spectator the extent of Elster's trickery and that Madeleine was a fraud:

> Two big questions are now raised: why did Hitchcock choose to break the first law of the mystery thriller and divulge the 'surprise' solution two-thirds of the way through the film? And what difference does the revelation make, in retrospect, to the significance of what has preceded it? . . . Our immediate reaction to the revelation, I think, is extreme disappointment. This can exist on a purely superficial level: we have come to see a mystery story and now we know it all, so what is the use of the film's continuing? Why should we have to watch the detective laboriously discovering things we know already? Much popular discontent with the film can be traced to this premature revelation, and in terms of audience reaction it was certainly a daring move on Hitchcock's part.
> (Wood 1991: 120–21)

Wood uses his essay to articulate explicitly the questions that he considers crucial to understanding the film and to judging its success. They are important to him as a spectator, and to other spectators too for whom the 'premature revelation' caused 'discontent'. The spectator may put any aspect under scrutiny, questioning its place and purpose, but Wood insists that in this case the film deliberately raises the questions. For Wood, divulging 'the "surprise" solution two-thirds of the way through' is a choice that invites questioning. Whether discontented or not, a spectator may simply view the moment as a significant turning point in the plot, and yet the moment holds out hope for a more critical spectator, who recognises it – as it 'break[s] the first law of the mystery thriller' – *as a choice*. The spectator conceives of it not simply as an important moment, but as a creative decision (as Wood does).

Indeed, *Vertigo* is 'daring' because it challenges its spectator to make judgements about its credibility and quality as a film, and risks disapproval. Aspects of narrative continuity, such as the one Wood chose

to discuss, and aspects of stylistic exaggeration may or may not be deliberate provocations, but it would be difficult to appreciate *Vertigo* without arriving at a justification for their appearance. Robin Wood and Tania Modleski give explanations of the dream sequence:

> This begins with an image of disintegration from earlier in the film – the posy which Madeleine plucked to pieces, dropped in the water and watched floating away immediately before her first suicide attempt. Again the posy (suggestive of a tight, unnatural order) disintegrates, only in the dream Hitchcock uses cartoon – crude cartoon at that – to show it: the image of the real flowers turned to paper flowers suggests that the possibility that the whole Madeleine ideal is a fraud is already nightmarishly present in Scottie's subconscious.
> (Wood 1991: 117)

> What is most extraordinary about this dream is that Scottie actually *lives out Madeleine's hallucination*, that very hallucination of which he had tried so desperately to cure her, and he *dies Madeleine's death*. His attempts at a cure having failed, he himself is plunged into the 'feminine' world of psychic disintegration, madness and death. Even the form of the dream, which is off-putting to many viewers because it is so 'phoney', suggest the failure of the 'real' that we have seen to be the stake of Scottie's confrontation with Woman.
> (Modleski 2005: 96–97)

For Wood, the dream not only uses cartoon but a 'crude cartoon', for Modleski, many viewers find it 'phoney', but both critics see it as deliberately artificial. For Wood, it reflects the fraudulence of the Madeleine ideal that is already in Scottie's subconscious. For Modleski, it represents a fundamental 'failure of the "real"' and expresses not only his problem with this woman but with Woman. The defence of the moment rests on establishing its consistency, despite its apparent incongruence, with other aspects, or more precisely their understanding of other aspects, of the film. This is not necessarily because they a priori assume coherence as an aesthetic criterion of value but because they want to demonstrate how the film has effectively *directed* them to (understand or experience) the moment. Indeed, for most of the spectators analysed in this essay, their viewing is guided by what *they think* the film means, and in this sense, their spectatorship is interpretive (or hermeneutical).

Rather than attempting to justify value, some critics *show their appreciation* through description and distinction. Harvey moves through a scene or sequence, susceptible to its progression, so when he finally reaches the moment where Novak 'is gazing out of the window into the light' he appreciates that it is *at this point* that her 'unmediated, cornered-animal quality seems most vivid and moving' (37). Murray Pomerance describes Madeleine's voice as 'articulate without being pompous, gentle and urging yet never hungry' (Pomerance 2004: 257). The intensity of Pomerance's appreciation of color takes him far beyond the red/green duality (with a splash of yellow) that satisfies so many sober commentaries:

> The delicate depth – constructed entirely of the play of colors – of the bouquet Madeleine purchases at Podesta's, miniature pink roses and blue forget-me-nots . . . The autumnal explosion and earthy richness of the architecture, pond, leaves, and lovers as Scottie and Judy amble beside the Musée des Beaux Arts . . . The stunning silver of Madeleine's silk suit. The Neptunian provocation of the turquoise in her gown at Ernie's and the inflammation produced by the flaring and dipping of illumination upon those scarlet flocked walls. Scottie's ethereal teal cashmere sweater, and his sincere chocolate suit. Elster's seductive, ruby office upholstery. The tedious blue of Scottie's sweater in the sanatarium or the sensuous dusty rose of Judy Barton's hotel room walls against the vexatious green of the EMPIRE HOTEL sign outside her window. The clear terrifying blue of that final sky.
> And what a choir are the many yellows in this film!
>
> (Pomerance 2004: 251–52)

Vertigo's extraordinary visual design invites the critic to become an enraptured spectator as Pomerance shows himself to be with regard to the symbolic and expressive virtuosity of color.

The analysis-conscious spectator

An involvement with the writer's involvement (with the film) is crucial to my final type of spectator. The analyses influence the way in which he moves through the film, his disposition and expectations. A piece of writing may persuade him to entertain, or identify with, a way of seeing

– flexibly yielding without surrendering. Simply a word or phrase may open up a perspective. In one mood, or at one time in his life, he may see *Vertigo* like James Harvey; in another mood, at another time, like Tania Modleski. His viewing may allow one perspective to dominate, it may entertain a few simultaneously, or it may proceed by way of an agile negotiation. This is testament to the multidimensional quality of the film, but also to a critically cultivated spectatorship. This spectator may sound a touch rarefied, or academic, but reading film analysis is to experience a formal, considered, extended version of something a companion might say to us in a conversation that will unavoidably colour our viewing. This spectator enjoys interacting with others: he is interdependent, and responsive.

Mulvey's essay has only a paragraph devoted to *Vertigo*, and the account is sketchy, but it presents a possible way of picturing the film, a way of seeing, following and comprehending its entire structure. Through its vocabulary – 'voyeurism', 'sadistic', 'erotic drive', 'obsessive', 'fetish', 'masochism', 'the look', 'symbolic order', 'patriarchal superego' and 'surrogate' – it constructs a world of meaning.[20] The essay reconstitutes the film through a thorough renaming. The spectator enters into a unique creation – Mulvey's *Vertigo*. The spectator's 'surrogate' is now not only Scottie, or the camera, or the director, or the conventions of Hollywood film, patriarchal or otherwise, but Mulvey's essay.

Notes

1. The word 'spectator' carries its own connotations – from sport, for example – and the substitution of 'audience' or 'viewer' may open up different implications.
2. I want to acknowledge that the history of Mulvey's essay is more complicated and involved than my brief account has indicated, especially with regard to its importance to feminist theory and in turn feminist theory's importance to film studies. Indeed, the influence of the essay is pervasive: accepted, adjusted, adapted, absorbed or rejected (sometimes by those who have not even read it). Merely the thought of it, I feel assailed by surrounding voices.
3. Although this is not necessarily the viewpoint that represents the actual moment of viewing. It is also worth remarking that although, quite often, the writer presumptuously equates 'the spectator' with their own view of the film, 'the spectator' sometimes behaves unlike the writer, and this can be disorientating. If a reader thinks that Mulvey's spectator is not Mulvey

the spectator, he or she may feel an irritating dislocation and even some condescension (especially if the spectator is being characterised as limited in capacity). The reader might find comfort in the thought, when required, that the spectator referred to is somebody else.

4 This essay is a companion piece to my essay 'Description' in *The Language and Style of Film Criticism* (Klevan 2011), and to the jointly authored introduction to that book entitled 'The Language and Style of Film Criticism' (Clayton and Klevan 2011).

5 The essay also devotes a paragraph to the Joseph von Sternberg/Marlene Dietrich films but once again appears to see them as *analysing* the processes of looking and 'visual pleasure' rather than lazily succumbing to them.

6 As Dudley Andrew says in his discerning survey piece, 'The Neglected Tradition of Phenomenology in Film Theory', '[W]e should consider much of Cavell's *The World Viewed* in light of [the] effort to describe the experience . . . of the very phenomenon of cinema in its totality. David Thomson's little-remembered *Movie Man* is likewise a descriptive foray into the experience of the movie complex' (Andrew 1985: 628).

7 Conversation in film and philosophy (philosophy conceived as conversation) is central in Cavell's work.

8 Although Cavell's writing in *The World Viewed* tends toward the epigrammatic and impressionistic, across the body of his work he adopts various modes.

9 Cavell discusses this point more fully in 'What Becomes of Things on Film?' when he compares *Vertigo* with *It's a Wonderful Life*. *Persona* (Ingmar Bergman, Sweden, 1966) and *Belle de Jour* (Luis Buñuel, France, 1967) are also important touchstones in the discussion (Cavell 2005: 1–9).

10 See my Cavellian discussion of *Vertigo* as a tragedy of scepticism (Klevan 2000: 13–17).

11 James Harvey says, 'It may be, in some sense, the most romantic film of all. It's the *defiance* of its romanticism that makes it finally so powerful and lingering – and maybe even unique. In prototypical romantic texts like *Wuthering Heights* and *Peter Ibbetson*, both book and movie versions, the romantic passion survives death. In *Vertigo* it survives disbelief' (Harvey 2001: 42).

12 Indeed, this is one of the assumptions behind Mulvey's 'visual pleasure' critique.

13 See Klevan (2000), especially Chapter 7, 'Unconcealing the Obvious'.

14 I also make these points with regard to a different passage of Harvey's in Klevan (2011a).

15 The spectator with whom I recently watched the film was reasonably concerned with Scottie's plight but was particularly disturbed that the film could play such a cruel trick on James Stewart.

16 Durgnat's use of the repetition of a consonant to aid compression is expertly exhibited earlier in his chapter: 'Scottie's house lies on a slope, lending certain scenes, in the context of laterality, a half-ominous, half-elegiac quality of decline' (Durgnat 1982: 293). The repeated use of 'l's allows the aspects to

slide into each other with the constant 'l' sound conveying the quality of slipping away. At the same time, an 'l' is also upright which gives the appearance of verticality (which plays against the 'laterality'). If this form of writing expressed a demonstrative moment of slipping or sliding, it would be more obviously appropriate. To apply it to a few unimposing establishing shots of Scottie's house discloses the implications – only 'half-ominous' – in the apparently ordinary (and stable).

17 See Clayton and Klevan (2011) and Klevan (2011b) for a reiteration of these points in different contexts.
18 Alan H. Goldman supplies a pithy classification in his book *Aesthetic Value*:

> Artworks are rarely conceived or described as mere physical objects or processes. Critics and laypersons alike ascribe properties to them beyond those described in physical terms. They use a large variety of terms in ascribing these properties. First, there are broadly evaluative terms: beautiful, ugly, sublime, dreary; second, formal terms: balanced, graceful, concise, loosely woven; third, emotion terms: sad, angry, joyful, serene; fourth, evocative terms: powerful, stirring, amusing, hilarious, boring; fifth, behavioural terms: sluggish, bouncy, jaunty; sixth, representational terms: realistic, distorted, true to life, erroneous; seventh, second-order perceptual terms: vivid, dull, muted, steely, mellow (ascribed to colors or tones); eighth, historical terms: derivative, original, daring, bold, conservative.
>
> (Goldman 1998: 17)

19 The attitude embodied in presentation is crucial but we are prone to disregard it in our formal analyses of film.
20 This point should not be lost simply because psychoanalytic vocabulary now customarily appears in film analysis.

References

Andrew, D. (1985; originally 1978) 'The Neglected Tradition of Phenomenology in Film Theory' in B. Nichols (ed.) *Movies and Methods Volume II*, London: University of California Press, pp. 625–32.

Cavell, S. (1979) *The World Viewed: Reflections on the Ontology of Film (Enlarged Edition)*, London: Harvard University Press.

—— (2005; originally 1978) 'What Becomes of Things on Film?' in William Rothman (ed.) *Cavell on Film*, New York, NY: State University of New York Press, pp. 1–10.

Clayton, A. and Klevan, A. (2011) 'The Language and Style of Film Criticism' in A. Clayton and A. Klevan (eds.) *The Language and Style of Film Criticism*, Abingdon: Routledge, pp. 1–26.

Durgnat, R. (1982) *The Strange Case of Alfred Hitchcock or, the Plain Man's Hitchcock*, Cambridge, MA: The MIT Press.

Goldman, A. H. (1998) *Aesthetic Value*, Oxford: Westview Press.
Harvey, J. (2001) *Movie Love in the Fifties*, Cambridge, MA: Da Capo Press.
Klevan, A. (2000) *Disclosure of the Everyday: Undramatic Achievement in Narrative Film*, Trowbridge: Flicks Books.
—— (2011a) 'Description' in A. Clayton and A. Klevan (eds.), *The Language and Style of Film Criticism*, Abingdon: Routledge, pp. 70–85.
—— (2011b) 'Notes on Stanley Cavell and Philosophical Film Criticism' in H. Carel and G. Tuck (eds.), *New Takes in Film-Philosophy*, Basingstoke: Palgrave Macmillan, pp. 48–64.
Modleski, T. (2005) *The Women Who Knew Too Much: Hitchcock and Feminist Theory*, Abingdon: Routledge.
Mulvey, L. (1985; originally 1975) 'Visual Pleasure and Narrative Cinema', in B. Nichols (ed.), *Movies and Methods Volume II*, London: University of California Press, pp. 303–15.
Perkins, V. F. (1972) *Film as Film*, London: Penguin.
Pomerance, M. (2004) *An Eye for Hitchcock*, New Brunswick, NJ: Rutgers University Press.
Rothman, W. (2004) *The "I" of the Camera: Essays in Film Criticism, History and Aesthetics*, Cambridge: Cambridge University Press.
Thomson, D. (1967) *Movie Man*, New York, NY: Stein and Day.
Toles, G. (2001) *A House Made of Light: Essays on the Art of Film*, Detroit, MI: Wayne State University Press.
Turvey, M. (2011) 'Wittgenstein' in P. Livingstone and C. Plantinga (eds.), *The Routledge Companion to Film and Philosophy*, Abingdon: Routledge, pp. 470–80.
Wittgenstein, L. (2001; originally 1953), *Philosophical Investigations*, G. E. M. Anscombe (trans.), Oxford: Blackwell.
Wood, R. (1991) *Hitchcock's Films Revisited*, London: Faber and Faber.

Further reading

Cavell, Stanley (1979) *The World Viewed: Reflections on the Ontology of Film (Enlarged Edition)*, London: Harvard University Press. (A classic, beguiling work of film and philosophy that explores the ontology of the medium.)
Durgnat, Raymond (1982) *The Strange Case of Alfred Hitchcock or, the Plain Man's Hitchcock*, Cambridge, MA: The MIT Press. (Especially strong on delineating the moral complexities of the films, and viewing them.)
Harvey, James (2001) *Movie Love in the Fifties*, Cambridge, MA: Da Capo Press. (*Vertigo* is one part of a vivid critical appraisal of 1950s American cinema.)
Modleski, Tania (2005) *The Women Who Knew Too Much: Hitchcock and Feminist Theory*, Abingdon: Routledge. (Unsentimental interpretations drawing out layers of complexity from the perspective of feminist theory.)
Mulvey, Laura (1985) 'Visual Pleasure and Narrative Cinema', in Bill Nichols (ed.), *Movies and Methods Volume II*, London: University of California Press. (Seminal essay on the 'male gaze' that deployed *Vertigo* as an example and was recently announced as the most frequently cited work in Film Studies.)

Perkins, V. F. (1972) *Film as Film*, London: Penguin. (A classic book that explores the sophisticated achievement of aesthetic synthesis particularly in 1950s American cinema.)

Pomerance, Murray (2004) *An Eye for Hitchcock*, New Brunswick, NJ: Rutgers University Press. (Original and involved accounts including a long essay on *Vertigo*.)

Rothman, William (2004) *The "I" of the Camera: Essays in Film Criticism, History and Aesthetics*, Cambridge: Cambridge University Press. (A range of philosophically imaginative essays exploring the complexities of viewpoint especially in relation to the role of the camera.)

Thomson, David (1967) *Movie Man*, New York, NY: Stein and Day. (Another classic book of film criticism generated by an awareness of the medium's ontology. From a similar historical period, it joins hands with Perkins's *Film as Film* and Cavell's *The World Viewed*.)

Toles, George (2001) *A House Made of Light: Essays on the Art of Film*, Detroit, MI: Wayne State University Press. (Sophisticated film criticism including a few essays on Hitchcock's films. The *Rear Window* essay is a penetrating piece of meta-criticism.)

Wood, Robin (1991), *Hitchcock's Films Revisited*, London: Faber and Faber. (A classic text on the director's work with clear and cogent interpretations and evaluations.)

Index

acrophobia, Scottie's 23, 32, 122, 127–8, 136 n10, 175
Alcestis (Euripides) 32–4, 36
Allen, Richard 182
art, works of in *Vertigo* 18–20, 28, 87 n12, 99; *see also* creative/memorial act; design; film, contrasted in *Vertigo* with painting; *kolossos*; *mimêsis*
artificiality 97, 99, 101, 103, 107, 183

Barr, Charles 126
Benjamin, Walter 186, 187, 191 n9, 192 n15
Birds, The (Hitchcock) 91, 112

Cavell, Stanley: *The Claim of Reason* 167 n8; *Contesting Tears* 45, 59, 62; *Pursuits of Happiness* 121; "What Becomes of Things on Film?" 38, 221 n9; *The World Viewed* 38, 49, 174–5, 184, 185, 191 n9, 191 n12, 192 n19, 199, 201–3, 211, 213–14, 221 n6; *see also* comedy, remarriage; melodrama, of the unknown woman
color: and design 177, 178, 179, 188; and fantasy 184–8; and sense of reality 53; as animating 178, 184, 188; compared with sound 182, 183, 188, 192 n15; discoloration 178–9, 182, 184, 188; film's black-and-white past 182–3; as narrative marker in *Vertigo* 74, 86 n2; painterly or in painting 174, 177, 183, 190 n7, 192 n18; psychological effects of 175; repetition of 74, 177–8; as revealing the unity of the world 174–88; as symbol 174, 177; as unifying *Vertigo* 74
comedy, remarriage: Hitchcock thrillers as unlike 46; *Vertigo* as like 66; *see also* Cavell, Stanley; *Rear Window*, and romantic/marriage comedy; reconciliation, marriage and romantic
comedy, screwball 131
copy 19, 22; *see also mimêsis*

creative/memorial act 90–1; in *Sans Soleil* 91, 94; in *Vertigo* 91–2, 94–5; and disturbance 91, 92, 94–5, 96; *see also* kolossos; madness; memory

D'entre les morts (Boileau and Narcejac) 1, 93
dependence 131, 144–6, 149, 170 n21, 170 n22
design(s): Elster's 19, 92, 98, 177, 180, 187; Midge's 97, 98, 181, 190 n8; Scottie's 35; of film 179, 180–1; of *Vertigo* 46, 57, 58, 60, 61, 68, 74, 75, 86 n2, 97, 99–100, 103, 104, 106, 177, 178, 179 as surpassed in/by *Vertigo* 69, 100, 103, 180; *see also* color; disruption in/of *Vertigo*; excess, and excessiveness
destructiveness: in *Sans Soleil* 90, 93–5; in *Vertigo* 91, 98, 102, 106, 107, 108, 109, 110; *see also* horror; violence
director: Elster as 30–1, 37–9, 46, 92, 179, 180, 190 n8; Scottie as 30–1, 37–9, 92; *see also* design
disruption: in Mulvey's text 198; in/of *Vertigo* 104; *see also* film as mad
doubling 27, 33, 79, 86 n5, 103, 139, 155, 169 n20, 176; in Sartre 143, 149; *see also* kolossos; replacement-figurine
drama 22, 23, 29–31, 41 n18, 94, 203
dream: as communication with another world 28; the dreamlike in *Vertigo* 95, 96, 98, 104, 105, 185; "dream reading" of *Vertigo* 46–7, 57, 106, 160–2, 184–5; in Freud 114–15; *see also* fantasy; Marker, Chris; reality; *Vertigo*, dream sequence

Durgnat, Raymond 214–15, 221–2 n16

Emerson, Ralph Waldo 45–6, 62, 65
everyday, the 110, 171 n27, 185, 187; *see also* fantasy, and the everyday or ordinary; magic; supernatural
excess, and excessiveness 100, 110, 182–3; *see also* design, of *Vertigo*; melodrama; theatricality
expressionism 182, 183, 191 n12

fall, the (Christian doctrine) 145, 167 n7, 189 n1, 189 n2; and falling in *Vertigo* 175
Family Plot (Hitchcock) 50
fantasy: and color in film 183, 184–8; and the everyday or ordinary 2, 161–2, 183, 185–8, 171 n27; erotic, joining in and consent 36–7; of rescue 30; Scottie's 35–7, 47, 141; as self-defeating 106; viewer's of *Vertigo* 140, 170–1 n25; the wish to enter 155, 159–60; *see also* dream; everyday, the; psychoanalysis; reality
film: and life and death 46, 92, 96–7, 98, 100, 106, 110; contrasted in *Vertigo* with painting 179–81, 184; as mad 94, 100, 108, 110; as magic 38–9, 47, 184; as mourning 39; as thinking 92, 94–5, 100; as world-disclosing 175; *see also* color; reality in film
freedom *see* dependence
Freud, Sigmund 49, 50, 116; *The Interpretation of Dreams* 114, 135 n2; *On Dreams* 114, 115

gaze: the camera and the 198; Carlotta's 159, 160; of the flower/jewel/eye/necklace in

Scottie's dream 50–1, 53; Judy's 60, 66, 69; Madeleine's 123, 139 n5, 150–1, 155–6, 159, 168 n13; Midge's 98, 133, 153, 155; Scottie's 164, 176, 194; Vertigo's 152; the viewer's 136 n9, 176, 194–5; of the woman in the credit sequence 151–2; of the woman in Scottie's dream 52, 53, 54, 55; see also knowledge; the "male gaze"; objectification, Scottie's flight from; spectatorship
gender: and Elster 74; and Madeleine 99–100, 107; and Scottie 106, 122; see also the "male gaze"
Goethe, Johann Wolfgang von 186, 191 n13
guilt, Scottie's 30, 33, 47, 68, 158, 170 n23, 175–6

Harvey, James 209–13, 216, 217, 219
Heidegger, Martin: Being and Time 175, 192 n16; Parmenides 110
Herrmann, Bernard x; score of Vertigo 1, 20, 95, 99, 100, 103, 105–6, 107, 108, 110, 171 n27, 192 n15; see also Tristan und Isolde
history 9, 89–90, 93, 95–6, 99, 102, 124, 125, 130, 157; see also love, romantic, shared history as condition of
Hitchcock, Alfred: biographical details ix–x; cameo in Vertigo 37, 74, 98; on color 179, 182; complicity of Elster with 69; complicity of the "real" Madeleine with 67; identification of Elster and Scottie with 37–8; identification of Judy/Madeleine with 58, 59; see also violence, or murderousness of Hitchcock's camera

horror: in *Sans Soleil* 93, 94; in *Vertigo* 96, 104, 108, 109; see also destructiveness; violence

identity: and romantic love 82, 84–5, 85–6; as duplicity 175–6; of Judy/Madeleine 61–2, 65–6, 90, 95, 97, 99–100, 107, 189 n3; of Scottie 106, 107
image: metamorphosis of Judy into 179; Scottie gripped by 122–5
imitation 19–20, 21, 23, 24, 27, 37, 39 n4; see also mimêsis
irony: and Elster 180; and fantasy 185; and Midge 181; color and traffic signs 177; identity as ironic 62; of Madeleine's name 141; of meaning 176, 189 n3; of Scottie's lines 109, 150; of *Rear Window*'s ending 119

joke, in *Vertigo* 169 n17, 177, 189 n5

Keane, Marian 40 n16, 41 n29, 162
knowledge: Midge's of Scottie 126–7, 130–5; Elster's of Scottie 127–130; of Judy 188; of Madeleine 158; women's 112–35; see also the look; objectification, Scottie's flight from
kolossos: ancient role of 27, 35; contrast with mimêsis 27, 35, 38; in *Vertigo*, 27–8, 31, 35–7, 38–9; and film 38–9; see also creative/memorial act; mimêsis; replacement-figurine; Vernant, Jean-Pierre

Lady Eve, The (Sturges) 45, 62, 189 n2
Letter from an Unknown Woman (Ophüls) 45, 62

look, the see gaze; Mulvey, Laura; Sartre, Jean-Paul on "the look"
love, romantic: and fantasy 36; and identity 82, 84–5, 85–6; and infidelity 84–5; and mimêsis in Plato 23; as bait 98; as infungible 83; properties-view of 78–80, 85; shared history, as condition of 81–3, 84, 85–6; valuing as autonomous agent, as condition of 80–1; whether realized in Vertigo 7–8, 37, 72, 78, 82–3, 84, 85, 87 n12, 162, 164–6; see also Sartre, Jean-Paul on "love"

Madeleine, the "real" 54–5, 67–8, 69, 87 n9, 143, 166 n1, 188
madness 89, 188; of memory 90–1; of film see film as mad; of Scottie 100, 130
magic 24, 26, 28, 34–5, 36, 37, 38–9, 64, 171 n27; see also film as magic; kolossos
"male gaze", the 116–18, 141–2, 195, 196; see also Mulvey, Laura
Marker, Chris: "A Free Replay (Notes on Vertigo)" 5–6, 46–7, 57, 64, 106, 160–1, 175–6, 185; La Jetée 5–6, 110 n2, 184, 189 n4; Sans Soleil 5–6, 89–91, 93–5, 97, 101–2
Marnie (Hitchcock) 62, 65, 69, 112, 113, 183
melancholy (melancholia) 18, 90, 125, 129, 175, 188
melodrama 2, 110; of the unknown woman 45, 46; see also Cavell, Stanley
memory: as creation 90–1; as lost 141; and madness 90–1, 94; of film 180; see also creative/memorial act
mimesis see mimêsis
mimêsis: and "mimesis" 39 n3; contrast with kolossos 27, 35, 38; in Plato 21–3, 26, 27, 31, 39 n3; in Vertigo 23–4, 25, 28, 29, 31, 34, 36, 38; Xenophon and 21, 26; see also kolossos; magic
Modleski, Tania 142, 149–50, 160, 197, 218
motherhood 99, 152, 165; Carlotta as "mother" 125, 157, 158–9, 160, 165, 169–70 n20; Madeleine's mother 125, 160; Midge as "mother" 47, 97–8, 131–2, 153, 160
mourning: Admetus as 33–4; film as 39; Scottie as 35, 37
Mulvey, Laura 40 n16, 113, 116–20, 141, 194–5, 196–8, 199, 204, 207, 220; see also disruption, in Mulvey's text; objectification, of women; Rear Window, and Mulvey

necrophilia 64, 154–5
North by Northwest (Hitchcock) 62, 112, 183, 189 n1
Notorious (Hitchcock) 66
Novak, Kim 38, 103, 108, 179
Nozick, Robert 82

objectification: of Lisa in Rear Window 118, 119; of Scottie 155, 162–3, 165–6; Scottie's flight from 151–66; two senses of 142–3, 146; of women 141–2, 146, 167 n4; see also Mulvey, Laura; Sartre, Jean-Paul on "the look"
objectivity, in film see reality in film
Ophelia (Shakespeare) 94, 188
Orpheus and Eurydice 1, 31–3, 40 n21, 158, 166, 171 n32

Perkins, V. F. 214
Philadelphia Story, The (Cukor) 42 n34, 96, 169 n18, 213

philosophy 3, 18, 20–1, 72, 73, 78, 94, 95, 203
Plato 21–3, 26, 27, 29, 30, 31, 39 n3, 39 n5, 39 n6, 79; *see also* mimêsis
Pomerance, Murray 219
Proust, Marcel 141, 165
Psycho (Hitchcock) 47, 50, 59, 64, 112, 113
psychoanalysis: and Hitchcock's films 112–13; and interpretation of *Vertigo* 30, 112, 113–36; Scottie's relation to 125, 129; *see also* Freud, Sigmund; Mulvey, Laura
Pygmalion 35

Random Harvest (LeRoy) 63
reality: and/in film 47–9, 57, 61, 180, 181; on the "dream reading" of *Vertigo* 161, 185; and the "dream sequence" in *Vertigo* 47–50, 52, 53, 57; and Judy's "confession" 61; *see also* artificiality; color, as revealing the unity of the world; fantasy; *Vertigo*, dream sequence
Rear Window (Hitchcock) 91, 112, 116, 124, 127, 136 n5, 183, 189–90 n6, 194; and Mulvey 113, 136 n4, 117–20; and romantic/marriage comedy 118–21, 136 n6; and *Vertigo* 3, 73, 121–2, 126–7, 136 n4, 136 n13, 136 n13; Toles on 206, 208
reconciliation, marriage and romantic: absent from *Vertigo* 40 n15, 121, 126; *Rear Window* and 118–21, 136 n6
reflection 3, 9, 95, 153, 169 n15, 181; *see also* film as thinking; philosophy
repetition 75, 78, 86 n1, 112, 176, 188, 189 n2

replacement-figurine 26–7, 40 n11; in *Vertigo* 34, 37; *see also* kolossos
representation 21, 22, 23, 27, 39 n4, 187; *see also* mimêsis
romance, *see* reconciliation, marriage and romantic; comedy, remarriage
Rope (Hitchcock) 31, 68, 91, 182
Rothman, William: *Hitchcock – The Murderous Gaze* 45–6, 47, 56; "Scottie's Dream, Judy's Plan, Madeleine's Revenge" 45–70, 92, 107, 171 n26; *see also* "*Vertigo*: The Unknown Woman in Hitchcock"

San Francisco 25, 27–8, 39 n5, 98, 105, 106
Sartre, Jean-Paul: on "the look" 142–9, 157–8, 167 n4, 164–5; 167 n6, 167 n9, 168 n10, 168 n11; on "love" 147, 149, 164, 165, 168 n10; on "vertigo" 149, 168 n12
scopophilia, Scottie's 128; *see also* Mulvey, Laura
spectatorship 194–222
Stella Dallas (Vidor) 45, 59, 62
Stewart, James 38, 42 n 34, 91, 95–6, 103, 129
supernatural 19, 24, 36, 40 n13, 79, 165; *see also* magic; everyday, the
surrealism 185, 191–2 n14

Tale of Winter, A (Rohmer) 63
theatricality 2, 61, 161, 171 n27, 180; *see also* melodrama
Thomson, David 199–201, 211, 221 n6
time: color and 186; film and 187–8; *La Jetée* and 189 n4; *Vertigo* and 50, 139–41, 152, 156–7, 175
To Catch a Thief (Hitchcock) 183

Toles, George 205–8, 210
tragedy 22, 23, 31; *Vertigo* as 67, 69, 110, 143
Tristan and Isolde, legend of 1, 165
Tristan und Isolde (Wagner) 1, 110, 141
Turvey, Malcolm 195

Ugetsu (Mizoguchi) 52

Vernant, Jean-Pierre 26–7, 40 n13; *see also kolossos*
Vertigo (Hitchcock): credit/title sequence 50–1, 55, 94, 95, 151–2, 185, 192 n15; dream sequence 47–57, 69 105–6, 178, 184–5, 188, 189–90 n6; flashback and Judy's "confession" 59–62, 68, 71–2, 107, 139; Hitchcock's cameo 37, 74, 98; score *see* Herrmann, Bernard, score of *Vertigo*; "vertigo shot" 96, 105, 169 n14, 176; *see also Rear Window*, and *Vertigo*

"*Vertigo*: The Unknown Woman in Hitchcock" (Rothman) 5, 28, 30, 35, 40 n14, 40 n17; Rothman on 45–6, 58–9, 61, 65, 66, 204–5, 207
violence 102, 104, 107, 110, 135; 155, 188; of "dehumanizing" objectification 146; of film 38; of film in *Vertigo* 98; or murderousness of Hitchcock's camera 45–6, 68–9; *see also* destructiveness; horror; Mulvey, Laura
voyeurism, in interpretations of *Vertigo* 141–2, 162; *see also* Mulvey, Laura

water 101–2, 104; 110 n3
Wilde, Oscar 19, 25, 69
Wittgenstein, Ludwig 48, 195, 209
Wood, Robin 142, 171 n28, 217–18
Wrong Man, The (Hitchcock) 48, 65

Taylor & Francis
eBooks
FOR LIBRARIES

ORDER YOUR FREE 30 DAY INSTITUTIONAL TRIAL TODAY!

Over 23,000 eBook titles in the Humanities, Social Sciences, STM and Law from some of the world's leading imprints.

Choose from a range of subject packages or create your own!

- Free MARC records
- COUNTER-compliant usage statistics
- Flexible purchase and pricing options

- Off-site, anytime access via Athens or referring URL
- Print or copy pages or chapters
- Full content search
- Bookmark, highlight and annotate text
- Access to thousands of pages of quality research at the click of a button

For more information, pricing enquiries or to order a free trial, contact your local online sales team.

UK and Rest of World: **online.sales@tandf.co.uk**
US, Canada and Latin America:
e-reference@taylorandfrancis.com

www.ebooksubscriptions.com

A flexible and dynamic resource for teaching, learning and research.

www.routledge.com/philosophy

Fight Club in the Philosophers on Film Series

Fight Club

Edited by **Thomas Wartenberg**,
Mount Holyoke College, USA

"An exciting, thoughtful, and punchy collection of essays exploring the complex screening of philosophical ideas in Fincher's *Fight Club*, including reflections on identity, gender, consumerism, nihilism, narration, reason versus the passions, and romantic comedy. A stimulating and enjoyable read for philosophers, theorists, students and film fans alike." – *Robert Sinnerbrink, Macquarie University, Australia*

Released in 1999, *Fight Club* is David Fincher's popular adaption of Chuck Palahniuk's cult novel, and one of the most philosophically rich films of recent years. This is the first book to explore the varied philosophical aspects of the film. Beginning with an introduction by the editor that places the film and essays in context, each chapter explores a central theme of *Fight Club* from a philosophical perspective. Topics discussed include:

- *Fight Club*, Plato's cave and Descartes' cogito
- moral disintegration
- identity, gender and masculinity
- visuals and narration.

Including annotated further reading at the end of each chapter, *Fight Club* is essential reading for anyone interested in the film, as well as those studying philosophy and film studies.

September 2011 – 180 pages
Pb: 978-0-415-78189-3 | Hb: 978-0-415-78188-6
eBook: 978-0-203-80800-9

For more information and to order a copy visit
www.routledge.com/9780415781893

Available from all good bookshops

www.routledge.com/philosophy

Blade Runner in the Philosophers on Film Series

Blade Runner

Edited by **Amy Coplan**, *California State University - Fullerton, USA*

Ridley Scott's *Blade Runner* is widely regarded as a "masterpiece of modern cinema" and is regularly ranked as one of the great films of all time. Set in a dystopian future where the line between human beings and 'replicants' is blurred, the film raises a host of philosophical questions from what it is to be human and to the nature of consciousness.

This is the first book to explore and address these questions and more from a philosophical point of view. Beginning with a helpful introduction, specially commissioned chapters examine the following questions:

- What is the relationship between emotion and reason and how successful is *Blade Runner* in depicting emotions?
- Can we know what it is like to be a replicant?
- What is the origin of personhood and what qualifies one as a person?
- Does the style of *Blade Runner* have any philosophical significance?
- To what extent is *Blade Runner* a meditation on the nature of film itself?

Including a biography of the director and annotated further reading at the end of each chapter, *Blade Runner* is essential reading for students interested in philosophy and film studies.

Forthcoming December 2013 – 180 pages
Pb: 978-0-415-48585-2 | Hb: 978-0-415-48584-5

Available from all good bookshops

www.routledge.com/philosophy

Philosophy and Film in the Routledge Philosophy Companions Series

The Routledge Companion to Philosophy and Film

Edited by **Paisley Livingston**, *Lingnan University, Hong Kong* and **Carl Plantinga**, *Calvin College, USA*

"The Routledge Companion to Philosophy and Film features incisive, illuminating, well-documented essays authored by a wide range of established major players and a new generation of philosophers of film. This book will be a godsend for teachers of the subject at all levels as well as an indispensable reference volume for anyone interested in exploring the invitation to philosophical reflection that the medium of film inexorably extends to us." – *Nancy Bauer, Tufts University, USA*

The Routledge Companion to Philosophy and Film is the first comprehensive volume to explore the main themes, topics, thinkers and issues in philosophy and film. The *Companion* features sixty specially commissioned chapters from international scholars and is divided into four clear parts:

- issues and concepts
- authors and trends
- genres
- film as philosophy.

Part one is a comprehensive section examining key concepts, including chapters on acting, censorship, character, depiction, ethics, genre, interpretation, narrative, reception and spectatorship and style. Part two covers authors and scholars of film and significant theories Part three examines genres such as documentary, experimental cinema, horror, comedy and tragedy. Part four includes chapters on key directors such as Tarkovsky, Bergman and Terrence Malick and on particular films, including *Memento*.

March 2011 – 684 pages
Pb: 978-0-415-49394-9 | eBook: 978-0-203-87932-0

For more information and to order a copy visit
www.routledge.com/9780415493949

Available from all good bookshops

www.routledge.com/philosophy

Aesthetics in the Routledge Philosophy Companions Series

The Routledge Companion Aesthetics, 3rd Edition

Edited by **Dominic Lopes**, University of British Columbia, Canada and **Berys Gaut**, University of St Andrews, Scotland

Praise for previous editions:

"This is an immensely useful book that belongs in every college library and on the bookshelves of all serious students of aesthetics."
– *Journal of Aesthetics and Art Criticism*

"The sheer eclecticism of this work – the variety of content, method, outlook and sensibility – shows the vigour and vitality that aesthetics as a branch of modern philosophy has come to assume in the last two or three decades. Its compilation is a real achievement, and it will appeal to a very wise range of readers. Some of these essays are, and will remain, classics of their kind."
– Richard Wollheim

The third edition of the acclaimed *Routledge Companion to Aesthetics* contains over sixty chapters written by leading international scholars covering all aspects of aesthetics.

This companion opens with an historical overview of aesthetics including entries on Plato, Aristotle, Kant, Nietzsche, Heidegger, Sibley and Derrida. The second part covers the central concepts and theories needed for a comprehensive understanding of aesthetics including the definitions of art, taste, value of art, beauty, imagination, fiction, narrative, metaphor and pictorial representation. Part three is devoted to the topics that have attracted much contemporary interest in aesthetics including art and ethics, environmental aesthetics and feminist aesthetics. The final part addresses the individual arts of music, photography, film, literature, theatre, dance, architecture and sculpture.

With ten new entries, and revisions and updated suggestions for further reading throughout, *The Routledge Companion to Aesthetics* is essential for anyone interested in aesthetics, art, literature, and visual studies.

Forthcoming April 2013 – 784 pages
Pb: 978-0-415-78287-6 I Hb: 978-0-415-78286-9

For more information and to order a copy visit
www.routledge.com/9780415782876

Available from all good bookshops

www.routledge.com/philosophy

A philosophical exploration of Proust

Proust as Philosopher
The Art of Metaphor

Miguel de Beistegui, *University of Warwick, UK*

"Miguel de Beistegui is the rarest kind of philosophical reader: one who follows Proust where he goes, rather than leading him to foreordained theoretical conclusions, one who learns about life from Proust, rather than translating him into terms already known. This book deserves a place among the very small number of works on Proust that are serious about the depth and richness of Proust's thought. And the beautiful translation of Beistegui's account of Proust's style and vocabulary will enrich any English language reader's sense of Proust's language." – *William Flesch, Brandeis University, USA*

Marcel Proust's *In Search of Lost Time* has long fascinated philosophers for its complex accounts of time, personal identity and narrative, amongst many other themes. *Proust as Philosopher: The Art of Metaphor* is the first book to try and connect Proust's implicit ontology of experience with the question of style, and of metaphor in particular.

Miguel de Beistegui begins with an observation: throughout *In Search of Lost Time*, the two main characters seem prone to chronic dissatisfaction in matters of love, friendship and even art. Reality always falls short of expectation. At the same time, the narrator experiences unexpected bouts of intense elation, the cause and meaning of which remain elusive. Beistegui argues we should understand these experiences as acts of artistic creation, and that this is why Proust himself wrote that true life is the life of art.

He goes on to explore the nature of these joyful and pleasurable experiences and the transformation required of art, and particularly literature, if it is to incorporate them. He concludes that Proust revolutionises the idea of metaphor, extending beyond the confines of language to understand the nature of lived, bodily experience.

August 2012 – 130 pages
Pb: 978-0-415-58432-6 | Hb: 978-0-415-58431-9

For more information and to order a copy visit
www.routledge.com/9780415584326

Available from all good bookshops

www.routledge.com/philosophy

New from Routledge Studies in Contemporary Philosophy

Race, Philosophy, and Film

Edited by **Mary K. Bloodsworth-Lugo**, Washington State University, USA and **Dan Flory**, Montana State University, USA

This collection fills a gap in the current literature in philosophy and film by focusing on the question: How would thinking in philosophy and film be transformed if race were formally incorporated moved from its margins to the center?

The collection's contributors anchor their discussions of race through considerations of specific films and television series, which serve as illustrative examples from which the essays' theorizations are drawn. Inclusive and current in its selection of films and genres, the collection incorporates dramas, comedies, horror, and science fiction films (among other genres) into its discussions, as well as recent and popular titles of interest, such as *Twilight, Avatar, Machete, True Blood, The Matrix* and *The Help*. The essays compel readers to think more deeply about the films they have seen and their experiences of these narratives.

Forthcoming March 2013 – 240 pages
Hb: 978-0-415-62445-9

For more information and to order a copy visit
www.routledge.com/9780415624459

Available from all good bookshops